THE KNIGHTS OF MALTA

THE KNIGHTS
OF MALTA

H.J.A. Sire

YALE UNIVERSITY PRESS
NEW HAVEN AND LONDON

Copyright © 1994 by H.J.A. Sire

Reprinted 1994

The right of H.J.A. Sire to be identified as the author of this Work has been asserted by him in accordance with the Copyright, Designs and Patents Act 1988.

Set in Linotron Bembo by Best-set Typesetter Ltd, Hong Kong
Printed and bound in Hong Kong through World Print

Library of Congress Cataloging-in-Publication Data
Sire, H.J.A.
 The Knights of Malta / by H.J.A. Sire.
 p. cm.
 Includes bibliographical references and index.
 ISBN 0-300-05502-1
 1. Knights of Malta—History. 2. Sovereign Military Hospitaller
 Order of St John of Jerusalem, of Rhodes and of Malta—History.
 I. Title.
 CR4723.S5 1993
 271'.7912—dc20
 92-47283
 CIP

A catalogue record for this book is available from the British Library.

I dedicate this book with absolutely no authorisation
and even less hesitation to

PAMELA WILLIS

whose work in making the Museum and Library of the
Order of St John, Clerkenwell,
the unique resource that it is for historians of the Order
requires the most expressive memorial.

CONTENTS

CONTENTS

PHOTOGRAPHIC
ACKNOWLEDGEMENTS

The following individuals and institutions kindly supplied photographs for inclusion in the book: on pages 2, 92, 106, 197, 215, 216 National Library of Malta; 5, 8, 21, 28, 35, 50, 55, 57, 77, 102, 104, 119, 122, 123, 124, 125, 128, 130, 131, 133, 139, 141, 142, 143, 144, 145, 146, 148, 149, 150, 151, 152, 157, 162, 164, 165, 172, 173, 194, 199, 203, 214, 223, 224 the author's collection; 10, 193, 194, 196, 211, 269, 170 Adam Weinand (ed.) *Der Johanniterorden, Der Malteserorden*, 1988; 17, 19, 22, 24, 58, 65, 67, 96, 105, 133, 154, 177, 178, 179, 180, 181, 183, 184, 185, 186, 213, 220, 228, 230, 237, 240 Museum and Library of the Order of St John, Clerkenwell, London; 18 Meron Benvenisti, *The Crusaders in the Holy Land*, 1970; 20 P. Deschamps, *Crac des Chevaliers*, 1934; 29, 31, 46, 86, 132 Bibliothèque Nationale, Paris; 32, 33, 37, 38, 53 Eugène Flandrin, *L'Orient*, 1853; 33 Albert Berg, *Die Insel Rhodos*, 1862; 40 Biblioteca Communale Augusta di Perugia (photo: Gabinetto Fotografica Nazionale); 41, 42, 43, 44, 45, 48 Biblioteca Nacional, Madrid; 47, 156 Archivo Mas, Barcelona; 61, 126, 216 Salle des Croisades, Versailles (photo: Agence Photographique de la Réunion des Musées Nationaux); 64, 78, 81, 219, 236 Mario Mintoff, Valletta; 67 Musée de l'Amée; 76 National Library of Malta; 79 H. Scicluna, *The Church of St John*, 1930; 87 Stadtarchiv Villingen (Baden-Wurttemberg); 88 Musée de la Marine, Paris; 95, 243, 246 contemporary print; 108 The Louvre (photo: Agence Photographique de la Réunion des Musées Nationaux); 109 Prado, Madrid; 121 Studio M. Martin, Milhaud; 127, 242 Order of Malta, France; 128 Tourist Office, Bourganeuf; 135 F. Ryan, *The House of the Temple*, 1930; 146 Instituto de Estudios Sijenenses, Sijena; 154 Private Collection, Madrid (photo: Francisco Bertendona Collection, Barcelona); 166 Ministero per i Beni Culturali e Ambientali, Genoa; 168, 170, 171, 200, 250, 252, 254, 255, 256, 269, 260, 262, 264 R. Prokopowski, *The Order of Malta*, 1950; 169 Pinacoteca di Faenza; 198, 201 Henry Brownrigg; 203 Michael Galea; 204, 218 Museum of Fine Arts, Valletta; 225 British Museum, London; 226, 272 R. Dauber, Die Marine des Johanniter-Malteser-Ritter-Ordens, 1989; 238 L.-O. Doublet, *Memoires Historiques*, 1883; 244 Private Collection; 268, 273 *Rivista Internazionale* of the Order.

Colour Plate Acknowledgements

The following individuals and institutions kindly supplied photographs for inclusion as colour plates in the book: plate I Museum and Library of the Order of St John, Clerkenwell, London; II, IV Biblioteca Nacional, Madrid; III, VIII Scala; V Bibliothèque de l'Arsenal, Paris; VI, VII, XII Bibliothèque Nationale, Paris; IX, XVIII, XIX, XX Mario Mintoff, Valletta; X Michel Durand, photographer, Dieulefit; XI Studio M. Martin, Milhaud; XIII Cristobal Guitart Aparicio; XIV Paisajes Espanoles, Madrid; XV Instituto de Estudios Sijenenses; XVI Museu d'Art de Catalunya; XVII National Gallery of Art, Washington; XXI the author's collection; XXII Order of Malta; XXIII Peter Drummond-Murray of Mastrick.

INTRODUCTION

THE AGE OF software, economists and pocket calculators has been caught napping; that of chivalry has crept up behind it and taken it unawares. A hundred years ago the Order of Malta appeared a mere honorific memory of the crusades: its Grand Master was an Austrian nobleman treated as a sovereign prince only by his own Emperor and the Holy See; it numbered little more than a thousand knights drawn from the innermost circle of the European aristocracy. Today the Order exchanges ambassadors with nearly sixty governments; it has more than ten thousand knights in thirty-nine national associations throughout the world; its decorations have been proudly accepted by republican heads of state from Africa to the United States; and above all it conducts an international Hospitaller activity with few equals in size, modernity and efficiency.

The resurgence of this nine-hundred-year-old institution, the crusading order of the Knights Hospitaller, to the position it holds today is one of the most surprising phenomena of the twentieth century. It therefore seems right, in offering this contribution to its historiography, to write of it as an institution of the present, and in particular to show the rich trail that the Order has left behind in the history, art and culture of the European nations. This is the purpose of the central section of the book, which pauses in the general narrative to describe the Order's various national groupings.

For the remaining historical account the original intention was simply to précis a story familiar from a long tradition of writing, but it became apparent that here too a new approach was necessary. Recent work has thrown completely new light on a subject which – apart from the first three centuries of the Order's history – has been largely the preserve of amateur historians. Works such as Braudel's masterly treatment of Mediterranean affairs in the sixteenth century, Gangneux's local study of Provence and Fontenay's articles on naval history have made a contribution of much greater precision, and annihilated the national propaganda that sometimes took the place of genuine history. The duty of reinterpretation makes it necessary to give prominence to topics which have hitherto been wrongly or obscurely presented, while more famous scenes such as the sieges of Rhodes and Malta, or the role of the Knights Hospitaller in the crusades, have been reduced to their bare bones. At the same time it has been impossible, in a book of this size, to substantiate every interpretation, and readers who find them unfamiliar are referred to the more detailed works cited in the notes.

A work which ranges over nine centuries and a whole continent cannot hope to escape many errors, especially in view of the almost millennial jungle of mis-statement which confronts every historian of the Order of St John. It is a subject in which excellent work is being done by many people all over the world, and if too many hoary errors have been repeated here their airing will still be useful if it provokes the better-informed to expose and denounce them. One of the efforts at correction attempted here is that of rescuing the names of members of the Order from the havoc wrought with them by monoglot chroniclers, and restoring them to a form which their owners would at least have recognised. The list of Grand Masters is also designed to provide more information of a national kind than is available elsewhere, but

here too there are gaps which it would be useful to fill.

Recently there has been established in France the Société de l'Histoire et du Patrimoine de l'Ordre de Malte; its purpose is to promote the study of the Order's history and in particular to recover from oblivion and neglect the great artistic and architectural wealth which that history has left behind. This book is offered as a contribution to both those ends, not in one country only but in all the lands whose past has been touched by the Knights of St John.

Finally, it may be appropriate to repeat the advertisement which Caxton prefixed to another chivalric history: 'Herein may be seen noble chivalry, courtesy, humanity, friendliness, hardiness, love, friendship, cowardice, murder, virtue and sin.' The survival of Malory's epic shows that these ingredients are capable of preserving a story over many centuries, just as the survival of the Order of Malta shows the power of ideals to sustain an institution through the vicissitudes of history and ideological change.

AUTHOR'S NOTE

WHILE THE AUTHOR recognises the kind assistance of individual members of the Sovereign Order of the Knights of Malta to his research, he is happy to make it clear that the historical interpretations advanced in this book are purely his own and, especially as regards the nineteenth and twentieth centuries, in no way reflect the official view of the Sovereign Order.

ACKNOWLEDGMENTS

I SHOULD LIKE first of all to express my thanks to His Eminent Highness the Grand Master of the Sovereign Military Order of Malta, Fra Andrew Bertie, who was kind enough to grant me two audiences and speak at length about the plans and aims of the Order.

My thanks are also due to the following members of the Sovereign Order whose help for my research has been invaluable: Their Excellencies Fra Cyril Toumanoff, Historian of the Grand Magistry, Fra Franz von Lobstein, Archivist of the Grand Magistry, and Fra José-Antonio Linati Bosch; likewise to Dr Francesco Rosato, Secretary of Communications of the Grand Magistry, and Antonietta Caffarella, Secretary of the Office of Ceremonial.

Other members of the Sovereign Order who have given me their very kind help are H.E. Fra Renato Paternò di Montecupo, of the Grand Priory of Naples and Sicily; Count Lexa von Aehrenthal, Chancellor of the Grand Priory of Austria, and Ritter Robert von Dauber of the same Grand Priory; Baron Jaromir Hruby de Gelenj and Professor Hugo Rokyta of the Grand Priory of Bohemia; Baron Raymond Durègne de Launaguet, M. Georges Dusserre and M. Lucien Gerbeau of the French Association; Doña Carmen de Aréchaga, Archivist of the Spanish Association, and Don Lorenzo Jaume of the same Association; Peregrine Bertie, Esq., Vice-President of the British Association, Peter Drummond-Murray of Mastrick and Professor Jonathan Riley-Smith of the British Association; and Roger de Giorgio, Esq., President of the Maltese Association.

Outside the membership of the Order of Malta, I acknowledge the very valuable help of Dr Anthony Luttrell; Miss Pamela Willis and all the staff of the Museum and Library of the Order of St John, Clerkenwell; Henry Brownrigg, Esq.; M. Michel Fontenay of the Sorbonne, Mlle Anne-Marie Legras of the University of Orleans, and Mme van der Sluys, formerly of the Bibliothèque Nationale; Dr Zeev Goldmann, and Mr Avner Gilad of the Israel Antiquities Authority; Don J.M. Palacios Sanchez, Doña Montserrat Audouart de Vallés and Don Mauricio Torra-Balari.

I would also like to thank the following who have provided me with illustrations: Dr Dominic Cutajar of the Museum of Fine Arts, Valletta, Michael Galea and Mario Mintoff (Malta); Mme Isabel du Pasquier of the Musée de la Légion d'Honneur, Paris; Nikos Kasseris (Rhodes); Don Miguel Lavilla, of the Instituto de Estudios Sijenenses, and Don Cristóbal Guitart (Spain); Herr Michael Wienand of Wienand-Verlag, Cologne.

Above all, I want to express my thanks to my mother, who besides making the research for this book financially possible, mobilised her friends to put me in touch with individual members of the Order of Malta and other historical and artistic authorities in Spain.

My apologies and thanks also go to anyone whose name has been accidentally omitted from among the many who have helped me in preparing this book.

PART I

The Long Crusade

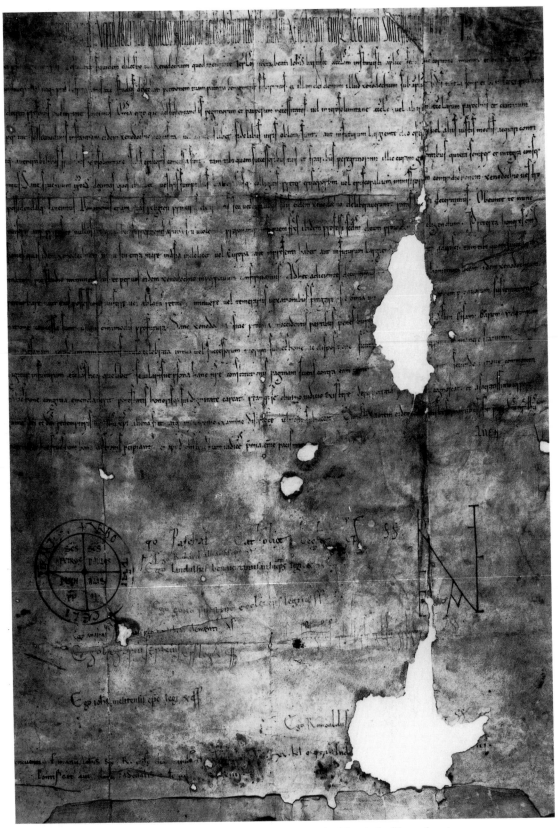

The bull *Pie postulatio voluntatis* of Pope Paschal II, recognising the Hospital of Jerusalem in 1113.

CHAPTER I

The Kingdom of Jerusalem

The Hospital of St John

FROM THE TIME when the Christian Church emerged from the age of persecutions, pilgrims came to Jerusalem to visit the places uniquely sanctified by the life and death of our Redeemer. Charity followed in time to shelter the pious throng, and by the year 603 there was a Latin hospice in the city, founded by Pope Gregory the Great, with which the later Hospital of St John claimed at least a spiritual continuity. Many vicissitudes, including conquest by Persians and Arabs, made the Holy Land often unwelcoming to travellers, and though the Moslems were generally tolerant of their Christian visitors even that security was revoked by the Caliph Hakem, 'a frantic youth,' in Gibbon's palmary phrase, who in the early years of the eleventh century destroyed the Holy Places and subjected the Christians in his kingdom to a fanatical persecution.

Hakem vanished mysteriously in 1021, after proclaiming himself God, and the return of freedom in the East coincided with the beginnings in Western Europe of the golden age of medieval pilgrimage. Jerusalem, the most holy of goals, was also the most difficult, yet as the Christian world gained stability the eastern journey lost many perils. The Italian cities were beginning to break into the Moslem monopoly of Mediterranean trade and to take an interest in the Levant. About the middle years of the century the Benedictine abbey of St Mary of the Latins was founded in Jerusalem by merchants from Amalfi, a city which at that time – before seismic movement first sank and then raised it from the sea – rivalled Venice and Pisa as one of the great mercantile republics of Italy. The monks of St Mary were certainly Italians and probably for the most part from Amalfi, the only western city that traded regularly with Palestine.

Like every monastic house, St Mary of the Latins performed from the first a duty of hospitality to pilgrims, but in Jerusalem that proved a task which soon called for a special dedication of labour. We know that before his death in 1071 the prominent Amalfitan merchant Mauro di Pantaleone was taking steps to provide shelter for pilgrims in Antioch and Jerusalem; but as he was not named as the founder of the Hospital of St John we may conclude that his efforts here only came to fruition after his death. At any rate by 1080 the Abbey of St Mary possessed, under the shadow of its walls, a house of refuge for poor pilgrims; it was built on the site where, according to tradition, the angel had announced the conception of St John the Baptist, and was dedicated in that saint's name.★

The servants of this hospice were a lay fraternity dependent on the monastery but constituting a separate community; the Augustinian rule was adopted, perhaps from an early period, though the documentary evidence does not go back before the mid-twelfth century.[2] Paschal II in his Bull of 1113 names as founder of the hospice Brother Gerard,[3] who directed its

★ The statement by William of Tyre that the original patron of the Hospital was St John the Almsgiver has no foundation except that the church of St John the Baptist on this site, which was given over to the Hospitallers, had been restored by St John the Almsgiver in the sixth century and had come to be known by his name. Contemporary documents show no other patron than the Baptist.[1]

3

fortunes for the first forty years at least and guided its development into a great hospitaller order. But few details of this remarkable man have come down to us. Even his surname (if he stooped to such luxury) and his birthplace are unknown.★ Though one tradition places his origin in Provence, probability suggests he was Italian. What is certain about him is his outstanding character and his exceptional ability as an administrator. Perhaps it is plausible to identify Gerard as one of the Amalfitan merchants whose alms had made the foundation possible, and to suppose that 'the humblest man in the East' had chosen to devote his life as well as his fortune to that charitable service. The early history of his house remains obscure, but after it had been in existence about twenty years a pilgrimage arrived in Jerusalem that was to make the Hospital of St John celebrated throughout the Christian world.

The First Crusade

The Byzantine Empire in the later eleventh century was staggering under the blows of the Seljuk Turks, and turned for aid to the papacy, despite the schism that divided them. Pope Urban II responded to the appeal by summoning a council of churchmen and nobles at Clermont, with the object of seeking armed help for the East and the freeing of the Holy Places. His words struck one of the hidden springs of history, and on that November day of 1095 he called into being the age of the crusades. He had hardly finished speaking when his hearers pledged themselves with tumultuous ardour to the cause he preached, crying 'Deus lo vult! Deus lo vult!' and tearing up strips of linen into crosses to wear as the badge of the Holy War.

Urban's call to arms was answered by all ranks of society, but it was the class represented at Clermont that made the success of the crusades possible: the 'powerful and honoured men, proud in the belt of secular knighthood', who had received his words. The wild impulse to Jerusalem and the fragile kingdoms of Outremer were distinctively their creation, and that

because of a convergence of military and social development that took place at this time. The knights – the heavy cavalrymen with their coats of mail, their lances and their powerful horses – were the arm to which the warfare of the age was yielding mastery. Because of the expense of their equipage, their rank was reaching a stage of identification with that of the manorial lords who were cohering at this time into a visible feudal estate. Urban spoke to them at the moment when they were ready to add religious dedication to the old warrior virtues. By taking up the banner of the crusade they created the ideal of chivalry, of which the military orders of the Church were to become the highest expression.

The army assembled by Pope Urban's exalted plea conquered Jerusalem in July 1099, and as the crusaders returned from the fulfilment of their vow the fame of the Hospital of St John was disseminated all over Europe. For Brother Gerard had risen to the occasion presented by these unusually forceful pilgrims, and, besides acting as – one suspects – the most efficient billeting officer the crusaders had encountered in their three-year campaign, had shown them a vocation of humble service that was not the least of the wonders they found at the tomb of Christ. To the lands where these reports ran the Hospital became, next to the Holy Sepulchre itself, the chief of the Christian institutions in the Holy City. Godfrey de Bouillon, the conqueror of Jerusalem, gave it its first endowments in the new feudal state; kings and nobles followed his example, so that within a few years the Hospital possessed rich properties in the Christian lands bordering the Mediterranean.

These were much more than ornamental gains; the resourceful Gerard was busy with vast schemes, not merely sheltering the pilgrims in Jerusalem but setting up a great network of spiritual travel from Western Europe to the Holy Land. By 1113 he had under his authority seven ancillary hospices, at Bari, Otranto, Taranto, Messina, Pisa, Asti and Saint-Gilles. Until then pilgrimages had almost exclusively followed the land route, making a brief sea crossing from Apulia to northern Greece and

★ The surname Tunc (fancified into French as Tenque or Tonque) seems to be an invention of the seventeenth-century writer Anne de Naberat,[4] and has been explained as a misinterpretation of the phrase 'Geraldus tunc...' in some unknown document. Although the error was soon exposed, the Order has shown a surprising pertinacity in attributing its foundation to Gerard Then.

then following the Roman roads to Constantinople and through Anatolia to Jerusalem; but Gerard's hospices were all (except Asti) in important embarkation places for the Holy Land, and their foundation seems to reflect a plan, very proper to an Amalfitan, to promote direct travel by sea. He probably instituted the service of maritime transport for pilgrims which became so extensive and so competitive beside the commercial carriers, that the city of Marseilles eventually limited the Hospitallers and Templars to a quota of 6,000 pilgrims a year. At the same time the material needs of the hospital, and of Outremer as a whole, were enormous; most of Gerard's European hospices also seem to have been goods depots, and the Hospital of St John became perhaps one of the most important organisers of the life-line of material supply which remained essential to the crusader states throughout the two centuries of their existence.

The Order of the Hospitallers

By 1113 Brother Gerard's organisation had reached a point where it called for corporate establishment, and Pope Paschal II issued the bull *Pie postulatio voluntatis*, giving ecclesiastical recognition to the Hospital and its daughter houses. The servants of the Benedictine abbey of St Mary thereby became the Hospitallers of St John, a foundation of marked novelty in the Church's history. They became the first of the great centralised orders of the middle ages, and their example was soon followed by the Cistercians and later by others;[5] but more than this, the originality of the Order lay in its practical aims: the Blessed Gerard devised a vocation for those who characteristically of their time sought a way of dedicating themselves to the religious life while preserving an active role in the world. It was a vocation especially well adapted to the Order's new field of recruitment, the crusaders who remained in the Holy Land after the fulfilment of their vows; just as the crusade had been presented to them as a form of pilgrimage to which they, as soldiers, were especially called, so they now turned their devotion to the task of helping those whom they had enabled to follow peacefully in their path.

From this aspect of the Hospitaller vocation flowed a development which was soon to prove even more revolutionary; for if Brother Gerard had worked to develop pilgrim travel from Europe, it was a chain in which one weak link remained. The First Crusade had opened up the Mediterranean route, and had given Western seafarers the use of some of the ports on the Levantine coast; but the road between these and Jerusalem was still far from secure, being exposed to incursions from cities such as Tyre and Ascalon which remained in Moslem hands. Gerard, who was remembered in his epitaph especially for his versatile energy, was not the

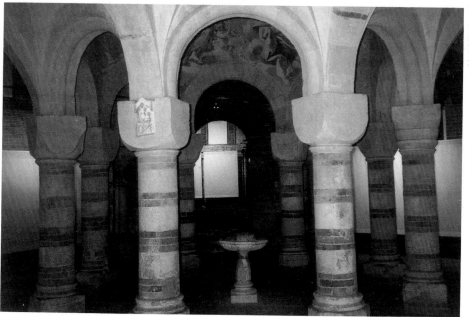

Twelfth-century prioral church of Asti, one of the seven European houses belonging to the Hospital in 1113.

man to shrink from this challenge. He may have been an Amalfitan merchant by origin, but in the siege of Jerusalem he had done all he could, as a non-combatant, to aid the crusaders by climbing onto the walls and throwing rolls of bread at the besiegers under pretence of pelting them with stones (perhaps not so much in a naive attempt to alleviate their shortage of provisions as to show them that they had a friend within the walls); he had subsequently been very successful both in winning the favour of the victorious commanders and in governing an Order increasingly recruited from former soldiers. We do not know when a military role appeared among the Hospitallers, but it would be entirely in character if Gerard saw the need for some of his subjects to resume their discarded coats of mail and ride with the columns of pilgrims on the dangerous road from the coast. The term 'caravans', which was later used for the military campaigns of the Order, betrays their origin in that primitive duty.[6]

The crusade had introduced the notion of war as a religious service; that of a religious order devoted to fighting had not yet been conceived, though it was being adumbrated in these early years of the eleventh century. A plan to found a *Militia Sacra* dependent on the Holy Sepulchre was aired; but the idea was to take form under different auspices. In 1120 a group of knights under Hugo de Payns vowed themselves to the protection of pilgrims in the Holy Land, animated by a spirit of religious dedication which in that age was not a flourish of romantic literature but a spring of action to practical military men. The King of Jerusalem, Baldwin II, gave them a headquarters in the Temple of Solomon, from which they took their name. In their first decade, when they were no more than a band of nine knights united by the rules of a religious sodality, their special task seems to have been that of guarding pilgrims along the River Jordan, a work which could well have been complementary to that of the Hospitallers. Which of the two institutes inspired the other, and which had greater armed strength at this early period, it is impossible to say.

Brother Gerard died in 1120 and his epitaph in the Convent he founded reads as follows:[7]

Here lies Gerard, the humblest man among the dwellers in the East;
The servant of the poor, a welcoming friend to strangers;
He was lowly in mien, but within him shone a noble heart.
The measure of his goodness may be seen within these walls.
He was provident in many things, painstaking in all he did;
He undertook many tasks of diverse nature;
Stretching out his arms diligently to many lands,
He gathered from everywhere the means to feed his people.

By the time of his death the vocation inspired by his example was already bearing fruit to disseminate one of the most vigorous orders of the medieval Church.

Hospitallers and Knights

According to tradition Raymond du Puy, who was elected to succeed Gerard, was a typical representative of the class from which the Hospitallers were now being recruited: a Frankish knight who had come to Jerusalem in the First Crusade and stayed to join the brotherhood of St John. His career as Master certainly supports the idea of a military origin, and he developed the role of the armed brethren of the Hospital far beyond their original calling. By 1126 the officers of the Hospital included a Constable;[8] two years later we find Raymond on campaign with the army of Baldwin II at Ascalon, a sign perhaps that his knights had passed from the role of armed guards to that of fighting in battles; and by the end of the decade Raymond was sending knights to fight in Spain.★

The Templars, for their part, had been pursuing their task with little recognition until in 1128 Hugo de Payns journeyed to France on a recruiting mission. He possessed the advantage that one of his followers was a kinsman of St Bernard of Clairvaux, who wrote for him the tract, *De laude novae militae*. As a result of his

★ An Aragonese charter of 1130 referring to Hospitallers travelling *cum suis armigeris* shows that active military brethren were already familiar in that country.

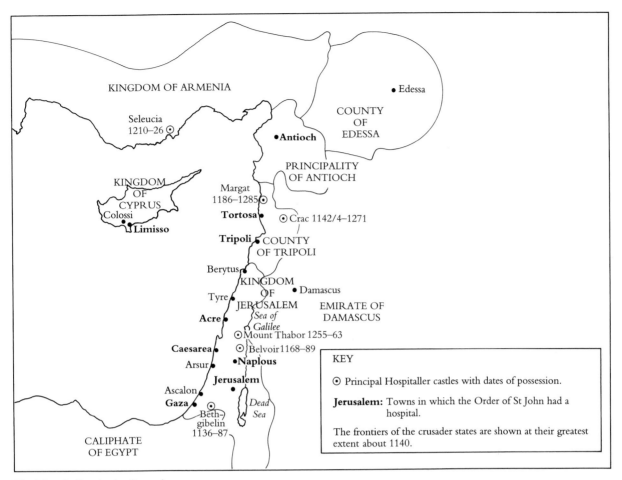

The Hospitallers in the Crusader states.

advocacy the small band of knights grew almost overnight into a large and powerful order, which became the strongest element in the military defence of Outremer. It certainly overtook the armed strength of the Hospital, and the example of the Templars – the very fact that the concept of a military order had been sanctioned by the Church – had far-reaching influence on the Hospitallers. From about 1140 the title of Master was borrowed from the Templars for the superior of the Hospital, to whom previously titles such as Prior or Rector had been applied.

Rapidly the needs of the crusader states placed growing burdens on the knights of the Hospital. In 1136, 'at the urging of the whole kingdom', King Fulk of Jerusalem granted them the castle and fortified town of Bethgibelin, a stronghold of the first importance on the southern frontier of his kingdom. They were placed there to defend the border against Egyptian attacks from Ascalon, to colonise the territory (and therefore to protect the colonists) and to form a base for an eventual conquest of Ascalon, which in fact they helped to take seventeen years later. In 1142/4 the Count of Tripoli likewise turned to the Hospitallers when he sought a vassal to whom he could entrust the defence of his eastern frontier: he gave them five castles, including the famous Crac, which they were to turn into the most powerful castle in the East. By 1148, in the Second Crusade, the Order was a recognised part of the military effort for the defence of the Holy Land.

How this new role affected the Hospitallers' internal life we do not know. Former knights and soldiers who had taken vows as ordinary brethren must gradually have been given tasks appropriate to their experience. There is no evi-

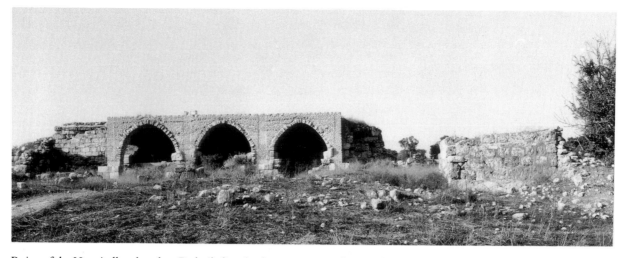

Ruins of the Hospitaller church at Bethgibelin, the first military donation to the Order (1136).

dence of any conscious decision to militarise the Order; until 1206, when the knights were constituted a separate class, nobody could properly describe himself as a 'Knight Hospitaller'. The Order may have relied for much of its military strength on *confratres* (a class known as early as 1111), men who without taking vows associated themselves with the work and spiritual benefits of the Hospital. Thus when we hear of four hundred knights residing in Jerusalem in 1163, and five hundred who marched against Egypt in 1168, we can be certain that these were not all professed: such numbers are greater than those of all the Hospitaller knights in Outremer in the thirteenth century. Yet the distinction between *fratres* and *confratres* was not clear-cut; a variety of vows developed and was not suppressed until 1216, when uniformity of profession was restored.

Important as this military development was, it was almost secondary to the vast expansion of the Order that took place under Raymond du Puy. In Jerusalem the Hospital overflowed its original site and engulfed the Abbey of St Mary, its mother house, which was obliged about 1130 to seek new quarters to the north-east. The buildings of the Hospital covered a square of 150 yards on the south side of the church of the Holy Sepulchre, and completely dominated the Christian quarter of the city. The precinct included the former abbey church of St Mary and the quaint little church of St John which gave the Order its name. The new hospital built

★ See below, p. 12.

in the middle years of the century was a vast hall measuring eighty yards by forty, 'a building so great and marvellous that it would seem impossible unless one saw it',[9] divided into many aisles by 124 marble columns, with a further 64 pillars engaged in the massive walls; they carried intersecting vaults twenty feet high. It had a capacity for two thousand pilgrims, and hundreds of knights and other brethren filled the quarters along the Street of David, on the south side of the precinct. So palatial was this great building that it was to be occupied by Saladin and the Emperor Frederick II when they respectively came into possession of the city.

Moreover in the 1140s Raymond was building another house to receive the pilgrims by sea who landed in Acre, a hospital whose grand proportions, dwarfed only by the mother house in Jerusalem, demonstrate the regal conception of this outstanding Master.★ He also directed the European expansion of the Order, which by the end of his rule was divided into at least seven national priories, two of them (Saint-Gilles and Aragon) already endowed with enormous estates. In 1157–58 we find Raymond, who is said to have been then about eighty, travelling in western Europe to organise these possessions. We do not know if he saw Jerusalem again before his death, which had taken place by 1160. His mastership of thirty-eight to forty years is the longest in the nine-hundred-year history of the Order, and it was as formative as that of the Founder himself. The Hospitallers had established themselves as one of the most flourishing religious orders in the Latin Church, with

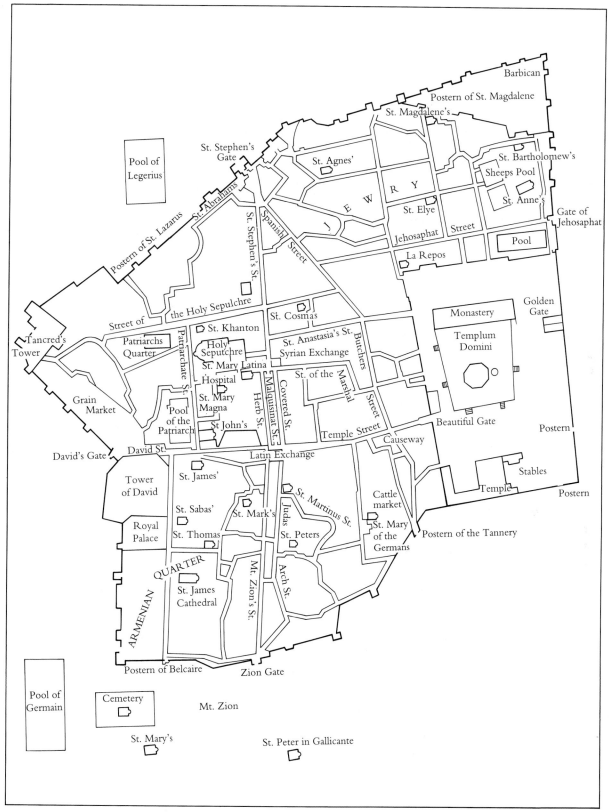

Barbican

Postern of St. Magdalene

St. Magdalene's

St. Agnes'

St. Stephen's Gate

St. Bartholomew's

Sheeps Pool

St. Anne's

Pool of Legerius

Postern of St. Lazarus

St. Abrahams

St. Stephen's St.

Spanish Street

J E W R Y

St. Elye

Jehosaphat

Street

La Repos

Pool

Gate of Jehosaphat

Street of the Holy Sepulchre

Patriarchate St.

St. Cosmas

St. Khanton

St. Anastasia's St.

Syrian Exchange

Butchers

Monastery

Golden Gate

Tancred's Tower

Patriarchs Quarter

Holy Seputchre

St. Mary Latina

Hospital

St. of the Marshal

Templum Domini

Grain Market

St. Mary Magna

Herb St.

Covered St.

Malquisinat St.

Street

Pool of the Patriarch

St John's

Temple Street

Beautiful Gate

Postern

David's Gate

David St.

Latin Exchange

Causeway

Stables

Tower of David

St. James'

St. Martinus St.

Cattle market

Temple

Postern

Royal Palace

St. Sabas'

St. Mark's

Judas

St. Peters

St. Mary of the Germans

Postern of the Tannery

St. Thomas

Q U A R T E R

Mt. Zion's St.

Arch St.

A R M E N I A N

St. James Cathedral

Postern of Belcaire

Zion Gate

Pool of Germain

Cemetery

Mt. Zion

St. Mary's

St. Peter in Gallicante

Map of Jerusalem in the 12th century.

9

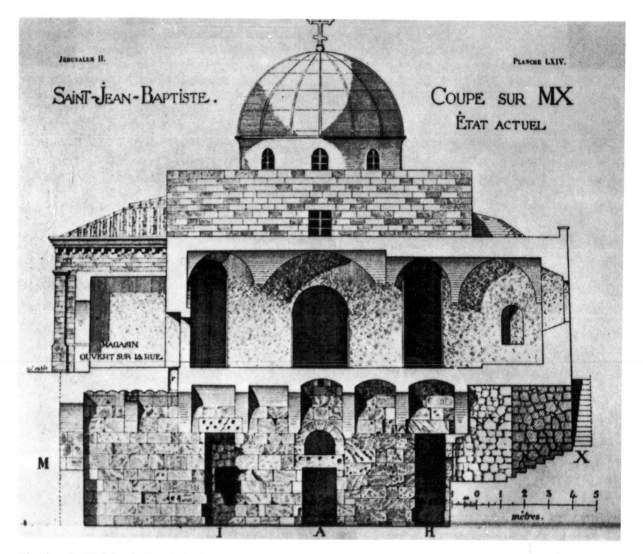

Jérusalem II. Planche LXIV.

SAINT-JEAN-BAPTISTE. COUPE SUR MX
ÉTAT ACTUEL

MAGASIN OUVERT SUR LA RUE.

M X

I A H

mètres.

The church of St John the Baptist in the Hospital of Jerusalem, cross-section.

numerous communities composed mainly of lay *fratres* and *confratres*, whose vocation served the ideal of pilgrimage and helped to turn the eyes of contemporaries to the Holy Land. Except in Syria and Spain there were few military brethren among them, and perhaps even Raymond did not realise that the knights whose role he had developed were about to become the dominant branch of the Order.

The Fall of Jerusalem

A rapid impulsion to the Order's military development was given by the election as Master of Gilbert d'Assailly, 'a man of high spirit, extremely generous, but unstable and vacillating in character'.[10] Under his rule the number of Hospitaller castles increased from seven or eight to twenty. In 1168 he was the prime mover in urging the ill-fated invasion of Egypt, intended to avert the junction of the tottering Caliphate with the Emirate of Damascus, and the consequent envelopment of the Kingdom of Jerusalem. The Templars opposed this campaign because it entailed the breaking of a truce with Egypt, and remained behind when King Amalric's army marched in October, with five hundred Hospitaller knights in its ranks. This was the first of the grave disputes between the two orders which bedevilled the history of the crusader states for ninety years, and it can be linked with the rise of the Order of St John to a

position of military equality, for it may have been an influence on the Templars' opposition that the promised division of spoils would have made the Hospital's possessions in the East greater than their own.

The consequence of the breach was fatal. The Caliph answered the attack by calling in as a saviour the Emir of Damascus, whom a year before he had resisted as an invader. The Christian army was forced to retreat, and Gilbert was so oppressed by the failure that soon afterwards he abdicated, precipitating a crisis of succession in the Order. Shiracouh, the general of Damascus, went on to overthrow the Egyptian monarchy, thus realising the very threat that the Christian campaign had been designed to avert; when he died in the moment of victory the government passed to his nephew Saladin, who by combining the powers of Egypt and Damascus ended the division of Moslem strength on which the Kingdom of Jerusalem had depended for its survival.

After this reverse Jerusalem declined rapidly towards its fall. Amalric died in 1174, and was succeeded by the leper King Baldwin IV; after a reign of increasing infirmity he left the crown to a child of eight and the regency to his cousin, Raymond, Count of Tripoli. The barons of Jerusalem swore to uphold his will after his death, but when the boy king died in 1186, Raymond was tricked into leaving the capital, and the crown was conferred on Guy de Lusignan. The promoters of this *coup d'état* were Renaud de Châtillon and the Master of the Temple, Gerard de Ridfort, who was a bitter enemy of Raymond.★ Alone in Jerusalem the Master of the Hospital, Roger des Moulins, remained true to his oath, and refused to surrender his key to the coffer of the royal insignia. At last, with a gesture of disgust, he threw the key out of the window to be picked up by the conspirators; but neither he nor any of his knights consented to attend the coronation.

Before the end of the year Renaud de Châtillon, in violation of a truce, attacked and captured a caravan travelling to Cairo. It was the opportunity for which Saladin had been waiting to fall upon the divided kingdom, and he prepared to invade when summer came. Guy de Lusignan was persuaded to seek a reconciliation with the Count of Tripoli, and as often happened the Masters of the two military orders were sent as mediators. When they reached the Castle of La Fève, to the south of Nazareth, they heard of a Syrian force whom Raymond had admitted into the country on reconnaissance. To Gerard it was a chance to strike at the Saracens and expose the treason of his old enemy; collecting 130 knights from the neighbourhood, he advanced to the Springs of Cresson, and there it was found that the enemy force was not the small scouting party that had been supposed but an army of seven thousand men. The Marshal of the Templars, Jacques de Mailly, advised retreat, and was supported by Roger des Moulins, but Gerard was still blinded by his determination to shame the Count of Tripoli, and turning contemptuously from the Hospitaller he taunted his Marshal: 'You love your blond head too well to want to lose it.' Mailly replied, 'I shall die in battle like a brave man. It is you who will flee as a traitor.' Stung by Gerard's taunt of cowardice, the Christian knights charged, and were destroyed. Roger des Moulins and his Hospitallers fell on the battlefield, and only Gerard de Ridfort and two of his knights escaped from the slaughter.

Two months later Guy de Lusignan led the army of the kingdom into an even greater disaster at Hattin, which resulted in the loss of Jerusalem. Saladin slaughtered his Templar and Hospitaller prisoners almost to a man[†] in recognition that, while the feudal lords could be brought to some compromise, no respite could be expected from the soldiers whose vows dedicated them to the Holy War. The remnant

★ The origin of Gerard de Ridfort's enmity towards Raymond was as follows: Raymond had promised him, on his arrival in Tripoli, the hand of the first suitable heiress in the County, but when the occasion arrived preferred the bid of a rich Pisan who offered the lady's weight in gold; as she turned the scales at a healthy ten stone the Count got a good price for her. Ridfort, like a prototype Foreign Legionnaire, sought solace from his disappointment in the Order of the Temple, of which he rose to be Master in 1185.

[†] The only exception was Gerard de Ridfort himself, who soon afterwards bought his freedom by ordering the Templar garrison of Gaza to surrender the city. His catastrophic career came to a fitting end during the siege of Acre: blundering to the last, he charged too far into Saladin's camp and was captured and immediately put to death.

of the Order of St John took refuge in their castle of Belvoir, but after a siege of eighteen months that too was forced to capitulate; the Hospitallers were allowed to march out and had no option but to withdraw entirely to the County of Tripoli, where they made the castle of Margat their headquarters.

St John of Acre

For nearly three years after the death of Roger des Moulins the Order was unable to elect a Master. When it finally did so, Richard the Lionheart and Philip Augustus of France had set out on the Third Crusade to retrieve the disasters of the Holy Land, and in view of this expedition the Hospitallers made a well-calculated political choice; the new Master, Garnier de Naplous, had been Prior of England and Grand Commander of France (half of which kingdom was then under English rule). He seems to have been a friend of the English king, and certainly worked closely with him in the crusade, being thus well placed to restore the fortunes of the Hospital.

One consequence for the Hospitallers clearly emerged from the jeopardy of the Christian East: there was now no doubt that they were above all a military order. As late as 1180 the Pope had been reminding them of their first vocation and telling them to avoid bearing arms unless absolutely necessary. In 1191 the view from Rome was quite different: 'Who could not admire how God's might powerfully flowers and perseveres in the said Order and brethren, where each day so many are sustained in arms, so many of the poor are cherished, so many are received into the hospice.'

The Statutes of Margat, issued in 1206, gave legal establishment for the first time to the military organisation of the Order. They introduced the distinction, already long existent among the Templars, between the knights and the sergeants. An entrant to the former class ought to be of legitimate gentle birth and to have received knighthood or the promise of it from a secular lord. The serving brethren and sergeants at arms were drawn from the middle class. These rules reflected the society of Outremer, in which the nobility had for the most part preserved its racial purity, whereas among the general population intermarriage with Syrians had taken place; it was therefore natural to see in pedigree a special proof of crusading virtue.

The process by which the knights came to monopolise power in the Hospital was a gradual one. Not until the late 1230s were they given precedence over the priests, who had hitherto held the first rank in the tripartite division of the Order; the Mastership was restricted to knights in 1262, though in practice it had probably been almost invariably since the death of Gerard in the hands of noblemen: by the 1270s all the high offices of the Order (except that of Prior of the Church) were reserved to knights.* Nevertheless the servants of the poor were slow to develop the sense of caste that existed among the Templars; when in 1259 the Pope permitted the knights to wear the red surcoat in war instead of the black monastic robe they lost little time in extending the privilege to all the fighting members of the Order.

Acre, after its reconquest by Richard the Lionheart in 1192, became the capital of the Kingdom of Jerusalem, a kingdom however which consisted of nothing but the coastal cities. The Hospitallers found that the real base of their power was now in their huge military estates in the north, and saw no point in abandoning Margat for a country where they had no territorial footing. It was perhaps the growing economic importance of Acre that persuaded them to make the city their headquarters a few years later. Their presence there had been prominent since the middle of the twelfth century, when (as the adoption of the name Saint-Jean d'Acre reflects) their church was the finest in the city. Here too they had the greatest of all their hospitals outside Jerusalem. The pilgrims' lodging, whose construction was begun in the 1130s, was a large rectangle which copied that of Jerusalem on a smaller scale, being divided into four longitudinal and six transverse aisles by stone pillars carrying vaults. At its south-western corner was a much loftier building,[11] whose ground floor was occupied by the Refectory, built around 1148. Its vault offers perhaps the first example of the Gothic style in Outremer and the room remained one of the most imposing

* The secular offices were those of Grand Commander, Marshal, Hospitaller, Treasurer and Drapier.

boasted by this city of palaces. The conversion of Acre into the royal capital outstripped the capacity of the hospital as it did that of the old walls of the city. The south-western of the corner-towers delimiting the large square of the Hospital buildings is said to have belonged to the thirteenth-century Master's residence. The knights had to be lodged in a separate house known as the Auberge, a vast palace, 'most noble and beautiful', built in the new suburb of Montmusard on the north side of the city, where they lived under the command of the Marshal.

The brethren's style of life was substantial without being luxurious. Each knight had four horses and at least one squire; he was served two meals a day in the Refectory; he owned two suits and mantles, one for the summer and another, fur-lined, for the winter, and he kept probably as clean as anybody of the time with three shirts and three pairs of drawers; by permission he could go to the public baths. That cloth of gold and silver and silken coverlets were found at least in houses of the greater dignitaries is shown by the statute ordering these to be bequeathed for the use of the Hospital, which then as in every century was stinted of no luxury. The vows of the knights bound them to live not *cum paupertate* but *sine proprio*, and the spirit of the Order always placed more emphasis on charity than austerity.

Hospital and Temple

The Templars and Hospitallers achieved by their efficiency and dedication an indispensable role in the defence of the Christian East. They have also been accused of playing a large part in its decline and fall through their mutual quarrels. 'Oh ancient treachery of the Temple! Oh long-standing sedition of the Hospitallers!' wrote Matthew Paris in an often-repeated rebuke. But what was taking place in the Kingdom of Jerusalem was something importantly different from the rivalry of two powerful orders. The

defeats of 1187 had gravely weakened the powers of the Crown, which were to be progressively encroached upon by the great feudatories, and in the clashes that this struggle caused we find the Templars habitually taking the baronial side and the Hospitallers that of the monarchy. The division clearly reflects a difference in the spirit and tradition of the two orders, whose springs are lost in the poverty of historical record. ★

The Emperor Frederick II became King of Jerusalem in 1225 by right of his marriage to Queen Yolanda, and their son Conrad inherited the title at his birth. When Frederick sent Riccardo Filangieri to the Holy Land as his representative, the barons prevented him from making good his commission anywhere but in Tyre; Acre was a virtual anarchy under a maze of jurisdictions. This suited the barons perfectly well, as did the fact that Frederick's regency would end in 1243, when Conrad legally came of age. The Hospitallers, however, lent themselves to a plot by Filangieri to rouse the monarchists in Acre and prevent the baronial party from perpetuating the regime of oligarchic liberty in the name of the absent boy king. One night in 1242 Filangieri came secretly from Tyre and was let into the city through a postern gate belonging to the Hospital, in whose house a council was held to carry out the royalist *coup d'état*. The plot was discovered, and the Hospital found itself under siege by the baronial party, supported by the Knights Templar. Pierre de Vieille-Brioude, the Master of the Hospital, marched down from Margat with an army and laid siege to the besiegers, and it was only the death of Vieille-Brioude and the agreement reached by his successor that put an end to a six-month civil war. The defeat of the royalist party was soon complete, for Filangieri fell into the hands of his enemies while attempting to return to Italy, and to save his life Tyre was surrendered to the barons.

This was one of the most dramatic of the clashes between the Hospital and the Temple, and the majority of the others can similarly be found to originate in questions of public policy. There were also disputes over discordant rights, inevitable between great corporations, but it is only the telescoping of a century and a half into

★ Compare also the judgment of Sir Steven Runciman (*History of the Crusades*): the Temple's policy 'had always been notoriously selfish and irresponsible', and 'The Hospitallers were throughout more temperate and unselfish.'

the narrative of a few pages that transforms the recurrent quarrels into a tale of unsleeping rivalry between the orders. In time the Hospitallers and Templars found these debilitating contests intolerable, and in 1258 they came together to work out an agreement for the settling of disputes and to bind themselves to mutual assistance in war against the Saracens;* they were thus able to enter the last thirty-three years of the Kingdom of Jerusalem in a solidarity that was, alas, too late to prevail against the unprecedented onslaught that fell upon them.

The Fall of Acre

The treaty of 1229 by which the Emperor Frederick recovered Jerusalem was not recognised by the Hospital, partly because the Church condemned it and also because it could be seen to offer no security if the Moslems returned to the offensive. The Hospitallers resumed possession of their old home and continued to give shelter to pilgrims, but the wisdom of not moving the seat of government was shown when after a mere fifteen years the city fell finally to the Turks. Yet as the Saracen armies ranged ever more menacingly over the interior of the country the coastal strongholds remained secure, supplied by the fleets of the Italian city states. Acre, with its thirty thousand or more inhabitants, its forty magnificent churches, its castle-like palaces and its double line of walls, was far the most splendid of the cities of Outremer. It had cast off the royal authority and was a chaos of seventeen jurisdictions, the Italian communities and the local magnates – including the Master of the Hospital – each governing a separate quarter; it was a city, as Gibbon says, of many sovereigns and no government, and law-breakers of one ward found profusion of sanctuary in the others. This paradise of *laissez-faire*, where luxury had reached a fabulous pitch, where glass, almost unknown in Western Europe, was in common use, and where silken awnings, it was said, stretched across the streets to shade them from the sun, was the principal mart of trade between Europe and the East, and it was supposed that the connexion was too valuable to the Moslems to be forgone by a religious war *à outrance*.

The crown of Jerusalem was inherited in 1267 by the kings of Cyprus, but ten years later their claim was challenged by Charles of Anjou, who succeeded in making himself master of Acre, thus further dividing the fated kingdom; when the Sicilian Vespers struck the southern flank of his empire the Lusignan kings were able to regain the city. In 1286 the fifteen-year-old King Henry came to take possession of his realm, and fittingly the feasts of his coronation were celebrated in the great hall of the Hospital, the Order which had for so long been the upholder of legitimate monarchy. Here, in the twilight of Christian Outremer, the handsome boy King held a glittering court, and there took place for two weeks an enactment of chivalric fable, the knights and noble ladies assigning themselves the roles of the heroes of the Round Table; and Lancelot, Tristan, Palamedes and the Queen of Femenie appeared in jousts and lavish feasts of gallantry.

The scene, though, was not Camelot but Lyonnesse, the last Christian battlefield between the mountains and the sea. In 1289 Tripoli fell to the Saracens and was destroyed; the next year the Sultan of Egypt moved against the opulent remnant of the Kingdom of Jerusalem. Though his death at the outset of the campaign gave the Christians a breathing-space, in April 1291 the siege of Acre began. Few reinforcements arrived from a Europe in which the crusade had been diverted to the interests of papal politics. The defence of the double walls was divided among the many authorities governing the city, the north-western sector being held by the Templars, with the Hospitallers immediately to their right. Both the orders carried out night sorties against the besiegers, but without success. After six weeks of siege the attackers broke through

* The third party to this agreement was the Teutonic Order, which had originated in Acre in 1193. In part it was a continuation of the German hospice which had existed in Jerusalem under Hospitaller jurisdiction, and at first the Teutonic Knights bore, like those of St John, the double character of hospitallers and soldiers. The Order of St John appealed to these facts to claim authority over the knightly foundation too, and their case was upheld by the Pope, who ordered the Teutonic Knights to recognise the supremacy of the Hospital. This claim was still being advanced in 1258, when it was formally excluded from the scope of the agreement between the three orders.

the outer wall to the right of the Hospitallers' position, and only a counter-attack by the two orders, in which the Marshal of the Hospital, Matthieu de Clermont, distinguished himself by his bravery, prevented them from passing into the city. On 18 May the Saracens launched their grand assault, and the fate of Acre was sealed. The city was overwhelmed in scenes of desperate confusion, on the walls where the knights fought with heroic efforts to keep back the swarming enemy, in the harbour where the citizens, with King Henry at their head, struggled for places on the departing ships. The Master of the Hospital, Jean de Villiers, gravely wounded in the defence of the crumbling walls, was carried by his squires to the ships and sailed away to Cyprus. Matthieu de Clermont returned to the battle and to his death. By nightfall Acre was in the enemy's hands; only the Templars fought on, retreating to their great palace at the south-western tip of the city. After ten more days of fighting the walls began to succumb to the mines of the besiegers, and as the Sultan flung two thousand Mamelukes into the breach the whole landward wall of the castle came crashing down, burying defendants and assailers together in its vast ruin.

All along the coast the Christian strongholds gave way like a fall of dominoes; by the end of July Tyre, Sidon and Berytus were lost, and in August the Templars abandoned Château Pèlerin and Tortosa; a few miles off the last-named town they possessed the small island of Ruad, which they continued to hold against a coastline entirely controlled by the Egyptian conquerors. In 1302 that too was given up, and not a watch-tower remained of the long dominion of the crusaders in the East.

CHAPTER II

Crown of Fortresses: Le Crac des Chevaliers

WHEN THE ARMIES of the First Crusade conquered Jerusalem, its government was entrusted to Godfrey of Bouillon. He refused the title of King, declaring that no man should wear a royal crown in the city where Our Lord had been crowned with thorns, but on his death in 1100 his successors, less obliged by idealism, established the Kingdom of Jerusalem. To the north, Raymond Count of Toulouse created the fief of Tripoli; Antioch was an independent Norman principality, and the short-lived County of Edessa completed the chain of crusader states. In 1198 the Armenians accepted union with the Roman Church and formed an allied kingdom under their own dynasty. To these lands strung out along the Levantine coast colonists came to begin the task of creating a European society that might stand on its own against the Moslem hinterland.

That objective, however, as soon became apparent, had little chance of being fulfilled. The resources commanded by the crusader rulers and feudatories could not provide the kind of military machine with which the Normans or the Spanish rolled back the Moslem frontiers in Europe. For this reason the Templars and the Hospitallers – both espousing at first no more warlike policy than that of guarding pilgrim caravans – were very rapidly seized upon as an auxiliary force to defend the crusader states themselves. The capacity of the two orders to recruit members continuously from Europe, together with their religious dedication and discipline, gave a resource which the lords of Outremer could not equal. If the Templars were pioneers on the field of battle, it was to the Hospitallers that the King of Jerusalem first looked when he sought a powerful frontier defence against Egyptian invasion.

In 1136 he entrusted Raymond du Puy with the newly fortified town of Bethgibelin, twelve miles from Ascalon. It was, in William of Tyre's words, 'a strong fortress surrounded by an impregnable wall with towers, ramparts and a moat', and was intended as the first of a circle of strong points from which to resist the Egyptian incursions, to make frequent attacks on Ascalon itself and eventually to conquer the city.

The town was given with a wide surrounding area including ten villages, and was the first of the great Hospitaller military lordships in the Holy Land. Although its ultimate purpose, the conquest of Ascalon, was not accomplished until 1153, the effectiveness of the Hospitallers in this kind of frontier work was evidently soon recognised, for in 1142/4 Count Raymond of Tripoli entrusted them with a far more ambitious work of protection in his own state. A few years before, the Count had lost control of the northern end of the valley of La Boquée; the Saracens had captured the Castle of Montferrand and turned it into a base from which they might range down the valley and reach the coastal cities. If they achieved this the county of Tripoli would be cut in two and a wedge would be driven between it and the Principality of Antioch. With that prospect, and as the County of Edessa tottered before a similar danger, Raymond decided to entrust this entire section of his frontier's defences to the Knights of St John. He made over to them five castles: Mardabech, Lac, Felice, Château Boquée and the castle to which modern French historians have given the name Le Crac des Chevaliers. ★ The Count and his nobles shared the expense of buying some of these properties to give them to the Hospital, and Raymond bound himself not to make peace with the Saracens

without the advice and consent of the Order. At the same time he transferred to the Hospital his rights to two towns which had already passed into enemy possession.

The fortifications of Crac at that time consisted only of the inner *enceinte* visible today, but it was already a sufficiently considerable stronghold for Raymond du Puy to offer it as a residence to the King of Bohemia when he arrived with the Second Crusade in 1147. Many other castles were later acquired by the Hospital, but Crac retained its standing as one of the chief centres of military and political command, as Wilbrand of Oldenburg styled it, 'the greatest and strongest of the castles of the Hospitallers, exceedingly injurious to the Saracens'. When in 1170 its castellan fell into Turkish hands while on a raid, his head was brought to Noureddin in Damascus, and that prince, we are told, rejoiced at the sight, for the castellan was a man held in high esteem for his bravery and piety, and was like a bone in the throat of the Moslems.

The remodelling of Crac after the fall of Jerusalem drew on two generations of experience of frontier defence. The Hospitallers' own contribution to the science of fortification was begun under the magistry of Gilbert d'Assailly, who initiated a vigorous military policy and acquired at least thirteen new castles. The most important of these was Belvoir in Galilee, which Gilbert bought in 1168 and immediately rebuilt. The strictly regular plan that was used created a prototype which was to influence castle design for the next three centuries. The centre was a lofty square keep with corner towers and a small central courtyard, a plan which went back to the Roman *castrum* and was standard in Byzantine fortification; the Hospitallers' own castle of Bethgibelin was of this type. The novelty consisted in surrounding this centre with a second line of walls which were a wider and lower replica of the first. Such outer walls were also a feature of Byzantine city defence, notably at Constantinople itself, but this was the first time the principle had been applied to a castle. It was as if Gilbert d'Assailly had conceived Belvoir as the compact and rigorously military capital of the great border fief which it overlooked and governed.

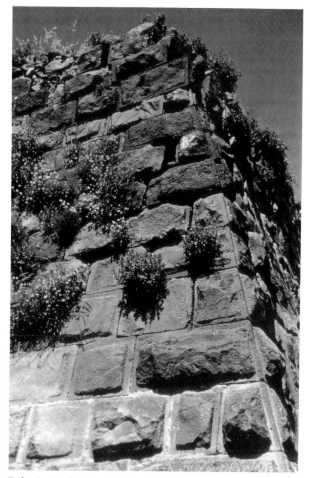

Belvoir Castle. Detail of walls.

The walls of the outer *enceinte* were backed by a continuous range of low halls whose roof provided a *chemin-de-ronde* about twenty feet wide. Around the walls a huge ditch thirty feet deep and sixty feet wide was hewn on three sides into the basalt rock of the mountain, and on the south side, where the ground sloped away, a barbican was built with its base fashioned into a glacis. The perfection of this design was enhanced by its colossal scale and the magnificent quality of its construction, and if Belvoir can claim to be the first concentric castle it is also true that few prototypes have ever embodied to such a high degree the merits of their class.

Belvoir is a monument to the princely vision of Gilbert d'Assailly, and its setting, which the name celebrates, is worthy of its grandeur. An

* In the early twelfth century it was known from its garrison as Hosn el Akrad, the Castle of the Kurds. On Frankish lips the name became Crat, later corrupted to Crac by assimilation to the important castle of Kerak in Oultrejourdain. Some modern writers have flung themselves into the spirit of the thing and adopted the form Krak.

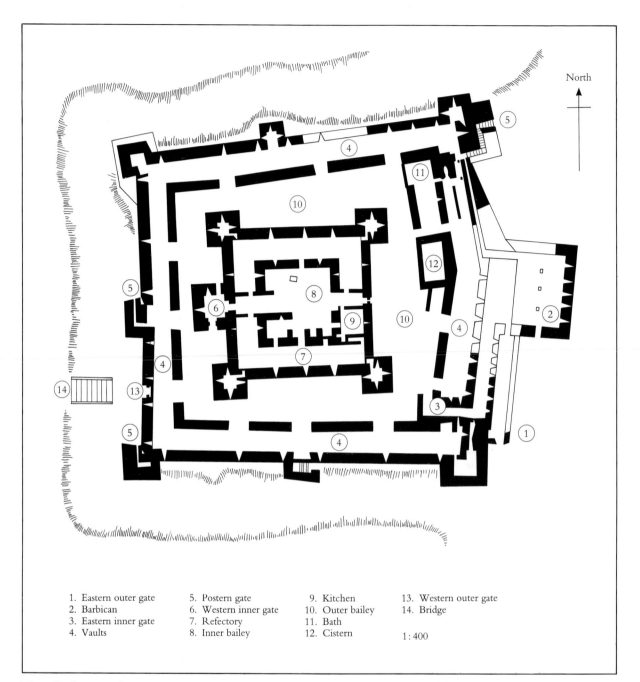

1. Eastern outer gate
2. Barbican
3. Eastern inner gate
4. Vaults
5. Postern gate
6. Western inner gate
7. Refectory
8. Inner bailey
9. Kitchen
10. Outer bailey
11. Bath
12. Cistern
13. Western outer gate
14. Bridge

1 : 400

Plan of Belvoir Castle.

Arabic writer described it as 'set amidst the stars like an eagle's nest and abode of the moon'. It looked out for many leagues over the valley of the Jordan and the Sea of Galilee, and beyond them to the mountains of Gilead and Golan where the Christian frontier with Damascus ran. Its exceptional strength was proved after the fall of Jerusalem in 1187, when all the rest of the kingdom except the almost impregnable coastal fortress of Tyre fell rapidly into Saladin's grasp. For eighteen months Belvoir held out, garrisoned by the knights of the Convent who had been expelled from Jerusalem. Saladin himself took charge of the siege but failed and turned north to complete the conquest of Tripoli. At the end of 1188 he returned, and only then were its defenders obliged to accept terms of surrender, marching out early in the new year to join their brethren in Margat.

The Kingdom of Jerusalem was by then lost, but in the northern states the Hospitallers were in a much stronger position. Besides Crac they had recently bought the coastal castle of Margat, where the Mazoir family had lived in great state for most of the twelfth century. The transaction was a good example of the way in which the nobility of Outremer progressively made over their more vulnerable possessions to the military orders. Saladin marched against both castles in 1188 but found them too strong to capture. The two lordships gave the Hospital such territorial strength in the north that Margat became the seat of the Order's government in 1188 and remained so for some years after the reconquest of Acre.

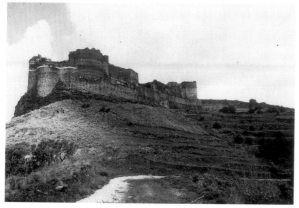

Margat Castle.

The knights might have been well satisfied with both Margat and Crac after defying Saladin, but they showed themselves disposed to take nothing for granted. It was the shortage of man-power suffered by the crusaders in the East that compelled them to put their trust in massive stone walls, and under this exigency they brought the science of fortification to a level of complexity which for the first time made obsolete the achievements of Rome and Byzantium. Of this development Crac is the most sublime example, in T. E. Lawrence's words, 'probably the most wholly admirable castle in the world'. In the late twelfth and early thirteenth centuries the Hospitallers set about applying the principles of the concentric design to Crac, equipping the castle with an outer line of walls. The result was another masterpiece, less regular in design than Belvoir but even more impressive in its adaptation to the needs of the site.

The Castle of the Kurds had been built overlooking the Boquée valley on the Gibel Alawi hills, not on the highest point but towards the northern slopes of the range, where the advanced position might allow a wider view. On three sides steep slopes gave the position great natural strength, but on the southern side it was commanded by higher ground. Here therefore were built the most concentrated defences, both of the original *enceinte* and of the outer wall, and there was no entrance on this side except one high above the ground, probably approached by a light bridge that was raised before battle.

The central buildings – the product of the Hospitallers' first stage of reconstruction soon after they acquired the castle – take the form of a ring of curtain walls strengthened by square towers and enclosing a large courtyard, with no inner keep. In the second rebuilding some of the towers were converted to round ones by being embedded in massive walls, and a huge talus was heaped against the curtain wall on the south and west sides, making it virtually indestructible. In the early years of the thirteenth century the outer *enceinte* was built, with twelve round towers. On the south side a triangular work was added, giving advance protection to the most vulnerable quarter and separated from the castle by a large dry ditch. An aqueduct of four arches spanning the ditch collected water from the summit of the ridge and provisioned the castle; it fed a moat, 230 feet long and from 25 to 50 feet wide, filling the space between the inner and outer walls. Its use would have been partly defensive but primarily as a reservoir to water the livestock required by a besieged castle; and from it tubs could also be drawn for the refreshment of the garrison, for residence in the East had educated the knights in the amenity of the bath. Their drinking water was supplied by wells in the central courtyard.

From the small town grouped on the north slopes under the castle's guard a road wound steeply up the hill to the entrance in the east side. The insignificant gateway disguises its role as the main approach to a great fortress, but behind it is the most elaborate of Crac's defences, the enclosed ramp that climbs in two hairpin bends to the inner walls. Any elation felt by conquerors of the outer gate would have been punished by the formidable journey this approach imposed upon them. Its successive stages are alternately

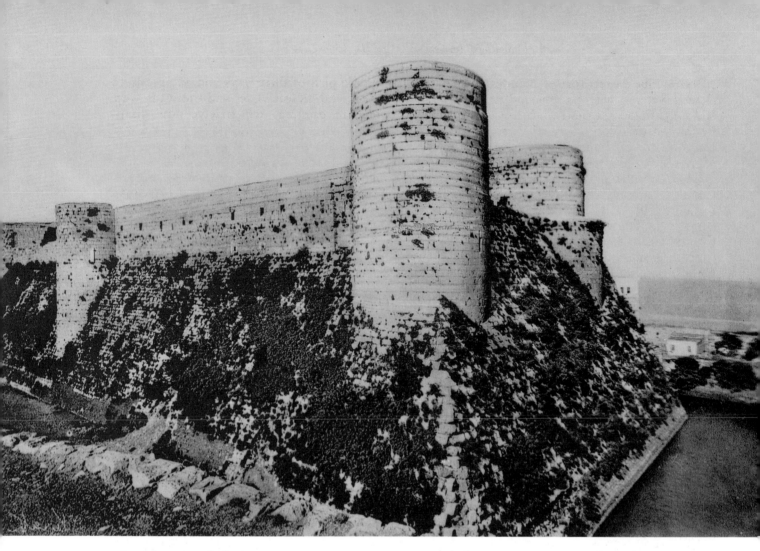

Crac: the moat and talus.

covered over or left open to confuse the invader with the contrast of shadow and glaring sunlight; inward-facing arrow slits and other devices gave the defenders the means to control it with deadly effect, and the first sharp angle was enclosed in an intricate chamber equipped with a portcullis to shut out or trap an attacking party.

If we imagine the easier case of a friendly visitor, his advance would bring him a little breathless but otherwise unscathed to the inner castle. This included the buildings that housed the garrison, intended to be a force of 2,000 men in times of danger. In the thirteenth century the Order of St John never had many more than 300 fighting men under vows in all Outremer, but these controlled an armed force of many times that number. Immediately below the knights

were the sergeants at arms; the bulk of the army consisted of native troops, including the Turcopoles,★ who as a light cavalry complemented the massive charge of the knights. The garrison of Crac at full strength had sixty knights at its head, with a somewhat smaller number of sergeants. At Margat, the Hospitaller castle second only to Crac in size, four knights and twenty-eight sentinels kept watch on the ramparts after nightfall.

Wilbrand of Oldenburg reports that Margat was provisioned for five years, and Crac certainly had the capacity for a similar hoard. An almost underground hall, thought to have been the communal refectory for the soldiers and noncombatants, is nearly 400 feet long. At one end is the bakery, whose flour was ground in the castle's windmill set high on the walls. Fresh meat was assured by herding livestock into the castle in times of siege. To supply these demands the great castles were built where the land was fertile; trav-

★ From the Greek *Tourcopoloi*, Turkish horse. The commander of this force, the Turcopolier, was often a sergeant at arms.

ellers describe the territory of Crac des Chevaliers as well watered with streams and rich in flocks and plantations of fig and olive. It was estimated by the Master of the Hospital that in their heyday the lands of Crac and Margat between them supported a population of ten thousand.

These populations had been built up largely by Christian colonisation. The Hospitallers attracted settlers by the privilege of *bourgeoisie* and granted charters to the villages they founded. Under the castle's walls on the north slopes a town of some consequence grew up, with a church called Notre Dame du Bourg. The Order followed the policy of acquiring land in large compact territories around its castles, and these became semi-independent palatinates, with the power to make peace and war, foreshadowing the Order's sovereign status in Rhodes and Malta. From the walls of Crac flew the flag which was known already in Saladin's time, 'the white cross of peace on the blood-red field of war', symbolising the protection that the Knights of St John gave their vassals for a century and a quarter.

As the years passed Crac softened its military severity with the grace of a religious house and the grandeur of a palace. The chapel, whose size marks the castle as a conventual dwelling, was built in its present form in the late twelfth century.

Its simple plan of three bays and an apse is 70 feet long and 28 feet wide, and the walls were covered in paintings which have now disappeared. Here the professed knights, priests and sergeants gathered daily, as their rule prescribed, for the singing of the monastic hours.

In the thirteenth century the south-western tower was remodelled, presumably as the lodging of the castellan, or perhaps for the occasional residence of the Master. A round chamber at the top of the tower was fashioned with a vaulted ceiling forming a dome. From four columns engaged in the wall spring intersecting arches which serve as the ribs of the vault, and a decorative frieze runs round the wall at the level of the capitals. This well-proportioned, airy room is lit by a spacious Gothic window looking east and framed in a cordon of sculpted flowers, a feature which combines with the window's size to mark it off handsomely from the functional slits of castle architecture.

A little later, in the middle years of the century, the great hall was built: 90 feet long, it ran alongside the long room identified as the communal dining room. The hall was presumably the refectory of the castellan and the brethren.

Crac: interior of the entrance ramp.

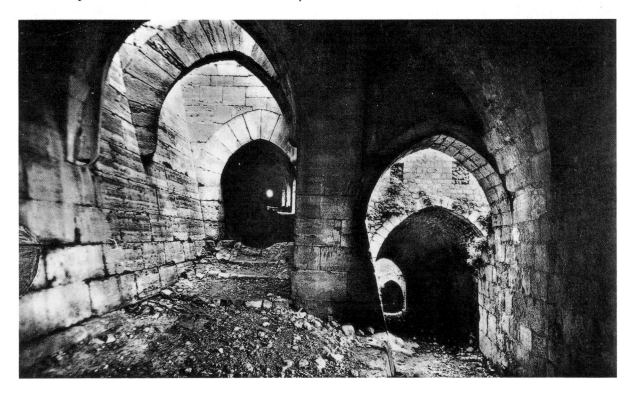

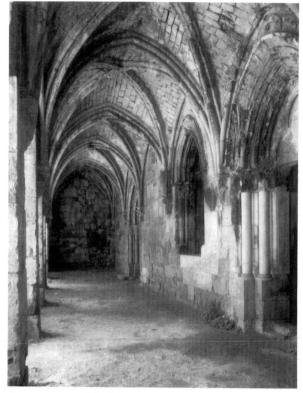

Crac: interior of the loggia.

Along its east side where it is entered from the main courtyard runs the finest of the architectural features of Crac, the cloister-like loggia of seven Gothic arches under which the knights could walk sheltered from the mid-day sun. Its style is wholly French and monastic, and has no parallel in the other castles of the Holy Land. The gracious and religious spirit it expresses finds an echo in the Latin couplet that was carved here in stone:

> Sit tibi copia, sit sapientia, formaque detur,
> Inquinat omnia sola superbia si comitetur.

'Though wealth be thine, and wisdom and beauty given, pride alone, if it goes with them, mars them all.'

The knights who were appointed to command such castles as Crac and Margat were relatively young men, who then went on to hold the high offices of the Order. Only when a knight's soldierly vigour was declining would he be sent to a Priory or Grand Commandery in Europe where his task was to gather and pass on the revenues that kept his brethren in the field. Two successive Masters had previously been castellans

of Crac: Hugues de Revel (1242–47) and Nicolas Lorgne (probably 1254–69). The major strongholds whose garrisons were commanded by castellans included Bethgibelin, Belvoir, Crac, Margat, and Seleucia in Armenia, which was held for a short period from 1210. With the Christian recovery in the thirteenth century, the Hospitallers received in 1255 the fortified monastery of Mount Thabor, near Belvoir, with an enormous lordship which restored the Order's territorial greatness in the Kingdom of Jerusalem. All these centres of command were supported by a string of subordinate castles with smaller garrisons which served as watch-towers and as secondary positions in the line of defence. In 1244, just before the second loss of Jerusalem, the number of Hospitaller castles reached what was perhaps its peak of 29, and over the years, with losses and reconquests, the Order is known to have held at least 56 castles at various points of the crusader states.

Perhaps the most important politically of the Hospitaller castles was Margat. As a fortress it did not quite equal Crac's colossal strength, though it rivalled Crac in the magnificence of its lofty setting, seeming, in the words of Wilbrand of Oldenburg, 'to carry heaven on its shoulders'. The sale of the castle to the Hospitallers in 1186 included the nearby city of Valenia, three abbeys and nineteen villages. Its position on the coast gave it easy communications with Tripoli and the other seaports, and for that reason it was chosen as the Order's headquarters after 1187 and survived until 1285 – only six years before the end of the crusader states. The bishopric and canonries of Valenia became perquisites of chaplains of the Order, and from 1212 the castle itself became the residence of the bishop.

Crac: the loggia of the great hall.

North

0 10 20 30 40 50 60 70 80 90 100 M

Plan of Crac des Chevaliers.

23

Crac: view towards the hospital.

After 1187 the burden of defence against the Saracens began to break the lay nobility, who withdrew to the safety of Cyprus, conquered by Richard the Lionheart in 1191, or to the rich pickings of the Byzantine Empire, which the crusaders began to dismember thirteen years later. The duties thus thrown off had to be taken up more and more by the military orders, which in the thirteenth century became the most important element in the defence of Outremer. The Lord of Arsur, north of Ascalon, sold his lands piecemeal to the Order of St John as the Moslem danger advanced; the transaction was complete by 1261, and by that time the Sultan Bibars had begun his formidable advance. In 1265 he attacked Arsur and took it after a siege of forty days; the loss was catastrophic to the Hospital: 80 or 90 brethren were killed and 180 taken prisoner – well over half the Order's entire fighting strength in the Holy Land. The fol-lowing year Bibars inflicted a similar loss on the Templars, capturing the Castle of Saphet 'of which they had spoken such great words', and won another crushing victory over the Christian forces at Caroublier, where the Order of St John saw a further 45 of its brethren killed.

Margat and Crac both held out against the Sultan's attack in 1269; but with such losses the days of Hospitaller power were numbered. When Bibars resumed his siege of Crac in 1271 the castle was garrisoned by a mere 200 men, instead of the 2,000 that were necessary for its proper defence. For over a week heavy rain prevented Bibars from bringing up his siege engines, but on 15 March, after a heavy bombardment, the Moslems forced the outer gate. A fortnight later they broke through to the inner *enceinte*. The garrison retreated into the lofty and powerful fortifications of the south wall, and defied the enemy's mangonels for ten more days. Then Bibars resorted to a ruse, sending a messenger pigeon with a supposed order from the Master that the castle be abandoned. On 8 April the knights negotiated terms of capitulation and were allowed to withdraw to the city of Tripoli. The conquest of the Syrian hinterland was complete, and nothing remained to the Christians but a string of castles and cities along the coast.

The power of the Hospitallers was now confined to the Castle of Margat and the shore beneath it, for Valenia and all the rich lands which had supplied it were in the hands of the enemy. Nevertheless after the death of Bibars the Order returned to the attack, and in 1280 carried out a raid into the Boquée valley, penetrating almost to Crac. Near Maraclea the raiders worsted a Moslem army sent to stop them, and a punitive expedition despatched by the Sultan was defeated under the walls of Margat. This aggressive policy was continued in succeeding years, until in 1285 the Sultan led a besieging force of exceptional strength against the vexatious outpost. The outcome repeated that of Crac: after a siege of something over a month and the mining of the walls the knights were allowed to ride out from their ruined stronghold. With a brief interval there followed in 1289 the loss of Tripoli itself and two years later the fall of the last remnant of the Kingdom of Jerusalem.

CHAPTER III

Rhodes: The Sovereign Order

Cyprus

FOLLOWING THE YOUTHFUL King Henry, the survivors of the fall of Acre took refuge in Cyprus. Here the Hospital already had extensive possessions, including valuable sugar plantations, and on its property at Limisso the Convent was officially established in 1292.

Two principal problems faced the Hospitallers: the first was to rebuild the Order after the appalling bloodletting at Acre, from which only seven knights had escaped with their lives. In 1302 the Chapter General laid down the number of knights and sergeants at arms that each country must send to bring the strength of the Convent to eighty fighting men; when we contrast this with the hundreds of knights who had garrisoned the castles of Syria we can appreciate the magnitude of the catastrophe from which the Order was struggling to recover.

The second problem was to find a strategic role after the loss of the Holy Land. It was plain, at any rate, that the knights could only continue the war of the Cross by taking to the sea, and this course was adopted without delay. A force of galleys was created which as early as 1293 was sent to the aid of Armenia, and in collaboration with the Templars several raids were made on Moslem territory, including an attempt, from the base of Ruad, to recover Tortosa. These efforts were doomed to failure. After the conquest of Acre, Egypt held the position of hegemony in the East which during the course of the fourteenth century it ceded to Ottoman Turkey. Neither the Kingdom of Cyprus nor the decimated military orders could hope to make any serious impact on its power. Cyprus,

regarding the orders as dangerous subjects, put difficulties in the way of their re-equipping themselves for war, and forbade them to extend their land-holdings, so that neither the Templars nor the Hospitallers were reconciled to it as a permanent base. Armenia still held out as the only Christian kingdom on the Asiatic coast, and if the Hospitallers had committed all their resources to its defence they would have espoused a heroic role, but one for which they would have received small thanks in Europe – or perhaps in Armenia, whose monarchy was even less welcoming than that of Cyprus. In these conditions the pinpricks against Egypt were the only alternative to complete impotence, and in 1302 the abandonment of Ruad was the recognition of their failure.

The Fall of the Templars

The penalty for this failure was being prepared in France. Here the crown had been inherited in 1285 by Philip the Fair, who in his avidity for absolute power sought to impose his control on the Church, and shocked Christendom with the outrage of Anagni, when his armed men broke into the palace of Pope Boniface VIII and threatened his life. Dante expressed the scandal in bitter lines:[1]

> Veggio in Alagna entrar lo fiordaliso,
> E nel Vicario suo Cristo esser catto,
> Veggiolo un altra volta esser deriso.

Boniface, though he faced his captors with a

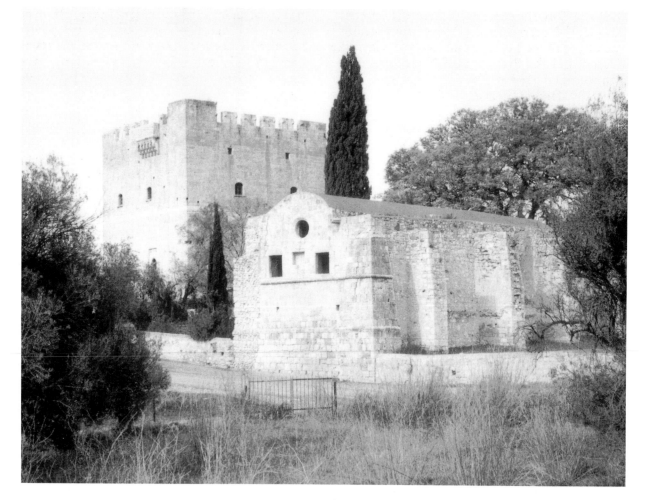

Fourteenth-century sugar refinery of the Knights at Colossi (Cyprus), with their castle beyond.

courage worthy of his imperious nature, died a month later, leaving King Philip with two ruling purposes: to blacken the memory of his late enemy, and to turn the papacy into a pawn of his own power. He secured the removal of the papal residence to Avignon, which resulted in the seventy years of 'Babylonian Captivity' and in the Great Schism that divided the Catholic Church for a further forty years.

With good reason Dante continued his denunciation by accusing 'the new Pilate', who not content with the outrage of Anagni went on to make the Order of the Temple the next victim of his tyranny. Though the wish to lay his hands on the Templars' fabled treasury was also a motive, essentially the persecution of the Order was part of Philip's plan to bring the Church into subjection, and hence to do away with a powerful military and religious body which might be an instrument of papal power against him.

The destruction of the Templars was ruthlessly planned while their chief officers were in France. On 13 October 1307, on a secret order, every Templar in the kingdom was arrested. There followed a catalogue of government propaganda, secret denunciations, interrogation by torture and show trials such as the present century has made familiar in the practice of totalitarian regimes. Philip IV accused the Templars of denying Christ, of idolatry and of other abominable crimes; his minister Guillaume de Nogaret, who had been excommunicated for the outrage against Pope Boniface of which he had been the agent, hounded the Order with all the sanctimoniousness of an evil conscience; and the puppet French pope lent the Church's courts and sanctions to the act of injustice. When he showed signs of wishing to bring to the trials a semblance of fairness, King Philip expedited procedures by burning fifty-four Templars alive

in Paris. With the extorted evidence as a pretext, Clement V decreed in 1312 the suppression of the Order of the Temple, and two years later the Master and the Preceptor of Normandy, who had retracted their confessions, were burnt at the stake. A famous legend declares that the last words of Jaques de Molay amid the flames were to summon his persecutors to justice before the Court of Heaven, and it is a fact that Clement V was called within a few days to answer that indictment, while Philip IV did not outlive the year.

A Kingdom in Rhodes

As to the Hospitallers, threats were uttered in King Philip's last years that he was preparing for them the same fate as for the Templars, but already the Order had taken action which put it outside the reach of any European monarch. In 1305 it elected as Master Foulques de Villaret, a genial and somewhat unscrupulous character who had already, as Admiral of the Order's fleet, taken a prominent part in the emergence of the Hospitallers' new strategic role. He came to office at a time when the eyes of all those who had interests in the Levant were turning towards the Aegean, a world which in those years appeared to be in the melting-pot. The elements in the situation were various: the beleaguered Empire of Byzantium clutching at the remnants of its dominions; Venice and Genoa scrambling for new markets after the loss of the Syrian ports; Angevin ambitions established in the Peloponnese twenty years before and rumbling with threats of revival; the new aggression of the Catalans striking at the heart of the Empire; and a cluster of Turkish principalities on the mainland taking advantage of Byzantine weakness to prey upon the islands. In the West schemes were being hatched to profit from this vacuum of power; Boniface VIII had originated a project to give King Frederick II of Sicily the island of Rhodes, and in belated pursuance of it the King's half-brother Sancho of Aragon, who was a Knight of St John, led an unsuccessful expedition to the Greek islands. With Clement V plans took a French direction, and the talk was of a general attack by western countries, led by France, against the Byzantine Empire. Of more immediate impact was the struggle for power between Venice and Genoa; in 1306 the Venetians seized the Genoese islands between Crete and Rhodes and were looking covetously at Rhodes itself.

There was opportunity here for anyone bold enough to see it, and Villaret's eyes, as he watched from Cyprus, fell naturally on Rhodes. With its excellent harbour and its fertile territory it would make an ideal independent base for the Order. Yet its present state was far from giving promise of its glory under the Knights; tenuously attached to the Byzantine Empire, the island had been for thirty years the fief of a series of Genoese admirals; its condition was lamentable, the city of Rhodes, of ancient fame, reduced to a miserable ruin; the Turks had invaded and partly occupied the island; the Genoese governor, Andrea Moresco, had been captured and imprisoned by the Cypriots for his piratical activities, leaving his brother to exercise the shreds of authority that remained to his office. It was a wretched prelude to one of the most brilliant periods of the country's history.

The Hospital's policy had traditionally been one of friendship with Genoa, at least since the War of St Sabas in Acre in 1257. Whether Villaret meant to support Genoa outright against Venice, or whether he merely saw the opportunity to exploit the flux of war, cannot be determined. At any rate it was essential to his plan to widen the Order's small naval resources. In the spring of 1306 the uncle of the two Moresco brothers, Vignolo de' Vignoli, who was as great a buccaneer as his nephews, came to Villaret with a plan to intervene in the chaotic situation of Rhodes. He claimed that the Emperor had granted him the island of Langò (as Cos was then known) and other fiefs, including a piece of Rhodes. He was ready to give up a share of his hypothetical realms to the Hospital in return for an agreement to conquer them together. It was a good bargain for Vignolo, who was enabled to give reality to his family's shadowy claims, and for the Order, which on Vignolo's death would succeed to his share of the conquests.

An expedition set out in Vignolo's ships in June 1306, and by the end of the year it had conquered the capital of the island, Filermo, on its lofty hill. The city of Rhodes probably fell in August 1309 (the month is known, but not the

year). In September 1307, only a few weeks before Philip IV's sudden blow against the Templars, Clement V confirmed the Hospitallers in their possession of the island. He made this grant to Villaret in person, who had travelled to the papal court and remained there for another two years, beguiling the European sovereigns with large talk of a crusade while he tried to raise the forces necessary to complete the conquest. In the confused state of the Aegean, Villaret seems to have walked a tightrope course between Genoa and Venice: now Genoa helped Byzantium to defend their common claims in Rhodes, now Villaret secured Genoa's support for his expedition of reinforcement; at one moment the Venetians resisted the Hospitallers' threat to their position in Langò, at the next they were appeased by Villaret's assurances of friendship. Somehow, out of the diplomatic and military confusion, the Hospitallers emerged the winners, and by the end of 1310 Rhodes was fully under their control.

By this adventure Villaret had won for himself the status of an independent sovereign; yet more triumphs were to follow. In Cyprus King Henry, the hero of the Arthurian court of Acre, had been deposed by his brother Amalric and

sent into exile, but in 1310 Amalric was assassinated and Villaret was named by Henry to act for him in the kingdom, thus becoming the arbiter of the royal restoration. Two years later the Hospitallers stepped immediately into the Templars' rich possessions in Cyprus, granted to them in Clement V's dissolution of the Order: an invaluable accession to their power in the island. In the mean time Villaret had firmly enforced the papal ban on trade in materials of war with the Moslems; since the promoters of that trade in Rhodes were the Order's Genoese allies, it was a demonstration that the manoeuvres of the past six years were not to be seen as a cynical abandonment of the religious war. The Genoese, never in two minds between God and Mammon, were very ready not merely to sell armaments to the Turks but even to make alliance with them against the chivalry of the Cross. It was a bad move; in 1312 the navy of the Order chased the Turkish fleet to Amorgos and captured almost the entire force, destroying the ships. The Genoese found no choice but to make a Christian peace. Further afield Villaret's star was no less resplendent; the death of Philip the Fair removed the threat to the Order in France, and above all Clement V's insistence on transferring the Templar lands to the Hospitallers made them the sole heirs to the greatest of the

The castle of the Knights at Lindos (Rhodes).

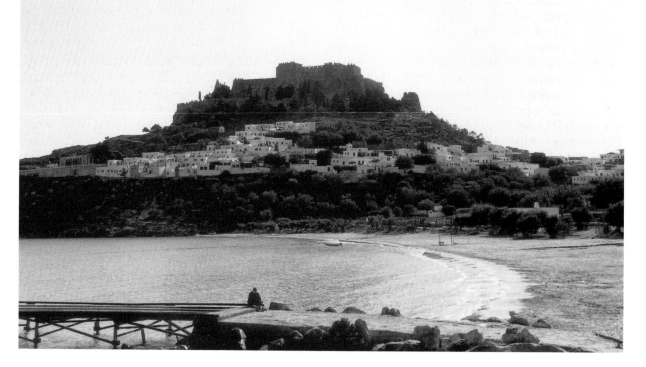

military orders, an outcome which no-one could have dared to dream of in the grim years of royal terrorism that had gone before.

In a few years Villaret had raised the Order from the dependence and disorientation that followed the loss of the Holy Land to a position of unprecedented power. It was an achievement to turn any man's head, and sadly Villaret was not immune from hubris. Enthroned in Rhodes, he adopted the state and methods of a despot. In 1317 he fled from his capital when an attempt on his life disclosed the feeling against him; he found himself besieged in Lindos, an object now of hatred to the knights who had acclaimed him as a hero. The rebels elected Maurice de Pagnac to replace him in the mastership. It was a situation which inevitably called for the intervention of the Holy See, and fortunately the Pope handled the crisis with acumen. Villaret was reinstated for form's sake but induced to abdicate; Pagnac was dispatched to the remote and arduous duty of defending the Hospital's lands in Armenia; and under papal direction the Order conferred the mastership on Hélion de Villeneuve.

The Pope's choice was as well judged as his diplomacy had been. Villeneuve was faced with formidable problems: the vast debts left by the conquest of Rhodes, the difficulties in making real the nominal transfer of the Templar lands, the disrespect for the crusading brotherhood that the fall of the Templars had taught the princes of Europe. A breakdown of the Order's government at this moment was the worst temptation that could be offered to royal predators. Villeneuve's attack on these problems kept him in Western Europe until 1332, while the Order's position in Rhodes was upheld by an able Grand Commander, Albrecht von Schwarzburg. In 1319 he took Lerro from the Greeks and destroyed a great Turkish force destined for the invasion of Rhodes; his victory removed the threat of Turkish conquest from the sphere of practical politics for over a hundred years. The peace of the next decade and more, during which the Hospitallers consolidated their government and recouped their strength, was founded on these feats of arms, by which the knights made the flag of St John once more the banner of Christian victory in the Eastern war.

The importance of the conquest of Rhodes in establishing a new role for the Order after the loss of the Holy Land can hardly be exaggerated. The Templars succumbed dramatically within a few years of losing their traditional task; two centuries later, the Spanish military orders barely reached the end of the *Reconquista* before being absorbed by the Crown. The Teutonic knights (whose example must have been part of the inspiration for Villaret's campaign) made a new vocation for themselves in Christianising and Germanising the Baltic lands, until the resur-

Silver coin of Grand Master Helion de Villeneuve.

gence of Polish power and more particularly the stab in the back administered by the German Reformation overturned their achievement. The special virtue of the Hospitallers' exploit was that it established the Order as a strong outer bastion in the principal area of Latin colonisation, an area in which nearly every Western state either possessed an interest or might contemplate acquiring one. If Villaret fully appreciated what he was doing in making the knights masters of Rhodes he must be reckoned a political genius of the first order. It is due to him that in the age of Francis I and Henry VIII all Europe continued to take it for granted that the Order of St John should be preserved as an independent military and naval force, and that even today the same Order pursues its international hospitaller tasks with the freedom and advantages of a sovereign body.

Here be Dragons

When Villeneuve died in 1346 and his brethren gathered to elect his successor, it is said that the Grand Commander, Dieudonné de Gozon, rose in the assembly and declared that on deep consideration he found no-one among his companions so fit to occupy that office as himself; awed by this sublime self-confidence the Hospitallers unanimously elected him to the magistral throne. It is also said that as a young knight Gozon had rid the island of a dragon that had been devouring young maidens in the neighbourhood of Rhodes. After several knights had lost their lives trying to kill it, the Master had strictly forbidden any more to make the attempt. But Gozon trained two large hounds especially for this fearsome hunt (with the aid of a model built from eyewitness accounts). His plan was put into effect; the wicked Worm was slain. So inexorable, however, was the discipline of the Hospital against disobedience that Hélion de Villeneuve upheld the threatened sentence and stripped Gozon of his habit. He later relented on the plea that the act had been for the public good, a grace but for which the Order would have been deprived of one of its most notable Masters.

We may be led astray by this tale if it prompts us to speculation as to the kind of animal that harassed Rhodes in the early part of the fourteenth century; what we can learn from it with certainty is that the Knights had taken the afflicted land of Rhodes and made of it a chivalric Isle of Gramarye. For the first time, as they had not been able to in Jerusalem or even in the lordly fastnesses of Belvoir or Crac, they had created their own knightly realm, moated by the sea, where the Master of the Hospital ruled amid a court of the noblest blood of Christendom: men of whose exploits legends were made.

Foulques de Villaret had chosen for the dwelling of the knights an island famous for its beauty since ancient times: claram Rhodon, which Horace had appealed to as a byword of loveliness when he wished to praise his own Tiburnian groves. The roses that grew there in abundance gave the island its name. There were fertile valleys whose produce sustained the knights, and the pine-clad hills gave timber for their fleet. More than a kingdom, Rhodes gave the knights a garden, and after the parched wars of Palestine they rested for a while in ease and splendour. We are told that Villeneuve, because of the economies to which he was constrained in his first years, later wished to throw off the imputation of meanness with a royal magnificence. In 1343 Pope Clement VI complained to him: 'The administrators of the Order ride great fine horses, feast on exquisite viands, wear magnificent apparel, drink from cups of gold and silver, and keep birds and hounds for the chase.' The Pope might rebuke the decline of religious poverty, but Rhodes reaped the fruit of secular amenity; in the forests roamed the herds of deer that the knights introduced in their love of the chase, and the ancient capital rose again in strength and beauty. An English visitor of 1345 thus described it: 'Within the castle walls are an archbishop and his metropolitan church, and the dwellings of the many citizens are like those of distinguished men. There are moneyers, armourers and all the artificers necessary to a city or a royal castle. Below the castle is the house of the hospital, a mother, nurse, doctor, protector and handmaiden to all the infirm.'

The City of the Knights

The rebuilding of the city of Rhodes reflected a very clear conception of the new state the knights had created. The Byzantine governor's palace on its little eminence overlooking the port was adopted as the Master's residence and, rebuilt, took on the character of a sovereign's palace. The walled Byzantine city (a much smaller area than that of ancient Rhodes) which sloped down from the palace to the port was appropriated in its entirety as the Convent or Collachio of the Order. Its straight main street (a relic of the Hellenistic city plan) ran down from the top of the hill – where a spacious loggia gave access to the palace on one side and the church of St John on the other – to the main façade of the cathedral just inside the harbour wall; on both sides the street was filled with the conventual buildings of the knights. The first hospital stood at the bottom of this street, and next to it, in the north-eastern corner of the Collachio, was the arsenal or dockyard, communicating by a

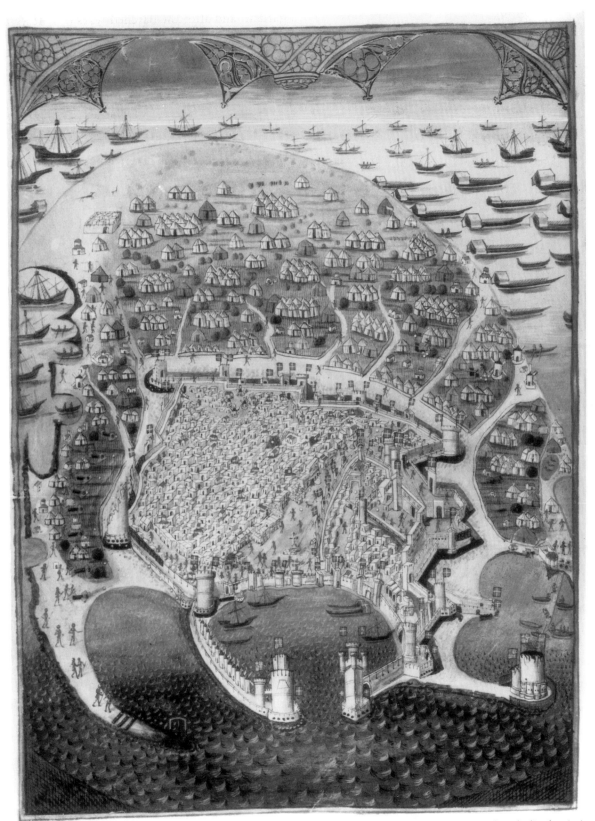

View of the city of Rhodes, from Guillaume Caoursin's history of the siege of 1480, *Obsidionis urbis Rhodice descripcio*.

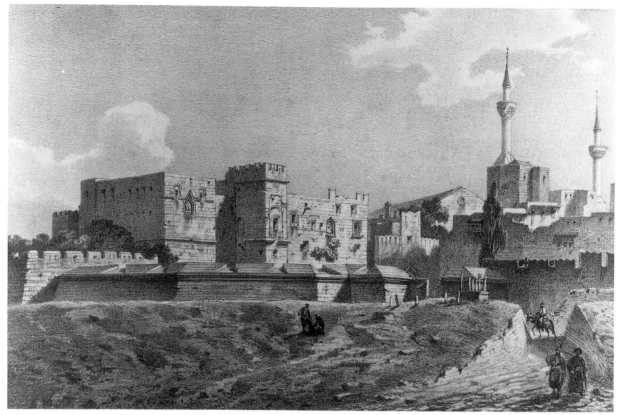

The Palace of the Grand Masters in Rhodes, before its destruction in 1856.

wide arch in its eastern wall with the innermost and best-defended part of the harbour.★

Whereas in Acre all the military brethren had lodged together in the huge Auberge, the move to Cyprus, where no such building awaited them, seems to have introduced the practice of living in small national residences. A capitular decree of 1301 gave official standing to seven 'Tongues', which in order of precedence were Provence, Auvergne, France, Spain, Italy, England and Germany. The head of each Tongue in the Convent was called its 'Pillar', and had reserved for him one of the great offices of the Order; as these had hitherto numbered only five, the posts of Admiral and Turcopolier were raised to the same rank, and the supremacy once enjoyed by the Grand Commander and Marshal was attenuated by the near-equality of the new seven.

The Order of St John grew rapidly in the first half of the fourteenth century, and there were apparently four hundred Hospitallers in Rhodes by the mid-century, against three hundred in all Outremer at the height of the Order's power there. For each Tongue there was built a spacious Inn, where its members dined under the eye of their Pillar.† In fact, of the three largest Langues, Provence had a separate Auberge for brethren from east of the Rhone ('Lesser Provence'), France lodged its chaplains in their own residence, and Spain had a distinct Catalan hospice. There are grounds for believing that the system of Auberges was not as fully organised as it later was in Malta, and that residence in these was reserved for brethren making a relatively short stay, the remainder living (usually in twos or threes) in the private houses that filled the rest of the *Collachio*. The Langues nevertheless remained the basis for the communal life of the Order and its military organisation, the defence

★ The identification by earlier historians of the small northern creek (Mandraccio) as the galley port is clearly mistaken. Its beach faced only the blank northern wall of the arsenal and cannot have had any naval use.

† Following the usage of English histories of the Order, these three terms will henceforth be given their French forms of Langue, Auberge and Pilier.

The Loggia and Street of the Knights, Rhodes, before 1856.

of the city's walls being allocated by sections among the seven nations.

The civil population had been evicted to the southern suburbs, from which only a single gate gave access to the walled town of the knights. The outer city was delimited in the middle of the fourteenth century by the first stage of the fortifications which made Rhodes one of the most impregnable cities in the Mediterranean. The town had the disadvantage of occupying the skirts of a long slope whose summit is at the old Rhodian acropolis half a mile to the south-west; consequently a huge ditch was cut between the walls and the rising ground beyond them, so that any troops attempting to scale the walls would have to trap themselves in a gully fifty feet wide and thirty feet deep, enfiladed by the fire of the defenders. Along the base of the high defensive walls, almost throughout their length, ran a crenellated *fausse-braie*, and the curtain walls were punctuated by square towers of considerably greater height, built forward of the walls themselves and connected to them by bridges arching over the *fausse-braie*. These free-standing towers were an innovation introduced by the knights in response to the early days of gunpowder, designed to prevent either the tower or the wall being brought down by the collapse of the other; it also constituted each tower a miniature fortress which could continue to sweep the neighbouring ramparts if they were overrun by the enemy.

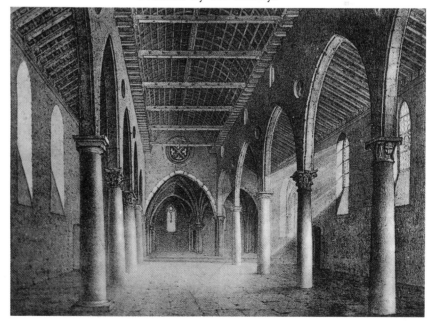

The conventual church of St John, Rhodes, before its destruction in 1856.

The Island Empire

After the confused early years of conquest, the Knights of Rhodes rapidly formed a coherent strategy of territorial acquisition. Not content with the matchless position of Rhodes, which oversees the gaunt hills of the Turkish coast for many miles, they set about acquiring a vice-like grip on that coastline and thus controlling the enemy's home waters. They abandoned Scarpanto (which they had briefly held) to the Venetians, and instead seized the small island of Simie, in the very jaws of the Gulf of Doris; the tiny outpost of Castelrosso, seventy miles to the east of Rhodes, likewise affronted Turkey across a narrow stretch of sea; by 1319 the knights held all the Southern Sporades as far north as Lerro, and though they temporarily lost Langò in the same year their remaining possessions gave them control of the Turkish coast for two hundred miles. The work of penning the Turks onto the mainland and crushing their earlier threat to the islands was the most important service the knights rendered to the Latin colonies of the Aegean. Though it lacked the idealism of their presence in the Holy Land, it was a very real defence of the interests of western Christendom in their new sphere.

For twenty years the main task of the knights outside Rhodes was the defence of Armenia. This phase ended about 1337, when the bulk of the kingdom fell to the Mamelukes, and when the resumption of the naval war in alliance with France, Venice and Cyprus enabled the Hospitallers to reconquer Langò. Its size and position controlling the Gulf of Ceramus made it the most valuable of the string of subject islands, and the castle which the knights built at the mouth of the harbour of Cos, facing the Turkish coast, succeeded the Armenian commandery as the Order's principal military stronghold outside Rhodes itself. The Bailiff of Langò commanded a garrison of twenty-five knights and a hundred Turcopoles, and every knight was required to spend at least one year of his service in this posting. The lie of the Order's possessions also implied control over the Cnidian Chersonnese, which was presumably the site of the unidentified Hospitaller castle and dependencies on the mainland.

The most dangerous enemy of the Latins to emerge at this time was the Emir of Aydin, who seized Smyrna, the largest commercial city on the coast of Asia Minor, and used it as a naval base to attack the Italian colonies. In 1344 a combined Venetian, papal, Hospitaller and Cypriot force, of which the Knight of Rhodes Giovanni

Latin Greece about 1400, showing the Hospitaller possessions.

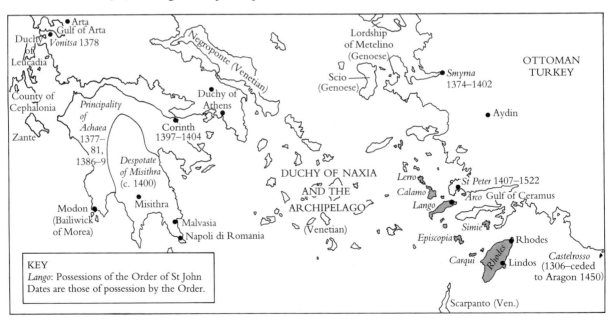

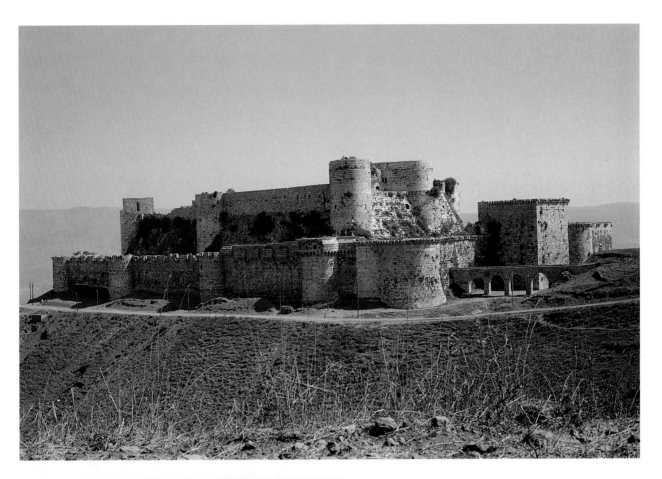

I. Crac des Chevaliers from the west. The square tower on the right is a later Turkish addition.

II. The Knights of St John going to war, from the 14th-century MS Libro de los fechos et conquistas del principado de la Morea, of Grand Master Juan Fernandez de Heredia. Biblioteca Nacional (Madrid) MS 10.131.

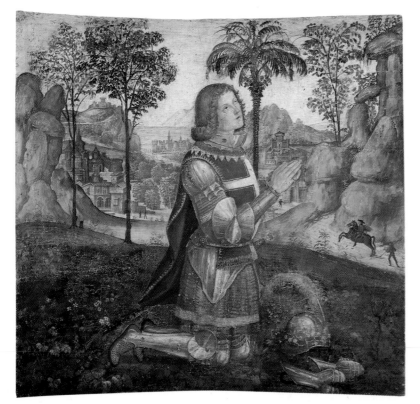

III. Fresco by Pinturicchio (Siena Cathedral) of Niccolo Aringhieri as a young Knight of Rhodes; an image which exemplifies the Arthurian aura that grew around the Order of St John in the Rhodian period. (Scala)

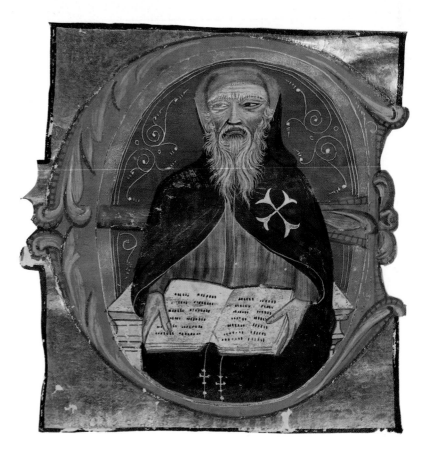

IV. Juan Fernandez de Heredia as Master of Rhodes, miniature from the *Grant Cronica de Espanya*. Biblioteca Nacional (Madrid) MS 10.134.

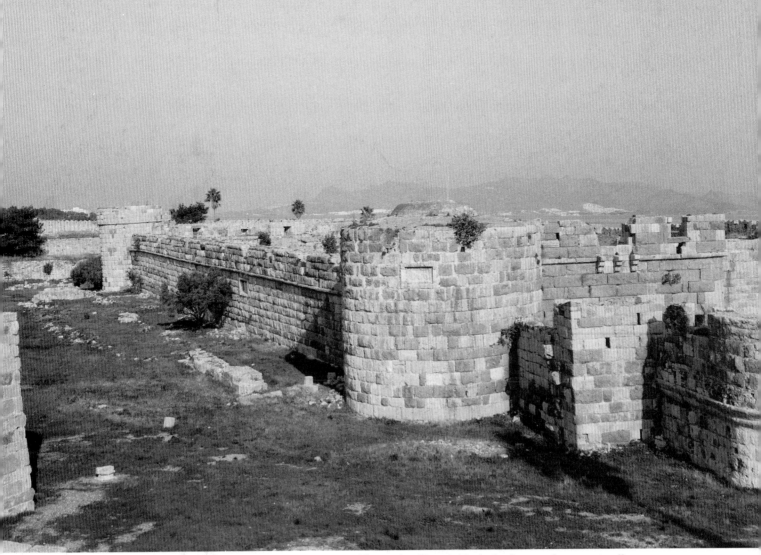

The castle of Langò (Cos): the fourteenth-century wall originally facing the harbour (the fortifications on the left were added in the late 15th century).

di Biandrate was soon appointed commander, took the city of Smyrna, though Gozon withdrew the Order from its defence three years later.★ After several years of inactivity Petrarch complained, evidently reflecting the point of view in Italy, 'Rhodes, the shield of the faith, lies inglorious without a wound.'[2] One may suspect that the Provençal Masters of the time were little interested in further wars whose main effect would be to promote Italian commercial interests in the Aegean, and it is significant that the popes' efforts to make Rhodes more active were linked with measures to give the other nationalities greater power in the Order.

The question of papal policy is of great relevance, for the fourteenth and fifteenth centuries mark the high point of papal control over the Hospital, and conversely of the Order's influence in the affairs of the papacy. The popes knew that, while other European states could from time to time be persuaded, when it chimed with their own interest, to resume the crusade, the Hospitallers were the only power they could consistently rely on. Their very independence in Rhodes freed them from political constraints and made them more susceptible to projects of Christian idealism. When in 1359 Peter I succeeded to the throne of Cyprus and revived the plan of conquering the Holy Land, the Knights of Rhodes leapt to the support of this policy of bygone chivalry. As in the thirteenth century, it was considered that Egypt was the key to Jerusalem, and in 1365 the harbour of Rhodes

★ This was after the bankruptcy of the Order's Italian bankers, provoked by the repudiation of his debts by Edward III of England, wiped out the Hospitaller war reserve of 360,000 florins.

saw the assembly of a great expedition of Cyprus, Venice and the Hospitallers against Alexandria. The Hospitallers, with a force of a hundred knights and four large galleys, took the Egyptians by surprise and made possible a successful landing. The result, alas, was one of the most disgraceful episodes in the history of the crusades, for Alexandria was easily captured, plundered and destroyed. The magnitude of the success wrecked the crusading alliance; the Venetians, furious to see their commercial position in Egypt ruined, withdrew from further action, so that Cyprus and the Knights of Rhodes were reduced to a series of indecisive attacks on the Asiatic coast. Five years later even the remnant of the Kingdom of Armenia, the last memory of crusader rule in Asia Minor, succumbed to the Mamelukes and the Turks.

The Nations in the Order

The division of Langues in 1301 reflected the dominance of the French-speaking knights in the Order. Each of the three French priories, Saint-Gilles, Auvergne and France, constituted a Langue of its own, while Italy comprised seven priories, and five priories of half a dozen different languages were confounded in the Langue of Germany. With the acquisition of the Templar lands more priories were created, but Provence was also divided, for some purposes, into two Langues, Greater and Lesser Provence, with double representation in the Chapter General.

How well or ill these divisions accorded with the national composition of the Order may be judged by five censuses, each of a very different character: the first is the decree of 1302 laying down the number of knights or sergeants that each Langue must maintain at the Convent; the second a decree of 1466 establishing an upper limit of brethren of all three classes at the Convent; the third a record of the brethren who voted in the magistral election of 1476; the fourth a census of brethren resident in Rhodes in 1513; the last an incomplete roll-call of knights and sergeants, but excluding commanders and Grand Crosses, made at the beginning of the siege of 1522.

★ See pp. 161–3 and p. 196.

Table 1

	Provence	Auvergne	France	Spain	Italy	England	Germany	Total
1302	15	11	15	14	13	5	7	80
1466	48	47	71	89	47	28	20	350
1476	38	36	36	81	37	14	16	258
1513	90	84	100	164	70	38	5	551
1522	51	26	62	108	47	11	6	311

The percentages are sufficiently consistent to be trustworthy, in spite of the diversity of the sources. A number of features invite comment: the first is the marked under-representation of Germany, and to a lesser extent of Italy, in the Convent, in proportion to the number of priories and commanderies with which they were endowed; this was a consequence of the special character of the Order and its possessions in those countries.★ The second is the striking advance of Spain after the fourteenth century. One illusion, dear to the hearts of French historians, that these figures dispel is that the Order was predominantly French: the numbers for those three Langues combined vary between 42 and 51 per cent of the total.

On the other hand, if we regard the French as having four out of eight Langues, this is a reasonable reflexion of their numbers; what was disproportionate was that half that representation was held by the Provençals. It is no coincidence that this arrangement was made during the heyday of their dominance in the Order, the period between 1296 and 1374 which shows an unbroken succession of Provençal Masters. This phenomenon had its roots in the political circumstances of the time: Charles of Anjou, the brother of St Louis, had become Count of Provence in 1246; in 1266 he conquered southern Italy, taking with him a host of Provençal and French nobles who formed the basis of his power as King of Naples; twelve years later he acquired the Principality of Achaea in the Peloponnese, where a French-speaking nobility was established. In the next generation the Angevins of Naples went on to obtain the crown of Hungary, and Louis the Great (1342–82) created a wealthy monarchy which, with his later sovereignty over Wallachia and Poland, overshadowed the whole of south-eastern Europe. Against the background of this confident imperialism the dominance of the southern French in the world of Latin Greece is easy to understand. The Langue of Provence enjoyed not only

its own priories (to which that of Navarre was annexed) but also the important commanderies and priories of the Kingdom of Naples, and from 1348 that of Hungary; until 1356 the powerful Bailiwicks of Cyprus and Langò were also reserved for it. It was this accumulation of capitular dignities that gave the Provençals their hegemony in the Order, in which democratic rule was neither then nor later a recognised principle.

The Master Roger de Pins (1355–65) used this power to favour his own nation, granting privileges to the merchants of Narbonne and Montpellier which made Rhodes for them almost a commercial colony such as Venice and Genoa possessed in the other Aegean islands. His successor Raymond Bérenger (1365–74) succeeded in removing the grossest fly in the Provençal ointment by deposing the Aragonese Fernandez de Heredia from the Priory of Saint-Gilles; in 1372 he even tried to appoint a Provençal to the Priory of Bohemia, but here he overreached himself and was forced to accept a Silesian nominated by the Emperor. For a number of years there had been attempts to loosen this national monopoly. In 1373 a Chapter-General ordered the Provençals

to share the Neapolitan and Hungarian dignities with the Italians, and a reform in the system of election the following year produced a French Master, the first from outside Provence for seventy-eight years.

Fifteenth-Century Rhodes

During the fifteenth century there arose the most important fortifications of the harbour of Rhodes. Before 1421 Naillac built the superbly lofty tower which bore his name, 150 feet high, decorated with four corner-turrets at the top; with the fortified quay and barbican which linked it to the city walls, it protected the naval dock next to the arsenal. The mouth of the harbour could be closed by a chain that stretched from this tower to another built on the opposite side. At the end of the Mole of the Mandraccio there was built in the years 1464–67 the Tower of St Nicholas, an exceptionally strong fortification

The harbour of Rhodes depicted before 1863, when the lofty Tower of Naillac (right) was brought down by an earthquake.

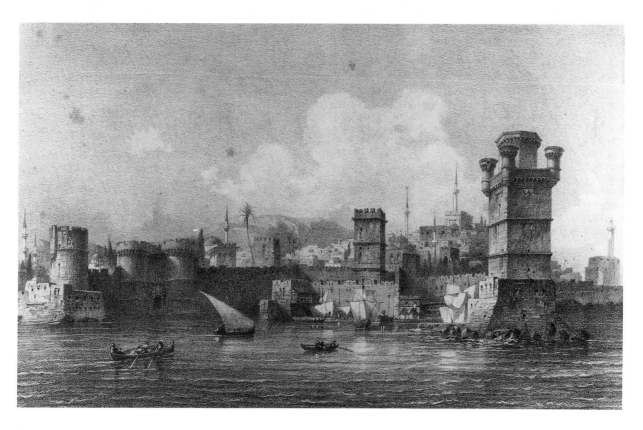

37

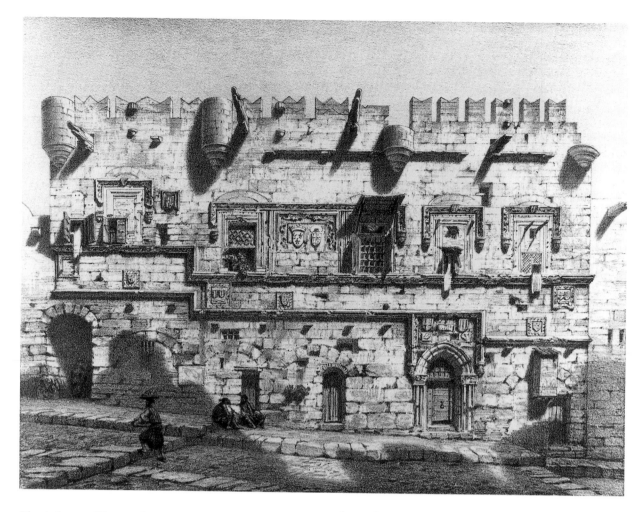

The Auberge of France, façade on the Street of the Knights.

designed especially for artillery, with walls 24 feet thick. It closed a gap in the defences revealed during the siege of 1444, when the Egyptians set up a battery here to bombard the city. Thrust out as it was five hundred yards before the walls, it controlled not only the approaches to the port but the low northern point of the island, denying it to any hostile force seeking to attack from that quarter.

Within the city the knights continued to embellish their Convent, and a magnificent new hospital replaced the more modest one that dated from the years after their arrival. The city of Rhodes as it is preserved today, with a perfection almost unique in Europe, reflects for the most part the rebuilding of the Convent after the siege of 1480. The Street of the Knights, with its sober stonework and intimate scale, gives us the best possible insight into the spirit of the Order

of St John. One can imagine the knights walking down this street in their black robes, carrying in their hands, as they do in so many pictures, the tasselled string of beads on which they counted out their hundred-and-fifty paternosters a day. The characteristic buildings are the Auberges, with their noble stone carvings facing the street and the graceful arcaded galleries of their garden fronts. These buildings are not the splendid creations of monastic or collegiate life, nor are they the grim fortresses that even merchants' town houses are in the Middle Ages; they are not castles – though the Auberge of France flourishes a few turrets for pomp's sake – and least of all are they barracks. The impression is as if a circle of country gentlemen of sober but companionable habit had built themselves a group of residences at once individual and social, with modesty and convenience as their dominant note, and with a humanity and civility at least a century ahead of their time.

The knights' conquest of Rhodes resulted in a sustained increase in the prosperity and population of the island. Merchants from Italy and southern France built up a wealthy society, whose culture and luxuries were shared by a growing class of westernised Greeks. In the government of their subjects the knights showed themselves wiser than the Italian merchant states, and only in the island of Nissaro, which they had granted in fief to the Assanti family of Ischia, was there any occurrence of the rebellions that unsettled the other Latin colonies. On one point the knights were adamant: the recognition by the Greek Orthodox of the authority of the Pope: from 1437 a Uniate metropolitan held office in Rhodes alongside the Latin archbishop. The Catholic and Orthodox union which was agreed at the Council of Florence, and which the Order did much to foster, was accepted by the urban Greeks, but the peasantry remained unreconciled to it, and this was perhaps the most stubborn obstacle to the wholehearted acceptance of the Order's rule. When Rhodes was surrendered in 1522 it was at the request of its Greek inhabitants, who had not shown the devotion to the fight against the Moslems that was later to characterise the Maltese. Nevertheless, many Greeks had grown to trust their benign overlords, and showed their loyalty by sharing the exile of the knights and their eventual settlement in Malta, in whose population they remained a significant element for many years.

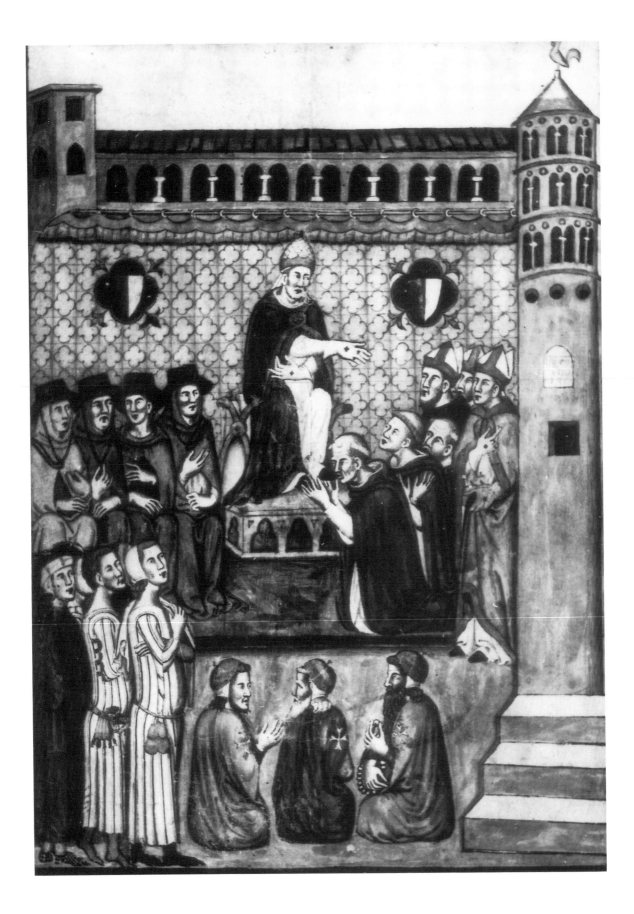

CHAPTER IV

A *Medieval* Grand Seigneur: *Juan Fernandez de Heredia*

A Royal Favourite

THE KNIGHTS OF St John had long been in the forefront of affairs in the East, but the increasing wealth of the Order in Europe also made its members men of consequence in their own countries, where they were to be found playing a leading part in national and international politics. Bonifacio di Calamandrana, one of the last to hold the office of Grand Commander of Outremer, was a rich and influential statesman who mediated in the rivalries between France, Aragon and Naples at the close of the thirteenth century. The popes of Avignon found the Knights of Rhodes especially useful servants, and around 1340 we find all the provinces of the papal states in Italy being administered by Hospitallers for their absentee master.

Juan Fernandez de Heredia would be notable enough as an example of these royal and papal ministers; he is all the more interesting for his exceptional mastership of the Order of St John and for his more unusual character as a bibliophile and patron of letters. He was born into a landed family of southern Aragon, presumably about 1310, and was a Knight of St John by 1328. While still in his twenties he was appointed to the former Templar commanderies of Villel and Alfambra, which his family's territorial influence in the area had apparently prised from royal control, and he thus benefited from the rule that anyone who recovered a property for the Order was entitled to hold it for life. His father held a minor place at court, in the household of the Infanta Leonor, and Heredia became the com-

panion of the heir to the Aragonese throne, Peter, with whom he shared a passion for the chase and also for literature and history.

His fortune was made when in 1346 the young King, who is known to history as Peter the Ceremonious, had Heredia appointed Castellan of Amposta. This office, in which he succeeded the King's great-uncle, Don Sancho (a former Admiral of the Order), had gained special weight through the acquisition of the Castle of Miravet and the vast estates owned by the Templars on the lower Ebro; as Castellan, Heredia became one of the greatest magnates of the kingdom of Aragon. He soon gave a presage of both his administrative talent and his taste for books by ordering the creation of the Cartulary of Amposta, in which all the charters of the Cas-

Heredia in middle age (miniature from the *Libro de los Enperadores*).

Pope Benedict XI with three Hospitaller attendants (foreground), 1304, illumination from the *Liber Indulgentiae*.

tellany were copied out, in a script of meticulous regularity, in six huge volumes; and he began exercising his lifelong patronage of learning by supporting students at the universities of Lerida and Montpellier, the future anti-pope Benedict XIII being apparently one of his protégés.

Heredia was entrusted with various royal missions, one of which took him to Avignon and inaugurated his involvement in the afairs of the papacy. He travelled in 1355 to Rhodes to enforce disciplinary and administrative changes that Innocent VI was seeking in the Order. It is hardly to be supposed that Heredia was well received by his brethren in the character of a reformer. He was the father of four illegitimate children; he was using his vast revenues to buy estates for his own and his family's enrichment; the high office he held had been gained in despite of his Order's proper rules of promotion, and he appeared to be bent on laying his hands on every priory of the Hospital within his sphere of influence. In 1354 he had been named Prior of Castile, though the opposition of Peter the Cruel, who intruded his own nominee into that dignity, prevented him from making good his claim. In 1356 he received the Priory of Saint-Gilles, thus combining the two most powerful offices of the Order in Europe.

The reason for this spectacular advancement was the high opinion that Innocent VI, like Peter of Aragon, had formed of Heredia's abilities. On his return from Rhodes the Pope entrusted him with the military protection of the papal state, and sent him with Cardinal Talleyrand on a diplomatic mission designed to avert the clash of the English and French at Poitiers; the attempt failed, and Heredia characteristically decided that if he could not stop a fight he would join it. He found himself on the losing side. The Black Prince at first was for executing an envoy who could thus flout diplomatic neutrality, but allowed himself to be persuaded that a ransom of ten thousand francs would be a penalty more satisfactory to all concerned. Heredia rebounded from this as he was to do from many other reverses to find himself appointed Captain-General of the papal army at Avignon.

In 1359 the Pope granted him leave of absence to fight for Aragon in its war against Castile – a war in which Heredia had already lent the important diplomatic service of negotiating with Henry of Trastamara, Peter the Cruel's half-brother, his taking of arms against the King; that sovereign's attitude over the Castilian Priory made Heredia's sympathies unequivocal. There followed a tug-of-war between the King of Aragon and the Pope for the services of their minister; so fierce was the Pope's eagerness that he first excommunicated Heredia to enforce his return and then promptly made him Governor

Heredia (miniature from the *Grant Cronica de Espanya*).

Heredia (miniature from the *Grant Cronica de los Conquiridores*).

of the Comtat-Venaissin. The splendid town walls of Avignon which Heredia built and which dominate the city to this day are a monument to this period of his career.

Avignon was at this time at the height of its splendour, under a series of able popes who created there a magnificent court and made the city the intellectual capital of Europe. It was a world in which Heredia was at home, both as a statesman and as a man of culture, and we find him during these years taking an active part in the revival of scholarship, building up his fine library, commissioning for it copies and translations of the classics, consorting with the Greek scholars who came to Rhodes, and taking a special interest in the history of the classical and modern Greek world of which, as a Knight of Rhodes, he had personal experience.

Heredia's influence suffered a blow in 1365 by the election of Raymond Bérenger as Master of the Hospital. As a Provençal long opposed to Heredia's dominance, Bérenger looked with no good grace at his accumulation of offices, especially the Priory of Saint-Gilles. Nevertheless stripping him of his acquisitions was not an easy matter; when the previous Master had tried to extract from Heredia the dues he owed to Rhodes, he had been defeated with the utmost aplomb through the appointment of a commission of cardinals which decided that the best

solution to the difficulty was the cancellation of all Heredia's debts to the Order. Bérenger had to travel to Avignon himself, and found the more willing ear of Urban V. Heredia retired to Spain and had to give up both Saint-Gilles and his nominal appointment of Castile.

For three years Heredia enjoyed undiminished prestige at the Aragonese court. He formed a close friendship with the heir to the throne, John, who was then a youth in his late teens and who acquired in these years an esteem and admiration for Heredia that were to endure a quarter-century of separation. It was largely due to Heredia's tutelage that John became the earliest perhaps of medieval princes to be interested in Greek literature, and his brief reign in Aragon saw a florescence of scholarship that not merely anticipated but in part influenced that of Renaissance Italy.

An important triumph for Heredia's policy occurred in 1369, when Henry of Trastamara succeeded in defeating his brother and establishing himself as King of Castile. Besides being a political benefit to Aragon, this victory permitted a solution to the question of the Templar lands in Castile, which the Order had been vainly claiming for half a century. By renouncing its rights in favour of the Knights of Calatrava, the Hospital was able to obtain in exchange their commanderies in Aragon. Heredia also used his power at court to foil Bérenger's efforts against him by adding the Priory of Catalonia to his emoluments.

In December 1370 Urban V died, and before the conclave met to choose his successor Heredia had already contrived to install himself in the papal palace. The new Pope, Gregory XI, was an energetic man of forty-two; he had been created a cardinal at the age of twenty by his uncle, the luxurious Clement VI, and during his long career at the court of Avignon had become a strong partisan of Heredia. The irrepressible Castellan was immediately restored to his military command and became a central figure in the great crusading plans that the Pope was hatching for the Order of St John. These included entrusting the defence of Smyrna, of which Gozon had washed his hands, wholly to the knights; Heredia was also invested with extraordinary powers as Lieutenant of the Order in Europe. He was to assemble a levy of 400 Knights Hospitaller and 400 squires and lead them on a new campaign into Greece.

Heredia in the guise of Mark Antony (miniature from the *Grant Cronica de los Conquiridores*).

Master of Rhodes

Before these plans matured, Heredia took part in a historic scene, the ending of the Babylonian captivity in Avignon. He commanded the fleet that took Gregory XI to Italy in 1376, and carried the Banner of the Church as the first pope for over seventy years came to lay his bones in Rome. The following year the Master of Rhodes died. The popes had been munificent to Heredia, but it was not mere indulgence that impelled Gregory XI to set aside the Order's rules of election and provide Heredia to the vacant mastership. This exceptional exercise of papal authority, which was accompanied by apologies to the Order and assurances that the precedent was not to be repeated, was dictated by the urgency of the Pope's crusading plans. It was essential in this critical moment that the ablest man in the Order should lead its destinies, even if the entrenched Provençal knights had to be overridden to ensure it.

The plans for the projected crusade were prompted by the new situation that had been created in the East. The Turks had leapt the Dardanelles in 1354 and by the early 1370s had penetrated to the Adriatic coast; they were clearly the chief danger confronting both Greek and Latin Christendom, and the object of Heredia's campaign may have been to set up a strong Hospitaller state in Greece as a bastion against Turkish power. Twenty years before, Innocent VI had proposed such a plan, which might have done something to remedy the feudal anarchy of the Morea, and as Heredia was then already prominent in papal foreign policy it is tempting to see his influence behind the scheme. It cannot have escaped him that a territory in Greece would be valuable to the Order both as a source of revenue and as a stepping-stone to Rhodes. Now, in 1377, he took for the Hospital a five-year lease of the Principality of Achaea, appointing a Hospitaller knight as governor; his object was to attack the Despotate of Arta, on the other side of the Gulf of Corinth, one of a number of small Albanian principalities that had been left in possession of Epirus after the disintegration of the Serbian Empire. The conquest of this state would in conjunction with Achaea give the Order control of the whole of western Greece. It is not clear why the Catholic lord of Arta should have

Initial from the *Grant Cronica de Espanya*.

been chosen as the first quarry of a crusade against the Infidel, except that he was engaged in war at the time against the neighbouring Venetian possessions of the Ionian islands, whose ruler was the widowed Duchess of Leucadia. Heredia

Illumination from the *Grant Cronica de Espanya*.

came gallantly to the rescue of this lady, offering her one of the Order's castles in Calabria in exchange for her town of Vonitsa, which was then under siege by the Albanians.

The highest hopes were aroused for this crusade, and St Catherine of Siena exhorted the Hospitaller Prior of Pisa, 'Bathe yourself in the blood of Christ crucified.' The force that Heredia led from Italy was far inferior to the 400 knights that had been envisaged, but it seemed sufficient for the initial war against Arta. Early in 1378 Heredia arrived at Vonitsa and asserted his Order's claim to the town; but at this critical point Gregory XI died, and the new Pope failed to send the supplies the army was expecting. While Heredia waited the enemy had time to prepare, and when he marched against the capital of Arta in the summer he was ambushed by the Despot's forces. The Master was taken prisoner and a large ransom was demanded for his release. The entire crusading enterprise of the papacy and the Order of St John had been reduced to disaster by a minor Albanian chieftain. The detailed circumstances of this unhappy expedition have been lost in understandable oblivion, and it must remain a mystery how a man of Heredia's ability could have been guilty of such outstanding mismanagement.

Although Heredia told his brethren to abandon him as a useless old man, the Chapter General in Rhodes ordered the raising of his ransom, and after less than a year's captivity the Master was free. In September 1379 he arrived in Rhodes to assume the government of the Hospital. His position, it might seem, could not have been weaker: he was a Spaniard at the head of an Order dominated by Frenchmen; his pluralistic career spent in royal and papal service, his un-statutory appointment as Master and his fiasco at Arta would have ruined any lesser man. Yet it was in this predicament that Heredia's greatness was most signally demonstrated.

Apart from this source of weakness, a more serious danger threatened the Order from the Great Schism which had just divided the Western Church. Gregory XI, as we have seen, died in 1378, having achieved the long-deferred object of restoring the papacy to Rome. When the cardinals met to elect his successor the populace of the city, anxious not to let their bishop escape again, beset the conclave shouting 'romano lo volemmo', or 'almanco italiano'. The conclave

elected the Archbishop of Bari, who took the name of Urban VI; but as the months went by the cardinals found their fidelity taxed by the Pope's undiplomatic harshness against laxity in the more powerful reaches of the Church. Withdrawing to their regretted pleasances of Avignon, they repudiated Urban and conferred the tiara on Robert of Geneva, a man unquestionably of the old cardinalitial school, who thereupon styled himself Clement VII. Europe divided itself on lines of national rivalry; France, the Spanish kingdoms, Scotland and Scandinavia gave their allegiance to Avignon; France's enemies – England and the Empire, including northern Italy, with its colonies in Greece – remained faithful to Rome. So finely balanced were the merits of the division and the weight of the contenders that the schism thus created defied all attempts to mend it for nearly forty years.

At Rhodes there was little hesitation between the two rivals; although the Avignon line are today regarded as anti-popes, in their own day they were believed legitimate by the greater part of the Catholic Church, and the ruling circle of Provençals and French in Rhodes declared immediately for Clement VII. No less predictably Heredia confirmed the allegiance of the Order. It was this that must have principally helped him to secure the obedience of his chief men, especially since the position of Rhodes as a Clementine outpost in the East was an exposed one: most of the other Latin colonies were of the Roman obedience, with Cyprus, though officially Clementist, divided by the influence of its Italian colonists. When in 1381 the Morea fell to the Roman cause the Hospital had to abandon a year early its lease of the Principality of Achaea.

The Last Years in Avignon

By 1382 Heredia's authority was sufficiently well established in Rhodes to allow him to leave the island, though his return to Avignon may have been partly motivated by the idea of trumping with papal support such opposition as still lingered among the leaders of the Order. One piece of business to which he was personally obliged arose from an incident the previous year, when a knight whom he was stripping of his habit for suspected murder pulled out a knife

and flung himself on the aged Master, who was saved by the quickness of the attendant knights in cutting down the attacker. The absolution of his defenders from the ecclesiastical penalties for killing a man in church was one of Heredia's first concerns on his arrival at the Clementine court.

It may be imagined that the Master's removal to Avignon did nothing to improve his standing with Urban VI, who promptly declared him deposed and in April 1383 appointed the Prior of Capua, Riccardo Caracciolo, Master under his obedience. Caracciolo tried to organise his section of the Order and sent the Piedmontese knight Ribaldo Vagnone with secret orders to Rhodes with the object of raising the Romanist brethren against the Lieutenant's government. He was almost immediately found out, however, and had to destroy his papers; he was taken under arrest to Avignon, where he died in a papal prison.

By the end of 1384 it was evident that the Roman danger to the unity of the Hospital was of little account, nor had the Schism disrupted the Order as it had the ecclesiastical structure of the Church. No Knight of Rhodes would by his own lights put a matter of papal politics above his loyalty to the Order; indeed there is evidence of a closing of ranks, and just before Germany was lost to his authority Heredia was able to

Silver coin of Heredia.

Tomb of Heredia in the collegiate church of Caspe (destroyed 1936–9).

secure, through the compromise of Heimbach, the ending of the schism maintained by the knights of Brandenburg for the previous sixty years. The danger of the Great Schism lay in the use that the self-interested might make of it for their private ambition or as an excuse to avoid paying their dues. The need for closer financial supervision may have been, indeed, one of the motives that persuaded Heredia, like Villeneuve in similar circumstances, to rule from western Europe. He showed his genius as an administrator and a diplomat by keeping the damage of the Schism to a minimum, contriving in time to double the value of the Order's revenues. Even in Italy the schism against Avignon was very partial, and when Caracciolo died in 1395 his followers had sunk to such insignificance that Boniface IX committed their government to a mere Lieutenant, Bartolomeo Carafa.

While he thus skilfully guided the Order, Heredia was still pursuing his private interests; one of them was his impenitent nepotism, which led him to distribute benefices of the Hospital to his relations and to enrich them with the lands bought over many years with his swollen revenues. His own illegitimate children left no posterity, but his brother Blasco was able to acquire enormous estates in southern Aragon, and to seat his family's power in the magnificent castle of Mora de Rubielos; his descendants became, as Lords and Counts of Fuentes, one of the eight grandee families of Aragon, and an important force in the politics of the kingdom. Heredia's nephew was successively Bishop of Vich and Archbishop of Saragossa. Another kinsman seems to have been Sancho Martinez de Heredia, who became Hospitaller Prior of Castile in 1386.

Heredia founded and richly endowed the collegiate church of Caspe in Aragon, creating a chapter of nine priests of the Order. In a special chapel he built his own magnificent alabaster monument: the sides of the tomb itself were carved with a funeral cortège of spiritual and temporal dignitaries under an arcade of Gothic tracery, and lying on the tomb as on a bier was the recumbent figure of the Master in his robes, with two miniature angels standing by his head and resting their hands upon his shoulders in a beautiful gesture of protection.

During the last fourteen years of his life in Avignon, Heredia's patronage of learning achieved its most glorious productions. The old warrior built up a library that eclipsed those of the cardinals and prelates of Avignon, not only in its size but in the universality of its interests. He corresponded with Coluccio Salutati, who was at that time leading the early steps of the Renaissance in Florence, and who regarded Heredia's library as containing almost any book one would wish to find. He was also in correspondence with his royal pupil in Aragon

and sent him a stream of books which had a great influence on the development of Catalan humanism. A project of special merit was the commissioning of a translation of Plutarch's *Lives* into Aragonese, a version which, after circulating in the graceful court of John I of Aragon, was in turn translated into Italian and became one of the most influential texts of the Florentine Renaissance.

More than the copies of the classics, the works that illustrate Heredia's masterly vision are the panoramic reviews of history which he ordered to be compiled. One of these is the finely produced *Grant Coronica de los Conquiridores*, a compendium of the great conquerors of history, from Hercules and Julius Caesar to the heroes of the Spanish *Reconquista*; another is the *Grant Cronica de Espanya*, in which the annals of his country, drawn from an encyclopaedic range of sources including Plutarch, are collected in two gigantic volumes. Perhaps the most impressive, both for its beautiful execution and for the breadth of its conception, is the double work, *Libro de los enperadores que fueron en Grecia* and *Libro de los fechos et conquistas del principado de la Morea*, a complete digest of the history of Greece since antiquity; the first book treats the Byzantine part of the subject and the second provides the Frankish complement down to 1377, the eve of Heredia's own unhappy incursion into the affairs of the peninsula.

Appropriately this *chef d'oeuvre* related to the country in which Heredia had always felt an especially keen interest, an interest which his recent experiences in Greece had only served to stimulate. In 1386 he bought for the Hospital the Angevin claim to the Principality of Achaea, and later appointed a Knight of Rhodes as Governor, but the chaos the peninsula suffered under the ambitions of warlords of different nationalities forced him to abandon his plans there; the defence of Smyrna had become a more urgent necessity in the face of the overwhelming threat presented by the Ottoman kingdom.

In 1393 the Turkish conquest of Bulgaria prompted the King of Hungary to turn for aid to his Western brethren, and there followed the last international crusade fought by Europe against the Moslems, launched with an enthusiasm that transcended the ecclesiastical schism. Heredia sent Philibert de Naillac, the Prior of Aquitaine, to command the contingent of Knights of Rhodes who sailed into the Black Sea and up the Danube

Initial from the *Libro de los Enperadores*.

to join forces with the western armies; another levy under Friedrich von Zollern marched from Germany. Heredia had not been fortunate in war, but he was spared seeing the last blow to his projects in the disaster of Nicopolis. He died in March 1396, probably not far short of ninety years old, after a career with no parallels in the history of his office. He exemplified the Knights of St John who, in Gibbon's phrase, neglected to live, but were prepared to die, in the service of Christ. His astonishing pluralism and grandiose style of life might be a gross abuse in the conspectus of the Order's laws, but they had their justification in Heredia's standing as a royal and papal minister and a patron of learning. Heredia drew a great fortune from the benefices of the Order, and cost it moreover a large defeat and a heavy ransom, yet when he died he left the Hospital his debtor: he had healed its divisions and built up its resources to enable it to sustain the important part it played over the next ten

years in the war of the Cross. A weak Master, or even an ordinary one, in the circumstances of his time would have left the Order in chaos. Thus the history of the next generation is an apposite gloss on Heredia's rule.

Heredia's Successors

On 25 September 1396 the crusaders faced the Ottoman host on the Danube; at first the charge of the French cavalry appeared to have won the day, but their impetuosity separated them from the rest of the army and the opportunity was seized by the Sultan Bajazet to turn defeat into crushing victory. The Knights of Rhodes fought well in the battle, but what especially distinguished them was their discipline and organisation. Disengaging their men from the catastrophe, Naillac and the Count of Zollern regained the ships with King Sigismund of Hungary and other survivors, and took them in good order down the Danube and back through the Straits of Constantinople.

Naillac, who had perhaps not known at Nicopolis that the Convent had already elected him Master in his absence, arrived in Rhodes to take command of the Order. The disaster Bajazet had inflicted on Christendom made the moment a critical one; the Turks followed their victory by making an incursion into the Morea, and this frightened the quarrelsome rulers of the peninsula into temporary sanity: Theodore, the Byzantine Despot of Misithra, ceded Corinth and the defence of the isthmus to the Knights of Rhodes in 1397, and soon afterwards sold his entire principality to them. The work done by the knights in their brief tenure of Corinth perhaps preserved the Morea for Christendom for another sixty years, for the Turks were unable to renew their invasion till the second half of the fifteenth century; but it certainly owed nothing to the assistance of the other Christian princes: the ruler of Achaea, Pierre de Saint-Superan, attacked the Rhodian possessions in 1401, and Antonio Acciaiuoli, whose father had made himself Duke of Athens partly with Hospitaller help, repeated the outrage two years later. Since by now the Order had made peace with the Turks and the danger of invasion had passed, Corinth was abandoned in 1404.

The events that caused this change of front sprang from the incursion of the Tartar tribes, when their Khan Tamburlaine the Great, ranging out of Samarcand, conquered an empire that stretched from India to the Euphrates. In 1401 he turned on the Egyptians and ravaged Syria. The following year he defeated Bajazet at Angora and destroyed the Turkish empire in Anatolia. He then marched in person against Smyrna, which the Knights of Rhodes had defended against the most determined efforts of the Turks, and the walls fell to the mining of 10,000 sappers.

The Moslem threat to Eastern Christendom was halted by these formidable blows, even though the death of Tamburlaine was followed by civil war between his sons, which enabled Turkey and Egypt to recover some of their losses. In 1403 Naillac took advantage of the situation to secure a very favourable commercial treaty with Egypt, including the right to rebuild the old hospital in Jerusalem; this treaty gave Rhodes a period of prosperous peace with Egypt till 1440. Naillac followed his success by building opposite Langò, on the Turkish shore, the powerful fortress of St Peter;* its purpose was to replace Smyrna as a refuge for Christians fleeing from servitude throughout Anatolia, from where they were carried across to swell the thriving community of Rhodes. As was shown by the choice of its patron saint, which it shared with the castle of Smyrna, both these strongholds served as the advance-posts of the propaganda which the popes directed at the subjected Eastern churches, and of which the Knights of Rhodes were the principal agents. The castle, which stood on a rocky promontory in the middle of the bay of Halicarnassus, neither gave control of the Carian peninsula nor added anything to the knights' hold over the channel of Langò; together with the small island of Arco, which commanded the approaches to the bay, it provided a safe enclave to vindicate to the Greeks its proud name of St Peter the Liberator.

Naillac followed in Heredia's footsteps by playing a notable part in papal politics. After twenty years of schism the support for Avignon began to fail. France withdrew her obedience from Pedro de Luna (Benedict XIII) in 1398, and Naillac was able to establish good relations with Boniface IX; in 1402 his confirmation of the anti-Lieutenant Carafa as Prior of Rome marked the virtual ending of the schism as far as the

* In Greek it was called Petrounion, whence its Turkish name, Bodrum.

Bodrum: view of the harbour with the castle of St Peter and the island of Arco beyond.

Order was concerned. A brief restoration of French favour to the anti-pope (1403–7) seems to have upset this concord, for on Carafa's death in 1405 Boniface's successor appointed a new anti-Lieutenant. The patience of Europe was eventually exhausted by the refusal of the two papal claimants to withdraw. In 1409 Naillac travelled to the West to take a leading part in the Council of Pisa, which declared both popes deposed and elected a third. It is evidence of the prestige enjoyed by the Order of St John that a layman should have been permitted such weight in a council of the Church. The Council of Pisa failed of its full aim, since the two previous papal contenders refused to abdicate and maintained small pockets of support, but within the Order of St John nearly all the Romanists joined the rest of their brethren in transferring their allegiance to Naillac's candidate; no-one paid any attention when Pedro de Luna retaliated by 'deposing' Naillac from the Mastership. The Roman Pope then abdicated and a new council at Constance deposed both the conciliar claimant and Pedro de Luna, who, abandoned by all except his immediate household, retired to his family's castle of Peñiscola; here, every day until his death in 1423, he is said to have solemnly cursed the four quarters of the world for their rebellion.

Besides Naillac himself, an important actor in the events that brought the schism to an end was the Prior of St John, Gautier le Gras, who took part in the conclave which elected Martin V in 1417. Naillac himself crowned the new Pope at the Council of Constance, and received in turn confirmation of his office, being thus enabled to complete the task of reuniting the *disjecta membra* of the Order. Like Heredia, Naillac was obliged by circumstances to spend many years in the West, and to concern himself with the highest matters of international relations. In 1410 we find him in London, endeavouring unsuccess-

fully to avert the resumption of the Hundred Years War. Not until 1420 was he able to return to Rhodes, where he died the following year. Though a Frenchman, he had continued Heredia's policy of employing other nationalities in high office, and it was another Aragonese, his Lieutenant Antonio de Fluviá, who succeeded him as Master.

Provençal dominance of the Order, which as we have seen reflected political conditions in Greece and its neighbouring states, had been undermined by a reversal of those conditions. The Angevins lost Achaea in 1386 to a Navarrese *condottiere*, and in 1442 the King of Aragon defeated their final attempt to recover Naples, throwing them back on their County of Provence; it was not long before the Provençal Langue had to yield its control of the Neapolitan commanderies. When a third Aragonese Master, Raimundo Zacosta, was elected, he found himself well placed to consolidate the advantage of his nation; the Langue of Spain was divided into Aragon and Castile, and that of Provence was re-fused into one, losing its double vote in the Chapter General.

Zacosta was later summoned to Rome to answer charges of misgovernment, and when he died there the Pope took the opportunity to secure the election of Giovan Battista Orsini, the first Italian Master at least since the twelfth century. Although French preponderance in the Mastership remained impressive until the middle of the seventeenth century, the office was now clearly open to all nationalities, and the main beneficiaries of the change were the Aragonese. We may imagine how the old politician Heredia, who had exploited so skilfully the power that emanated from the great Castellany of Amposta, would have relished the knowledge that the influence he had won for his nation would be multiplying its consequences for generations after his death.

V. First page of the *History of Eutropius*. Bibiothèque de l'Arsenal (Paris) No. 8324, showing the arms of Heredia.

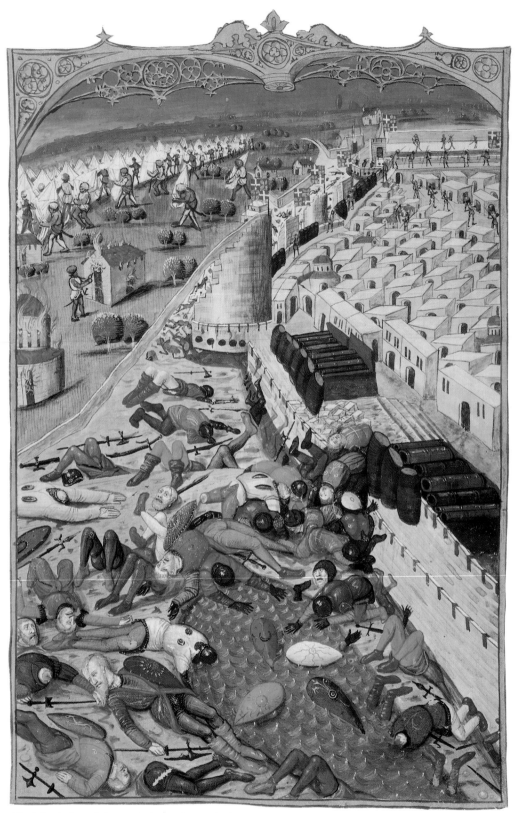

VI. The defeat of the Turkish attack on Rhodes, from Caoursin's history of the siege of 1480, *Obsidionis urbis Rhodice descripcio*. Bibl. Nat. (Paris) Ms Lat 6067.

CHAPTER V

The Three Sieges

The First Siege of Rhodes

ARMA VIROSQUE CANO. Our story carries us to a period of eighty-five years in which the Order of St John, comparable in numbers to the population of a village, produced three leaders and three feats of arms worthy of an empire. Turkey, after its defeat at the hands of Tamburlaine, had required half a century to recover its position in Asia; but in 1451 its sceptre was assumed by Mahomet II, who in twenty-eight years extended his rule from Armenia to the Venetian Gulf. It was his first exploit that most deeply stirred Europe, the taking of Constantinople which brought to a close the more than millennial history of the Eastern Empire; but even that glory was eclipsed by his succeeding triumphs, for continuing with hardly a pause he seized Athens and overran the Peloponnese, subdued the Empire of Trebizond and the Lordship of Mytilene, deposed the Wallachian Prince Dracul the Impaler, a legend of bloodthirst only less terrible than his victor, followed the conquest of Bosnia at one extremity of his empire with that of Caramania at the other, wrested Negropont from its Venetian masters, routed in Armenia the Turcomans of the White Horde, extended his dominion to the Ionian islands, and made the Serene Republic his tributary.

It was this warlord, armed with the merited fame of invincibility, who at the close of the year 1479 prepared his forces for a crushing descent on Rhodes. Weightier enemies had occupied Mahomet for a quarter of a century, but there was a special defiance in the presence of this small gadfly on the periphery of his empire. Unlike the Italian merchants, the Knights of Rhodes were in Greek waters expressly to make war upon the Crescent, and while the other Latin possessions declined, Rhodes had grown stronger every year under the virile government of the knights. The Sultan assembled a huge army, estimated by some contemporaries at 70,000 men,[1] and the heaviest artillery ever yet deployed against a fortified city, bristling with the ballistic monsters favoured by the science of the time; they made their landing in Rhodes in May 1480.

The garrison of the city consisted of 600 knights and sergeants at arms and 1,500 to 2,000 soldiers, besides the able-bodied inhabitants of Rhodes. At their head was the fifty-seven-year-old Pierre d'Aubusson, one of the most accomplished Grand Masters ever to have led the Order. A man of fine presence, of cultivation and humanity, a polished diplomat and, as the siege was to show, a courageous leader in war, Aubusson had been the virtual ruler of the Order during the last three years of his ailing predecessor Orsini, and had been elected Master in 1476. He had been active in improving the defences of Rhodes against the attack which, as was shown by the repeated Turkish raids in the 1450s, was constantly in the mind of the Ottoman monarchy.

Faced with the formidable ditch that guarded the walls on the south and west, the Turkish commander, Mesic Pasha, sought the key to a quick victory on the northern side. The Tower of St Nicholas could deny or grant all access from that quarter, and at the same time its exposed position seemed to invite attack. After a heavy bombardment of ten days an assault was launched by a fleet of galleys that appeared swiftly rounding the northern point of the island. But

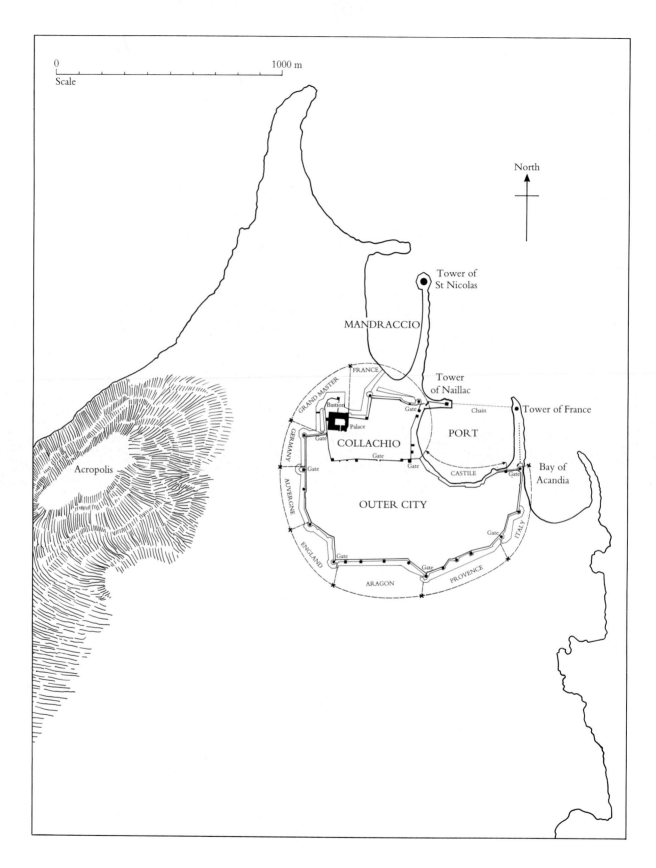

Tower of St Nicolas (the minaret is a Turkish addition).

Mesic had seriously underestimated the resistance of this immensely strong fortification. The assaulting troops were thrown back by withering fire; the galleys were scattered by fireships; and hundreds were drowned when they were forced into the water.

Mesic now extended his bombardment to the southern walls, and for days mortars rained destruction inside the city; one ball fell through the Master's refectory into his cellar, destroying (as one chronicler lamented with a fine sense of life's essentials) a hogshead of excellent wine. After another intensive bombardment against St Nicholas, a new attack was launched using a floating bridge, which under cover of darkness was towed almost into position before the alarm was raised. From the emplacement before the Master's palace and the adjoining walls, guns poured their fire into the massed troops standing

Map of Rhodes, 1480, showing the allocation of sections of the walls among the Langue.

six abreast on the pontoon. Fighting continued all night in the glare of the fireships, and when dawn broke the waters of the bay, strewn with floating corpses, proclaimed the second failure of the Turkish attack.

These two costly defeats seriously damaged Mesic's chances of bringing the siege to a successful conclusion. He now concentrated on attacking the landward side, and subjected the city for six weeks to a fearsome bombardment. He found a weak spot at the easternmost end, where the walls stood almost with their feet in the bay of Acandia and it had therefore been impossible to mask them in a deep ditch. By late July incessant pounding from across the small bay had reduced this wall to rubble, and on the 27th a great assault began. Huge masses of men hurled themselves forward, and before long the standard of Islam was planted on the Tower of Italy. In this moment of danger Aubusson,

53

though already lamed by an arrow-wound in the thigh, led a small group of knights in climbing a ladder to the top of the wall, where on the narrow walkway they held back the enemy from spreading westward along the walls. As the tide of battle turned the Master was struck by a spear that pierced clean through his breastplate into his lung, and was carried away out of the fight; but somehow the victorious surge of the Turks had been converted into panic-stricken retreat, and they streamed back towards their camp, while the Knights of St John followed in pursuit, 'cutting them down like swine', and so pressing home their advantage that they overran the camp, captured the banner of the Grand Turk and carried it back to the city in sign of victory.

After seeing their nearest approach to success turn to disaster, the Turks abandoned their hopes, and Mesic re-embarked his army after a siege of eighty-nine days. The all-conquering sword of Mahomet II had broken on the walls of Rhodes; but the significance of the knights' victory was far greater than to ensure their continuance for another generation in Levantine waters. Mahomet had simultaneously planned the conquest of Italy, and in the same summer months that the knights were defending Rhodes his armies invaded the peninsula, capturing Otranto and ravaging Apulia, till the failure of the eastern venture caused them to withdraw. If Rhodes had fallen, nothing would have stood between the conqueror of Byzantium and the heart of Latin civilisation. Mahomet died in the spring of the following year, while he was preparing to lead in person a second expedition against Rhodes. He ordered to be written on his tomb not his prodigious conquests but his last defeats: 'I designed to conquer Rhodes and subdue Italy.'

Recovery and Splendour

Aubusson's life was at first despaired of, but not for nothing was he the head of the most famous hospital in Europe, and the Order's physicians restored his health. The victor of Mahomet found himself hailed as the greatest soldier in Christendom, and the means to rebuild Rhodes were provided by a timely stroke of fortune. The death of Mahomet II was followed by a war of succession between his two sons, and the younger, Zizim, took refuge in Rhodes. Aubusson exploited the occasion by offering to keep the prince under permanent guard, and in return the Sultan Bajazet II paid him a handsome pension and sent him what were to be the Order's most treasured relics: a thorn from Our Lord's crown and the right arm of St John the Baptist, which had been placed in the imperial treasury of Constantinople in the tenth century by Constantine Porphyrogenitus.

After transferring Zizim to France, Aubusson was obliged to give him up to the unscrupulous Innocent VIII, who mingled ecclesiastical threats and rich rewards to lay his hands on this uniquely valuable hostage. He annexed to the Hospital the Order of the Holy Sepulchre, with its chief priory at Perugia and all its endowments;* and he conferred on Aubusson a cardinal's hat and the rank of Papal Legate for Asia. It was also from this time (1489) that the title 'Grand Master', though it is known from as early as 1177, began to be regularly used. We may be allowed to rejoice that Aubusson, having earned by playing splendidly the part of a soldier the right to play equally splendidly the part of a politician, was able to enjoy wringing every drop of advantage from his good fortune. He died in 1502, leaving Rhodes at the summit of its prosperity.

Within a few years of the siege the Vice-Chancellor of the Order, Guillaume Caoursin, had employed his diplomatic gifts to spread the fame of the knights all over Europe, and had published his beautifully illustrated history of the siege, glorifying the heroic resistance of the knights, of whom 231 had died in the epic defence. Spiced also with the romantic story of Zizim and his imprisonment in the castle of Bourganeuf, the history thrilled the contemporary taste for chivalric romances, to which the printing press gave ever-widening popularity. As

* The religious order of the Canons of the Holy Sepulchre had acquired donations throughout Europe whose initial purpose was to support the patriarchal church of Jerusalem. It is not to be confused with the 'Knights of the Holy Sepulchre', whose dubbing was initiated by the Franciscan custodians of the Holy Places in the fourteenth century, and who were never a religious or crusading order. The modern papal Order of Knights of the Holy Sepulchre was instituted by Pius IX in 1847; but that of St John has always continued to style itself the Order 'of the Hospital of Jerusalem and of the Sepulchre of Christ'.

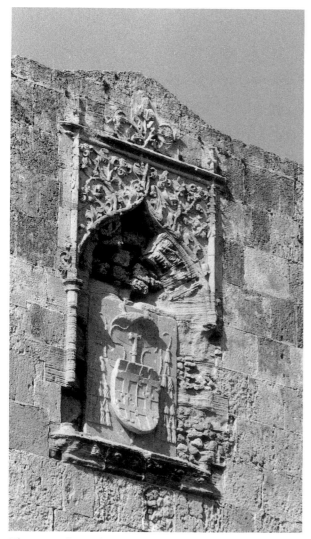

The arms of Grand Master Aubusson (with the cardinal's hat) on the sea wall of Rhodes.

and stone projectiles by bronze cannon firing iron balls, whose force and accuracy, with smaller bores, were more effective than the gaping monsters of 1480. Charles VIII's invasion of Italy in the 1490s gave dramatic illustration of the change, which overnight made all medieval fortifications obsolete. The lessons were quickly learned by the Italians, who became the acknowledged masters of the science of ballistics and fortification. In turn the Order of Rhodes became one of their most innovative clients, for it faced an enemy which was advancing by rapid strides to the position of superiority in artillery which it enjoyed over Europe for much of the sixteenth and seventeenth centuries.

A comparison between the thin medieval walls that face the harbour of Rhodes and those built at this period on the landward fronts is sufficient to demonstrate what a very much more serious affair siege warfare had become. The walls were thickened again to nearly 40 feet and raised to the same height as the towers (which from their original free-standing design had already been joined to the walls for greater strength).★ The top of the walls was furnished with a slanting parapet pierced by splayed gunports – the first use in history of this feature. The ditch was enlarged into a huge canyon, with a formidable apparatus of inner earthworks, casemates and concealed batteries, in which a whole army could have perished in vain.

The Italian Grand Master Fabrizio del Carretto introduced further innovations, employing the engineer of the Emperor Maximilian I, Basilio dalla Scuola. At this time engineers were experimenting with round towers called rondels, of which Carretto's Tower of Italy with its surrounding bulwark forms the most elaborate example; but the trend against them that began shortly after 1522 shows that they did not prove their worth in the siege. On the other hand the huge Bulwark of Auvergne, which was built in front of the Gate of St George in 1521, just in time for the siege, has been identified as the first true example of the bastion; with its angled front which permitted enfilading from all sides, this improvised fortification proved to be the model for one of the cardinal elements of fortress architecture for the next three centuries.

was intended, the book, with its vivid engravings, was a superb piece of propaganda, and brought the Order of the Hospital to a new peak of fame. In the generation after 1480 the number of knights in the Convent rose by over one third, as young men flocked to the citadel of that fabled chivalry.

In the initial rebuilding of the city the walls were increased in thickness from seven to seventeen feet, but this precaution was immediately left behind by the developments of the time. What revolutionised siege warfare was not gunpowder itself but the replacement of iron guns

★ The usual trend at this time was to lower walls to present a smaller target, but at Rhodes this was not an appropriate measure, since the enemy artillery would already be firing from higher ground, and most of the height of the wall was in any case sunk in the deep surrounding ditch.

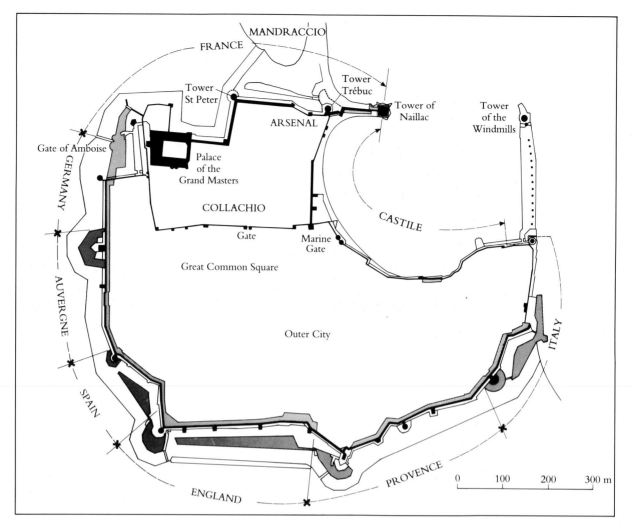

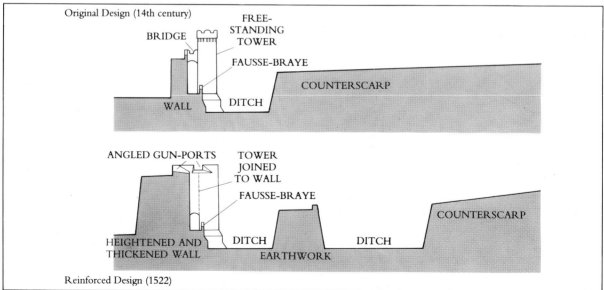

Top: Map of Rhodes, 1522, showing the new fortifications.

Bottom: The walls of Rhodes: typical cross-section.

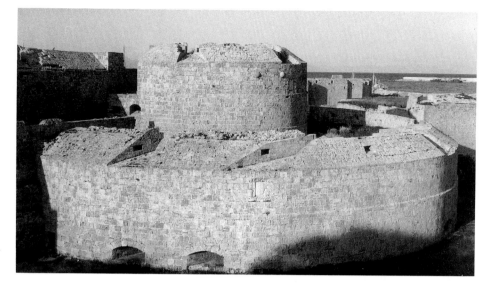

The tower and bulwark of Italy.

The Second Siege of Rhodes

By the time of Carretto's death in 1521 Rhodes was probably the strongest and most modern fortress in Christendom, and comparable improvements had been made at Langò and at St Peter, which still defied the Turks on their own shores. The election for a new Grand Master was contested between the two most notable members of the Order at the time, the Grand Prior of France, Philippe Villiers de l'Isle Adam, and the Chancellor, the Portuguese André do Amaral. Amaral was an old enemy of L'Isle Adam, having quarrelled with him over tactics in the naval action at Laiazzo in 1510,★ and it was a bitter affront to him when the election went to his rival, who was not even in Rhodes at the time. Villiers de l'Isle Adam was a member of one of the noblest families of France, a collateral descendant of the Grand Master who had been carried from the ruin of Acre, and an uncle of the Constable Anne de Montmorency, 'the first baron of France'. On his arrival in Rhodes he showed his spirit in a defiant answer to the veiled threat he received from the Grand Signior informing him of his recent capture of Belgrade.

Soliman the Magnificent, who had ascended the Ottoman throne a few months before L'Isle Adam's election, was the greatest ruler in the history of his empire, under whom both the power and the civilisation of Turkey reached their zenith. After the death of Bajazet, the short

★ See p. 87.

reign of Selim (1512–20) had been occupied in the conquest of Syria and Egypt, the effect of which was to leave Rhodes almost wholly encircled by Ottoman power. The stranglehold the Knights of St John had on trade between Egypt and Turkey was all the more intolerable now that both countries obeyed the same lord, and after crushing a fleeting threat from Hungary, Soliman's first concern was to remove this obstacle for ever. He was not content with the summer campaign with which Mahomet had hoped to reduce the stronghold of the knights; he was determined to stay in Rhodes until it fell, and with that resolution the fate of the island was sealed.

In mid-July 1522 Soliman personally led to Rhodes an army even larger than that of 1480.[2] The defenders numbered only some 500 knights and sergeants (having had shorter notice of the attack than in 1480), with 1,500 soldiers and the Rhodian citizens; but further reinforcements arrived as the siege progressed. Soliman ignored the temptation of an attack from the sea which had been the undoing of the earlier attempt, and concentrated on the land siege. The impregnable walls that confronted him left him no course but to make the siege primarily one of mining, and he had brought with him a force of thousands of sappers. On their side the defenders had with them the Venetian Gabriele Tadini da Martinengo, one of the most famous military engineers of his day, who had defied the orders of his own government for the privilege of serving the Knights of St John, and had slipped into

Medal portrait of Gabriele Tadini da Martinengo.

popular man whom it was easy to accuse, especially in view of his enmity with the Grand Master. The witnesses against him were of a worthless credit; and if a man of such prominence had been in league with the enemy the fact would be known from Moslem sources. Three centuries later, however, new evidence emerged of possible treachery in the siege. In 1856 a flash of lightning caused the destruction of the church of St John from an explosion in its vaults, which had long been sealed up. The hoarding of a great quantity of powder there could explain why, when the city was supposed to be provisioned for a siege of twelve months, the defenders found themselves early on with a shortage of munitions, though the identity of the traitor must remain uncertain: the concealment of gunpowder was not a charge made by Amaral's accusers. ★

By December the condition of the defenders was desperate: the smaller islands of the knights' domain had surrendered, and the garrison had been withdrawn from Halicarnassus to aid the main defence; the repeated attacks had caused heavy casualties; gunpowder was almost exhausted; the enemy mines were already within the city; and no effective reinforcements were arriving from Europe, whose principal countries were mutually at war. Soliman had shown his determination to prolong the siege throughout the winter, a rare measure in the warfare of the time, but which when resorted to was almost invariably effective. After five months of siege, the Rhodians came to L'Isle Adam begging him to accept Soliman's offer to let the knights depart with the honours of war. The Grand Master refused but his council urged him to give way. It is to L'Isle Adam's credit that he should have held out for the course of honour, but it is also to the credit of his advisers that they saw the realities of the situation and opposed an outcome that would have entailed the near-destruction of the Order. The knights' tenure of Rhodes had for seventy years been a *tour de force* which could not be continued indefinitely; it was inconceivable that Europe, even in a time of peace, could have sustained the Order against an Ottoman army permanently encamped in the island; the battle-line between Christendom and

Rhodes at the last moment. He invented a subterranean listening device consisting of a taut parchment diaphragm which set little bells ringing at the least vibration, and by building transverse tunnels he was able repeatedly to bury the attackers in their own ruins. He also introduced the practice of perforating the walls with spiral vents to disperse the blast of the mines. But even these tactics availed little against the enemy's superiority in numbers, and there were three moments of special danger, on 4 and 24 September and 30 November, when gaps blown in the defences by huge mines enabled the Turkish hordes to swarm on to the very walls of the city; each time they were thrown back at heavy cost to both sides.

In October the most enigmatic incident of the siege occurred, when the Chancellor Amaral was accused of collusion with the enemy, after a servant of his was found with a message urging them to continue the siege. Amaral was alleged to have declared when L'Isle Adam was elected that he would be the last Grand Master of Rhodes. Even under torture he refused to speak, either in confession or in defence, and he was executed for treason. Nevertheless it is difficult to believe in his guilt; Amaral was a haughty and un-

★ The explosion destroyed not only the church itself but the whole of the upper part of the knights' city, including the loggia at the top of the Street of the Knights and the Grand Master's palace, most of which had hitherto remained standing. One may judge from this the enormous quantity of gunpowder that must have been hidden away.

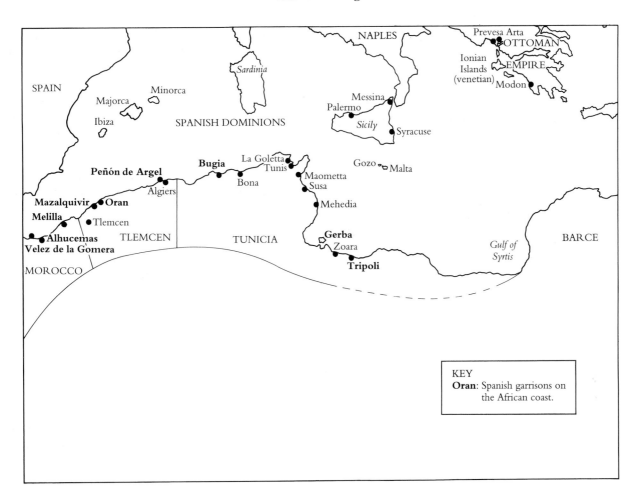

SPAIN

Majorca

Minorca

Sardinia

Ibiza

SPANISH DOMINIONS

Messina

Palermo

Sicily

Syracuse

NAPLES

Prevesa Arta

OTTOMAN

Ionian
Islands
(venetian)

EMPIRE

Modon

Peñón de Argel

Bugia

La Goletta

Tunis

Gozo

Malta

Algiers

Bona

Maometta

Susa

Mazalquivir **Oran**

Melilla

Tlemcen

Mehedia

Alhucemas

Velez de la Gomera

TLEMCEN

TUNICIA

Gerba

Zoara

*Gulf of
Syrtis*

BARCE

MOROCCO

Tripoli

KEY
Oran: Spanish garrisons on
the African coast.

North Africa about 1525.

Turkey, on any realistic estimate, had shifted hundreds of miles to the west, and all the Order could usefully do was to withdraw to a new and more tenable position on that line.

On the first day of the new year, 1523, the white-haired L'Isle Adam led his brethren down to the harbour where the Order's fleet awaited to sail on its last voyage from Rhodes. 'It saddens me,' Soliman is reported to have said, 'to have to oblige this brave old man to leave his home.' For the rest of his life he was to regret increasingly that he had permitted it. The knights sailed from Rhodes to Candia and thence by way of Messina to Civitavecchia in the papal states. L'Isle Adam was appointed Guardian of the conclave which in November 1523 elected Clement VII, who was a knight of the Order and former Prior of Capua. The Pope gave the Convent a temporary residence at Viterbo, where it remained for nearly four years.

The Choice of Malta

It fell to L'Isle Adam now to travel about the courts of Europe seeking help to establish the Order in a new home and to undertake the reconquest of Rhodes, which remained his dearest goal. The choices open to him were in reality very simple: Venice had the best-sited

possessions in the Greek islands, but the Republic's unchanging aim was to preserve its peaceful trade with Turkey, and there was no chance of its offering the knights a territory to resume a war which it had always heartily detested. But while the Turks had been creating their immense power in the East, another empire had been advancing with slower steps at the other end of the Mediterranean. The union of Castile and Aragon and the conquest of the Moorish kingdom of Granada were followed by the seizure of a string of strategic points on the north African coast, including, in 1510, even distant Tripoli. The recovery of Naples from the French in 1504 confirmed Spain's position as the leading power in the central Mediterranean. When the fall of Rhodes freed Turkish naval power to advance to the west, the two empires were face to face. Clear as this situation was, it was to be dramatically accentuated when in 1526 Soliman the Magnificent won the Battle of Mohacs and made himself master of nearly all Hungary. The young Charles V became, through the same event, King of Hungary and Bohemia, and in 1529 he had to defend Vienna itself from Soliman's attack. His empire was thus not merely the bulwark against Turkish advance on every front; it was also the only Christian state capable of matching in strength the huge Ottoman monarchy.

The consequence of these facts was to make Charles V the natural patron of an Order devoted to the same secular struggle. More, there was, geographically, only one territory that the Knights of St John could seriously contemplate as their new base: Malta, an ancient dependency of the Aragonese crown of Sicily. Charles V offered this fief immediately in 1523, together with the Spanish stronghold of Tripoli, and a deputation of knights reported on the island's 'fine large harbours, big enough to accommodate any size of fleet', as well as its unrivalled strategic position, equally suited to blocking a Turkish advance into the western Mediterranean and to serving as a base for a counter-attack towards Rhodes. Unfortunately one fact stood in the way of acceptance: the French knights were not prepared to lend the Order as a cheap defence of the Spanish dominions. The war between Spain and France which had prevented any help being sent to Rhodes was still continuing, and the French were determined to accept no suzerain but their own king, however strategically inap-

propriate. Early in 1525 Francis I was captured at the Battle of Pavia, and he remained a prisoner in Madrid for over a year. It is said that this prevented him from carrying out his intention of establishing the knights in the islands of Hyères; if so, we may be glad of an accident that averted the Order's rapid and sure decline into ornamental uselessness.

The national jealousy of the French, which was to hamper the Order's action for half a century, kept the knights inactive at Viterbo and Nice for seven years, while recruitment languished[3] and the Turkish threat grew unchecked. L'Isle Adam had further worries to distract him: the rulers of England, Portugal and Savoy took advantage of the Order's misfortune to lay hands on its revenues and threaten complete expropriation. In these difficult years the Grand Master showed that he united the gifts of a diplomat to those of a soldier, and he succeeded in appeasing these predators. He could do nothing about Germany, where the Reformation was making its first ravages; many commanderies were raided by revolutionary Anabaptists or subjected to crippling taxes by princes and cities, though it was not until after the move to Malta that they felt the full impact of the Reformation.

In 1527 a majority of the Chapter General assembled in Viterbo voted to accept Malta, but while the European war continued the opposition of the French Langues could not be overcome. In the same year war and plague in Italy obliged the Convent to leave Viterbo, but its destinaton was Nice, in the dominions of the Duke of Savoy. The *Paix des Dames* at last opened the way to an agreement, and in July 1529 the Convent began its journey towards Sicily; the knights had already undertaken the defence of Tripoli the previous year. Yet so bitterly did the French fight against the inevitable that the act enfeoffing the Order with Malta and Tripoli could not be signed until March 1530. A final storm arose when it was discovered that the grant did not include the right to coin money, and Charles V had to concede that privilege quickly to prevent the arrangement from foundering when it had seemed already agreed. These rearguard actions explain why, although the knights actually arrived in Malta in June 1530, their official entry was not celebrated until November.

The Knights of St John took possession of

Grand Master Philippe Villiers de l'Isle Adam adoring the Child Jesus, from the Chapel of the Holy Name in the Temple Church in Paris (1529). The monument was destroyed in the French Revolution but this statue was saved and restored in the 19th century.

their new fief, subject to the duty of offering a falcon every year in token of fealty to Charles V and his successors as kings of Sicily. As they surveyed their acquisition the contrast with Rhodes, where a famous city, a large and fertile territory had awaited their advent, was forbiddingly apparent. Malta and its annexed islands of Gozo and Comino formed a domain of 120 square miles, with a sparse population of 12,000 which was nevertheless too large for the barren terrain; for that reason Charles V's donation guaranteed the *tratte*, an arrangement to supply Malta with corn from Sicily free of duty. The capital was the walled town of Notabile in the centre of Malta, but the knights chose as the necessary base of their operations the ample harbour in the east, where the small fishing town of Birgu (in Italian, Il Borgo) jutted out into the water on a hump-backed promontory. L'Isle Adam quickly fortified this and improved the fort of Sant'Angelo at its tip, but the works were strictly provisional, for his ruling purpose

remained the reconquest of Rhodes. As a preparation, in 1531 he sent an expedition to Modon, where the Order had once owned the large estates which formed its Bailiwick of the Morea. His intention was to capture this town as a stepping-stone to the East, but the attempt was dogged by misfortune; a contrary wind caused a signal to be missed and prevented a co-ordinated attack, and though Modon was captured it was immediately retaken by a large Turkish force of whose proximity the knights had been ignorant.

This serious defeat destroyed the hopes of an early return to Rhodes, and L'Isle Adam's efforts to establish conventual life in the Order's new home were clouded by altercations among the knights, which are said to have hastened his end. As he lay dying in Malta in 1534 he may have felt that his leadership had been a record of failure; and yet his companions could have said to him in the words of Sir Ector to Launcelot, 'Thou wert never matched of earthly knight's

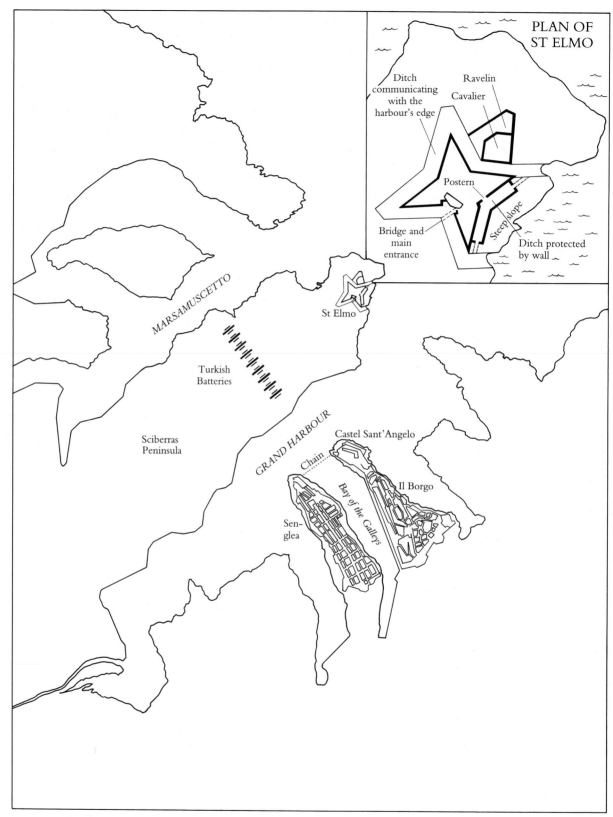

PLAN OF
ST ELMO

Ditch
communicating
with the
harbour's edge

Ravelin

Cavalier

Postern

Steep slope

Bridge and
main
entrance

Ditch protected
by wall

MARSAMUSCETTO

St Elmo

Turkish
Batteries

Sciberras
Peninsula

GRAND HARBOUR

Castel Sant'Angelo

Chain

Il Borgo

Bay of the Galleys

Sen-
glea

The siege of Malta 1565.

hand, and thou wert the goodliest person that ever came among press of knights.' His greatness was clouded by adversity, for though Charles V might pronounce, 'Nothing in the world was so well lost as Rhodes', the loss of prestige entailed by such a defeat was a heavy burden to carry. L'Isle Adam nevertheless raised it, overcoming both an international situation of exceptional difficulty and the resistance of his own countrymen to the strategic duty of the Order. The nine centuries of the Order's history do not show an abler or a nobler leader.

The Spanish Period

If in 1523 Charles V already looked towards the Turkish menace in offering Malta to the knights, within a few years the need for their presence there had been redoubled in urgency. The area of mounting danger was North Africa, whose political division at that time was very different from that of later centuries. Its centre was dominated by Tunicia, a large kingdom stretching from the Gulf of Syrtis to beyond Bougie; the capital, Tunis, had been for over a century the most important African city west of Cairo, with a population of some 30,000. Algiers and Tripoli were secondary ports, both of which were brought under Spanish control early in the century. In the west, Morocco and Tlemcen had for some years been faltering under the impact of Portuguese and Spanish expansion, but this advance provoked in its turn the rise of the Barbary corsairs. The most famous of them, Chaireddin, known as Barbarossa, seized Algiers with his brother in 1516; he lost little time in placing his lordship under the rising star of Turkey, and in 1529 he ousted the Spanish from the fortified rock which controlled the harbour. From this conquest began the history of Algiers as the chief corsair port of Barbary, a position it maintained for three centuries. The new threat to Spanish and Italian waters was clear enough, but it was soon turned into a far graver one: Barbarossa travelled to Constantinople to be appointed High Admiral of Soliman's navy, and in 1534 he seized Tunis and annexed it to the Ottoman Empire.

His exploit was one of the most signal Turkish successes of the century; the conversion of the leading kingdom of Barbary into an Ottoman vassal, with the extension of Turkish sea-power over the entire southern Mediterranean, posed such a threat to Christendom that Charles V called together a virtual crusade to reverse the loss. With the exception of France, all the principal Mediterranean states contributed their fleets and soldiers. The Grand Master Pietro del Monte threw the Order's resources into the venture. In July 1535 the Christian fleet appeared before Tunis with the Emperor at its head; but it was within the city itself that the issue was decided. The Knight of St John, Paolo Simeoni, who was held there as a slave, roused his fellow captives in rebellion, and Barbarossa was obliged to flee. Charles V restored the King of Tunis and left a Spanish garrison at La Goletta, which together with those at Bougie and Tripoli kept Tunis in vassalage to Spain for the next forty years.

When Charles V granted Malta and Tripoli to the Knights of St John his aim, certainly, was to make them the first line of defence of his Italian lands, and not least to support Spain's control of the Tunisian kingdom. Yet it is wrong to say that in doing so he diverted the Order from its proper task. In attack, the imperial campaigns were the best vehicle for the knights' war against the Infidel; as to defence, the Moslem threat fell, by geography, overwhelmingly on the Italian and Spanish shores of Charles V's empire. By contrast France carried its rivalry with the Emperor to the length of concluding in 1536 an offensive treaty with the Turks, who were thereby enabled to strike deep at the heart of Christendom, their corsairs plundering Christian shipping and ravaging the exposed coasts. The consequence of this shameful alliance was to make the traditional predominance of the French in the Order of St John an obstacle to its proper duty, while conversely it led to a period of unprecedented Spanish influence in the Order's affairs.

It would therefore be appropriate to speak of the years which opened with the reconquest of Tunis as the Spanish period of the Order's history, and the more so because it was a time when the military prowess of Spain and her ideals of chivalry and religious militancy gave their tone to Catholic Europe. The symbol of this hegemony within the Order of St John was the long reign of the Aragonese Juan de Homedes, who was elected Grand Master in

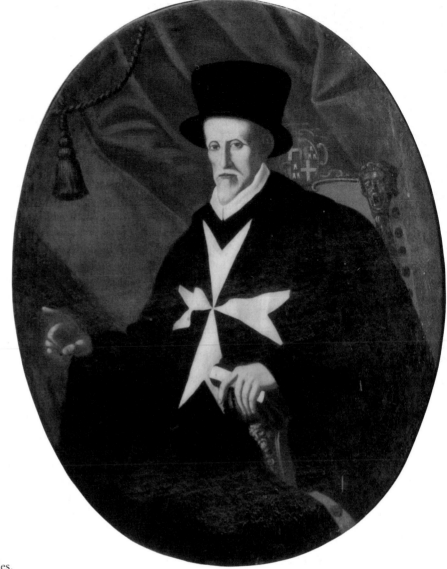

Grand Master Juan de Homedes.

1536. He came to government at precisely the time when France made its treaty with Turkey, and the seventeen years of his rule were filled with the baneful consequences of that alliance. The international conflict was moreover reflected by unprecedented rivalry within the Order he ruled. Charles V's dominion over Castile, Aragon, Germany and much of Italy assured him the total or partial loyalty of four of the Langues of the Order, a state of affairs which threatened to overturn the advantage formerly enjoyed by the French. After Henry VIII swallowed up the priories of England and Ireland, the dwindling band of English Catholic exiles also increasingly became clients of the Emperor. The anti-Spanish party in the Langue of Italy seems to have maintained its strength,[4] but if that element failed the danger was that the subjects of Charles V would sweep the board, winning the predominance which the French had traditionally regarded as theirs by natural right.

In these circumstances we can understand the resentment of the French knights, and we can understand too their wounded pride at the consciousness that their country was betraying the cause to which they had dedicated their lives. Less sympathy is due to those chroniclers who have imposed the distortions of the French party

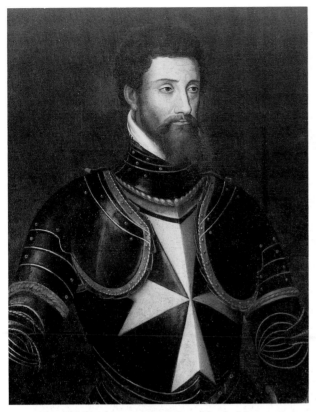

Leone Strozzi (posthumous portrait, of doubtful accuracy).

as the prevalent history of the Order. Bosio's sly denigration of Homedes[5] was elaborated by later historians into a veritable black legend, representing the Spanish Grand Master as a hated tyrant, elected through an intrigue, who enriched himself and his family at the Order's expense, whose personal jealousies made him exclude his best subjects from their due opportunities, and whose avarice was responsible for the loss of Tripoli. These charges, each and severally, are the work of propaganda, as is the misguided orthodoxy which has represented Spanish influence on the Order as an alien burden on its natural destiny. Given the national alignments of the time, it is a view that does not so much distort the truth as stand it on its head.

The first task that confronted Homedes was that of turning Malta into a secure base for the Order's martial undertakings. Military experts had already pointed out that the Borgo was a difficult site to defend, being surrounded on all sides by higher ground, including the peninsula of Sciberras across the harbour. Their advice was to build a new city on Sciberras itself, but such an enterprise was beyond the Order's means, and would have implied that Malta was a permanent home. Homedes therefore followed L'Isle Adam in preferring the provisional fortification of the Borgo. The Knights of St John could not see, as we can, the centuries of Ottoman power that lay ahead, and the ambition of returning to Rhodes continued to animate them. But much had to be done to guard the Borgo against even a moderately strong Turkish attack. Homedes employed one of the leading military engineers of the day, Antonio Ferramolino; under his direction Castel Sant'Angelo was turned into a powerful fortress, with a large cavalier★ commanding the town and the harbour. The ditch between the castle and the town was deepened to make it a sea-filled moat, isolating the castle from the adjoining peninsula and forming a refuge into which the galleys were withdrawn during the Great Siege. Later Homedes extended the scheme of defence to include the neighbouring peninsula to the west, known as L'Isola, and he ordered in Venice the huge chain, of which each link was said to have cost a hundred ducats, that enclosed the intervening creek against an enemy attack. Like the fort of St Elmo which Homedes began building on the tip of Sciberras, the fortifications of L'Isola were only completed under his successor, Claude de la Sengle, the peninsula being thence named Senglea.

While these walls rose, the knights carried the war to the enemy, and continued to lend their aid to Spanish arms. In 1541 Charles V attempted to cap his success at Tunis by ousting Barbarossa from Algiers. Four hundred Knights of Malta – a force seldom if ever exceeded in an offensive campaign – supported the venture, but the tardy ways of Spanish administration delayed the expedition until too late in the season. An autumn storm shattered the fleet and left the army floundering in mud; the troops were forced to re-embark, with the Knights of Malta conducting a desperate defence of the rearguard in which they suffered the terrible loss of seventy-five knights. This costly sacrifice of chivalry prevented the retreat from turning into the rout and massacre of the imperial army.

It would have been happy for Christendom if

★ *Cavalier*: see footnote, p. 69.

its woes had been only in blood gallantly shed. Two years later Europe stood aghast to see the Turkish fleet under Barbarossa sail to Nice to help the most Christian King despoil the Duke of Savoy of the remnant of his dominions that he had left him five years earlier; and when the work was done Francis I placed Toulon at the disposal of the Turks to winter in, clearing its people out of the town for the infidels, so that it spent Christmastide as a sort of second Istamboul. The Florentine Leone Strozzi, a bitter enemy of Charles V, put politics before his duty as a Knight of Malta so far as to assist in the capture of Nice and to command the fleet which escorted Barbarossa back to Patras the following spring, an outrage for which Homedes stripped him of his habit and of his Priory of Capua.

The years following 1545 were an interval of peace in Europe, but they served for the worst demonstration of national rivalry within the Order of Malta. In the Chapter General of 1548 the anti-Spanish majority voted for the Convent to abandon Malta and transfer itself to Tripoli. The motives for this decision were wholly political. In the 1520s the French had argued the difficulty of defending Tripoli as a reason for refusing Charles V's donation; now, however, they calculated that the Order would enjoy greater independence from Spain in a remote African fortress than in an ancient dependency of the Aragonese crown. The Chapter General ordered that fifty knights should be transferred to Tripoli every year until the whole Convent had moved. Fortunately for the Order, the Grand Master treated the plan with the contempt it deserved; he contented himself with appointing as Governor of Tripoli the Marshal Gaspar de Vallier, with a garrison officered wholly by French knights, thus at once rubbing the noses of the French in their own folly and ridding himself of the most intractable elements of the opposition in Malta.

The peace of 1545 proved to be of short duration. Barbarossa had retired after his exploit at Nice, but he found a worthy successor in Dragut, his inferior in fame but not in ferocity or in ability, who continued to terrorise the Mediterranean. In 1550 Spain and the Knights of Malta combined forces to capture Dragut's base of Mehedia and trapped the corsair himself on the island of Gerba. At this point Henry II of France resumed war with the Emperor, in support of the defeated Protestants of Germany, and he urged Turkey to attack Charles V before the expiry of their truce. Soliman demanded that Charles should withdraw from Gerba, and the Mediterranean was once again immersed in war.

Dragut, after escaping cleverly from Gerba, was invested with the command of the Ottoman navy, thus renewing the formidable combination that had earned Turkey its triumphs in the time of Barbarossa. He sought to avenge himself for his loss of Mehedia by taking Malta from its knights, and fell upon the island in July 1551. The defences were too strong for him, however, and he found an easier prey in Gozo, where he seized most of the inhabitants as slaves. Not content with this, he headed immediately for Tripoli, subjecting the fortress to a close siege with all the military power of Turkey behind him.

In this predicament the French ambassador to Turkey, Aramont, arrived in Malta on his way to Constantinople. Homedes asked him to go to Tripoli and negotiate the lifting of the siege, on the grounds that the town was defended by Soliman's allies, the French. Aramont accordingly changed his course for Africa; but on arriving there he quickly decided that the position was hopeless and negotiated not the lifting of the siege but the surrender of the town. Le Vallier and his knights were transported comfortably to Malta in the ambassador's galleys, while his troops were handed over into Turkish captivity.

The entire history of the Order scarcely contains a more dishonourable episode; the statutes decreed the automatic loss of habit for any knight who surrendered a post to the enemy. But Le Vallier arrived in Malta full of excuses: he blamed Homedes for not spending more money on the fortification of Tripoli; he blamed his Calabrian troops, who were of poor quality (his three years' command had apparently not improved them) and had mutinied during the siege – a fact which in itself should have earned him a court martial; their captivity was a just punishment for their disloyalty. It was also the punishment of the Maltese and Rhodian soldiers whose discipline had remained unbroken. Homedes, confronted with what had all the appearance of a politically inspired betrayal, wanted to bring the Marshal to trial, but a tumult of French knights and the intervention of

Breastplate of Grand Master Homedes.

Grand Master Jean de la Valette.

Henry II prevented it, and Le Vallier remained in prison without facing a worse sentence.★

In the humiliation entailed by this heavy reverse, generosity or desperation prompted Homedes to pardon the atrocious Strozzi for his transgression at Nice, restore him to his dignities and summon him to Malta to help take revenge for the loss of Tripoli. The counter-stroke proposed by Strozzi, conceived and executed with his own characteristic arrogance, was the sending of a large expedition against Zoara, to the west of Tripoli. Strozzi made a landing here in 1552 and quickly captured Zoara, but he then allowed his troops to disperse in search of plunder, and the Turks counter-attacked, turning the expedition into a disastrous defeat in which the Order lost eighty-nine knights and sergeants at arms.

These calamities clouded the last years of Homedes's reign, and in 1553 the Turks combined with the French to invade and ravage Corsica, striking as deep into Western Europe as in the attack on Nice ten years before. That September Homedes died, after a magistry of

★ The loss of Tripoli affords an example of the distortion of the Order's history by anti-Spanish propaganda: accounts of the event have generally suppressed the role of the French ambassador in the surrender and retailed the accusations of the French party as the true version, including the allegation that Homedes bribed the judges to secure Le Vallier's condemnation – in a trial which never took place.

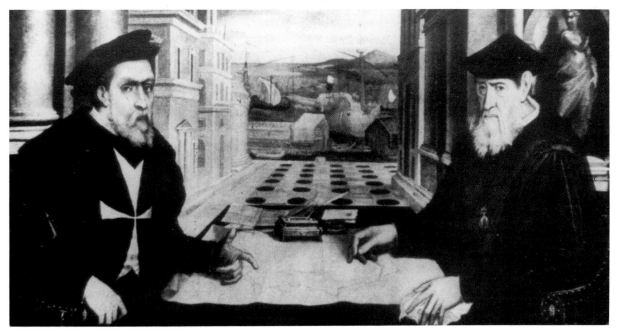

seventeen years, which was the longest of the century and the most important and most valuable to the Order after that of Villiers de l'Isle Adam. In spite of the exceptional internal difficulties that faced him, Homedes completed or began virtually all the defensive dispositions in Malta that enabled the Order to resist the Great Siege. Above all, he saw the overriding importance of retaining Malta, and upheld it against the factious opposition of his enemies. There is every reason to describe him as the architect of the victory of 1565.

After the brief reign of Claude de la Sengle, the Order in 1557 elected as its Grand Master the Gascon Jean de la Valette Parisot, who since his reception as a knight at the age of twenty had offered a life of unwavering dedication to the Order. His staunchness of character was to be invaluable in restoring the morale of the knights after the heavy blows of the recent past and of his own early magistry. His first acts, unfortunately, suggested that his policy would continue to be dominated by the obsessions of the French party in the matter of Tripoli. He immediately released Le Vallier, whom La Sengle had kept in prison, and consoled him with the titular Bailiwick of Langò. He also began hatching a plan to recover Tripoli with the Viceroy of Sicily, the Duke of Medinaceli, who was a personal friend of his. After the reverses suffered in Africa by the Spanish in the last few years, Tripoli was by now an irrelevance to them, and the consent of Philip II was given only with reluctance. The Spanish forces, supported by the Knights of Malta, landed in Gerba early in 1560, but the cumbersome preparations had given the Turks ample warning; their fleet appeared off Gerba and heavily defeated the Viceroy's; the troops on shore, after holding out for some weeks, had to surrender before they could be rescued.

The defeat was one of the worst blows to Spanish sea-power suffered in the sixteenth century; for four years the Mediterranean was at the mercy of the Turkish fleet and the Barbary corsairs. If the Turks had attacked Malta during that period, Spain would not have been able to mount a relief expedition, and the island might well have fallen. Although the ships of Malta had extricated themselves more successfully than the Spanish from the defeat at Gerba, La Valette was certainly as alive as anyone to the danger; he began negotiations to move the Order to Corsica, but as the island's Genoese masters demanded too high a price, and as the years passed without a Turkish attack, his fears abated and he began planning to fortify Sciberras — a project which lack of money made for the moment equally impossible.

The Siege of Malta

In 1564, after four years of painful naval reconstruction, Philip II of Spain appointed Don Garcia de Toledo Captain General of the Sea, and gave him the commission of recapturing Velez de la Gomera, a small island off the Moroccan coast which had been seized by the Algerine corsairs. Toledo's preparations were typical of the man: thorough, meticulous, even over-careful. The island was taken with the support of the Knights of Malta; it was a small success, but a significant one. After so many ill-prepared and disastrous expeditions, there was a new method at work in the Spanish high command. Toledo was rewarded by being named Viceroy of Sicily in succession to Medinaceli.

This appointment, it could well be said, was the salvation of Malta. The Viceroy was keenly aware of the exposed position of Malta on Sicily's southern flank. Other distractions had so far prevented the Ottoman Empire from attacking, but the blow might fall at any moment. When Toledo visited La Valette in April 1565, they both knew that a huge force had already left Constantinople, and though it had several possible destinations, Malta was one of the most likely. Toledo had asked Philip II for an army to face this threat, but it would be a long time in coming. In the mean time the Viceroy would send 1,000 men (from the normal Sicilian garrison of 3,000) to reinforce Malta. He returned to Sicily, leaving behind his son Fadrique, who was received as a Knight of St John and was to lose his life in the siege.

The destination of the Turkish force was indeed Malta, where it landed on 19 May; its crossing from the Aegean had been so swift as to catch even its leaders unprepared. Dragut, the Governor of Tripoli, who had been accorded the general direction of the campaign, did not arrive until nearly a fortnight later. The besieging force

numbered as many as 40,000 men. Those at La Valette's command were some 540 knights and sergeants at arms, 400 Spanish troops (all that had arrived so far of the promised thousand) and perhaps some 4,000 Maltese capable of bearing arms, besides the rest of the population who could help during the siege.

The defence of Malta is one of the epics of military history. The knights had two advantages absent at Rhodes: the barrenness of Malta and the length of the Turkish lines of communication precluded the siege from being continued over the winter; the island must be reduced in a single summer campaign. For their part, the knights knew that if they could only hold out long enough their rescue was being organised in Sicily by one of the most competent commanders in Europe; what they did not know was how long their endurance was to be tried. Against these advantages, the Borgo was an incomparably weaker position than the city of Rhodes had been, with the defects of position that have been described. Its defences were designed to resist a strong raiding party such as Dragut's in 1551; against a large army with all the machinery of a siege its chances were almost hopeless. And yet it was the knights' achievement to defend it for almost four months.

In Sicily, the problem facing Garcia de Toledo was an agonising one. He had asked Philip II for 25,000 men to relieve Malta, but armies of such size were only available for the largest campaigns, and took many months to prepare. The best Spain could do at short notice was to concentrate its Italian garrisons to form an army of 12,000, together with a further 4,000 collected in a three-month journey of the fleet which started at Seville and followed the whole coast of eastern Spain and western Italy, arriving in Sicily in mid-August.★ Even then Toledo only had 60 galleys at his disposal, against the 180 of the Turks. A successful rescue depended on two essential conditions: that Toledo could elude the Turkish fleet to land his force in Malta without a naval battle, and that the resistance of the knights should so wear down the besieging army as to offset its overwhelming numbers.

La Valette knew that the siege was to be a struggle of endurance. He calculated correctly that the Turks would first seek to secure Marsamuscetto harbour as a disembarcation place for their fleet, and would begin the campaign by trying to capture Fort St Elmo, which commanded the entrance to the harbour. Conversely, if La Valette could deny the Turkish fleet the haven it needed, he would seriously hamper the enemy's capacity to carry on the siege. The longer St Elmo held out, the longer the town would be safe from capture. La Valette determined to prolong the life of St Elmo far beyond its normal defensive capacity, concentrating in this apparently insignificant outpost fully half his heavy artillery.[6]

St Elmo was a small fort which had been built in the 1550s for the exclusive purpose of resisting a sea-borne raid. Its star-shaped plan of four salients was strengthened by a single ravelin on the eastern side;† situated at the extreme point of Sciberras, the fort was virtually at the mercy of a siege from the landward side, in which the enemy's artillery would command it from the higher ground in the middle of the peninsula. In recent years La Valette had slightly mitigated this defect by building a cavalier in the ravelin, occupying most of the area of the latter and completely changing its character.‡ Even so, the fort was at a severe disadvantage, and the Turks estimated the time required to capture it at three days; they would probably have been right, but for the crucial importance that the Grand Master had given to the defence of this post, and for one particular circumstance: La Valette was expecting the remaining 600 men whom Toledo had promised him by 20 June, trained soldiers and artillerymen with a value out of all proportion to their numbers. Their

★ Admiral Jurien de la Gravière assures us that this was by no means a slow operation by the standards of the time. If so, this underlines how much Spain depended on the heroism of the Knights of Malta to hold a position so exposed and of such strategic importance to its empire.

† *Ravelin*: a V-shaped work built in front of the walls and defensive ditch of a fort to mask its walls from artillery fire directed from the same level or below – in this case a bombardment from the sea.

‡ *Cavalier*: a free-standing tower, built behind the walls of a fort, from which the defenders could direct their fire against assaulting troops. The unusual positioning of this cavalier, 'in front' of the walls, is only explicable on the grounds that it was designed as a defence against attack from the landward side, St Elmo being small enough for the cavalier to direct its fire over the whole fort.

arrival might enable St Elmo to hold out indefinitely; if St Elmo fell first, the Turks would complete their stranglehold on the Borgo by both land and sea, and they would never arrive at all. At all costs, St Elmo must survive until 20 June.

So completely did the Turks underestimate their task that they began by setting up their batteries only on the north-western side of Sciberras, to avoid being harassed by fire from Castel Sant' Angelo; the Grand Harbour was left free to the defenders, and though the garrison of St Elmo suffered heavy casualties from the fire pouring into the centre of the fort, the wounded could be ferried out every night and reinforcements brought in. When Dragut arrived at the end of May he quickly amended such feeble methods, and the new batteries he set up began to imperil this lifeline. On 4 June he executed one of his boldest strokes: under cover of darkness a party of Janissaries crept round the north-western side St Elmo along the shore and seized the ravelin at dawn, the covering fire from the centre of Sciberras preventing any effective attempt by the garrison to eject them. The danger was now that the Janissaries would storm the cavalier and be able to command the centre of the fort from both sides. The Turks, however, preferred the easier method of reducing the cavalier to rubble with their artillery, dislodging the defenders, while they built up the ravelin itself with earth and stones and filled in the intervening ditch. It was only a matter of time before they overlooked the fort itself and would virtually be able to walk onto its walls.

It was a desperate position for the defenders, and they sent repeated messages to La Valette that the fort could no longer be held. But the Grand Master was adamant: whatever the cost, St Elmo must stand until the reinforcements arrived. In the most heroic episode of the siege, with the Turkish artillery pouring down fire on them from one side and infantry entrenched within a few yards of them on the other, the garrison of St Elmo contrived to hold out for nearly three weeks more. On 23 June, with the built-up ravelin and cavalier now overlooking the fort, the Turks launched their grand attack; the battle raged all day, and by the end of it 200 of the 260 defenders lay dead, but astoundingly St Elmo was still unconquered. That night the survivors took Communion in the fort's chapel.

Not one of them remained unwounded: bodies were blasted into strange contortions by their injuries and eyes stared out wildly from faces blackened by gunpowder. Two of the knights who were too crippled to walk had themselves carried onto the walls in chairs to face the enemy, and when in the morning the last Turkish attack was launched St Elmo still took an hour to die. Mustapha Pasha, the Turkish general, vented his anger by having the bodies of the dead knights nailed to crosses and set afloat in the Grand Harbour under the eyes of the Convent. La Valette replied by ordering his prisoners to be beheaded and their heads fired from cannon into the Turkish lines.

La Valette had good reason for bitterness: St Elmo had fallen, and the promised reinforcements had not arrived; the huge sacrifice of his men appeared in vain. That it proved not to be so was due to the extraordinary boldness of the commander of the force from Sicily, Melchor de Robles. Three times his expedition had tried to land against the vigilance of the Turks, and three times it had been forced back. It arrived off Malta again just as St Elmo fell, but Robles disembarked his men in the north of the island, marched them round its western and southern sides, and under cover of a timely fog entered the Borgo on the night of 29 June. The Turks paid dearly for their slowness in transferring their siege-lines from St Elmo to the town. The relieving force, which is known as the *Piccolo Soccorso*, consisted of the remaining 600 soldiers Toledo had promised, with 56 professional gunners and 42 knights who had not been able to reach Malta before the siege began. And the contribution of St Elmo had been incalculable: it had gained five precious weeks, and though 1,500 men had been lost in its defence the casualties on the Turkish side were at least 6,000, perhaps a fifth of the invading army;[7] at their head was Dragut himself, who had been killed by artillery fire while directing operations on Sciberras. As Mustapha Pasha surveyed the ruins of St Elmo he is said to have lamented, 'What will the parent cost when the child has been purchased at so heavy a price!'

The siege of the Borgo and Senglea was to continue for more than two months further. The first main assault of the Turks was launched on 15 July, when a large force of boats crowded with soldiers sailed out from the innermost part

of the Grand Harbour and tried to storm the weaker position of Senglea; the attack on the south-western shore was repelled with the help of a palisade of underwater stakes, while a group of boats which tried to sail round the point and break into the Bay of the Galleys was annihilated by a concealed battery at the foot of Castel Sant' Angelo. The issue was a massacre reminiscent of those which repaid the Turkish attacks on St Nicholas in 1480. Throughout the succeeding weeks, while the Turks maintained their punishing bombardments from higher ground, the defenders performed prodigies of valour. On 7 August, when an overwhelming attack by the Turks had brought Senglea's castle of San Michele almost within their grasp, a raid on their camp by cavalry from the still-unharassed Notabile called them back, robbing them of a victory which would have put half the Order's double position in their hands.

By early September the defenders were at their last gasp: there were perhaps 5,000 dead within the walls including 219 of the knights, and the number of men capable of bearing arms was a mere 600. Yet the time when the Turks would have to strike camp and seek winter quarters was also approaching; it was a question of whether the defence could be broken in the few weeks remaining. At this point the long-delayed relief arrived, the *Gran Soccorso*.★ After a previous failed attempt, Garcia de Toledo brought the first half of his army across the sea, sailing by night in such complete silence that the boatswains were forbidden to use their whistles. At dawn on 7 September he entered Mellieha Bay, landed his 8,000 men, still in the same complete silence, in less than two hours, and sailed off again to pick up the other 8,000 before the Turkish fleet realised he was there.

The effect of this stroke was to sow panic in the besieging army. On 8 September the defenders of Malta saw the Turks running for the ships, and the siege was at an end. When Mustapha discovered the size of the force that had

landed, he tried to countermand the retreat, but his army's superior numbers could not compensate for its loss of morale. As the Ottoman fleet carried the army back to Constantinople, the news reached Soliman of the costliest defeat of his reign; and in Europe there was a new epic to celebrate. The power of the Ottoman Empire had been humbled by Malta in its four months of heroic resistance.

The Significance of the Sieges

If we compare the three sieges described in this chapter we may be surprised to find that it is the least known that had the widest importance. If Aubusson had lost Rhodes in 1480 the Turks might have been masters of Italy twelve months later. The taking of Rhodes in 1522 merely confirmed the footing of overwhelming strength that Turkey had by then gained in the Levant. The stand at Malta in 1565 was of enormous moral importance to Europe, since it halted the advance of Turkish power which for thirty years had seemed irresistible; on the other hand one has to recognise that if Malta had fallen it would probably soon have been retaken, with much less difficulty, by the Spanish; and even if that attempt had failed the further advance of the Turks could have been contained, though at the cost of devoting a far larger share of Spain's military effort to the Mediterranean. The struggle to avert the loss of the Netherlands and the despatch of the Armada to England might have been impossible, and, in short, the verdict of the seventeenth century would have been reached in the sixteenth. Thus the main effect of the defence of Malta was perhaps to assist the European hegemony that Spain enjoyed for the next seventy-five years.

For the Knights of St John, on the other hand, the importance of the siege was incalculable: if

★ The slowness of the Spanish aid to Malta left all the glory of the siege to the knights, and distracted notice from this extraordinarily skilful operation by which Garcia de Toledo brought the siege to an end. Nevertheless the denigration of Toledo's role by French historians and their copyists is a singular achievement of bias and professional incompetence: one may cite the much-repeated story that he was dismissed from the Viceroyalty of Sicily for his supposed cowardice or treachery towards Malta and died in disgrace. It is a matter of easily accessible record that he remained Viceroy till 1568, that he was created Duke of Fernandina and Prince of Montalban, and that he was the chief military adviser to Don John of Austria at the time of Lepanto.

they had lost two islands in the space of half a century their reputation as the shield of Christian Europe could hardly have survived. The Order would doubtless have disintegrated into national fragments, an obsolete relic of the past. Instead La Valette and his band of knights had given Europe an exploit of such enduring resonance that two centuries later Voltaire could write, '*Rien n'est plus connu que le siège de Malte.*' The fame of 1565 was to make the Knights of Malta the acknowleged paragons of Christian chivalry for as long as that ideal held sway in Europe.

CHAPTER VI

Malta

Valletta, the New Capital

ROUSED BY THE Great Siege, the monarchs of Europe awoke suddenly to the importance of the work of defence performed by the Knights of Malta. France, Spain, Portugal and the Papacy all sent large sums of money, at last rendering possible the project, to which the near-destruction of the old Convent gave added cogency, of building the Order's capital anew on Sciberras. Before the end of 1565 the Pope sent his military engineer Francesco Laparelli, a pupil of Michelangelo, to design a new fortified city for the site.

Yet in the Convent minds were divided: knowing how close the Turks had come to success, many knights advised immediate withdrawal to the continent. If thirty years of Ottoman victories had killed their dream of a return to Rhodes, the doubt now was whether they could hold Malta. Although the building of the new *piazza* had been his own plan before the siege, and although a large Spanish army guaranteed the island against a second attack in 1566, the Grand Master hesitated. Not until he was urged to build the city by Philip II – who had been shown a model of it – was he able to make up his mind, but on 28 March 1566 he laid the foundation stone of Valletta.

The peninsula of Sciberras, with its commanding height, its flanks moated by the deep water of the Grand Harbour and Marsamuscetto, and its connexion with the mainland reduced to a narrow neck, had all the defensive advantages that the Borgo lacked. Laparelli decided against enclosing the whole peninsula, a plan which would have given unnecessary dwelling space

and too long a perimeter to defend; he traced the landward walls to include the summit, which he crowned with the cavaliers of St John and St James. Entry was afforded by a single central gate, flanked by huge bastions laid out before the two cavaliers. A dry ditch, cut very deep and wide, separated these walls from the ground later called Floriana, then a bare slope along which few besieging generals would have contemplated sending their troops. The walls overlooking the water projected in bastions as the accidents of the ground suggested, with Fort St Elmo incorporated into the trace at the tip of the peninsula.

Within this enclosure the ground was divided into a grid pattern in the manner of a model Renaissance town, while the building regulations enforced a standard of urban design such as no existing city had yet conceived; all houses must have a water-tank and sewer; façades must be designed by an architect; corner sites must be embellished with pilasters or other decoration. The knights were encouraged to build private houses by a provision exempting these from the *spoglio* they were obliged to leave to the Order. The result of these measures was the emergence of one of the finest urban compositions in Europe: as Sir Walter Scott called it, a city built by gentlemen for gentlemen.

La Valette died in 1568, when construction had been in progress for only two years, and was buried in the city which bore his name. His successor was Pietro del Monte, who urged on the work with great vigour. Laparelli left Malta in the same year and was replaced by his Maltese pupil Girolamo Cassar as the architect of Valletta, which may be regarded as his creation. So impatient was Del Monte to move into the new

capital that he suspended the plans to build a magistral palace on the highest point of the city (where the Auberge of Castile now stands) and took over a house which had been built by his nephew in the centre, and which was later extended into the existing palace. The Grand Master and Convent transferred themselves from the Borgo to Valletta on 18 March 1571.

Del Monte, who had commanded the defence of Senglea in the Great Siege, was perhaps the ablest Grand Master of the century after Villiers de l'Isle Adam, though his rule was regrettably short. He had at least the fortune of seeing the Christian triumph at Lepanto which confirmed the Order's own victory of 1565. Unfortunately it had been preceded by one of the rare disgraces in the naval history of the knights, when the cowardice of the General of the Galleys led to the loss of three ships in an action against the famous corsair Ucialli in 1570. As a consequence the Order had only three remaining galleys to contribute to the Christian fleet. They were given the place of most danger and corresponding honour on the right wing, where they faced the squadron of El Louck Ali, the ablest of the Turkish commanders and the only one to extricate himself with credit from the defeat. He overwhelmed the opposing Christian wing and boarded the *Capitana* of the Order, though it was defended with such ferocity that when retaken it was found to contain alive only two knights senseless from their wounds and the Order's General, Pietro Giustiniani, with five arrows in his body, while around them with the corpses of their companions lay those of 300 Turks who had been killed in seizing the vessel. The standard-bearer, the Aragonese Don Martin de Herrera, had been parted from his flag by a gigantic blow that sliced through his temple and neck and took away his entire left arm and half his shoulder – a wound that he took with him into revered old age as Castellan of Amposta. The story of the battle resounds with other prodigies of valour performed by the Knights of Malta, but for them Lepanto was as bitter a glory as Algiers or the Great Siege, since the crews of two out of their three galleys were almost annihilated.

Modern historians have been hard put to it to justify Lepanto's contemporary fame as the event that transferred the mastery of the Mediterranean from Moslem to Christian hands.

Spain was unable to follow up its advantage against the rebuilt Turkish fleet in 1572, the Turks made good their conquest of Cyprus, and in 1574 El Louck Ali drove the Spaniards from La Goletta and definitively annexed Tunis. In view of these sequels, one may wonder how Lepanto can be seen as a decisive victory at all. It only appears so when taken in conjunction with the siege of Malta. Those two Turkish defeats marked the end of a generation of seemingly irresistible advance into Christian waters; their lesson was not that Turkey was in retreat but that neither side could realistically hope to extend its power beyond the barrier of the sea. The gain of Cyprus and Tunis thus represented a consolidation of Moslem frontiers rather than a threat to Christian ones; and although Ottoman control of North Africa was to exact a heavy toll on European shipping for a century and more, Spain could shift her attention to northern Europe knowing that the balance of Mediterranean power was unlikely to be seriously disturbed.

In Malta the outcome of these two victories and the relaxed tension that followed them was a somewhat unhappy period in the new Convent. Young men took the habit in these years in overwhelming numbers,[1] and the task of controlling and assimilating them devolved on the maimed veterans of an older epoch. The cross of profession, which had retained in Rhodes and in the Borgo its religious severity, beckoned to every mettlesome young nobleman, and a tone of debauchery and riot blemished the last decades of the century. When La Cassière made commendable but pedantic efforts to enforce the traditional discipline, he was ousted by a rebellion and had to run to the Pope for help. His successor Verdale also appears a somewhat absurd figure, whose similar dependence on papal support is shown by the cardinal's hat he accepted to shore up his authority and the years of his magistry that he spent in Rome.

On the other hand, the fading of the Turkish war relaxed Malta's strategic links with Spain, enabling the French knights to recover their normal hegemony; the new capital and palace gave a fresh show of sovereignty, as the Grand Masters assumed a grandeur that matched and in time surpassed that developed by Aubusson in the last age of Rhodes. La Cassière, with a lack of tact and elegance equally characteristic of

him, decided to extend Del Monte's palace by annexing the Italian Auberge that had just been built next to it; the combined façade was improvised with a utilitarian gauntness it has never been able to shake off, whatever splendours have been lavished on the interior. A spacious suite of state rooms was provided, unified in design by a deep frieze which Matteo Perez d'Aleccio painted with frescoes of the Great Siege and other scenes of the Order's history.

Verdale added to the graces of his court by building a country residence at the Boschetto, on the highest point of Malta, an admirable hunting-box standing four-square to the Mediterranean breezes, and exemplifying with its angled corner-towers and surrounding moat the contemporary fashion for military architecture on which Valletta was itself one of the principal influences. The ground floor contains a somewhat clumsy barrel-vaulted hall with the career of Verdale depicted in childishly congratulatory frescoes. To one side, Cassar's remarkable spiral staircase, similar to the grander one he built in the palace of Valletta, leads to a fine lofty salon on the first floor whose tall windows look out on the best view in Malta. The wooded slopes surrounding the residence sheltered the Grand Master's menagerie and provided most of the scarce hunting of the island.

In Valletta the seven Langues were building themselves the Auberges and adjoining national churches which gave their special character to the city. The Auberges are much larger than those of Rhodes, with less variety of style, showing the disadvantage of having been designed simultaneously by the same architect. Their uncompromising squareness and the massive rusticated quoins that frame them almost like corner-towers give them decidedly the air of a garrison town, even if, as in the Auberge of Italy, this is enriched by an undeniable grandeur. Perhaps the finest of the early Auberges is that of Provence, whose pilastered front is one of the better examples of Cassar's odd Mannerist style; the dining hall, a double cube of 45 feet, was later painted with elegant wall panels in the style of châteaux of the age of Louis XIII.

The Development of Malta

This well-built capital was the model for a country which had also been transformed by the advent of the knights. The Order of St John had assumed the sovereignty of a people who treasured the claim to be one of the oldest Christian communities in Europe, having received their faith from St Paul, who was obliged by shipwreck to spend the winter of 59–60 AD in the island. He found a population of 'barbarians' – that is to say, Latin had not superseded the original Phoenician speech, and that may be why, after the Arab conquest in the ninth century, a dialect of Arabic, of the same Semitic family, established itself as the national tongue. Malta was the last place to fall, in 1091, to the Norman dominion of Sicily, but a Moslem rebellion in the 1120s necessitated its reconquest, after which it remained part of the Sicilian kingdom until Charles V's donation to the knights. Despite the tradition of Malta's millennial loyalty to St Paul's teaching, a census of 1240 shows that only a quarter of the population were then Christian, and the evangelisation of the remainder had to wait for the arrival of the missionary orders in the fourteenth century.

Like others throughout the Mediterranean, the coasts of medieval Malta were kept almost deserted by the danger of pirate raids; when the knights arrived, the only city, Notabile, sheltered behind ancient walls in the centre of Malta, while Rabat similarly kept as much as possible of Gozo between itself and the sea. Notabile was the residence of the Bishop and of the small body of families of Sicilian and Aragonese origin who constituted the baronage of Malta. This group retained some of the characteristics of a colonial society imposed on the native population, and had formed itself into a close oligarchy, whose privileges it was pleased to define as the liberties of Malta. The knights at once saw in it the chief rival to their authority and lost no time in stripping it of every vestige of power, even denying to the Maltese entry into the Order as knights.* The barons retreated into provincial seclusion within the walls of Notabile, turning their backs on the cosmopolitan society and culture of Valletta, and their alienation from

* A similar ban on native entrants had been enforced by the Teutonic Order in Prussia.

the Order was to last throughout the period of its rule in the island.

In proportion as they spurned the nobility, the knights favoured the people of Malta, whose lot correspondingly prospered under their government. A transformation like that of Rhodes occurred with the arrival of the Order: a scanty and impoverished population preyed on by pirates grew into a large international community; the private and corporate wealth that the Order brought to Malta, its enormous building works, its military and naval requirements, were all elements in creating a thriving economy. In time the *corso* (the privateering against Moslem shipping), became a lucrative source of revenue, the magnificent parish churches that embellish even the villages of the island having been largely financed by it. It has been calculated that in the second half of the century the naval and corsair fleets gave employment to fully one quarter of the active portion of the population, which had risen by then to sixty or sixty-five thousand souls.[2]

Prominent Grand Masters

The troubles of the Grand Masters in the last three decades of the sixteenth century were aggravated by conflicts of jurisdiction. The bishops of Malta, whose appointment Charles V had kept in the hands of the Kings of Sicily, flaunted the ecclesiastical exemptions of a swollen household and a clergy often more zealous for its rights than its ministry. With imprudent piety La Cassière had doubled the problem in 1574 by requesting from the Pope the appointment of an Inquisitor to guard against Protestant contagion. This official combined his commission with that of papal ambassador, and lost no opportunity to interfere in the Order's government, making Roman supervision a minuter and therefore a pettier influence than it had been at Rhodes.

It may be said that normality was restored to the Order by the magistry of Alof de Wignacourt, whose personality and skill in overcoming the difficulties of his predecessors gave him almost a wizard's reputation among the Maltese. He gave new vigour to the war against Turkey and Africa, and suffered in retaliation the only Turkish attempt to repeat the invasion of 1565. In 1614 a fleet of sixty galleys succeeded in landing an army, as part of a wider attack on Sicily, but the incursion was defeated in alliance with the Spanish forces.

An incident of a scarcely more peaceful nature was the brief stay of Caravaggio in Malta, whither he fled in 1606 after killing a man in Rome. From this period in his life stem a number of paintings: two portraits of Wignacourt, a fine St Jerome painted for the chapel of the Langue of Italy, a sleeping Cupid now in the Pitti palace; but the undoubted masterpiece is the *Decollation of St John* painted for the Oratory of the conventual church. It is a magnificent composition, with all the solemnity of light and shadow of which Caravaggio is master, and free of the vulgarity that is often equally characteristic of him. Caravaggio was rewarded for his work

Grand Master Alof de Wignacourt.

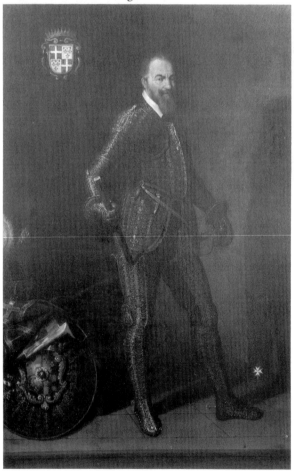

The Gardens of the Palace of Sant'Antonio.

with a knighthood of Grace, but it was a fleeting honour, for by the end of 1608 he fled, after fresh misdemeanours, in search of a new sanctuary.

Antoine de Paule added a third magistral residence, that of Sant'Antonio, enlarging a country house which he had built before his election and embowering it in spreading groves of orange and lemon trees. In 1631 he summoned the last Chapter-General for 145 years, at the same time commissioning a census of the Order which gives us a rare statistical glimpse of its composition. Table 2 shows this, along with a separate enumeration of knights made in 1635.[3]

Since Italy failed to count its chaplains and sergeants at arms, full conclusions can be drawn only from the lists of knights. Comparing them with those of the Rhodian period, we see that the three French Langues remain at 44 per cent of the total; the Spanish have fallen back since the sixteenth century; the Germans give the impression of having risen, but only because

these lists give their full numbers, whereas the earlier figures merely reflected their representation at Rhodes. The most striking change is the great surge forward of the Italians, for whom the Order of Malta was now of special strategic significance.

Table 2

| | 1631 | | | | 1635 |
	Knights	Chaplains	Sergeants	Total	Knights
Provence	272	47	40	359	277
Auvergne	143	20	18	181	144
France	361	20	74	455	342
Aragon	110	30	3	143	101
Italy	584	–	–	–	589
Castile	239	25	17	281	222
Germany	46	6	3	55	40
Total	1,755	148	155	–	1,715

Further light can be shed by the record of admissions of knights over the previous eighty years.[4] General recruitment to the Order declined steadily from its enormous peak after the Great Siege, and the figures of 1631–5 probably represent a reversion to normality both in overall numbers and in national composition.* In the last four decades of the sixteenth century receptions from Italy alone vastly outnumbered those of the three Langues of France, whose recruitment also seems to have suffered from religious troubles at home in the last twenty years of the century; but after 1600 the normal equilibrium was restored.

One of Paule's last acts was to begin the construction of the Floriana fortifications, so named after their designer, the papal engineer Pietro Floriani, who was called in to remedy the deficiencies of the land front of Valletta. Ignoring that commission, he proposed the building of a completely new line at the neck of the Sciberras peninsula. One must suspect that his motive was to show off his abilities as a military architect, for his design is a masterpiece of seventeenth-century fortress architecture. No doubt the first military order in Europe could afford to indulge itself in this expensive showpiece, and the space thus enclosed was gradually turned into an elegant suburb of Valletta.

A Grand Master equal in stature to Wignacourt, though denied his length of reign, was the Navarrese Martin de Redín, a late sprig on the tree of Spain's imperial age, whose masterful personalities Brantôme had admired among the Knights of Malta: 'You would have called them Princes, they were so well set up, they marched so arrogantly, with so fine a grace.'[5] After holding many high military posts in Spain he was in the strategic position of being Viceroy of Sicily when the magistry fell vacant in 1657; he had already been a strong candidate in 1636, but the fear that Spanish predominance then inspired prompted him to withdraw his candidacy. He owed his election partly to the catastrophe of Spanish power in the intervening years, and his elevation began the eclipse of the dominance the French had long enjoyed in the Grand Magistry. It has been suggested that the convenience of good relations with the Order's feudal overlord was behind the fact that five of the seven elections between 1657 and 1697 were won by subjects of the King of Spain; but Sicily and the suzerainty of Malta subsequently passed out of Spanish hands, and yet the Order continued to elect Spaniards and Portuguese in preference to Frenchmen, an extraordinary reversal of tradition. Among the reasons for this must be the disappearance of the danger of Spanish political domination and the increasing pull that the monarchy of Versailles exerted on the service of the French nobility.

The magistries of the brothers Rafael and Nicolás Cotoner were notable for a great artistic enrichment of Valletta at the hand of Matia Preti, a Calabrian nobleman who was granted knighthood of Grace and devoted his long life to

Monument of Grand Master Perellos in the church of St John.

* Except in one minor respect: numbers of German knights dropped sharply after 1620, no doubt in consequence of the Thirty Years' War. Their admissions previously were not significantly lower than those of Aragon and Auvergne.

Stalls of the chaplains of the Order in the church of St John, Valletta.

the service of the Order. In the 1660s he applied himself to transforming the church of St John, which had been built by Cassar in the typically bare and uneasy style that is still exhibited by the façade. The interior was a long vaulted tunnel whose design seems to imitate the library of the contemporary Escurial, but with the peculiarity that the arch of the vault is very slightly broken, apparently to recall the ship-like construction of the conventual church of Rhodes. Preti approached the problem of embellishing this surface with the utmost boldness, covering every inch of the vaulted ceiling with scenes representing the history of the Order, working prodigies of perspective and *trompe-l'oeil*, with false shadows falling across the mouldings. The sanctuary was enriched at the same time with the magnificent statuary group of the Baptism of Our Lord by Giuseppe Mazzuoli and with a sumptuous baroque altar, while the floor of the church was being turned generation by generation into a carpet of multi-coloured marbles formed by the tombs of the knights, resplendent with heraldry and funerary symbolism. Together with the Gobelins tapestries commissioned by Perellós, these works transformed the nave into a warm, colourful composition whose breadth and comparatively modest height endow it with peculiarly welcoming proportions. The side chapels, which were allotted one to each Langue,

79

were also being embellished with paintings and with exuberant monuments of Grand Masters; the chapel of Our Lady of Filermo received the devotion and care of the whole Order, and the solid silver gates given to it in 1752 exemplify the opulence in the appointments of the church under the patronage of the knights. The whole interior constitutes one of the chief jewels of baroque architecture in Europe.

Nicolás Cotoner was Grand Master when the fall of Candia to the Turks placed Malta in the front line against the renewed advance of the Ottoman Empire. He therefore set in hand the project of enclosing the Three Cities on the south side of the Grand Harbour in the ring of walls known as the Cotonera Lines, behind which the entire population and livestock of Malta could have sheltered against an invasion. The danger of such an event receded in the years after 1683, but revived in the eighteenth century, specific alarms being raised as late as 1707, 1714 and 1722. Work therefore continued irregularly on this vast design, which completed the achievement of turning Malta into the strongest fortress in the Mediterranean.

By the second quarter of the seventeenth century Malta presented a picture of security and prosperity. The *corso* of the knights had enabled France to gain control of the lucrative trade with Turkey, and having served that purpose virtually disappeared, leaving Malta as the beneficiary of the new pattern of trade thus established. By eliminating Barbary piracy in the Straits of Sicily, Malta had also captured a great deal of the traffic formerly obliged to go through the Straits of Messina, a route which since 1680 had declined markedly in importance. The consequence was to make Valletta increasingly the commercial hub of the Mediterranean. This advantage was expoited by Manoel de Vilhena, who made such a historic improvement of the Lazaretto that the island in the Marsamuscetto on which it stood came to be known as Manoel Island. All ships sailing between Asia or Africa and European ports had to submit to quarantine, and, while French merchants had an equally efficient centre in Marseilles, those heading for Italy or Spain, which were not so well provided, found that a stop in Malta became the most convenient way of satisfying that duty.

By the time Manoel came to the throne the feudal vassalage to Sicily had been virtually forgotten, and the Grand Master enjoyed an untrammelled position as a sovereign prince. Manoel's actions were founded on a full assumption of that status; he was the first ruler of the Order to put his own head on his coinage; the fine magistral palace he built in Notabile was an embellishment in the same line, as was the beautiful theatre in Valletta where the plays and operas acted by the knights contributed to the amenity of life of both the Order and its capital.

The Constitution of the Order

While he ruled as an absolute prince in Malta, the authority of the Grand Master among his brethren remained limited by the ancient statutes.★ His immediate advisers were the Venerable Council, composed of the high officers of the Order; they were the Bishop of Malta, the Prior of St John and the Conventual Bailiffs, who enjoyed the style of 'Venerable' and headed the seven Auberges. The seven great offices established in the early fourteenth century† had been augmented by those of Grand Bailiff in 1428 and Chancellor in 1462, while that of Treasurer was subordinated in the middle of the fifteenth century to the Grand Commander's department, and the Drapier was in 1539 renamed the Conservator. The resulting eight offices, with their precedence, Langues and responsibilities were as follows:

1. Grand Commander (Provence): Finance.
2. Marshal (Auvergne): Overall command of the armed forces, and of the army in particular.

★ Until the end of the eighteenth century the Order continued to be styled 'the Holy Religion (or Order) of St John of Jerusalem', or more colloquially 'the Order of Malta' or simply 'the Religion'. Appellations such as 'Sovereign Military Order' and 'Prince Grand Master' have only been adopted since 1798, to affirm a status which had ceased to be universally obvious.

† See p. 12 and 32.

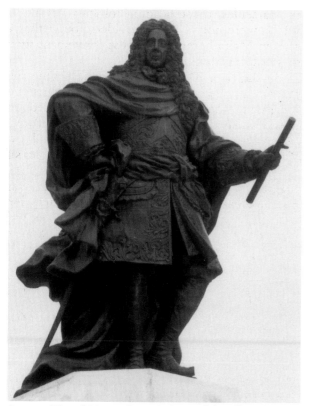

Statue of Grand Master Antonio Manoel de Vilhena in Floriana.

required to be resident at any time, the place of the remainder was often filled by their Lieutenants. With the addition of two representatives from each Langue, this council became the *Consiglio Compito*, and there was a more inclusive body, the *Sagro Consiglio*, which every Grand Cross had the right to attend. In the eighteenth century a Congregation of State was developed, wholly nominated by the Grand Master, and became the effective cabinet for political affairs.

According to the statutes a Chapter General had to meet every five years and, as it was the only body that could authorise increases in responsions and other dues, it was much in demand in the period of high expenditure from 1530 to 1612, during which fifteen chapters were held in Malta. There was then a pause of nineteen years, and after the Chapter General of 1631 this institution, like other parliamentary bodies in Europe, found itself shelved by the ending of the inflationary period of the sixteenth century, for it was 145 years before the financial needs of the Order necessitated its recall. Its rules imposed an admirable brevity: general discussion by the delegates was limited to sixteen days, and then a committee of one Grand Cross and one knight from each Langue was elected to complete deliberation on outstanding business.

Since 1297 the method of electing a Grand Master had been linked with the sevenfold division of the Langues, an electoral college of fourteen being chosen by the brethren. Not until 1374 were these required to be drawn two from each Langue.★ By the Maltese period a system of Byzantine intricacy had developed:[6] elections must be held within three days of the death of a Grand Master so as to avoid external interference, especially from the popes. They were held in the conventual church, initially under the presidency of the Lieutenant appointed for the interregnum. Each Langue met in its own chapel and elected one knight to represent it;† to make it more difficult for bribery to operate at this point, in 1634 Urban VIII ordered three knights instead of one to be elected from each Langue. The function of these eight, or twenty-four, was to choose a President of the Election (to whom

3. Hospitaller (France): The *Sacra Infermeria* and other medical services.

4. Conservator (Aragon): The clothing and material supply of the Order.

5. Admiral (Italy): Administrative charge of the navy; effective naval commands, from that of General of the Galleys downward, were open to all the Langues.

6. Turcopolier (England): The obsolete command of the Turcopoles was replaced with that of the coastal watch-towers. This office was fused with that of Grand Master in 1582 but was revived in 1783 when the Anglo-Bavarian Langue was instituted.

7. Chancellor (Castile): Chancery and foreign affairs.

8. Grand Bailiff (Germany): Fortifications.

As only four of the Conventual Bailiffs were

★ Germany, however, was so scantily represented in Rhodes that it had at one time no vote at all (the Hospitaller being brought in to provide a thirteenth) and only one vote until after 1461. The division of Spain into two Langues then raised the electoral college to sixteen.

† The process was further complicated by the disappearance of the English Langue, which required the eighth place to be filled through co-option by the other seven (and after 1634 three places to be filled by the other twenty-one).

the Lieutenant surrendered his place) and a triumvirate consisting of one knight, one chaplain and one sergeant, each from a different Langue; whereupon their part in the election was over. The triumvirate then elected a fourth member, the four chose a fifth, each time from a different Langue, and so on until their number reached sixteen, of whom at least eleven must be knights and none might be a Grand Cross. The sixteen finally elected a Grand Master by simple majority, with a casting vote exercised if necessary by the President. The system was so aleatory that any direct bribery would almost inevitably miss its mark, but prominent Bailiffs expended great energy and wealth in gathering support when a vacancy in the magistral throne was imminent, and the three days of interregnum found the Convent a hive of intrigue. 'During these three days there is scarce a soul that sleeps in Malta,' wrote Patrick Brydone,[7] and knights went about masked to avoid giving away their lobbyings and allegiances.

Since 1206 the Order had been divided into three classes: knights, chaplains and sergeants at arms or serving brethren, all of whom were designated 'of Justice' if they had taken their vows according to the full rules proper to their rank. In the thirteenth century the qualification for a knight was to be legitimately born of a knightly family. In the 1350s we begin to find the requirement of nobility on both the father's and the mother's side,[8] and a statute of 1428 introduced the rule of nobility *de nom et d'armes*,[9] that is to say of at least four generations in the male line. A different criterion, that of 'four quarters of nobility', became prevalent in the sixteenth century; the knights applied to the breeding of valiant warriors the same principles as to the breeding of a good hunting-hound or war horse, and they required the candidate to prove that all four of his grandparents were noble.★ Neither rank nor wealth could prevail against this rigorously genetic view. An *hobereau* or *hidalgo* with no more than a horse and a sword to his name, provided he could show a pure pedigree in the career of arms, received preference over the son of some duke of ample acres who happened to have been guilty of a *mésalliance*.

By 1550, when Homedes made it statutory, the rule of four quarters probably represented the established practice of all the Langues, and each country was developing ways to stiffen it. The French called for eight quarters; the Spanish and Portuguese, with their concern for *limpieza de sangre*, stipulated that each of the four quarters should be free from the taint of Moorish or Jewish blood or of heretics condemned by the Inquistion; the Italians required two hundred years' nobility in all four lines; the Germans applied the test of sixteen quarters together with other minutiae customary in the noble colleges of their country.

These different qualifications, which were in place by the Chapter General of 1598, reflected national customs regarding chivalry and nobiliary bodies. For example the rule of sixteen quarters was one which had appeared in Germany as early as the fifteenth century, and there was no time when an intermediate proof of eight quarters is known to have been exacted. Candidates did their best to prove all sixteen, and were judged with greater or lesser tolerance on the result. By the late sixteenth century the strictness was absolute, so that in 1599 the Swiss knights, who were unable to meet those standards, had to be given a papal privilege of presenting their proofs *more helvetico*, with only the eight quarters which by then were customary among the French. By the middle of the next century the Germans were insisting on territorial nobility for every quarter, ruling out the urban patriciates and university degrees that had formerly been accepted as equivalents – a reflexion of the downfall of urban society occasioned by the Thirty Years' War.

The four Chapters General between 1598 and 1631 confirmed the national rules and strengthened them with increasingly strict requirements as to the documents and methods of proof. Knights of Grace could be admitted who fell short of these standards, but only four at a time, the honour being a reward for special merits. As ennoblement by office-holding or purchase became increasingly common in Europe, the proofs of nobility were jealously guarded to exclude entrants from the law courts or the counting-house; but conversely ennobled

★ 'Nobility' should be understood in its continental sense, and that which it retained in England before the Reformation, a sense of which 'gentry' is the counterpart in modern English.

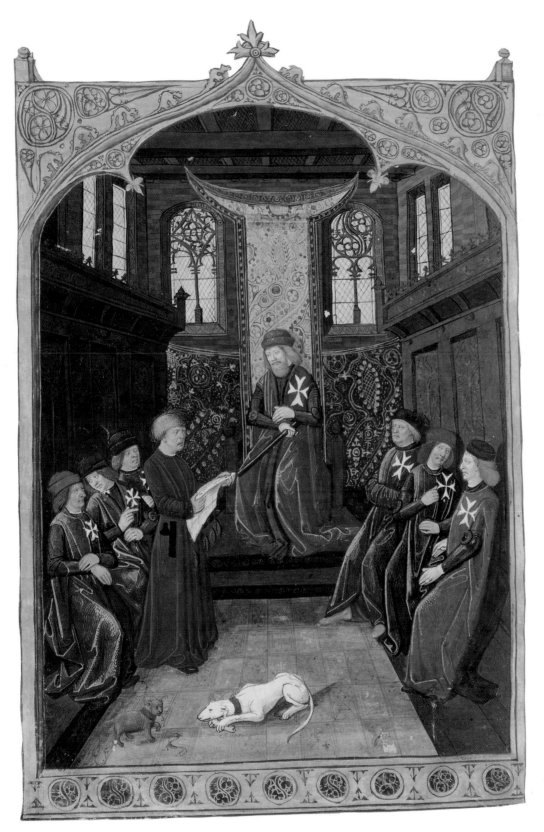

VII. Grand Master Pierre d'Aubusson among his knights, from Caoursin's history. Bibl. Nat. (Paris) MS Lat 6067.

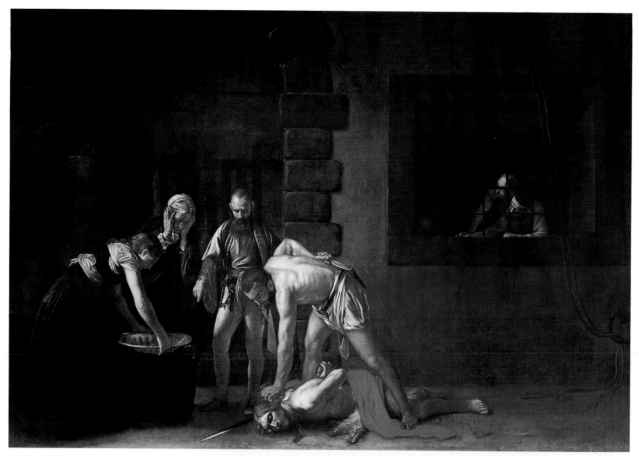

VIII. The Decollation of St John, painted by Caravaggio for the Oratory of the Church of St John, Valletta. (Scala)

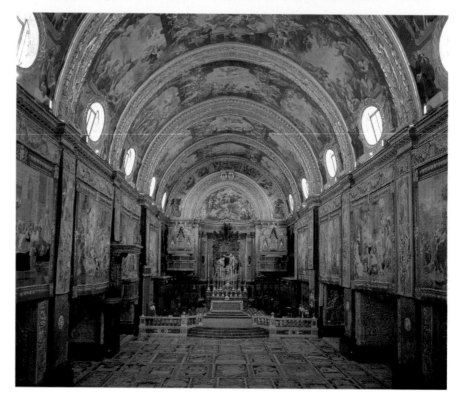

IX. The conventual church of St John in Malta, 'with all the chivalry of Europe within its walls'. The floor is made up of the marble tombstones of hundreds of knights.

families seem to have raced to place their sons in the Order as early as their genealogy permitted, since such an acceptance was the crowning proof of their having arrived among the *noblesse d'épée*. A typical example is Admiral Suffren de Saint-Tropez, the great-great-grandson of a successful lawyer who acquired *noblesse de robe* and married his son into the old nobility. His case also shows that the Italian proof of two hundred years might well be stricter than the French, at least in theory. In practice the prevalence of urban patriciates (which other countries did not count as real nobility) and the ease with which influence could extract papal dispensations where pedigrees were too short gave the Italian Langue a different colour.

The traditional way of admission was as a 'Knight of Majority', entering the novitiate at the age of between sixteen and twenty. The reception of twelve-year-old boys as Pages of the Grand Master increased in the sixteenth century, and in 1612 their number was raised from eight to sixteen. Admission of even younger children 'in Minority' by special dispensation also increased, and the Chapter-General of 1631 authorised a hundred Bulls of Minority to be granted, requiring double the reception fees of the Knights of Minority and Pages. This proved so popular that the privilege was extended indefinitely, those who entered by it rapidly outnumbering the other two classes. Pages and Knights of Minority enjoyed seniority from the date of their reception, but had to perform at the normal age the same novitiate and other duties as the rest.

After a twelve-month novitiate the knights took simple vows, performed their Caravans (three in the sixteenth and eighteenth centuries, four in the seventeenth)★ and could take their solemn vows at the age of twenty-one. Once they had completed five years' residence in the Convent they were qualified for a commandery; but a knight would have been ill advised to withdraw to his country and wait for such honours to fall on him. Seniority in the competition for these took second place to merit, which was computed by the civil and military offices a candidate undertook. The average knight therefore spent years in Valletta serving

★ See pp. 92–3.

† See p. 92.

on the multitude of Congregations that administered the Order and the principality, and above all (if he could afford the expense involved) seeking the command of a galley or sailing ship which was the most conclusive title of all.† Even when he received his commandery he might wish to stay on, competing for higher offices such as those of General of the Galleys or Pilier of his Langue which brought with them the Grand Cross and the chance to aspire to the magistral throne; but in such a case he was expected to leave the Auberge and buy a house of his own.

In the Auberges each knight had a set of rooms, where he was waited on by his servant, but in military austerity. Splendour was reserved for the public rooms; in the dining hall, where knights were obliged to eat four times a week, they sat among tapestries, brocade and trophies, and ate from solid silver dishes. Grand Crosses, when they dined with their Langue, had the privilege of a velvet-covered bench, and the Pilier presided alone on a raised dais, with a carpet and cushion at his feet, seated in a blue velvet armchair under the banner of his Langue. On his munificence depended the richness of the fare that reposed on his brethren's silverware, for a Bailiff who aspired higher than a mere Priory would supplement the Auberge's commons out of his own pocket, looking to the day when his reputation for splendour would carry him to the magistral palace; and on Thursdays and Sundays the plain provision of every day would be varied by more lordly entertainment.

The other two professed classes were the conventual chaplains and the sergeants at arms or serving brethren (the last being employed in the hospital); they were required to be merely of respectable family, without servile or mechanical origins, though many of the priests were in fact drawn from the same noble families as the knights. A small number of more modest commanderies than those of the knights were reserved to them. As to the women's convents, some of the greater ones, such as Sijena, Alguaire and Beaulieu, demanded the full proofs of nobility obtaining in their Langues; others were content with simple nobility or required their nuns to be of good social position, while in all of them there were lay sisters who wore the half-cross like the sergeants at arms.

Parallel to the three ranks of professed there

were equivalent classes which required no vows of their members. The cross of Devotion was, before the nineteenth century, a rare honour generally reserved for Knights of Justice who were led by family obligations to renounce their vows and marry; the Grand Cross was also sometimes bestowed on personages of high rank, and even rarer was the conferment of the cross of Devotion on ladies. A few families had been granted the hereditary cross of Devotion, for example the Wignacourts, who had given two Grand Masters to the Order, and the Dukes of Noailles, descendants of the Chevalier d'Arpajon who had fought alongside the Knights of Malta at Candia. Much more numerous were the priests of Obedience who served the Order's churches throughout Europe. The Donats (a term that had come to supersede that of *confratres* since the thirteenth century) were men and women not of noble rank who were thus rewarded for special services, and who were entitled to the half-cross like the third class of the professed.

CHAPTER VII

The Navy of the Religion

The Crusading and Rhodian Periods

FOR ALL ITS appearance of a late development, no tradition of the Hospitallers is more ancient than their link with the sea. The Blessed Gerard established a network of sea travel to the Holy Land, and it may be that the extensive carrying fleet which the Order had at the service of pilgrims by the thirteenth century was already a feature of the earliest years. The first documentary mention we have of a ship of the knights is that of a dromond – a predecessor of the galley – which in 1165 transported Alexander III and his cardinals from Montpellier to Italy. This type of vessel was perhaps used to protect the convoys of 'round ships' which plied the route to Jerusalem.

The activity thus developed enabled the Hospitallers and Templars in 1187 to make a swift adaptation to sea warfare, when their galleys drove off the Saracen ships in the siege of Tyre. Though this is an isolated example of naval action by the military orders it demonstrates that they had both the means and the experience to turn to sea fighting when the need arose.

For the thirteenth century we have fuller details. At Acre the Hospitallers had their own dockyard, where they built small ships for coastal traffic. The importance of the Provençals in the Hospital's naval concerns seems to have been already established, and a treaty with Marseilles in 1233 mentions Guillaume de Valence as the Order's *commendator navium*.[1] Thirteen years later, when Louis IX prepared a fleet for the Seventh Crusade, he chose the Hospi-

tallers' vessel *Comtesse* as a prototype for twenty of his new ships; the Order also commissioned its own fleet for this crusade and took part with it in the capture of Damietta. In 1264 the Prior of Saint-Gilles, Feraud de Barras, was commander of the French navy.

It was the loss of the Holy Land that obliged the Knights of St John to exchange the horse for the ship. From Cyprus they made naval expeditions in alliance with the Templars, and in 1299 the office of Admiral appears; the conquest of Rhodes and the brilliant naval exploits of the next decade were demonstrations of the mastery that the knights swiftly acquired in their new element.★ Their strong naval role both permitted and was defined by the conquest of the chain of islands along the Turkish coast; and by 1374, when they were entrusted with the defence of Smyrna, they were established as the guardians of that coast over a stretch of more than three hundred miles. Venice, Genoa and other European powers had larger navies, but the concentrated brilliance of the Knights of Rhodes was a unique attribute. Then and for five centuries to come, the function of the Order's navy was that of a *corps d'élite* which could be used in any joint enterprise of the Christian powers; with an average of only four galleys at any time, it was too small to make any independent impact of its own, and once the Order had acquired its island empire its role in Rhodes was essentially defensive.

An upheaval in the situation in the East was caused by Tamburlaine's victories, especially his conquest of Smyrna in 1402. Instead of protecting Christian trade with Turkey, the Knights of Rhodes found a new occupation in attacking the shipping of a country now wholly in enemy

★ See p. 25 and pp. 27–9.

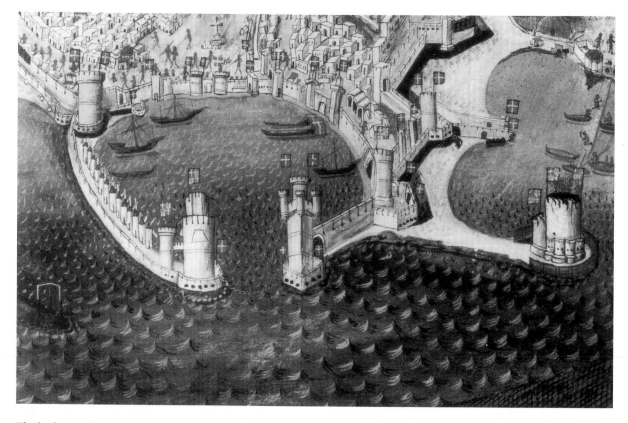

The harbour of Rhodes, showing the galley port (right side of the main port) next to the wall of the Arsenal. The Mandraccio harbour can be seen to the right of the picture.

hands. The coastline they faced, with its numerous promontories and straits which ships had perforce to negotiate, offered the perfect setting for ambushes – so perfect that it remained a favourite haunt of the Order's corsairs even after the withdrawal to Malta. The knights developed the tactics of hunting in packs of two galleys, one to hide behind some headland while the other drove the merchantman on to the chosen point. With these activities they were turning the tables on the Turkish corsairs, who until the Christian capture of Smyrna in 1344 had posed a formidable threat in Aegean waters.

By 1462 the supply of Turkish captives, who were impressed as rowers, was sufficiently constant to permit the abolition of the *servitudo marina*, a form of compulsory sea service for the Greeks which the knights seem to have inherited from the Byzantine administration of Rhodes; henceforth the use of galley slaves to form

two thirds of crews became invariable, while *buonavoglie* (volunteers, often enlisted because of debt) supplied the rest. The predatory exploits of the Order aroused the hostility of Venice, whose empire in the East was now at its zenith, and whose interests demanded unruffled relations with the Moslem world. To the citizens of the *Serenissima* Rhodes was 'a thorn in their eyes and a lance in their sides'.

Such was the ascendancy of the knights over the sea as to threaten even distant Egypt, so that in 1440 the Egyptians tried to seize Castelrosso; but the attempt demonstrated the crushing superiority of the Rhodians. After capturing the enemy fleet, the knights disembarked and in a swift battle destroyed the Mameluke army. Four years later the Egyptians essayed a much more ambitious descent on Rhodes, and put ashore an army that besieged the city for forty days. Baffled by the strong walls and defeated again at sea, they had to acknowledge failure, and the attempt ended the brief resurgence of Egyptian power.★

★ This siege is thought to have been the model for the siege of Rhodes in the fifteenth-century Catalan chivalric novel by Joanot Martorell, *Tirant lo Blanc* (Chapters 98–108). Though the narrative tells us little about the real siege it gives us a glimpse of the position that the 'Knights of the White Cross' held in contemporary romantic literature.

A graver danger emerged with the Ottoman conquest of Constantinople. In 1473 the Roman Grand Master Orsini commanded the galleys in person in the alliance of Venice, Naples and Rhodes against Turkey, but it was not until the Ottoman defeat before Rhodes itself and the death of Mahomet II that the tide of conquest was halted. The succeeding forty years constitute the high point of the Order's naval effectiveness in the East, with a chain of brilliant successes matching those of the early fourteenth century.

The Order's Ships

The knights began at this time to use a Great Carrack as an adjunct to the galleys; this type of ship, stepping three or four masts, carried more sails, had a higher superstructure, and was longer (with a proportion in breadth to length of one to three) than the medieval round ships, representing an intermediate type before the later galleons; in the early sixteenth century the piercing of the hull for gun-ports began. The Order's Carrack seems to have been used as a supply ship, greatly extending the capacity of the *flotta sottile* (of the galleys), especially in land attacks. Its first example appears about 1478.[2] In 1507 the knights captured the huge Egyptian ship *Mogarbina* off Candia, the finest prize their fleet had ever taken; she was christened the *Santa Maria* and served as the new Great Carrack till 1531.

A more conspicuous victory was achieved in 1510, when the fleet destroyed a joint expedition planned by Turkey and Egypt against the new presence of the Portuguese in the Indian Ocean. After routing a superior force at Laiazzo and capturing fifteen ships, the knights made a landing, drove off the Turkish troops and burnt the huge store of timber from which the projected fleet was to have been built, reducing the Mahometan alliance to a pile of ashes.

In 1522 the Order undertook its most ambitious ship-building project, laying down in Nice

Relief of a galley fight off Rhodes, early 15th century, from the tomb of Commander von Massmünster at Villingen.

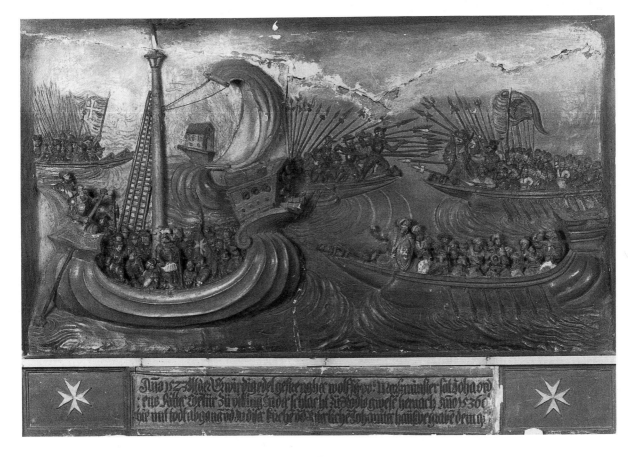

the *Santa Anna*, a prodigy typical of the international naval competition of the time. When she was commissioned in 1524 she was the most powerful ship in the Mediterranean, with four masts, a displacement of 3,000 tons, a metal-sheathed bottom – thought to be the first in naval history – two gun-decks bearing fifty heavy cannon besides lighter guns, and an armoury for 500 soldiers and 100 knights. Carrying provision space for six months at sea, a huge bakery, a veritable grove of cypress and mandarin trees, and a multitude of fires that could be kept burning on board, she was also able to serve as a floating palace for the Grand Master and his court, in which they rode out the plague at Nice for many months. In 1531 she repulsed an attack by twenty-five ships under Barbarossa; the following year she served in the attack on Modon, and she was the pride of the Christian fleet when Charles V took Tunis in 1535. The *Santa Anna* was a precursor of the sixteenth-century galleons, but she suffered the disadvantages of a prototype, as well as being hugely expensive to keep up, and when the Order's financial difficulties – in particular the loss of the English Langue – compelled her abandonment

in 1540, the fact that she was broken up, not sold, shows that this magnificent vessel was already considered obsolete after sixteen years' service.

Henceforth we find the Order commissioning a new galleon every twelve or fifteen years, though none on such an ambitious scale until the *Gran Galeone* which Wignacourt had built in Amsterdam in 1617, and which was reckoned one of the strongest and most beautiful ships in the Mediterranean. It was the last of its kind, however, for from 1645 the Order abandoned sailing ships for sixty years. This change is presumably connected with the involvement in the War of Candia (1645–69) and the consequent availability of the Venetian bases in Greek waters, and would thus confirm that the main function of the galleon was to serve as a support and supply ship to the galleys.

The sixteenth and seventeenth centuries were the golden age of galley warfare, and in this the 'Navy of the Religion', to use the name under which the fleet of Malta won renown throughout the Mediterranean, made its special contribution.

Explanatory engraving of a galley of Malta, by Fürtenbach, 1629.

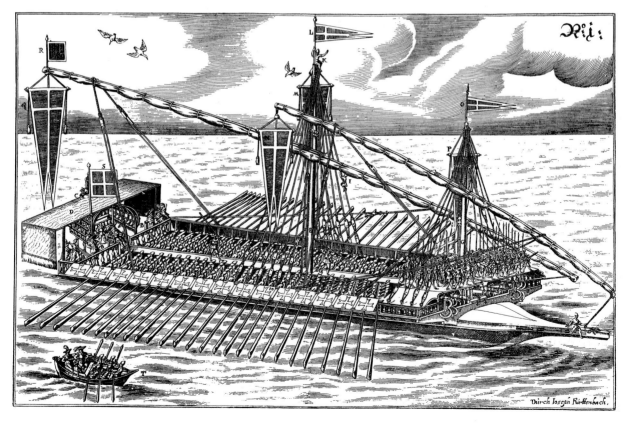

The Maltese galley was a distinct type – to be adopted by France in the seventeenth century as the model for her Mediterranean navy – different from either the Venetian or the Spanish and Genoese pattern. It was also larger and stronger than those of other navies, except for the largest Venetian galleys, so that it was able to sail throughout the year instead of being confined to the brief summer season from May to September. The Spanish saying about a storm 'which only the galleys of Malta could weather' was a tribute to the skill of the island's shipbuilders as much as of its seamen.

Under the propulsion of 150 to 180 oars, and with its two huge lateen sails which permitted sailing very close to the wind, the galley was unrivalled in speed and manoeuvrability; its very shallow draught made it ideal for swift dashes along the coast and into corsair-haunted inlets, and it remained indispensable for action against the Barbary states until the end of the eighteenth century. Besides their efficiency, these superbly disciplined ships presented a magnificent appearance, and the sight that an English visitor described of 'six galleys of Malta coming in all their pompe' as he sailed out of Valletta was one which must have thrilled Christian hearts and swollen the pride of the Order all over the Mediterranean world.

After a brief attempt at independent action in the early years in Malta, the principal role of the Order's navy between 1535 and 1576 was to support the Spanish, in the frequent 'junctions' of the two fleets. No other course could have served the Order's purpose of resisting the overwhelming threat of Turkish power. Strategically if not in formal command, the Order's galleys acted as a squadron of the Spanish navy, as was seen in the countless actions of this time: Tunis, Prevesa, Algiers, Mehedia, Velez de la Gomera, Gerba, Lepanto, La Goletta, and finally the great *razzia* along the Barbary coast in 1576. After that date Spain and Turkey drifted towards a truce in which each side respected the lines of the other's sphere of power.

The Corso

There followed a seventy-year lull in naval affairs matched by an increase in the activity of the Barbary corsairs, who became at this time the scourge of the Mediterranean. This gave rise to the most characteristic phase of the Order's policy, in which it devoted itself to protecting Christian shipping and mounting its own corresponding onslaught on Mahometan trade. The phenomenon of Barbary piracy had begun in earnest when Barbarossa made Algiers his base in 1529, and the lead that city acquired as a corsair centre was never lost. The fortunes of the other ports were more fluid: Dragut turned Tripoli into a corsair state on the model of Algiers after capturing the town from the Knights of Malta in 1551, and for a generation its marauders were the most feared in the Mediterranean, so that people said to their friends embarking in Italy, 'God save you from the galleys of Tripoli!' The Maltese response was fierce, including two attempts, under La Valette and Verdale, to reconquer Tripoli, and by 1612 the corsair fleet there had fallen to a mere two vessels.

Its place was taken by Tunis, whose rise began after the town's conquest by the Turks in 1574. The Tunisians, facing the Knights of Malta in the same narrow seas, took a leaf out of their enemy's book by building similar large, strong galleys, so that their corsairs were the only ones whom the Maltese were ordered not to attack unless they possessed at least equality of numbers. The ill-starred clash of the two fleets off Saragosa di Sicilia in 1625 demonstrated the need for this precaution.[3] The apogee of Tunis as a corsair state was reached under Yusuf Dey in the years 1610–37. Tunis became the main base of the Dutch and English pirates who invaded the Mediterranean at this time and taught the Berbers the use of the *berton*, a swift, small, manoeuvrable, heavily-armed sailing ship which proved ideal for attacking commerce. With this new weapon the Barbary corsairs spread terror over the sea, taking advantage of Spain's resumption of war with the Dutch in 1621 and especially of its war with France from 1635. At their height around 1640 there were some 150 corsair vessels – most of them very small raiders – operating from the Barbary ports. Algiers was an enormous city built entirely on state piracy, with 100,000 inhabitants, a quarter of them Christian captives; it was larger than Genoa or Marseilles, far larger than Barcelona or Leghorn. One hundred marauding vessels of all

kinds sailed from its ports, and the guild of corsair captains dominated the city's government. The coasts of Spain and the southern Italian lands were ravaged by audacious slave-taking raids, their economies ruined by the attacks on shipping.

The Moslem *corso* at this time far outstripped that which the Knights of St John had long conducted against the Ottoman Empire. On their installation in Malta they had resumed their harassment of Levantine shipping, and as the North-African ports fell under Ottoman control these too became the object of attack. Such expeditions were undertaken by private enterprise, whether of knights or of civilians, who acquired letters of marque to sail under the Order's flag. Their objective was to board and capture Moslem ships and bring them back to sell as prizes; the captives were either held to ransom or, if able-bodied, sold as galley slaves to the Maltese or other European governments; raids along the Moslem shores also contributed to this supply. An elaborate schedule of distribution reserved 11 per cent of the booty to the victorious captain, 10 per cent to the Grand Master, and so on down to a small proportion set aside for the nuns of St Ursula.

In 1562 the Duke of Tuscany founded the Order of Santo Stefano in an imitation that was the sincerest form of flattery of the Order of St John; it even had as its badge the same eight-pointed cross, in reversed colours. Operating from Leghorn, the Knights of St Stephen were, especially in the first half of the seventeenth century, the closest rivals of Malta in the privateering war, while Marseilles, Toulon and Majorca were also significant centres. Nevertheless geography as well as the warlike character of its knights made Malta the chief stronghold of the Christian *corso*.

The traditional European view used to depict a scene of cruel and unprincipled piracy on the part of the Moslem, and a heroic fight against it by the Christians. More balanced study shows that the two parties were engaged in the same activity: regulated privateering under their nations' flags, and their organisation and methods were very similar. The Barbary corsairs were licensed by their princes and financed by local businessmen, who received a dividend from the profits; like the Christians, they treated their prisoners fairly well and were scrupulous

in respecting the virtue of the women. Nevertheless revisionism goes too far in suggesting that there was nothing to choose between the two opponents. The differences were small, but they were all in favour of the Christians. Perhaps the most important is that a high proportion of the Barbary corsairs were Christian renegades, the lowest dregs of the European coasts, who adopted Mahometanism and sailed under Barbary flags because if captured they could only be condemned to the galleys, whereas outright piracy would have entailed hanging. It is hard to imagine that this difference was not reflected in their conduct. It was certainly reflected in their tactics. The Barbary vessels carried few guns and large crews, aiming at swarming aboard their victim and capturing it intact; the Maltese ships, by contrast, were famous for their gunnery, since their ethos emphasised combat more than rapine. They also specialised less in slave-taking raids on land, although these were undoubtedly a regular part of their activity. It is also possible that, in spite of the strict prohibition against harming Christians, the more unscrupulous Maltese corsairs took part in the lawless depredation that ravaged the Greek Archipelago, though evidence for this comes only from hostile sources.[4]

Some general writers – whose approach to the subject is impressionistic – assert that the Knights of Malta engaged in indiscriminate piracy, regardless of their ostensible aims. If nothing else, this allegation shows an ignorance of the Order's economy, since Catholic powers would have had easy redress against such behaviour in confiscating the commanderies within their frontiers. Such dubious activity as there was discloses the prevalence of legality rather than its absence. For example, when during the Franco-Spanish war French corsairs under the Order's flag attacked Spanish ships, a protest to the Grand Master Lascaris obliged them to desist. The Maltese sometimes attacked English and Dutch ships trading with Turkey, but the excuses given – for example that the enemy had stolen from Maltese vessels – indicate that even in Malta this was not considered legitimate. There was also high-handed action by captains of all nations who commandeered grain-carrying ships in times of scarcity, though in such cases the cargo was eventually paid for. In general the rules of the *corso* were very fairly applied: they

protected Greek merchants sailing under the Turkish flag (a principle which the prize court of Leghorn did not admit till 1733); such captains could challenge a capture in Malta's own courts, and, at least until the late seventeenth century, they were readily granted redress.

A vast reversal of the balance of privateering in the Mediterranean took place in the second half of the seventeenth century. From about 1650 the Dutch and English began to send punitive expeditions which exacted respect for their flags from the African Regencies; France added her own weight a decade later. As a consequence Tunis transformed itself after about 1670 into almost an ordinary trading nation with little corsair activity, and by the end of the century the Algerian corsair fleet had dwindled to a mere two dozen vessels. By contrast an enormous expansion took place in the Maltese *corso*, which reached its peak in the years 1660–75. The characteristic of these years was a strong shift of activity from Barbary to the Levant, and to attacks on the rich 'Caravan' sailing between Constantinople and Alexandria by way of Smyrna. The lure of capturing that fabulous source of wealth provoked the knights to the most audacious exploits, and is reflected in the fame of Gabriel de Téméricourt, who in 1669 succeeded in taking an enormous galleon together with some smaller ships. This lucrative area was almost monopolised by the French knights, while the more proletarian Barbary *corso* was largely left to civilians. Up to thirty corsair ships, manned by four thousand men, were operating under the flag of Malta at this time, and so heavy was their scourge on Moslem trade that the Turks voiced the question, 'Is France as powerful as Malta?'

The answer, as it happened was provided by France herself. The effect of the Maltese onslaught on the Levant was to enable the French to capture a large proportion of the Turkish carrying trade; and this in turn gave them an interest in the prosperity of their trading partner: hence an order from Louis XIV in 1679 withdrawing French subjects from the Levantine *corso*.[5] The popes also obliged the Malta corsairs to give the Holy Land a wider and wider berth, and were increasingly strict in protecting even schismatic Christians from molestation. The Grand Masters fought a rearguard action, establishing the *Consolato del Mare* (1697) as a lay court to replace

that of the Order (which was subject to papal jurisdiction) and likewise granting their own flag as secular princes instead of the Order's flag; Maltese corsairs even resorted to taking the flag of other sovereigns, such as the Prince of Monaco; yet all these expedients were neutralised one by one, and by 1733 the Maltese *corso* appeared to be completely dead, though in fact it was merely dormant. For that matter, the virtual expulsion of Moslem shipping from the Mediterranean had left it with almost no field of action.

The war of the *corso* has been the object of somewhat misdirected criticism on the assumption that it was mere pillage with no strategic effect. Its wider consequences were in fact substantial: by forcing the maritime trade of the Ottoman Empire into the hands of European countries it hastened the economic, and thus the political, decline of that empire. More particularly, by destroying secure trading links between Turkey and the Barbary Regencies, it also weakened political ties, and led to the independence of the latter from Constantinople. Having thus isolated the African states it kept them weak; the Maltese *corso*, which remained active in Barbary after it had withdrawn from the Levant, ruined the coastal economy of Tunis and Tripoli far more thoroughly than the Moslems ruined that of Spain and Italy. Repeatedly in history state piracy has been a means of breaking into a rival's trade monopoly, and the winner in the war is the country which emerges with trading supremacy in the area of conflict. Applying that test, the Mediterranean privateering war resulted in an overwhelming victory for the Europeans.

The Role of the Navy

The attention the above activities have always received may nevertheless produce a distortion of emphasis; for, while it was certainly the Order's policy to make Malta the chief centre of the Christian *corso*, privateering in itself was not the official activity of the knights. By definition it was a private enterprise, privately financed. The Order's resources and the bulk of its active members were devoted to the navy, which

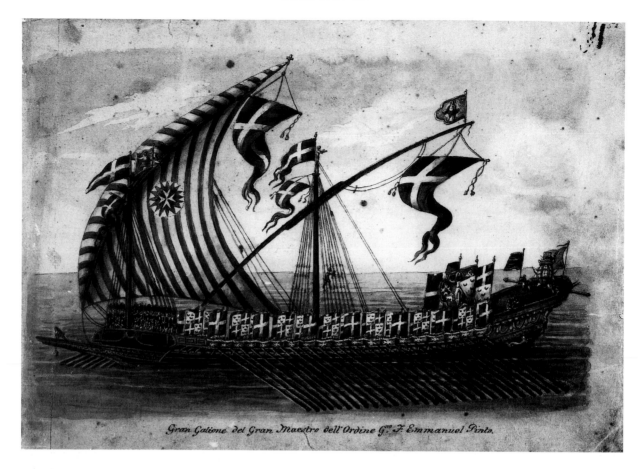

Galley of Grand Master Pinto.

operated with different aims. As has been noted, the fighting fleet consisted mainly of galleys, on which every knight was required to serve three 'caravans' to qualify for a commandery. These were expeditions of at least six months, and each galley carried twenty or thirty *caravanisti*, whose youthful ardour and national rivalry were a guarantee against any promptings of caution. Captaincies were conferred on knights fresh from their caravans, and even the Generals of the Galleys were remarkably young, facts that explain the renowned audacity of the knights' attacks.

Capturing Moslem ships was a major part of the fleet's task, though its chief quarry was enemy corsairs rather than merchantmen; as the main value of a prize was in the ship itself and the captives, the sacrifice was not a great one. The crew had to be content with their pay, and did not receive a share of the booty as in the corsair ships. Nor did the fleet make slave raids

on shore, though it often made not dissimilar attacks on strategic posts, in which captives were taken. These were not the only ways in which its activity bore a similarity to that of the privateers. The expense of maintaining a galley (reckoned at 20,000 *scudi* a year in the seventeenth century, 30,000 in the eighteenth) was borne wholly or partly by the captain himself; the command of a General of the Galleys required an expenditure of 30,000 to 50,000 *scudi* a year. Yet the knights undertook the posts willingly, because a captaincy gave a preferential right to a commandery, and the Generalship entitled one to the Grand Cross and correspondingly rich benefices. The prize-taking urge was therefore provided not so much by avarice as by the need to finance one's career as a knight. By using the ambitions of its members, the Order was thus able to maintain a fleet at a fraction of its real cost; nor, in general, is it likely that the wealth knights drew from their eventual dignities really repaid their outlay in qualifying for them.

From 1576 to the middle of the seventeenth

century the fight against the Barbary corsairs was the principal task of the Order's navy; its increasing difficulty is shown by the fact that despite the ending of the Turkish war the number of galleys rose from four to seven and the required number of caravans was increased from three to four in 1600. The energetic Alof de Wignacourt (1601–22) did his best to promote the activity of the Order, especially its landings on the African coast, but the ill-success of these, amounting sometimes to disaster, obliged the knights to confine themselves to the sea.[6] Their sorties were often made in winter, while the galleys of other nations were in port, and they specialised in the task known as 'cleaning the islands' – those of Italy and Spain, where the corsairs were wont to lurk. In 1639 and 1640 attacks were made on Tripoli and La Goletta. During these years when the Barbary states were at their most powerful, there is nothing more remarkable than the presence, in the very jaws of the enemy, of a strong, independent, increasingly well-defended Christian port sending out aggressive expeditions to counter the activities of the corsairs.

For the decline of the Barbary *corso* in the second half of the century credit is generally given to the European naval powers, specifically Holland, England and France, yet two qualifications need to be made to this view: the first is that expeditions of the Catholic powers against Africa were always strongly supported by the Knights of Malta, who were regarded as the specialists in that field.★ The second is that, while the sea-power of the European nations was in the long run of greater weight, it was exerted to enforce respect for each country's flag; attacks on competitors' trade were regarded with indifference, if not positive complacency. This influence therefore reduced Barbary privateering only by reducing the proportion of Mediterranean shipping which the corsairs were free to prey upon. The action of the Knights of Malta was of more direct effectiveness, as can be seen from the fact that Algiers, though it was the port most exposed to the European navies, remained the chief centre of the Barbary *corso* until its conquest

in 1830, while the others sank into insignificance. The reason is simple: Algiers was 650 miles from Malta, and Tunis and Tripoli only two hundred.

The Venetian Wars

It was one of the knights' most resounding exploits in the corsair war that introduced a new phase in the Order's naval action: in 1644 Gabriel de Meaux de Boisboudran captured off Rhodes a great Turkish Sultana which proved to be carrying the chief eunuch of the court together with one of the Grand Signior's concubines and her infant son.[†] This kind of behaviour in the Levant earned the detestation of Venice as much as it had done during the Rhodian period. Nevertheless the Venetians had been happy to supply the corsairs with naval stores and buy their prizes; and the Sultan Ibrahim, while enraged by this crowning affront, remained sufficiently calculating to select Venice and not Malta as the object of his revenge. He took the incident as a pretext to bring to an end Venice's remaining colonial presence in Crete. In the twenty-four-year War of Candia which ensued, the Knights of Malta held themselves honour-bound to help their erstwhile enemies in resisting the Turks, and thus initiated eighty years of alliance with the Serene Republic.

By the middle 1650s the allies were in a sufficiently strong position to carry the war onto the enemy's doorstep; with the Maltese fleet under Gregorio Carafa – the future Grand Master – they fought a number of actions at the mouth of the Dardanelles against numerically superior Turkish forces. The battle of 1656, in which the Turks lost 47 galleys and 46 sailing ships, was one of the most crushing naval defeats in that nation's history. Despite this the allies did not succeed in their aim of driving the Ottoman navy out of the Mediterranean, and by 1669, when the last Maltese relief expedition arrived, the position of Candia was desperate. The knights were entrusted with the bastion of

★ For example the French attack in 1664 on the Algerian port of Gigel (under the command of the 'Chevalier Paul') was supported by the Order's galleys and a battalion of troops.

† He became the celebrated *Padre Ottomano*, after being taken to Malta to be brought up by the Dominicans, whose order he entered.

Sant'Andrea, the most endangered part of the city's defences, so breached that the enemy was almost upon the walls; but in July the party of volunteers from France decided that the position was hopeless and withdrew; the Knights of Malta had no choice but to do the same. 'I lose more,' wrote the Venetian governor, 'by the departure of these few but most brave warriors than by that of all the other forces.' Crete passed into the hands of the Ottomans, but Venice recognised the assistance that Malta had given in the long struggle by granting the knights the unique privilege of bearing arms in the Republic's territories.

The new comity with Venice was displayed again in the war provoked by the Turkish siege of Vienna in 1683. While John Sobieski of Poland came gallantly to the aid of Austria, the Pope organised a holy league with Venice and Malta, and the power of Turkey was rolled decisively back. In those heady days, which seemed to revive the age of the crusades, the Venetian, papal and Maltese navies won a string of victories between 1684 and 1694: Santa Maura, Prevesa, Coron, Navarino, Modon, Napoli di Romania, Castelnovo, Malvasia, Valona and Scio. The galley fleet of the Order was at the height of its power in these years, with eight of the largest and strongest galleys in the Mediterranean, superbly trained and with the unmatched experience of the knights' ceaseless war against the Infidel.

In the years 1715–18 Turkey and Venice were again at war, and in 1716 the navy of the Order fought, in co-operation with the Pope's, its last sea battle with the Ottomans. Although the Turks recovered the Morea, this war was their last effort as a serious danger in the Mediterranean, and unofficial negotiations led to a tacit truce between Malta and the Sublime Porte from 1723.

The Eighteenth Century

The period following 1723 has been described by historians of the Order of St John as one of naval decline. For all its prevalence, that view is founded on a primal ignorance of the area most relevant to the question: the development of the North-African states, of which a brief outline is

necessary. All three of the Regencies succeeded in increasing their independence from Turkey at the beginning of the eighteenth century, and two of them accompanied this with an expansion of their real power. Algiers conquered Oran and Mazalquivir from Spain in 1708; Tunis remained weak and subject to Algerian intervention. Tripoli is the case most pertinent to our subject: the corsairs, driven from the other Regencies, had taken refuge here, and Tripoli re-emerged as a strong corsair centre in the second half of the seventeenth century. The position of the Regency was further strengthened by the accession of the Caramanli dynasty in 1711; its founder, Ahmed Bey, extended his rule to Cyrenaica, exacted tribute from the Fezzan, and sought to build up his naval power.

Parallel to these developments came the break-up of Spain's Italian dominion as a consequence of the War of Succession. Sardinia was granted to the Dukes of Savoy in 1720; Naples was weakly held by Austria from 1707 and became independent under Bourbon rule in 1734. As a result, instead of a single empire defended by the Spanish navy (and here, for naval purposes, we should include the Papal States), there were left three minor powers, each with an insignificant fleet and each pursuing its independent defence. These were conditions which the Barbary states could have exploited to achieve local dominance in the central Mediterranean; that they did not do so is due essentially to the Order of St John.

The first signs of the reponse to the new threat appear at the beginning of the eighteenth century. In its alliance with the Venetians, the Order had found it most efficient to specialise in galley warfare; now, however, it was faced with a serious naval rival nearer home, against whom it had to fight alone. The decision was therefore taken to diversify the fleet, to reduce the number of galleys to five (later four) and to build four ships of the line, of between fifty and sixty guns, to which a fifth captured one was quickly added. This mixed fleet first put to sea in 1705 under Castel de Saint-Pierre, who had a grand design to sweep the Barbary corsairs from the Mediterranean with the support of the European powers. As the latter were busy fighting each other, his plan had little chance of being realised, but for the next half-century the Knights of Malta struck a series of formidable blows at the Tripolitanian navy, preventing the Bey from

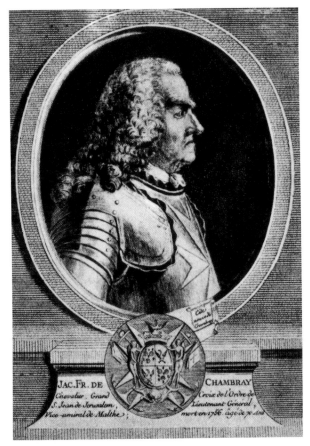

Jacques François de Chambray.

matching his power on land with corresponding power at sea.

An early success was the capture of the *Soleil d'Or* in 1710 by Joseph de Langon, who was killed in the action. The figure most closely associated with the feats of the sailing squadron was the ferocious Jacques de Chambray, a strong advocate of the superiority of the ships of the line, who in 1723 received the command of the *Saint-Vincent*, of 52 guns, with a crew of 300. In his first cruise, sailing off Pantelleria, he came upon the Vice-Admiral of Tripoli with an armament of 56 guns and a crew of 400, and captured the ship after a fierce fight, winning the most important victory for the Order since 1700. Chambray's exploits continued for another twenty-six years, until he retired in 1749 with a string of victories behind him. Under his command, the mixed fleet of the Order attained, in the 1740s, the peak of its strength, with six sailing ships (three of them of 60 guns) and four

galleys. As a consequence, Tripoli was obliged to recognise defeat, and under Ali Caramanli (1754–93) a semblance of friendly relations was maintained with Malta, peaceful trade being developed between the two countries.

An achievement of less immediacy, but striking in the longer historical view, was the blocking of the recovery of Tunis. That city had traditionally enjoyed one of the most favoured positions on the North-African coast, as was shown by its own greatness in the Middle Ages and that of Carthage in antiquity. Yet from the time of the knights' arrival in Malta the days of Tunis as a nodal point in the Mediterranean were numbered. Competing with it for mastery over the Straits of Sicily, the Knights of St John ensured that Tunis remained the weakest of the Barbary Regencies, transferring to their own island the centrality that had belonged to its African neighbour.

The myth of naval decadence therefore needs to be replaced with a different analysis: until 1722 the Knights of Malta had fought Turkey in alliance with the other Christian powers, and their role in that conflict had necessarily been that of auxiliaries, however brilliant. After the truce of 1723 the stage was narrowed, but the knights' role became a central one, and we find them operating in the middle years of the eighteenth century with a greater degree of independent effectiveness than at any time since the Rhodian period. Their influence can be illustrated by drawing a circular map of a thousand miles' diameter centred on Malta; this area was occupied by two Moslem and three Christian states whose naval weakness was on the one side enforced, on the other protected, by the navy of Malta. Only on the north-eastern fringe of the circle does Maltese sea-power give way to Venetian. The Order exercised this role not only directly but through its function as a naval academy for the European fleets. The Papal States, Naples and Sardinia (none of which had a navy equal in strength to Malta's) would have had no officer corps worth looking at without the Knights of St John. Thus the local balance of naval power in this vast area revolved round Malta and its few hundred knights, who succeeded in crippling the maritime development of North Africa. That this achievement appears a small one – that we take the weakness of the African states for granted – is itself a measure of its success: in the

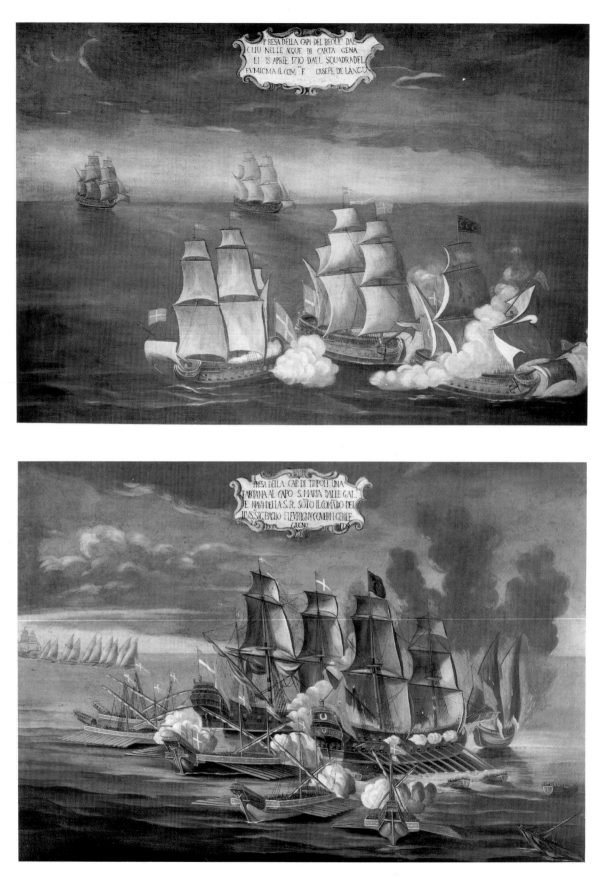

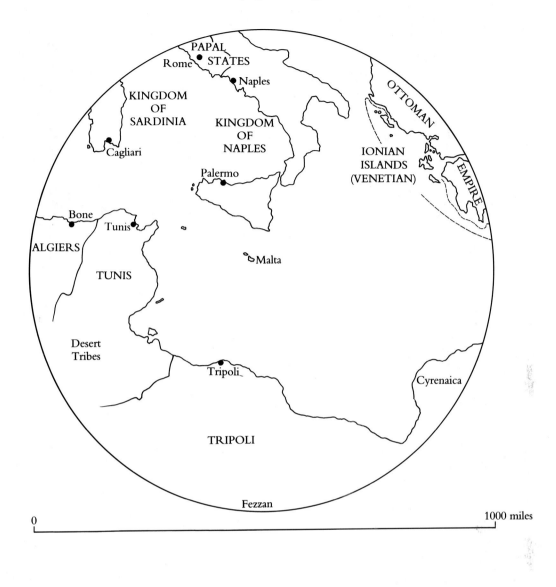

Central Mediterranean 1720–1797.

early seventeenth century the Barbary Regencies had been naval powers on a level with England and France; in the eighteenth, if the Order of Malta had not stood in their way, conditions were ripe for them to recover a portion of their dominance at the expense of the Italian states.

By the last third of the century the knights' success was so complete that they seemed to have left themselves nothing further to do.

Opposite: Views of two actions of the navy of the Order, early eighteenth century.

The Regencies had stopped building anything but xebecs and similar small craft, because any larger ship was immediately captured or destroyed by the Knights of Malta. As a consequence we find a gradual reduction in the strength of the Maltese navy and a shift to bombarding operations (such as the support for the French attack on Tunis in 1770) and in particular to action against Algiers, which remained the only significant corsair base. The Algerians were attacked in 1772, 1775, 1783 and 1784 in collaboration with Spain, which was making an effort at this time to dispose finally of its ancestral enemy. In 1784 a ship of the line and three galleys supported the Spanish attack

on Algiers,★ after which the Maltese squadron remained cruising in Algerian waters, at Spain's request, maintaining pressure on Algiers in preparation for a further campaign the following year. Unfortunately Spanish resolution petered out into an unsatisfactory peace treaty; the opportunity of a decisive victory was lost, and Algiers lived to plague Christian shipping for a further forty-five years.

The appearance that the corsair threat had become negligible was nevertheless delusive. Such activity had always shown a resurgence in a period of general war, especially one in which both Spain and France were involved (for example in the 1740s and early 1760s); and the Mediterranean was about to witness one of the longest such periods in its history. The years 1793 to 1814 permitted the Barbary *corso* to recover a vigour it had not known for a long lifetime. Algiers increased its corsair strength from ten small vessels and 800 Christian captives in 1788 to thirty ships and 1,642 captives in 1816. Tunis and Tripoli enjoyed a similar revival. At first this trend was contained by corresponding ac-

tivity in Malta: not only did the *corso* revive (nine privateers were licensed in 1797 alone) but the navy redoubled its efforts and in the five years 1793–98 it captured eight prizes, almost as many as in the whole of the previous thirty years. The last of these was taken only a few days before the French attack on Malta.

Despite its greater strength, the British navy based in Malta after 1800 did little to continue the work of the Order of St John except in the interests of its own trade. Algiers remained a corsair centre until its conquest by the French in 1830. Tripoli, under Yusuf Caramanli (1795–1832), became a serious nuisance to many countries, as was demonstrated by the repeated expeditions against him: by the United States in 1803–5, by Britain in 1816, by Sardinia in 1825, by Naples in 1828 (a disaster for the Neapolitan navy), and by France in 1830. The expulsion of the knights from Malta thus underlined the impartial policing work they had performed for the benefit of all nations and the remarkable naval effectiveness they had maintained in the central Mediterranean.

★ At the same time a ship of the line and two frigates were helping a Venetian operation against Tunis. In the previous two years a force had taken part in an Austrian push down the Danube against Turkey. The years 1783–84 may well have been the time of the Order's most intense naval activity since the seventeenth century.

X. Le Poët Laval, a 12th-century fortified village of the order, showing the commandery chapel (ruined) and the castle beyond. Michel Durand, photographer, Dieulefit.

XI. La Couvertoirade, a 15th-century fortified village of the Order. Photo studio M. Martin, Milhaud.

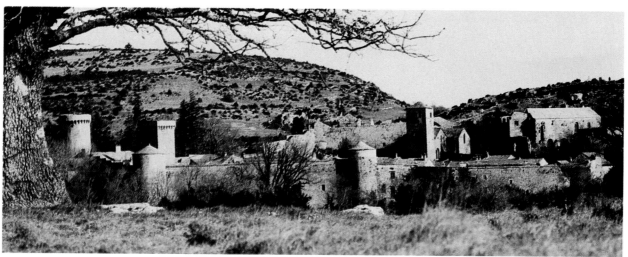

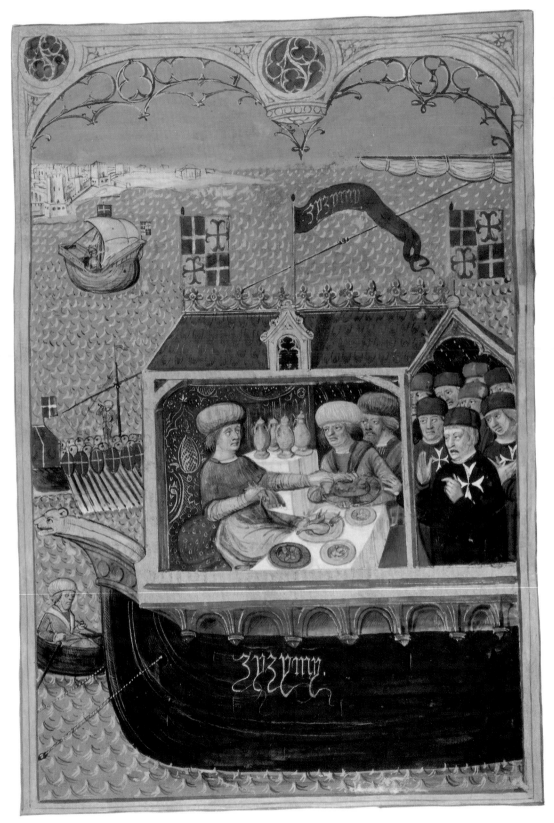

XII. Prince Zizim is feasted by the Knights of Rhodes on board ship, from Caoursin's history.
Bibliothèque Nationale (Paris) MS Lat. 6067.

PART II

The Order of St John in Europe

CHAPTER VIII

Introduction

The Growth of the European Priories

LIKE OTHER RELIGIOUS orders, the Hospital of St John was the beneficiary of numberless donations throughout Latin Christendom. The mainstream of its history, flowing through successive centres of its government from Jerusalem to Malta, was fed by the national tributaries from which it drew its material and human resources. These tributaries however had a life of their own, subordinate in purpose yet sometimes as fully developed as that of the great monasteries; if their spiritual function was less intense, their interaction with the society around them was fuller, and through them the history of the Knights of St John is interwoven with the religious, social artistic, military and political life of every European country.

Benefactions to the Hospital of Jerusalem began to appear in the flood of enthusiasm for the institutions of the Holy Land created by the First Crusade. During the first third of the twelfth century we find a wave of grants to the Hospital, but it is very strikingly a Provençal and Spanish phenomenon. Italy was curiously unresponsive to the trend, apart from what appears to be heavy support by Amalfitan merchants and some foundations in the extreme north-west, where Provençal influence may have been at work. In the middle third of the century the tide of devotion begins to lap into northern France and England.

It was not until after the Second Crusade (1147–48) that support for the Hospital became general throughout Europe; its first donations in the Empire, Hungary, Poland and Scandinavia appear at this time, and in Italy we see the beginnings of the network of pilgrims' hospices which formed a characteristic part of the Order's work. Hitherto, as far as we know, the whole of the Hospital's European organisation was governed from two points: Messina and Saint-Gilles. The first may have controlled Italy, or at least the Kingdom of the Two Sicilies. The second had a vast jurisdiction which included all of France, Spain and England; though local priories appear in Portugal, Castile and England about 1140, they were at first subordinate to the Priory of Saint-Gilles. From the 1150s however the three priories of Aragon, Castile and Portugal were independent, and after 1170 they were linked by the office of Grand Commander of Spain.

The Grand Commanderies established a distinction between the local jurisdiction of the priors and the wider work of co-ordination over several countries. From 1171 we find the Grand Commander of Outremer (so named from the Palestinian point of view: the Grand Commander in Jerusalem was the first of the great officers of the Order), who virtually took over the jurisdiction formerly held by Saint-Gilles. After 1178/9, when a Priory of France was created for the north of the kingdom, there appears a Grand Commander of France to oversee that Priory and Saint-Gilles. A similar office for all Italy is found in 1188, for Germany in 1249; but the areas entrusted to these dignitaries were fluid and evidently chosen for the requirements of the moment. In the late thirteenth century the four Spanish priories were co-ordinated by the Grand Commander of Outremer, whose designation *Grant et General Comendador en las partidas denant mar*[1] shows that the taste for sonorous titles developed early among the Hospitallers

The seal of Manosque, 1216, showing the early form of the cross of St John.

The priories were groupings of local houses whose name varied over the centuries. In the Rule of Raymond du Puy they are referred to as *obedientiae*, and names such as *domus* and *mansio* are later found. The most frequently used terms are *preceptoria* and (increasingly from the thirteenth century onward) *commendatoria*. The latter derives from *commendare*, to entrust, and the head of the house was called the *commendator* (a piece of bad medieval Latin for *commendatarius*), the trustee. This word was further corrupted in French and English into *commandeur* and commander, where the alien notion of command has intruded.★

A preceptory or commandery was seldom a single consolidated estate; the majority consisted of a 'head', where the preceptor resided, and a number of 'members' distributed over a larger or smaller area according to how densely the Order was endowed. In Denmark one house was founded in each diocese, while the kingdoms of Scotland, Norway, Sweden and Poland all had to rest content with a single preceptory apiece. The nature of the properties also varied widely, between baronies with feudal jurisdiction and assorted rights accumulated over the centuries, such as the advowsons of churches, fishing rights and occasional dues of hospitality to travelling brethren. Many commanderies had 'members' of this type scattered over twenty or thirty villages; some of the richer ones might have interests in a hundred or more.

The origins of these varied possessions are traceable to the great surge in devotion to the Hospital that marked the twelfth century. As often as not, the donor wished to give his person as well as his property to the new Order. A nobleman might enter as a knight and give his manor; a peasant could only give perhaps a vineyard or a cow, but he too wished to be received into the brotherhood, and so the houses of the Order became a refuge for the devout from all walks of life: some were knights, chaplains or serving brethren who had taken the full vows; others, similarly ranging from the noblest to the simplest, lived in the preceptories as mere *confratres* who in return for their donation were entitled to share in the Order's life and spiritual benefits. This novel role of the Hospital in offering an intermediate way of religious dedication between the cloister and the world was one of the keys to its success as a religious order in the twelfth century.

Those who made substantial gifts were often appointed preceptors to administer them for life, a convenient way of recognising the donor's generosity and of providing local managers for new properties. The principle could be applied even to a minor priory; thus the nobleman Juan Martinez de Mañeru entered the Hospital about 1230 with a substantial estate, and from 1240 to 1250 we find him serving as Prior of Navarre.[2]

Women too joined the Order in this way, and many are to be found in the twelfth and thirteenth centuries as commanderesses. But religious discipline frowned on community of sexes, and in the last quarter of the twelfth century convents began to appear. The foundation of Buckland in Somerset in 1180 is a classic case, the convent being formed by eight nuns collected from six separate English preceptories. By the year 1200 women's priories also existed at Sijena and Cervera in Spain, Martel in Quercy, Pisa in Italy and Manetin and Prague in Bohemia.

The expulsion of the Hospitaller nuns from Jerusalem has been cited as the occasion for these foundations, but the dates fail to tally. The

★ In this book 'preceptory' is generally used for the medieval period, 'commandery' for the modern, more or less in line with contemporary usage.

theory may be a confusion with what happened on the fall of Acre, when the sisters of the Hospital were indeed forced to return to Western Europe, for no women's convent was established in Cyprus or Rhodes.★ Four or five new foundations or re-foundations took place at exactly this time: Penne in Italy (1291), Beaulieu and Fieux in France (1297–98), La Rápita (*c.* 1290) and perhaps San Juan de Acre in Spain. In the sixteenth century the number of nuns' houses in Europe rose to seventeen.

Like all religious houses, the preceptories of the Order were expected to give shelter to travellers – an obligation limited by custom to three days; but only a minority were expressly designed as hospices on the pilgrim routes. A few of these, for example Genoa, were fully-fledged hospitals with a large capacity, but most probably had no more than a chapel with a hall beside it where the travellers ate and slept. Writers have often represented the Order of St John as maintaining a great network of free hospitals in the twelfth and thirteenth centuries, and have contrasted its early charity with a supposed decline into idleness and luxury in the later Middle Ages. Both parts of this picture are fantasy. The charity of the early foundations consisted chiefly in the building of convenient lodging places for the vastly growing number of medieval travellers; it was a characteristic element of the Order's work, but only part of a much wider trend in which many religious bodies were active. The pilgrims paid for their lodging according to their means, though apart from occasional endowments from the richer visitors this was a system which made hospitality a charge rather than a source of income.

Two developments brought an end to this early increase: the growth of the money economy and of urban life which enabled ordinary inns to supersede the hospices as stopping-places, and the growing number of *Maisons-Dieu* and hospitals which replaced them as refuges for the sick. In all Europe the host of small houses of the twelfth and thirteenth centuries gave way, for obvious practical reasons, to the fewer and larger hospitals of the main towns, while the increase in vagrancy and violence after the Black

Death made the easy hospitality of earlier times harder to maintain. Specific instances illustrate the changes: in Genoa the large hospital of Pammatone, founded in 1470, absorbed twelve of the smaller establishments of the city; only the four largest, including that of St John, were left open. In 1557 the Pammatone sought to annex the Order's hospital as well, and the attempt was frustrated only by the intervention of the Pope. Where such pressures could threaten even a large house like Genoa, it was impossible for the smaller hospices to continue in being.

Further examples show that it was precisely the hospices that were most needed that survived: thus at Lodi the Order had two hospices, one inside the town and another on the road several miles outside it; the former was amalgamated with the Ospedale Maggiore in 1457 but the other continued to function until 1616. A small hospice at Voghera in Piedmont served travellers until it was suppressed by the French revolutionary regime.[3] Hospices in the remoter places were likewise maintained, for example at Salgesch on the Simplon pass, at Malcantone in Ticino, and in many places of the Pyrenees.

Besides sheltering travellers, the larger houses, especially the heads of priories, maintained substantial 'families' of brethren, donats and corrodaries[†]. Some of them functioned as novitiates, for among the donats were young nobles awaiting admission as knights. This is the only evidence we have of a novitiate before the fourteenth century,[4] but as the large communities declined it became normal for knights to perform their novitiate in Rhodes and later in Malta.

Administration

For a century and a half the main duty of the European properties to their mother house was to send the materials needed by the hospitals of Jerusalem and Acre. The Statutes of 1181 stipulate the quantities of cotton sheets, fustian and cotton cloth, felt, sugar for the confection of

★ A recent work, *Rhodes et ses Chevaliers* by J.C. Poutiers (p. 78), credits Rhodes with an imaginary convent of nuns. As an explanation of its ultimate fate we are given the story that these ladies were left behind by their perhaps chivalrous but absent-minded brethren and were sold into slavery under the Turks.

† For corrodaries see p. 183.

Cross of the Order from the castle of St Peter, Bodrum, *c.* 1510, an early example of the rectilinear 'Maltese' shape.

medicinal syrups, and other commodities that were required of the various priories.[5] Preceptors were also enjoined to send on their superfluous revenues, but given the needs of the pilgrim hospices and the local communities these were seldom considerable. The military tasks of the Order were financed essentially by the territories of castles such as Bethgibelin, Belvoir and Crac. These easy-going conditions obtained until the 1260s, when the Sultan Bibars swept through the crusader states, pinning the garrisons of the military orders into their castles. The crisis coincided with the magistry of Hugues de Revel (1258–77), perhaps the outstanding figure of the thirteenth century and one of the greatest administrators ever to have governed the Order. In an eloquent and able letter of 1268 he reminds the Prior of Saint-Gilles: 'For some eight years now we have drawn no revenues at all in the entire Kingdom of Jerusalem, and everything we possessed before the gates of Acre has fallen to the enemy.'[6] The territories of Crac and Margat which had once supported a population of ten thousand were lost, and the garrisons of those castles were beleaguered in what had been their ample dominions.

Faced with these dangers, Revel began a radical reform in the administration of the Order. He began the practice of summoning Chapters General at frequent intervals to strengthen the links between the European brethren and the Convent. He held six Chapters during his magistry; the first, in 1262, enforced defined monetary contributions, known as responsions, and fixed their level at one third of the house's income. Whereas formerly preceptors had been appointed by their priors, as a further measure of centralisation preceptories 'of grace' were henceforth to be granted by the Chapter General.

From this time also seems to date the division of the Order into the national bodies which by the 1290s had been given the name of Tongues. Revel's letter of 1268 enumerates seven areas as the separate sources of the Hospital's revenues: the three French priories of Saint-Gilles, Auvergne and France, together with Spain, Italy, England and Germany. The Grand Commanderies (whose principal function seems to have been the collection of revenues) gave unity to some of these groupings of priories; in the early fourteenth century however the Grand Commanderies were abolished, while the Tongues were embodied in the conventual lodgings in Rhodes which became the sevenfold base of the Order's constitution.

An earlier administrative change affected the tenure of the priors; at first these had been replaced very rapidly in office, and were generally recalled to Jerusalem after a few years. The example of Saint-Gilles shows us an average tenure of four years between 1108 and 1244; at the latter date, however, we find the practice instituted of appointing priors for ten years, and the following two centuries show an average

twelve-year tenure. Appointments came to be renewed indefinitely, Guillaume de Reillane being the last to relinquish the Priory (in 1352) at the end of his second ten-year term, and by the fifteenth century at least priories and bailiwicks were in practice held for life.[7]

The structure of the Hospital's possessions was revolutionised by the gain of the Templar lands after the dissolution of that order in 1312. The details of this transference leave no doubt that the Templars were the richer order, though in some countries such as southern France and Italy there was probably a rough balance between the two, and in others such as Castile, Navarre, Ireland, the Rhineland, Scandinavia and Bohemia the Hospitallers had a local preponderance. In most of France, Aragon, England, Scotland and Brandenburg the Hospital acquired estates many times the value of its own, in spite of the expenses and losses of the transference. The prioral seats of Paris, Rome, Venice and Hungary were moved to the much grander Templar houses that became available, and there were similar changes where both orders owned commanderies in the same town, for example in Montpellier and Bordeaux. The acquisitions gave rise to the creation of four new Hospitaller priories: Aquitaine and Champagne in the Langue of France, Toulouse in Provence and Catalonia in Spain, while in Italy the combinations of two or three priories that had been customary gave way to a fixed sevenfold division from the middle of the fourteenth century.

The Templar lands were not gained without lengthy opposition, which it required great expense to overcome, and these burdens were piled on those brought by the conquest of Rhodes and the extravagance of Foulques de Villaret in his new princely state. The Hospital thus faced a second grave financial crisis when Hélion de Villeneuve was elected Master in 1319. By stringent economies and assiduous diplomacy he succeeded in lifting the debts that weighed on the Order, so that by 1340 it was both immensely rich and expanding its numbers in the clear recruiting field left by the extinction of its rival.[*] Nevertheless the innovations of Villeneuve's magistry seem connected more

Cross given by Pope Pius V to Grand Master La Valette, 1566.

with national organisation than with efficiency. It was in 1320 that the great offices were apportioned among the Langues according to their precedence, the allocation being as follows: Provence, Grand Commander; Auvergne, Marshal; France, Hospitaller; Spain, Drapier; Italy, Admiral; England, Turcopolier.[†] In 1330 the Master was given the right to grant two commanderies in each Priory every ten years to knights serving in the Convent.

The third crisis of the Order's finances came during the Great Schism, when the anti-Master Caracciolo attempted to organise much of Italy and Germany in rivalry to the established government. The division aggravated problems already caused by the economic disruption after the Black Death. Once again an outstanding administrator, Fernandez de Heredia, enabled the Order to overcome this danger. He carried out a general purge of the easy-going commandery households (though these had already been devastated by the plague), and the old

[*] The legacy of the Temple was wholly material; its knights were obliged to join other religious orders but were forbidden to enter that of St John.
[†] It is not clear whether any office was ascribed to Germany before the Langue's complete disappearance from Rhodes about 1340. The office of Treasurer remained unattached to any Langue.

'families' gave way to a more utilitarian structure which left the Commander usually the only professed resident in each house. So effective were Heredia's methods that the Hospital's average receipts from its priories rose from 22,700 florins per annum in the period 1367–73 to 38,500 florins in 1378–99, in spite of the losses occasioned by the schism.[8]

The financial survival of the Hospital was thus achieved at a heavy cost to its communal life as a religious order. That would doubtless have declined in any case as the piety directed towards the Holy Places lost its crusading roots, and other local factors were in operation: Provence, one of the principal areas where the large communities of brethren had flourished, was ravaged by war in the late fourteenth century. As far as the life of the priories was concerned, the militarisation of the Hospitallers is a feature of the later Middle Ages. New foundations became very few and were largely confined to *juspatronats*, which gave the donor's family the right of nomination. One significant exception to this picture must be named: Germany, where the communities of priests and lay brethren flourished and new foundations continued to be established throughout the fourteenth and fifteenth centuries.

In 1343 the responsions were supplemented with the charges of Mortuary and Vacancy. By the first, the revenues of each priory or commandery from the death of its holder until the following 1 May (but only if he died after St John's Day, 24 June) reverted to the Treasury, as did the whole of the next year's revenue in Vacancy fees. By ancient rule each brother's property at his death ('spoils') was bequeathed to the Order, but he was entitled to leave one fifth of it (known as his 'quint') by will.★

In 1358 collection of all dues was taken away from the priors and put in the hands of receivers appointed for each priory. As priors absented themselves on the Order's or royal business these officers were often charged with the administration of the prioral lands, and efficiency in his duties would recommend a candidate for higher posts. A system of appointments developed which was retained until the French Revolution. Every five years commanderies in each priory were bestowed in rotation, the first appointment by the Grand Master, the second by the Order's Council, the third by the prior, and all others by the Council. One of the richest commanderies in each priory was also set aside as a magistral appointment independently of the quinquennial rotation.

A commander was entitled to promotion (*émutition*) to a richer benefice if he had improved the value of his previous one in his five years' tenure, and commanderies were therefore divided by value into those of first acquisition (*chevissement*) and improvement (*méliorissement*). Since every commandery possessed a scattered retinue of 'members', it was not difficult to find a remote property that had been neglected by earlier incumbents; but the rule ensured that the Order's properties benefited from steadily improving management. Merit or influence might enable a knight not only to accede to a richer commandery but also to hold two or three (seldom more), and by the seventeenth century such accumulations were common, especially in the hands of Grand Crosses, a

Knight wearing a pendant cross on a ribbon, in the style of the late sixteenth century. Cavalier d'Arpino, *Vita e Costumi dei Cavalieri*.

★ Besides these revenues from the Order's own properties, the Treasury received the 'passage money' that every brother paid on his reception.

dignity at first attached to the fixed offices of conventual and capitular bailiffs, but later bestowed with some freedom *ad honores*.

Visitations of all the commanderies had to be carried out by the priors or their officers at least once every twenty-five years, and the report drawn up, known in Italian as a *cabreo* (*caput breve*) described each property, often with detailed illustrations, and with a record of its value that would determine a commander's claim to promotion.

Some of the prioral seats, such as Portugal, Castile, Amposta, Saint-Gilles and later Heitersheim, were endowed with large estates which gave them stability of residence. In other cases the prior had to be provided with revenues by the allocation of five commanderies as his 'chambers', and the prioral headquarters often remained nomadic for centuries. The Prior of Catalonia did not settle in Barcelona until 1561, and Lyons became the fourth and last seat of the Prior of Auvergne in 1787. By the fifteenth century the Pilier of each Langue had the right to claim a priory as it fell vacant, but tiresome longevity might keep him waiting for many years. To remedy this difficulty capitular bailiwicks began to be multiplied: hitherto that status had been attached to the commanderies in the East which entitled their holders to a seat in the Chapter General. The bailiwicks thus distinguished – Acre, Armenia, Cyprus, Langò, Negroponte and the Morea – came to be preserved as titles with their old precedence and rights after their real bases had been lost to the Turks. The first western commanderies, besides the Priories themselves, to receive the same status were the great lordships in southern Italy: Sant'Eufemia (first known as a bailiwick in 1289), Naples (1294), and Santa Trinità di Venosa (1317). In the fifteenth century such dignities began to be systematically created, being attached to commanderies of exceptional value: Majorca (1428), Eagle (1433), Santo Stefano di Monopoli (1435), Manosque (1466) and a dozen more in later years, so as to give most of the priories one such bailiwick apiece. A Pilier had the option of claiming one of these prizes, though if he did so he was not entitled to the next vacant priory.

These endowments perhaps slipped through the Order's system of incentives to good management, for by the eighteenth century Manosque and Sant'Eufemia were in a notoriously decayed state. Yet maladministration is not necessarily to blame; both bailiwicks are examples of lordships which had important jurisdiction in the Middle Ages, Manosque being governed almost as an independent state. In the fourteenth century the commander's authority began to be weakened by a wave of constitutionalism which swept over the towns of Provence, and effective government passed increasingly to the consuls. By the eighteenth century all the Bailiff's seigneurial rights had been progressively sold for cash, and the revenues were not even those of a good commandery, so that the Bailiwick had to be reendowed with members of the commandery of Avignon.[9] It was an extreme example of what happened where the Order possessed feudal jurisdiction rather than property.

The Hospitallers in Feudal Europe

Throughout the middle ages it was common practice for the Order to commute such jurisdiction as it was granted for money or other tangible benefits. Since the purpose of its estates was the support of the Convent, the Hospital like the Temple was one of the chief promoters of the money economy in rural Europe, and both orders were known for their experience in storing treasure and shipping it across the seas. In the Priory of Toulouse a common feature is the cession of jurisdiction in the Order's villages to the Crown or to a neighbouring lord in return for the building of the village walls. The granting of charters of privileges to the villagers themselves was likewise a way of encouraging settlement. The philosophy of the Hospital was expressed by the Master Villaret when granting a charter to Le Burgaud in 1296: 'The more the town grows in consequence of the liberties accorded to the inhabitants, the more the house of St John also will prosper.'[10]

The panorama of the Order's possessions, as it is seen in grants, disputes and customs, reveals to us the whole structure of the medieval manorial economy, with the mill, the dovecote, the fish-pond, the hunting rights, the dues in kind, the interdependence of lord and peasant and the reciprocity of duties. When the knight Fortanier de Lat came to take possession of his commandery of Cours in 1459 he found himself first required to swear protection to his vassals: 'que ed lor sera bon souber e leyau e lor gardara

lur for e lurs costumas e lurs franquesas e lurs usatges elos gardara de tort e de forsa de sui e d'autruy de son loyau poder.'[11] Only when he had sworn this on a missal and a relic of the True Cross did the consuls of the village take their oath of fidelity to him as their lord.

Vassalage was symbolised, in the companionable manner of the time, by lord and peasant sitting down together to a meal. At home it was the commander himself who was the host; at Montfrin (Saint-Gilles), to perform the act of vassalage the peasant went to the house of the commander, taking his kettle with him, and after lighting the fire proceeded to eat and drink with him at his table. Further abroad the code of hospitality was reversed. At Caignac (Toulouse) the commander visited his vassals once a year, having the right to descend upon them with his entire household and his dogs, and anybody else he happened to have picked up on the way, and after dinner he received the payment of eight *sols*; the company were then obliged to rise and depart immediately unless their host expressly invited them to stay.[12]

The lord's various means of control over the economy of the manor were jealously guarded. One of these was the right over the oven where the villagers must bring their grain for baking. At Fronton (Toulouse) they paid one loaf in twenty as their due to the lord. The custom was not without its opponents among champions of a free market, some of whom at Puymoisson (Saint-Gilles) in the late fifteenth century claimed the right to build their own oven. When the commander appealed to the law, the courts decided with Solomonic wisdom that the villagers had indeed the right to build as many ovens as they pleased, but they could only bake in the commander's.[13] The commander's mill at Sainte-Vaubourg in Normandy which went by the name of Quicangrogne (*Quoiqu'on grogne j'y moudrai*: let then grumble, I'll grind) speaks of a similar assertion of manorial privilege. Such restrictions may have been irksome, yet when the Revolution overthrew them as marks of servitude the peasants found that they had been better off in a regimen of custom than in one of market forces. At Puymoisson, a historian has calculated, the cost of baking is relatively higher under modern conditions than it was when the commander's right so incensed the peasantry. At Fronton the peasants deserted the markets

Knight of Malta wearing a metal cross on chains; the rectilinear form had become fixed by this period (late 16th century).

after the Revolution, refusing to sell their produce at the fixed prices by which the Convention attempted to control the new economic anarchy; and at Villedieu-les-Bailleul in Normandy there was a protest at the loss of forest, water and game rights, besides the cheap administration of justice in the manorial courts that vassals had enjoyed under the Order.[14]

The type of manorial commandery here described was to a large extent the product of the absorption of the Templar lands. The case of the Priory of France, which found itself with 200 commanderies on its hands, illustrates the enormous accession of wealth brought by that change. The 200 commanderies were amalgamated into 108 by 1373, and eventually to 53. By this process one may say that the social model of the Hospitaller commandery changed from the priest's rectory to the nobleman's manor, and the reservation of the vast majority of commanderies to knights reflected the same change.

Consolidation continued until the early decades of the sixteenth century, and by about the year 1530 the Order had some 630 commanderies throughout Europe. The Reformation deprived it of the four priories of Dacia, Brandenburg,

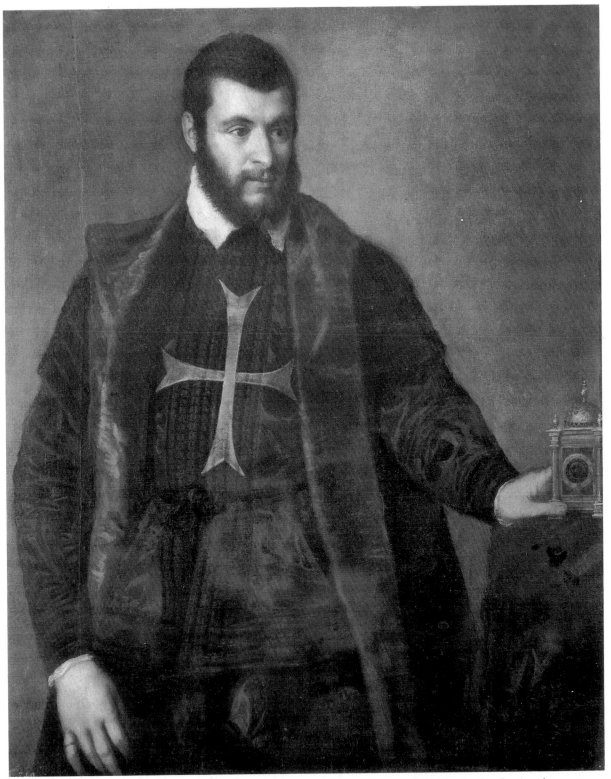

Portrait of a knight by Titian, c. 1550. The cross has been crudely painted on later, and indicates that the sitter became a Grand Cross. This may be a portrait of Leone Strozzi during the time when he was deprived of his knighthood.

England and Ireland, to which may be added Hungary, which suffered from Protestant theft as much as from the Turkish conquest. Germany also lost many commanderies and Bohemia a few, but here the Catholic victory of the seventeenth century recovered the losses not only of the Reformation but of the Hussite wars. In the remaining priories the period from the mid-sixteenth to the mid-eighteenth century is one of substantial stability.

A development in nomenclature was the use of the title Grand Prior. This appears as early as 1136, when it is applied to the Prior of Messina,[15] but the first to use the title regularly seems to have been Emery d'Amboise as Prior of France (1483–1503).* His successor François de Lorraine had this custom recognised by the Grand Master in 1548.[17] A usage which conveniently distinguished the Prior of France from the other priors of the kingdom was extended indiscriminately in the general inflation of titles characteristic of the period. The holders of the Italian bailiwicks also took to calling themselves Priors,† and the style of Grand Prior seems to have been officially adopted by the Priors of Capua and Barletta in 1653.[19]

Prosperity and Fall

Over a period of centuries, the incentives for good administration yielded a natural result. It has been calculated that the revenue of the six priories of France was multiplied by a factor of 24 in nominal value between 1533 and 1776; this represented an improvement of between 150 and 200 per cent in relation to the price of grain and of 200 per cent in relation to wages.[20] Such figures cover a wide variation: if at one extreme we have Manosque, whose value had almost disappeared, at the other there are the commanderies in the Austrian Netherlands, all of which became extremely rich: Piéton had 51,600 livres a year in 1783;‡ Slype had 41,000 livres four years later; the richest of all was Chantraine, with 60,000 livres in 1773, a larger income than any of the Grand Priors enjoyed except those of France and Champagne.[21]

Before the later eighteenth century commanderies were by no means luxurious; the most general impression left by their buildings is one of extreme modesty. At Sainte-Eulalie-de-Cernon (one of the richest commanderies in France), we see a manor such as only the most rustic country gentleman would have been satisfied with, though houses in towns are consistently more commodious. In many cases it is clear that if the commander had not been a bachelor he would not have been able to maintain a gentleman's rank at all; when the commander of Mons died in 1688 his executors remarked in astonishment: 'Difficilement on peut croire que le dit défunt fut si mal en habits et sans linge.'[22]

The situation was improved by the enormous increase in *rente foncière* in the later eighteenth century, which made the commanderies very comfortable endowments. A writer of 1789 maintains that most Knights of Minority were commanders by the age of thirty with an income of eight or ten thousand livres, and that commanders in general enjoyed better incomes than three-quarters of *brigadiers* and lieutenant-colonels in the army.[23] This prosperity makes the increasing entry of knights into the Order easy to understand.

Growing numbers in their turn put pressure on the existing commanderies, and the second half of the eighteenth century brings a change in the hitherto stable structure of the Order's properties. Everywhere the trend of the later Middle Ages was reversed and rich commanderies were split up to form new ones. An ambitious response to the new need was the acquisition in 1776 of the Order of St Anthony, with forty commanderies and a revenue of nearly 200,000 livres, but compensation payments to the surviving Antonites absorbed most of the income until

* The Priors of England are said to have styled themselves Grand Priors from about 1440 onward,[16] and their claim to superiority over Ireland may have been the particular reason, just as the Prior of Messina may have been given the title because of his authority over subordinate priors in Italy in 1136.

† This privilege was officially granted to the Bailiff of Santa Trinità di Venosa as early as 1419.[18]

‡ The average value of the French commanderies was then 15,770 *livres*, about £650 sterling at the official exchange rate, but of much greater domestic purchasing value.

the French Revolution swallowed up old and new commanderies alike. The creation of many new commanderies in Italy and their reservation in 1784 to natives of the respective Priory is another reflexion of the same pressure.

In central Europe the Order made large gains which were virtually cost-free. Perhaps the least useful was the Grand Priory of Poland, founded in 1776 with six family commanderies. The Grand Priory of Bavaria (1780) was the largest single accession of wealth the Order had received since the fall of the Templars. The 'reunion' of the Grand Bailiwick of Brandenburg with the Order in 1763 was little more than nominal, even when its knights resumed the payments of responsions, but like the other foundations it was a sign of the Order's continually growing prestige. The other side of the coin was the cupidity which the splendour of the prioral dignities excited in various monarchies, and by the eighteenth century four of them – Portugal, Castile, France and Rome – were disposed of at their sovereigns' pleasure, being thus virtually lost to the Order.

On the eve of the French Revolution the possessions of the Order of Malta in Europe presented an impressive spectacle, rich with the accumulations of centuries. The feudal rights and customs and the multifarious charities that had grown up around them had not yet been disturbed by militant rationalism and secularism. If the medieval pilgrims' hospices had long ceased to function, most commanderies retained their ancient customs of alms to the poor. New additions to such centennial obligations were rare, but they were not unknown. At Poitiers, the seat of the Grand Priory of Aquitaine, a hospital for incurables was founded in 1727;[24] at Gröbnig in Silesia the hospital underwent continuous improvement and enlargement throughout the eighteenth century, and in 1788 its capacity was increased to enable it to admit women as well as men;[25] and when the Order of St Anthony was acquired it was only the greed of the Comte de Provence that prevented the knights from carrying out their plan of founding a new hospital in the mother house at Saint-Antoine-en-Viennois. The activities of knights such as Antonio-Maria de Bucareli, who as Viceroy of New Spain between 1771 and 1779 established a foundling hospital and a hospice for the poor in Mexico, illustrate the opportunities for extending the Hospitaller tradition outside the ambit of its ancient possessions.

The destruction of this immense wealth of endowment was initiated by the French Republic, when in October 1792 it confiscated all the Order's property within its frontiers. As the revolutionary wars spread over Europe, the German commanderies west of the Rhine and the commanderies in northern Italy suffered the same fate, though the Emperor Paul founded two Russian priories which partly offset these losses. In 1802 the King of Spain turned the four priories under his rule into a royal order. Thus, when in the same year the remaining priories were asked to give their votes to fill the vacant magistral throne, there were only eleven left to do so: Venice, Rome, Capua, Barletta, Messina, Germany, Bohemia, Bavaria, the two Russias and Portugal. All the Italian properties were seized after the French conquest of the peninsula in 1806, when those of Germany and Bavaria were also confiscated. In 1810 Russia suppressed both its priories and the King of Prussia expropriated the Silesian commanderies formerly belonging to Bohemia.

After the Restoration the Order found itself in possession of six priories: Portugal, Messina, Capua, Barletta, Rome and Bohemia, but royal or papal control over all of them was so complete that they yielded little or no profit to the Lieutenant's government. The three Neapolitan priories were suppressed in 1826 and only a small remnant could be scraped together to found the Priory of the Two Sicilies in 1839. The combined Priory of Lombardy and Venice, restored in the same year, had little to its name besides a crop of family commanderies. Portugal was lost in 1834. The strongest possession of the Order was the Bohemian priory, the only one whose life had continued unbroken, and so it remained until the Nazi period. In 1938 politics required it to be split into two parts, Bohemia and Austria, and the former was stripped of all its properties by the Nazi and communist regimes. The Grand Priory of Austria still enjoys full control of its ancient endowments, including the important house of Mailberg, which offers the unique case of a commandery which has preserved an almost uninterrupted existence since the twelfth century.

A NOTE ON THE MAPS

MOST OF THE maps in Part II are adapted (by kind permission of the compiler) from those drawn up by Michel Fontenay in conjunction with his paper, 'Les Chevaliers de Malte dans le "Corso" Mediterranéen' contributed to the Colloquy *Las Ordenes Militares en el Mediterráneo Occidental* (1983, published in 1989, Madrid). The boundaries of the priories have been carefully ascertained by reference to the dioceses they covered. The location of commanderies is discovered by identifying every place-name mentioned in the official returns of 1533, 1583 and 1776. The number of points marked is much larger than the number of commanderies, because of creation and suppression of commanderies during that period, change of residence from one place to another, use of two or more place names for one commandery, etc. The maps therefore merely indicate the general distribution of the Order's properties.

The map of Germany has been completed with the aid of the map in A. Wienand, *Der Johanniterorden, Der Malteserorden* (3rd edition, 1988) and the map of Dacia in the *Annales de l'Ordre Souverain Militaire de Malte* (1972), p. 69.

The map of England is based on that kindly provided by Miss Pamela Willis, Curator of the Museum and Library of the Order of St John, Clerkenwell. The map of Ireland has been compiled by the author.

The number of commanderies given under each priory is taken from eighteenth-century lists and roughly indicates the position between about 1550 and 1750.

Nuns' convents which changed their location during their history are shown in the place where they spent most time; their distribution taken as a whole may be anachronistic for any one point of time.

A minus sign before the date of foundation of a priory etc. indicates the first known mention, where the actual foundation may be earlier.

SYMBOLS

♀	Seat of Priory
⊙	Seat of capitular Bailiwick
⊕	Possession which was a Priory and Bailiwick at different times
☐	Collegiate church or community of priests
△	Convent of nuns
● k	Commanderies reserved to knights
● cs	Commanderies reserved to chaplains and sergeants
♀ ⊙ ♀	Possessions which lost their status as Priory, Bailiwick
●—	(Priories of Germany and Bohemia) commanderies lost at the Reformation
●—	(Grand Bailiwick of Brandenburg) commanderies lost between 1370 and 1648

112

MAP KEY

The Tongue of France

Priory of France 1178/9

♀⊙	Corbeil 1223–1315 (1644, became a bailiwick attached to the office of Treasurer of the Order)
♀	The Temple (Paris) 1315
⊙	Saint-Jean-Latran (titular Bailiwick of the Morea attached to it in 1676)
□	Corbeil 1223
□	Jordoigne 1173
●	57 k, 10 cs

Priory of Aquitaine 1315

♀	Angers fourteenth century
♀	Poitiers?
●	26 k, 5 cs

Priory of Champagne 1315

♀	Voulaines fourteenth century
□	Rheims fifteenth century
●	18 k, 6 cs
●	Frontier between France and the Empire c.1320.

The Tongue of Provence

Priory of Saint-Gilles c.1115

♀	Saint-Gilles c.1115–1621
♀	Arles 1621
⊙	Manosque 1466
□	Aix 1234
△	L'Hôpital-Beaulieu 1288
△	La Vraie-Croix de Martel c.1200 (secularised 1589, restored 1658)
△	Les Fieux 1297 (joined to Beaulieu 1611)
●	53 commanderies

Priory of Toulouse 1315

♀	Toulouse 1315
△	Toulouse 1623
●	28 commanderies

The Tongue of Auvergne

Priory of Auvergne 1233/36

♀	Olloix fourteenth century
♀⊙	Lureuil fifteenth century (Bailiwick c.1475–c.1530)
♀⊙	Bourganeuf c.1475–1787 (Bailiwick from 1787)
♀⊙	Lyons 1787 (previously Bailiwick of Lyons and Devesset from c.1530)
△	Saint-Antoine-de-Vienne 1784
●	40 k, 11 cs

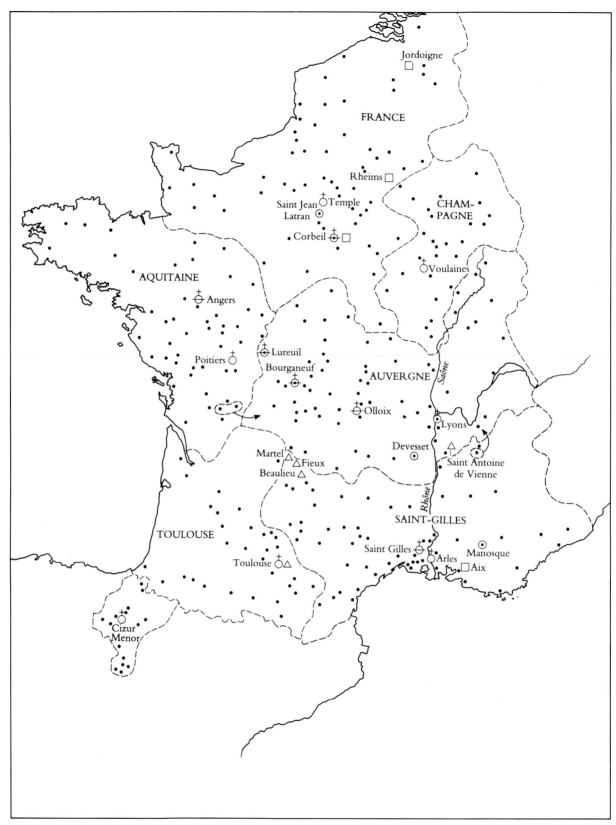

The Tongue of France.

114

CHAPTER IX

The Tongues of Provence,
Auvergne and France

PROVENCE

The First Foundations

WHEN PRECEDENCE WAS distributed among the Langues in the fourteenth century the first place was given to that of Provence, on the grounds that the Founder himself had been a native of that country. This may or may not be simply a reflexion of the predominance the Provençals then enjoyed in the Order. The tradition that the Blessed Gerard was born at Martigues, on the Rhône delta, where the church and hospital of the Order dated from well before 1222, may have existed by about 1280, when his relics were transferred from Acre to Manosque;[1] it suffers from certain implausibilities, not the least of which is that Martigues did not yet exist in Gerard's time. Nevertheless the precedence of Provence at least in wealth of endowment can be traced to the Order's very earliest years. The admirable archivist of Saint-Gilles, Jean Raybaud, believed that Gerard spent several years in Provence before 1108 personally receiving donations, and attributed to him a friendship with the Bishop of Toulouse, Amiel Raymond Dupuy.[2] The journey would be in harmony with the statement in his epitaph: 'Provident and active in every way, he stretched out his arms to many lands to receive whatever was needful to feed his people.'

Yet the same local bias would be explicable without such personal connexions. It was under the Count of Toulouse, Raymond of Saint-Gilles, that the largest of the Christian armies

had embarked on the First Crusade, and in no other country was the spirit of that adventure more strongly propagated. This area, the home of the richest civilisation of its day, the cradle of chivalry and romance, set its stamp on the states of Outremer. One would expect the Hospital to thrive here, but the scale of its early expansion is still remarkable: no fewer than forty-one villages, in a well-defined area around the comital city, were given to the Hospital in the first third of the twelfth century. And yet the beginnings of this florescence were almost fortuitous; in 1101/2 some nobles of the Lauragais gave the village of Puysubran, east of Toulouse,★ to the Holy Sepulchre, but the bishop regarded the donation as being for the benefit of the Hospital of St John, which was scarcely yet thought of as having independent status.[3] The idea was rapidly taken up; Poucharramet, a little way south of Toulouse, was given in 1102, some property at Léguevin, to the west of the city, in 1108, the more northerly Campagnolles in the Larzac in 1109,[4] and other donations which cannot be exactly dated belong to this early period.[5] In Toulouse itself a church given in 1106 had to be returned, and the Order was not definitively established in the city until 1114–16.[6]

By 1108 Brother Gerard had a 'prior', by the name of Durand, acting for him in Provence, receiving and organising the new endowments. In that year a nobleman of Comminges, Forton de Hautefage, offered the Hospital an estate at Fonsorbes so vast that Gerard referred the matter back to Durand before accepting it, and it was taken on condition that Forton administered it himself. We do not know the boundaries of the territory, but it must have measured ten or twenty thousand acres,[7] and it formed the

★ The village is now called Pexiora.

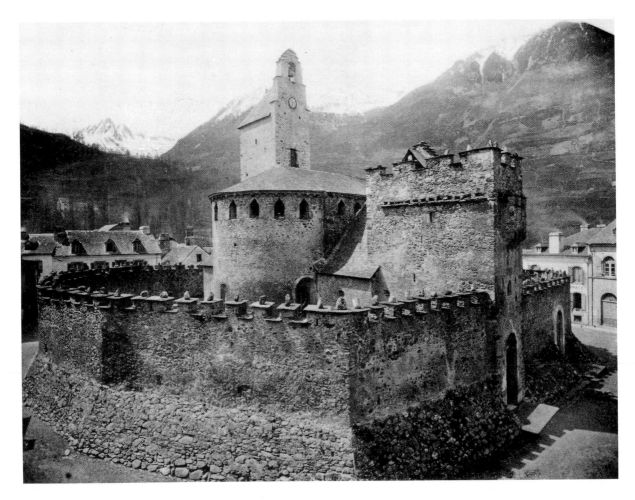

Fortified church of the Order at Luz Saint-Sauveur, *c.* 1260.

nucleus of a remarkable work of colonisation that the Order undertook in the forest of Comminges, to the south of Toulouse. The task of establishing peasant settlements in this region, inhabited by a sparse, half-outlawed, half-pagan, half-nomadic population, was begun by founding sanctuaries known as *sauvetés*, their limits marked by crosses at the four points of the compass. Those who took refuge here were exempt from secular authority and enjoyed the protection of the Church – here in the person of the Order of St John – whose anathema fell upon any who violated the peace or the privileges of the place. By the middle of the twelfth century the Hospitallers had founded forty-one such villages in Comminges and the Toulousain, and the choice of such a young order to undertake the task of reclaiming the forest from savagery is a pointer to the military character it already possessed within a few years of the First Crusade.★

Most of these villages still exist, and bear witness to the work of regular colonisation: at Boussan the nucleus is a square of 25 yards consisting of forty plots clustered about the church, with orchards or vineyards all around, also in neat rectangles, and further out the larger tracts of ploughed land. At Saint-Sulpice-de-Lézat, where the Hospitallers received the grant of the church in 1110/14, a spaciously laid-out village of half-timbered houses preserves all the regularity of a Roman town. A foundation that was to attain special importance was that of Fronton, to the north of Toulouse, made before 1122. The Hospitallers were given 300 plots to build a village, and the magnificent castle they added to protect it became a favourite residence

★ This interpretation is strengthened if the Prior in France in 1108 can be identified with the Durand who was Constable of the Hospital in January 1126 (see p. 6).

of their priors in the Toulousain. They were entitled to a shoulder of every boar and a haunch of every deer killed in this domain, of whose hunting rights they were no mere passive enjoyers.

Under different jurisdiction, east of the Rhône, the bishop of the then imperial city of Gap gave the Hospitallers a church by 1105, and the Count of Albon enriched this foundation with the grant of a fief in 1112;[8] at about the same time the priest Etienne Raymond of Gap founded a pilgrims' hospital at Saint-Gilles on the Rhône, soon to be endowed with great wealth and wide authority. By 1115/16 it was the seat of the Prior, Brother Pons (who had succeeded Durand in 1110) and of a small community which included Etienne himself as chaplain, a deacon, and three knights of the Order; the presence of these last is noteworthy as illustrating the strength of the military personnel of the Hospital at such an early date, even though they may well have been veterans of the crusade who had laid aside their swords.[9] One of them, Peter of Barcelona, who was praised by William of Tyre as 'noble according to the flesh but nobler still in spirit',[10] was almost certainly one of the electors in 1120 of the Master Raymond du Puy,[11] under whom the military role of the Order was to be fully developed.

The choice of Saint-Gilles as a residence was as natural as the strength of the Order itself in the country: the city was then at the height of its importance, through the alluvial vagaries of the Rhône which made it the brief successor of Arles as the main sea-port on that river, and it had a famous fair which brought it trade from all southern France. It was a nodal point of the pilgrim routes leading to Compostella and over the Alps to Rome and the East; and it was itself a centre of pilgrimage, with the magnificent basilica of the saint which Pope Urban II had consecrated in 1096. For an Order concerned with the pilgrimage to the Holy Land it was an obvious administrative centre. Its position enabled it to straddle the Rhône frontier, and during the course of the Middle Ages the Priory's possessions in the delta were to grow to a princely estate of nearly a hundred square miles, two-thirds in Languedoc and a third on the east bank of the river.[12]

The jurisdiction of the Priory embraced separate preceptories that were coming into being at this time: that of Capestang in the Narbonnois existed by 1115; the bishop of Arles gave Trinquetaille, just outside the city, in 1115/16, Etienne de Gap being its first preceptor, and the house was soon to receive rich favours from the great Provençal family of Les Baux.

The Provençal World

The marriage of Raymond Bérenger of Barcelona to Douce of Provence in 1112 linked their two counties for over a century; for the Hospitallers, the union was reflected in the tenure (1116–19) by Peter of Barcelona of the Priory of Saint-Gilles, which received jurisdiction over the foundations already appearing in Catalonia and soon all over France and Spain. As endowments increased, separate priories were created in the Peninsula in the middle of the century, following political boundaries; and in 1178/79 a division of a strikingly different kind was made with the creation of the Priory of France, which embraced the northern half of the kingdom. It was a separation that cut across the north–to–south boundary of the Angevin empire (and for that matter the frontier of the Holy Roman Empire along the Rhône and Saône), and reflected instead the cultural and linguistic difference which, in the language of the time, divided the territory of ancient Gaul between 'France' and 'Provence'.* Its consequence was to draw the Priories of Saint-Gilles and Aragon for the moment closer together – again a reflexion of cultural ties. The two priories continued sometimes to be held jointly until about 1207, and Catalans remained interchangeable with Provençals in the two offices for a further fifty years.

The crusade against the Albigensians revealed the esteem which the Hospitallers in their first century garnered among the ruling families of

* This division had its origins in the greater Romanisation of the Visigoths and Burgundians in southern Gaul, compared with the more Germanic state created by the Franks in the north, and the frontier between the two cultures explains why the most central region of France is called La Marche. In these chapters 'Provence' and 'Provençal' are used in the sense proper to the period being described.

all this Mediterranean world. Peter II of Aragon and Raymond VI of Toulouse were two princes who incurred the ban of the Church for their supposed sympathy with the heretics, but who preserved the loyalty of the Hospitallers. The King of Aragon, when he fell excommunicate at the Battle of Muret, received burial from the Hospitaller nuns at Sijena. The Prior of Saint-Gilles himself, Pierre de Faucon, travelled fruitlessly to Rome in 1208 to beg for the lifting of the excommunication of Raymond of Toulouse, who showed his reciprocal devotion as he lay dying, still unpardoned, fourteen years later. When a Hospitaller priest threw his habit over the Count to ensure his burial as a brother of the Order, the Abbot of Saint-Sernin tried to tear it off, but Raymond, who had lost the power of speech, clung on to it. In spite of this evidence of his disposition he continued to be refused Christian burial and his coffin was kept unburied in the Order's house in Toulouse.

By contrast the Templars were more closely tied to Simon de Montfort's crusade – an ironic prelude to their fate a century later, when they were destroyed by accusations of heresy. Yet the roles of the two orders owed less to ideology than to their respective strengths in northern France and Provence, for the clash was largely one of two cultures. There was no question of any Hospitaller sympathy with Catharism; the Viscount Aimery VI of Narbonne, a lifelong enemy of the heretics, died in 1239 a brother of the Order, and one of Simon de Montfort's own followers endowed it with the preceptory of Renneville, the property of an Albigensian lord which he had received as the spoils of conquest.

To the east of the Rhône, where these troubles did not penetrate, the Hospitallers were even more strongly entrenched. The growing activity of Marseilles as a port of embarkation for the Holy Land made their house here important, and they possessed the quarter which still bears the name Saint-Jean, though the property itself was seized by Louis XIV in 1660 to build a fort. The close ties of the Order with the Counts of Provence date from the first arrival of the House of Barcelona. Bérenger Raymond was laid to rest in 1144 in the preceptory of Trinquetaille; Sanche became a *confrater* in 1196 when he was governor of Provence for his young nephew Alphonse II, who in his turn became a *confrater* before his early death and was buried in the

Order's church at Aix. He left a child, Raymond Bérenger V, who was educated by a Hospitaller tutor, Blacas d'Aups, and who in 1234 decided to turn the church of Saint-Jean d'Aix into a memorial to his father and the burial-place of his family, founding a collegiate church of twelve Hospitaller priests. He chose to build in the Gothic style, till then unknown in Provence, a decision characteristic of the love of the arts shown by Raymond – whom his son-in-law St Louis called the wisest and most illustrious prince of his age – and his brilliant Countess Beatrice of Savoy. This church of simple elegance became the resting-place of its founder, his father, his wife, his infant son, and his daughter Beatrice, who brought Provence as a dowry to Charles of Anjou and ascended with him the throne of Naples.

The alliance between the Order and the House of Provence was for a time inspired by their common enmity towards the Counts of Forcalquier: Count Guigues had bequeathed to the Hospitallers the eastern half of his state in 1149, but his successors prevented them from taking possession until 1208. Once secured, the legacy became for half a century the Order's most splendid possession. The walled town of Manosque, which was its capital, commanded the valley of the Durance, with a strong castle and formidable arsenal; its jurisdiction spread over more than one hundred square miles, and two thousand peasants laboured on the Order's lands. Under the remote suzerainty of the Emperor, the Castellan of Manosque, as the commander was known at this period, governed a state comparable in rank, if smaller in extent, to those of the Counts of Savoy or the Dauphins of Vienne. But its glory lasted only while the House of Barcelona ruled in Provence. In 1262 Charles I of Anjou imposed his suzerainty, albeit on easy terms, and the commander's jurisdiction later succumbed to the progressive encroachments of both sovereigns and subjects.

The Angevins likewise undermined another Hospitaller possession, the city of Orange, which had been granted in its entirety by the House of Les Baux. In 1307 Charles II made the Order exchange half the city for six manors in Provence, thus further sapping the feudal independence that had marked its presence in the region. Another instance, though on a smaller scale, was Le Poët-Laval, granted to the Hospital in the

The convent of L'Hopital-Beaulieu, entrance to the chapter house.

twelfth century; the castle and elaborate fortifications of the hill-village exemplify the military power the Knights Hospitaller exercised in this part of what was then the County of Valentinois.

The Golden Age in Provence

The expansionist ambitions of the House of Anjou failed to alienate the loyalty of the Hospitallers, which was upheld at this time by a series of exceptional figures: the first was Feraud de Barras, Prior of Saint-Gilles (*c*.1244–64) and Grand Commander of Outremer, who organised his Order's support for the Seventh Crusade, helped Louis IX to create the necessary fleet and later commanded it. He improved the administration of the extreme west of his priory, whose activity was growing in importance, not least with the maintenance of pilgrims' hospices in the Pyrenees. The remote mountain preceptory of Gavarni was the home of twelve brethren, who around 1260 built the fortified church at

Luz. Feraud's coadjutor was Bérenger Monge, who was named preceptor of both Manosque and Aix about 1249. In the latter town he found the collegiate church half-finished (Raymond Bérenger had died in 1245) and brought the work to completion. A devout and retiring man and an excellent religious, he was repeatedly administrator of the Priory of Saint-Gilles though he refused to be invested with that dignity, and after long years of service he gave up both his preceptories in 1298, two years before his death. If his work at Saint-Jean d'Aix entitles him to be called its second founder, he was also responsible for the flourishing of the House of Manosque as a religious community, which by 1271 numbered 46 members between professed brethren, sisters, donats and *confratres*.

In 1271 Guillaume de Villaret was appointed Prior of Saint-Gilles, a position he was to hold until his election as Master a quarter of a century later. He was made the first Vicar of the Comtat-Venaissin on its cession to the papacy and governed it for sixteen years. Like Bérenger Monge, with whom he was united by friendship and common responsibilities, he was also a councillor of the Count of Provence; he resigned the administration of the Venaissin in 1290, when Charles II entrusted him with the negotiations to end his war with the King of Aragon. He found time to protect the interests and expand the possessions of his Order, which was then in the death-throes of its presence in the Holy Land. Reputedly a native of Gévaudan, in 1283 he bought the seigneury of Belcoste on the slopes of Mont Lozère, from which the Order was to spread its influence over the whole region.

When Villaret was elected Master in 1296 he was reluctant to move to the unhappy refuge of the Convent in Cyprus; the flourishing and stable base which the Order had developed in Provence seemed to him a better centre of government, and he continued to administer Saint-Gilles for four years, holding a Chapter General at Avignon and Marseilles in 1297. He established or reorganised three women's convents in Quercy: the hospital of Beaulieu, which had been founded by the Thémines family and given to the Order in 1259, was reformed as a nunnery, receiving its rule in 1298 and becoming the French mother house; the

convent of La Vraie-Croix de Martel, dating from about 1200, was subjected to it; and a new foundation, Les Fieux, which received the Master's sister as its first Prioress in 1297, was likewise made subject to Beaulieu. From this period sisters disappear from the larger Hospitaller communities such as Saint-Gilles and Manosque, where they had hitherto figured.

Villaret's administrative ability strengthened the position of the Hospitallers in Europe after the disaster of 1291; but he eventually saw the wisdom of being on the scene of their military activity, and left for Cyprus in 1300. Provence soon produced another great Hospitaller in Hélion de Villeneuve, who became Lieutenant of the Master and commander of Manosque in 1314, attaining the Mastership itself in 1319. Two equally difficult tasks fell to him: to organise the acquisition of the Templar lands, and to restore the Order's finances after the extravagances of Foulques de Villaret's reign. These tasks kept him in Provence for thirteen years after his election as Master.

With its political patchwork, the Langue of Provence was a microcosm of the varied problems the Order encountered, according to the whim of different rulers, in making effective the papal decree of 1312. The Dauphin of Vienne and the Count of Savoy raised no difficulties.[13] In France there was no hope of taking possession of Templar property while Philip the Fair lived, but Louis Hutin ordered the transfer in 1315. King Robert of Naples permitted the same for Provence in 1319, but was much slower in doing so in Italy. The continued support of the popes was necessary in persuading the princes, and diplomatically Villeneuve gave up the Templar legacy in Cahors to John XXII and various Provençal possessions to the Pope's nephews in exchange for acquisitions in southern Italy.

Whatever the external problems at this time, the Provençals found no difficulty in establishing an overwhelming preponderance within the Order itself. In 1314 they annexed to their Langue the Priory of Navarre and asserted a right to those of Capua and Barletta, with the valuable bailiwicks belonging to them. The magistral election at Avignon in 1319 and the Chapter General at Arles the following year contributed to the strengthening of their power, the latter reserving for Provençal knights the

dignity of Grand Commander, the first of the great offices of the Order.

Though not so extensive as in the north, the lands of the Temple brought the Hospitallers a great accession to its wealth in southern France. The Templar house of Montpellier became known as Saint-Jean-le-Grand to distinguish it from the old Hospitaller preceptory in the same city, and became the regular meeting-place for chapters of the Priory of Saint-Gilles. The transfers necessitated a division of the Provençal Langue, which by 1317 was reorganised into four priories: Provence (east of the Rhône, with its headquarters at Manosque), Saint-Gilles, Toulouse and Navarre. Villeneuve chose to keep the first (which he assumed in 1317) in his own hands after his election as Master: a proof of its political importance especially now that its territory included the papal residence; the Priory also received a separate Auberge in the Convent that was being built in Rhodes, as if it were a Langue of its own. When Villeneuve laid down the Priory in 1330 Saint-Gilles and Provence were held jointly by Guillaume de Reillane for twenty years, and this *ad hoc* union became permanent, although it cut across frontiers and the distribution of auberges in Rhodes. From about 1380 to 1440 the commanderies west and east of the Rhône were even conferred separately on members of the two auberges.

The fourteenth century was the great age of florescence of the Order of St John in southern France; its principal communities ranked among the most important religious houses in the country: in 1338 Manosque had 51 residents, Le Poët-Laval had 42 and at least three other preceptories had households of thirty or more, between professed brethren and donats. The women's convents were equally flourishing, and l'Hôpital-Beaulieu was adorned with the virtues of St Flore; born about 1309, she entered the convent at the age of fourteen, and in her short apostolate before her death in 1347 distinguished herself by her charity to the poor; while the convent survived a gallery was lovingly preserved where she had received a vision of Our Lord carrying the Cross.

A striking feature is the calibre of the noblemen who devoted themselves to the service of the Order: besides the long line of Provençal Masters one may cite Géraud de Pins, Pierre de l'Ongle, Guillaume de Reillane, Isnard d'Albar, Bertrand

and Jean Flote, Jean de Savine, Dominique d'Alemagne, men of great worship in their day who served their sovereigns in high office and extended their nation's influence to Navarre, Naples, Hungary and Cyprus.

Wars and Divisions

The end to this happy age was brought by the disasters of the later fourteenth century, beginning with the Hundred Years War, which devastated the lands west of the Rhône. Provence in the narrower sense remained immune until the outbreak of its own war of succession; the papal schism of 1378, which gave rise to it, was followed by a sixty-year conflict in which the second Angevin dynasty (which obeyed Avignon) made good its claim to Provence and intermittently disturbed its rival's tenure of Naples, while the House of Durazzo (which upheld the Roman popes) kept a precarious hold on Naples and never succeeded in conquering Provence.

The Hospitallers avoided translating their allegiance to the Avignon anti-popes into political partisanship, but neutrality was breached by the commander of Manosque, Jean de Savine, who helped Louis of Anjou take possession of Provence and fought beside him in his invasion of Naples. In the 1390s Louis II's absence on

Sainte-Eulalie de Cernon, a 15th-century fortified village of the Order, the seat of one of its richest commanderies in southern France.

campaign in Italy enabled rebels to devastate Provence, and by the end of the century the Hospitaller preceptories in the County were ruined. For Manosque by 1411 its great days were a thing of the past; its community had sunk from 51 to 21, its revenues from 2,000 to 530 *livres*. The thriving religious communities declined to mere endowments for individual knights.

In 1398 confusion was worse confounded when France withdrew its obedience from the anti-pope (Benedict XIII), while Louis of Provence continued to acknowledge him, and the two parties attempted to install rival candidates in the Priory of Saint-Gilles. When France decided to submit to Avignon again the Order's nominee took up residence in that city, evidently reconciled with Benedict XIII. The situation was clarified, at least locally, when the Council of Pisa elected a third Pope in 1409, since France, Provence and the Hospitallers all supported the conciliar claimant, and Benedict XIII was forced to abandon Avignon.

The dynastic war in Naples continued even after the ending of the Schism, until in 1442 Alfonso V of Aragon annexed the kingdom to his own, and the Provençal nobility found itself with no *locus standi* in Naples. In 1466 the right of Provençal Hospitallers to the Neapolitan commanderies was formally abolished, as was the double representation of their Langue in the Chapter General. It was a reflexion of the complete *bouleversement* which ensured that the line of Provençal Masters from 1296 to 1374 found no successor till the sixteenth century.

From their possessions in Gascony, the English were able to range widely over southern France and cause terrible devastation during both the fourteenth and the fifteenth centuries. When the war ended it became the Order's policy to lease commanderies, such as that of Pézenas, at easy rates to noblemen who had been ruined by the conflict, thus forging with many families links of attachment that sometimes endured for centuries.[14] Another relic of the wars endures in the Larzac, a large territory which was the richest of the Templar legacies to the Priory of Saint-Gilles. Over this vast heathland, which acknowledged for nearly five centuries the lordship of the Knights of St John, one may travel for miles without seeing a house, though the rock forms walls, towers and castles as if trying to hoodwink one with evidence of a populous antiquity; the

shapes are deceptive, but the *Causse* was at one time more thickly peopled, reaching the peak of its prosperity with the wool industry in the seventeenth century. Its capital and the seat of the commanders was the village of Sainte-Eulalie-de-Cernon, built on the slopes of a lovely wooded river valley typical of those which intersect the Massif Central. To protect the inhabitants from marauding bands the Order built in 1440 three walled villages at Sainte-Eulalie, La Cavalerie and La Couvertoirade, little microcosms of medieval urban life which survive to this day. At La Couvertoirade one might think that nothing had happened within its walls since they were built, except for five centuries of dilapidation.

The great Provençal Hospitallers of the past found few worthy successors until Charles Aleman de la Rochechinard, known as 'the Good', whose tenure as Prior of Saint-Gilles was an unbroken record of pious benefactions. The most important was the refounding in 1506 of the decayed collegiate church of Saint-Gilles with provision for four priests and two clerks, whom he endowed with the *fief noble* of Silvegodesque in his native Dauphiné. His many gifts include the 'Rhodes Missal' with its rich illuminations, which he gave to the conventual church in 1511. As a former Captain of the Galleys, Aleman combined the martial and religious traditions of the Hospitallers, as did his successor, Prégent de Bidoux (1468–1528), one of the greatest of French seamen, who entered the Order in 1504 with a distinguished naval career already behind him. He exemplifies the repeated reliance of France on the Order of St John in her successive efforts to create a Mediterranean navy: he was given charge of the formation of a fleet of galleys, with which he raised the siege of Genoa in 1507. In 1511 the King created for him the title of *Amiral de la Mer du Levant*; he fought successfully in the Channel against England and, after succeeding Aleman as Prior of Saint-Gilles in 1514, defeated the Genoese off Aigues Mortes. The Turkish threat to Rhodes caused him to resign his office and to fit out a fleet, with which he defended Langò and reinforced Rhodes during the siege. He later defended Marseilles against the imperial invasion of Provence, and after conducting the embassies of the Order to the courts of France and England he was killed fighting against the Turks in 1528.

Le Poët Laval, a street in the village, with the commandery built in the 17th century.

The fate of the Order's commanderies in southern France reflects the devastation that the Wars of Religion inflicted on ecclesiastical property. At Saint-Gilles the church and prioral palace were sacked in the 1560s, and the Priors withdrew to Arles across the Rhône, where the peace had not been disturbed. A little further north, however, the commandery of Le Poët-Laval was entrusted in 1569 to Pierre de Gabriac, who promptly withdrew to his family estates, leaving the commandery in the possession of a Protestant *châtelain*; he was not replaced until 1590, and the interval of seigneurial favour allowed the Huguenots to gain control of the village. The church was destroyed and the Catholics were reduced to such a small minority that until 1895 the commandery chapel served as their parish church. In Quercy the Prioress of Martel became a Protestant in 1589 and handed over her convent to the consuls of the town.

Prioral palace of Saint-Gilles in Arles (built as the commandery of Trinquetaille in the 14th century), stonework in the main court.

Such defections were rare, however, and for the most part the Knights of Malta were in the forefront of the Catholic cause. The Chevalier de Tourette was one of principal scourges of the Huguenots in the Priory of Toulouse, and was strongly supported by the two Joyeuse brothers Antoine Scipion and Cardinal François, who by royal favour held the Priory in succession (1583–88 and 1588–94).

The religious wars struck Languedoc again in the seventeenth century, and the palace of Saint-Gilles was destroyed in 1622. The prioral residence was therefore moved definitively to Arles, where the commandery of Trinquetaille had been rebuilt with a fine situation on the river-front by Melchior Cossa (Prior of Saint-Gilles 1475–1510). Moreover the fear, provoked by courtiers' nominations at Toulouse and in Paris, that this most magnificent of the Order's dignities would soon attract royal cupidity led to a radical dismemberment of its vast estates, from which between 1645 and 1661 five new commanderies were created. Thus what had once been a very rich priory became one of the poorest, a change symbolised by the new residence: though a magnificent commandery, it is an extremely

modest palace. Nevertheless its two quaint little courts, its comfortable nooks and galleries and the handsome stonework characteristic of the medieval houses of Arles give it great charm.[*] Across the street from it, and boasting a fine carved portal and arcaded courtyard, is the commandery of Saint-Luce (both houses date originally from around 1360, when the devastations of the time drove the two commanders within the city). The Order of Malta acquired a prominent place in Arles society, as is shown by the fashion for *Arlesiennes*, fanciful variations on the eight-pointed cross worn as jewellery by the ladies of the place; and the palace was sumptuously redecorated by a son of the city, Honoré de Quiqueran-Beaujeu, who was Grand Prior from 1637 to 1642.

Religious Reform

The reign of Louis XIII saw the transformation of the religious life of France by a new generation of noble *dévots*, of whom the Chevalier Gaspard de Simiane in Provence affords a heroic example.[†]

[*] The house, in the Rue du Grand Prieuré, is now the Musée Réattu.

[†] See p. 219.

Ruins of the convent of Beaulieu.

A paradigm of the religious change is offered by the priory of l'Hôpital-Beaulieu, the most aristocratic of the Order's three convents in Quercy, where the nuns were required like knights to prove eight quarters of nobility. The Order had strong links with the close-knit nobility of this region, the commander of La Tronquière holding the rank of third Baron of Quercy; and since the middle of the fifteenth century the office of Prioress of Beaulieu had been handed down from aunt to niece, great-niece or cousin within a small circle of allied families. At the beginning of the seventeenth century the convent exemplified the widespread relaxation of monastic life: the nuns spent much time visiting their families, attended feasts in the neighbouring châteaux, and received guests at the convent, both male and female, with an unmonastic kiss. In 1596 the Prioress, Antoinette de Beaumont, gave the habit to her seven-year-old niece, Galiotte de Gourdon de Genouilhac, who was expected to succeed her according to long precedent. But Galiotte grew up with no taste for the frivolities of Beaulieu; she withdrew to lead a life of prayer in the seclusion of Les Fieux, where the community had declined to a mere four nuns, and at the age of nineteen she was made Prioress. Such was her direction of this house that in 1611 Madame de Beaumont named her coadjutrix at Beaulieu itself and resigned effective government to her, the two

priories being merged by papal bull. Galiotte proceeded to recall Beaulieu to the fruitful tradition of St Flore, but unhappily her life was even shorter than her forerunner's: she died in 1618, not yet aged thirty. The nuns elected a new co-adjutrix, Françoise de Faurie la Mirandol, who was to succeed Madame de Beaumont as Prioress.

Unfortunately this did not please Galiotte's brother, the Comte de Vaillac, who saw his family, as a result of this new earnestness, losing its control of the Priory; he wanted it for his daughter, Galiotte II, who was then one year old. He persuaded the comfortable Madame de Beaumont to resign her office to Antoinette de Vassal de Couderc, who in her turn undertook to give way to Galiotte II when she was old enough. The coadjutrix and her supporters – the majority of the convent – were indignant; a conflict developed which the Prior of Saint-Jean d'Aix was sent to resolve, but he mishandled the affair, first taking the side of the coadjutrix and then accepting the assurance of the new Prioress that she intended to uphold Galiotte's reform. To dispossession the *dévotes* now added a sense of betrayal; Madame de Faurie la Mirandol and six of the nuns seceded from the convent.

In 1623 Antoine de Paule, who had witnessed the dispute as Prior of Saint-Gilles and therefore Visitor of Beaulieu, was elevated to the Grand Mastership, and he intervened with more generous indignation than wisdom. He ordered

Madame de Vassal de Couderc to resign the Priory, and her followers to place themselves under the authority of Madame de Faurie; when they refused, he instructed the Prior of Saint-Gilles to admit no more nuns to Beaulieu. The Marquis de Thémines, as the descendant of the Founder, brought a law-suit against this measure and won it; relations between the convent and the Order had reached complete severance by 1634 when the sixteen-year-old Galiotte II stepped into the prioral dignity. But the niece proved to be made in the same mould as her aunt; in her sixty-eight years' tenure of the Priory she gave Beaulieu new statutes and did her best to impose religious discipline. Except that the Prior of Saint-Gilles lost the right of visitation, full unity with the Order was restored. In 1623 Paule had installed the seceding nuns in Toulouse, in a house known as La Cavalerie overlooking the Garonne; when Martel was restored to Catholic hands in 1658, some nuns of this community went to take possession of it, and the Langue of Provence thus had again three women's convents, all of them much better in their practice than those of a century before.[15]

The second half of the seventeenth century saw the rebuilding of the prioral palace of Toulouse, with an attractive arcaded courtyard, by the Prior François de Robin-Granson.★ An exuberant contemporary of his was Jean-Claude Viany, prior of Saint-Jean d'Aix from 1667 to 1720. A great upholder of the rights and dignity of his office, he quarrelled with the city of Aix and defied an archiepiscopal interdict by processing to his church in all the glory of mitre and pontifical cross which were the sign of his ecclesiastical exemptions. His bust, preserved in the prioral church, shows us the man, pig-headed and grandiose. He restored and over-decorated his church in rich baroque and built beside it a palace for himself and the chapter of St John.† It is in considerably grander *tenue* than either of the prioral palaces in Arles or Toulouse, but all three are characteristic of the buildings of the Order in being exactly typical of the architecture of their respective cities.

Bust of Jean-Claude Viany, Prior of Saint-Jean d'Aix 1667–1720.

The Knights of Provence and the Navy

Richelieu's efforts from 1620 to re-create a French navy in the Mediterranean relied heavily, like their predecessor a century earlier, on the Knights of St John. The Cardinal despatched the Chevalier des Roches to Valletta to gather technical information on the galleys, whose design was adopted for those of the French fleet. Numerous Knights of Malta were associated with the command of the fleet, and the Grand Prior of France, Amador de la Porte, with its administration as *Intendant* of the navy. When in 1628 the siege of La Rochelle put an end to the political power of the Huguenots, the Order lent its Great Galleon as the flagship of the blockading fleet, whose commander was the Bailli d'Estampes-Valency. A little later the Bailli de Poincy directed as governor and naval commander France's first colonial acquisitions in the Caribbean.

★ The house is now the Hôtel des Chevaliers de Malte, in the Rue de la Dalbade.

† Now the Musée Granet in the Place Saint-Jean.

The most celebrated name of this period is that of 'Le Chevalier Paul' (1598–1667) the son of a Marseilles washerwoman and a governor of the Château d'If. After Louis XIV ennobled him and adorned him with the surname 'de Saumur' for his exploits against Spain, the Grand Master promoted him from Sergeant to Knight of Grace and sent him a rich jewelled cross, an honour he reciprocated by presenting the Order with a fully-armed ship worth six or eight times more. 'Fastueux pour la grandeur de la France, mais humble pour lui-même', he received Louis XIV splendidly at Toulon in 1660 and died the most distinguished naval commander of his age.

While Spain was the chief enemy, the galley fleet was looked upon as the cavalry of the French navy, and its officer corps was recruited as heavily as the Order of Malta itself from the nobility of Provence, sharing the same training and the same prestige. After 1690 the Mediterranean fleet was overshadowed by the Atlantic. Here too the Knights of Malta were notably represented (to digress a little from the Langue of Provence) by *Le Tigre* Jean-Baptiste de Valbelle (1627–81), and by Anne-Hilarion de Tourville (1642–1701) who won the battle of Beachy Head in 1690, held off an Anglo-Dutch fleet twice the size of his own at La Hogue in 1692, and ended his days as a Marshal of France.

In the eighteenth century the Provençal Knights of Malta furnished two of the greatest figures of the French navy. François de Grasse (1722–88) who commanded the French fleet in the American War of Independence and by fighting the battle of Chesapeake Bay compelled the surrender of Cornwallis; Pierre-André de Suffren de Saint-Tropez (1729–88) achieved even greater fame by winning five victories against the English in Indian waters between January 1782 and June 1783 and received the title of Vice-Admiral of France. In 1790 the officer corps of the French navy included sixty-five Knights of Malta, among them a vice-admiral, four *chefs d'escadre*, one *chef de division* and four captains.

Bailli Pierre-André Suffren de Saint-Tropez, by Batoni.

THE LANGUE OF AUVERGNE

The nobility of Auvergne were prominent both in the crusading movement which issued from the consecrated height of Clermont and in the ensuing change of the Hospital of Jerusalem from an Italian to a Frankish character. Robert Count of Auvergne, who took the habit shortly before 1140 and was immediately advanced to the greatest offices of the Order, was the nobleman of highest rank to have sought admission up to that time, and he played an important part in developing the military role of the Hospitallers.[16] Cast de Murols, who was Master in the early 1170s, is also known to have been an Auvergnat.

The origins of the preceptories of this region have not been studied by the historian of the Priory, but were doubtless contemporaneous with those of Provence. The earliest foundation known to us happens to be Bourganeuf, the future prioral house. This small stopping-place on the pilgrim route between Vézelay and Rocamadour was given to the Hospitallers shortly before 1169, when they built the simple parish

Virgin and Child given by the Prior of Auvergne in 1319 to the church of La Sauvetat Rossille (Clermont-Ferrand).

Its original territory was bounded on the east by the Rhône, the whole of Burgundy remaining attached to Provence. At the time the Priory of Auvergne was quite exceptional in the Order, only that of Navarre being smaller, and the temporary ascendancy of a close-knit group of Auvergnat knights is the most likely reason for its creation. In 1293 the Priory had at least twenty-four preceptories.[19]

The Priory underwent a marked change after 1313, when it was enlarged not only with the Templar lands but with a large territory within the Holy Roman Empire,[20] thus losing its former linguistic and political homogeneity.* The important preceptory of Olloix, just south of Clermont, was ceded by the Templars in 1309, while their trial was still in progress. The Priors seem to have immediately moved their residence here, or to the preceptory's castle of Mont-ferrand east of the city. Into this prioral estate was incorporated the old Hospitaller preceptory of La Sauvetat-Rossille, which existed by about 1262. In the fourteenth century the knights turned it into a classic example of a *bastide*, a strongly fortified village which is replicated underground by a network of interconnecting cellars under the houses, complete with a tunnel to the fields outside. The church still shelters a Virgin and Child, richly painted, gilded and enamelled, that was presented in 1319 by the Prior of Auvergne, Odon de Montaigut.[21]

In the fifteenth century the prioral residence was at Lureuil in Poitou, an oddly peripheral location whose choice perhaps obeyed the territorial interest of some Prior from that region.† The same motive was certainly behind the move to Bourganeuf made by Pierre d'Aubusson about 1475; he belonged to a powerful family which governed the almost independent Viscountcy of La Marche (on whose western border Bourganeuf stood) from the ninth century until 1527. The commandery had been growing in importance since the thirteenth century and was held by the Priors of Auvergne (and successive Grand Masters) Jean de Lastic and Jacques de Milly; the former built the tower which bears his name.

church; the town grew up around it, and the church was later expanded to its present size. The preceptory of Villefranche in Berry already existed in 1172, when it was endowed with lands by the Seigneur de Vierzon.[17] Auvergne remained at this period subject to Saint-Gilles.

A number of thirteenth-century Masters have been claimed as Auvergnats, one of whom, Guérin Lebrun, a native of Velay, carved out the Priory from that of Saint-Gilles in 1233/6.[18]

* The boundary between the Priories of Auvergne and Saint-Gilles was redrawn to the advantage of the latter along the River Isère in 1471.

† It was already a sufficiently magnificent commandery in 1308 to house the Master Foulques de Villaret while he was dancing attendance on the papal court at Poitiers.

The castle of Bourganeuf, prioral seat of Auvergne: the Tower of Zizim (1484).

Commandery of Lavaufranche (Auvergne). The tops of the towers were cut down in the egalitarian enthusiasm of the Revolution.

Aubusson compensated Lureuil for its loss of prioral status by making it a bailiwick. He was also responsible for the most romantic episode in the history of Bourganeuf, where the castle served as prison to Prince Zizim, brother of the Sultan Bajazet.★ After agreeing with the Sultan, in return for a pension of 45,000 ducats, to keep Zizim removed from any further disturbance to the Ottoman throne, Aubusson commissioned his nephew Guy de Blanchefort to escort the hostage to Bourganeuf, where he arrived having caused amorous turmoil among the daughters of the châteaux he passed on the way. In 1484 Blanchefort built the Tour de Zizim to house the prince and his attendants. It must have been a strange impression caused among the rustic hills of La Marche by this princely exquisite, who bathed every day, drank spiced wine regardless of the Koran, and composed in verse the tale of his captivity – perhaps with as much fantasy as that of a Turkish poet who imagined his gilded life:[22]

Dix-huit garçons d'une taille charmante,
Chacun fils d'un Ban,
Tiennent dans leurs mains ravissantes
Le verre d'or plein de vin pétillant.

★ See p. 54.

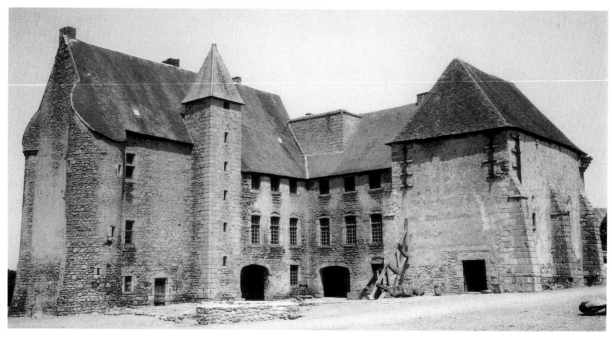

But the walls of Bourganeuf confined Zizim for only three years, until Pope Innocent VIII contrived to gain possession of the captive. When Charles VIII invaded Italy in 1494 he obliged the Pope to give up his prisoner, but before the transfer could be carried out Zizim died (of poison, it was immediately said, since Cesare Borgia was involved in the affair), leaving behind him a legend of misfortune in the castle where he had been so exotic a guest.

When Villiers de l'Isle Adam was Master the Bailiwick of the Langue was transferred to the commandery of Saint-Georges de Lyon, which possessed a large four-towered house overlooking the Rhône. It was allotted as its principal member the rich commandery of Devesset and Verrières, with properties in a hundred parishes, and was often known as the Bailiwick of Lyons and Devesset.★ Relations with the city of Lyons were not always smooth: for example in 1555 the Bailiff decided that the quota of corn he was permitted to export free of duty was unnecessarily low. He ordered his boats to break through the city's chain, whereupon the Council sent its officers down the river to seize the boats and arrest the boatmen. In 1697 Lyons went further and withdrew the Order's exemption altogether, thereby joining the list of cities whose nobles in retaliation were denied admission as knights, so that the ladies of Lyons who aspired to that honour for their sons were obliged to go for their *accouchements* to La Guillotière.

A note of conviviality and often of culture seems to mark the Hospitallers of Auvergne. One commander of Montchamp, a veteran of the siege of Rhodes, left a library which included Erasmus, Lucian, Sophocles and Petrarch, besides a treatise on dice; a later commander at Ayre matched Montesquieu, Pascal, Boileau and La Fontaine with *Les Amours de Spichée*, *La Mercure Galante*, *L'Académie des Jeux* and a royal cookery book. At Villejésus a roguish commander must have been at the origin of the local customs: every newly married groom in the village had to present his bride in the commandery, where she danced for the company to the sound of the bagpipe, with the commander as her pair if he felt so inclined. On New Year's Day a procession was formed in which four children naked from the waist down (or up, in this case) hung upside-down carrying a *roitelet* in a cage of twigs, while the villagers shouted 'Vive le roi!' (a reference to the bird) and blew a trumpet as the fancy took them; on reaching the parish church the children were given the chalice to kiss and were presented with loaves of bread as a reward for their exertions.[23]

The Langue of Auvergne retained commanderies outside the French kingdom, for example in Savoy, where in 1667 the Duke created a *Régiment de la Croix Blanche* officered by Knights of Malta.[24] In French Switzerland the commandery of Genevois suffered greatly from the Reformation until in 1617 Jacques de Cordon d'Evieux was appointed its commander; from that moment we find a story of religious renewal which includes some of the greatest names of the French Counter-Reformation: St Francis de Sales, Bishop of Annecy (whose uncle had been a commander of Genevois), St Jeanne de Chantal, and the Commander de Sillery, who renounced his sword as a Knight of Malta to take holy orders and who gave 40,000 *livres* to help the Lazarists establish themselves at Annecy, while Cordon d'Evieux gave them his house. He also helped to found the Tridentine seminary of the diocese, rebuilt the church of the commandery at Compesières,† and conducted a saintly apostolate to which it is due that Compesières contains even today the highest proportion of Catholics of any district in the Canton of Geneva.[25]

The Langue of Auvergne was the main beneficiary of the suppression of the hospitaller order of St Anthony of Vienne, which had been founded to care for sufferers from the disease known as St Anthony's Fire. The order owned some forty commanderies mainly in the Dauphiné and adjacent regions. By the pact of union in 1777 the Abbot-General became a Bailiff of Malta and the 108 canons regular assumed the eight-pointed cross as conventual chaplains; the Order of Malta acquired revenues of 196,600 *livres* (£8,150) a year, from which it paid pensions to the ex-Antonines. Nevertheless its claims had been opposed by the Order of St Lazarus, originally founded to care for lepers but refashioned as an order of chivalry by the French

★ In 1750 Lyons became the headquarters of the Priory, but the change was not made official until 1787, when Bourganeuf was made the Bailiwick.

† The commandery, just outside Geneva, now contains a small museum of the Order of Malta.

Commandery of Compesieres (Geneva).

monarchy in the eighteenth century. Unlike the Knights of Malta, who retained their nursing vocation, its members were noblemen who had never gone within a malacca cane's length of a leper, but its Grand Master was the Comte de Provence (later Louis XVIII), who was well placed to assert his claims. Although he yielded the main point of the union, he extracted 112,000 *livres* (£4,800) in compensation for some commanderies held in common by the orders of St Anthony and St Lazarus (1781). The costs were met by selling part of the Antonine property, and the plan of founding a hospital at Saint-Antoine-en-Viennois, the mother house, had to be abandoned; instead there was established (1784) a new priory of nuns who would not only pay a 'passage' fee for the privilege of becoming *Dames Maltaises* but would be charged from the abbey's revenues with the pensions of the former Abbot-General and nine chaplains. Unfortunately the nuns found their honours more welcome than their obligations, and after four years' dispute, during which the Receiver of Auvergne tendered his resignation to avoid handling the affairs of these noble ladies, it was only a direct royal command that compelled them to abide by the terms of their foundation.[26]

THE LANGUE OF FRANCE

The early enthusiasm for the Hospital in Europe was a Mediterranean phenomenon, and it is hard to identify any foundations within the later territory of the Langue of France which can be dated certainly to the first third of the twelfth century. Possible examples include the 158 *arpents* of land that the Archbishop of Sens is said to have given in 1102, presumably to found the preceptory of Launay-lez-Sens;[27] and the preceptory of Villedieu-les-Sauchevreuil in Normandy, which Henry I of England founded before 1135.★ The year 1133 sees three donations: that made by the Abbess of Liessies of one eighth of the allodium of Piéton, in the County of Hainaut, augmented by a further gift from the Count in 1139; the foundation by the Lord of Boncourt of the preceptory of the same name near Laon; and the church and domain given by Louis the Fat at Theil, near Cerisiers, on the south-eastern border of the Ile-de-France, an estate which his son enlarged with lands in the Forêt d'Othe.[28]

In 1129 the Templar Order was approved by a Church council at Troyes; its Master, Hugues de Payns, was a native of the region and gave his manor as one of its first endowments, and the Templars immediately gained an overwhelming advantage in most of France. Donations to the Hospital remained sporadic in the middle third of the century and only became frequent in the last. In 1178/9 a Priory of France was carved out of the jurisdiction of Saint-Gilles, but its territory was smaller than that of the future Langue. In 1223 the most important donation up to that date was made by Queen Isburge, widow

★ This estate, now known as Villedieu-les-Poêles, received a further donation at Argentan from Queen Matilda about 1140, and was subsequently a member of the preceptory of Villedieu-les-Bailleul. The village preserves to this day a Sodality of the Blessed Sacrament which dates from the time of the knights, and a procession of the Order is held there every four years on the feast of Corpus Christi.

Thirteenth-century tithe-barn and dovecote of the commandery of Le Bourgoult (Normandy).

of Philip Augustus, when she founded a collegiate church of thirteen Hospitaller priests at Corbeil and chose it for her own burial-place; it became for a century the normal residence of the Priors of France – who were usually priests – and the seat of the prioral chapters. Even with a royal foundation, however, the Priory of France could not muster sufficient weight in the Order to claim precedence over the small Priory of Auvergne, which appeared a decade later.

The status of the Priory was transformed by the suppression of the Templars. The vast possessions of that Order in the kingdom comprised the four provinces of France, Normandy, Aquitaine and Provence, a division reflecting their preponderant strength in the north. The Hospitaller Langue of France found its properties multiplied several times over by these acquisitions, which Louis le Hutin authorised in 1315, and it became necessary to divide it into the three Priories of France, Aquitaine and Champagne. Even with this division, the new Priory of France found itself in possession of 200 commanderies, and a rapid consolidation had to be made, reducing them to 108 in 1373 (of which 72 were of Templar origin) and eventually to 53, each of them naturally much richer than in early days.

If this accession of wealth spread a glow of

The castle of Voulaines, prioral seat of Champagne.

bonhomie among the Hospitallers the fact is not apparent from the lawsuit which the brethren of Ponthieu brought against Enguerran de Fieffes in 1336; they complained that he had 'ramené plusieurs gens qui audict Marais estoient assemblez, lesquels audit lieu il feyst dansser, caroller, pipper, tourner, et commanda a cesser, et donna

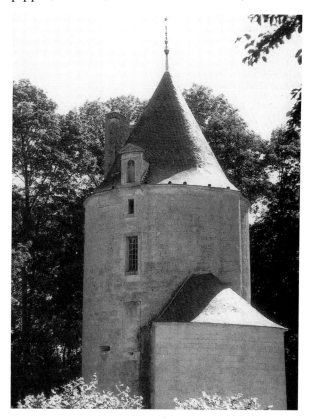

une paire de gants à une nommée Honnerelle de Vaulx, comme à la plus belle et la mieux dansant: laquelle chose Messire Enguerran a faict ou faict faire sans le congé ou licence des religieux.'[29] Contrasting this attitude with the jovial habits of the commander of Villejésus, one may regret that the *religieux* had taken on here the dour character of their country.

The seat of the Priory was transferred from Corbeil to the Temple in Paris, a great walled enclosure with a magnificent four-turreted gatehouse and a round church extended in later centuries into a medley of naves and chapels. The old commandery of Saint-Jean-de-Latran or L'Hôpital Ancien in the quarter of the Sorbonne (which had been the prioral residence from 1178/9 to 1223) was given over to the law students of the university, a faculty with which the Order established an important connexion. Brethren began to be sent here in the fourteenth century to acquire the knowledge that the Order needed for the management of its affairs in a more complicated age. A forerunner of these may be seen in Guillaume de Reillane, a graduate in law who governed the Priory of Saint-Gilles with great ability for twenty years (1332–52). Closer to Paris we find the Prior of Corbeil, Simon de Hesdin, who was a distinguished theologian of the Sorbonne, while the Dean of the canon law faculty in 1389, Gautier le Gras, later Prior of the conventual church at Rhodes, went on to take part in the Council of Pisa, and was a member of the conclave that elected Pope Martin V in 1417.

The appalling devastation caused by the English during the Hundred Years War is amply attested by the Priory of France: when a census was taken in 1373 the revenues of the commanderies had suffered heavily. Even worse was the situation in the middle of the fifteenth century, which yields a scene of universal devastation and commanderies empty of both men and flocks. Recovery came in the second half of the century, and a notable Prior emerged in Emery d'Amboise (1483–1503), future Grand Master and uncle of the Cardinal d'Amboise who in 1498 became chief minister of France. Like his nephew, Emery wielded great territorial power in the northern regions; he held many commanderies in pluralism and was the first holder of his office to style himself 'Grand Prior of France'. In the Temple he built a new house for the brethren, while

The Prior of Corbeil, Simon de Hesdin, in a 14th-century manuscript.

the church was steadily being beautified by the foundation of individual chapels. The enclosure of the Temple, in which the Grand Priors exercised high, middle and low justice, enjoyed exceptional privileges, exempting its residents from taxes and from prosecution for debt. In the seventeenth century its wealth and magnificence increased still further as the Marais was converted into an aristocratic residential suburb.

It was inevitable that such a rich prize should begin to attract the interest of the Kings of France, so that the Priory came increasingly to be conferred upon royal protégés. A precursor of these (1537–39) was Jacques de Bourbon, known as the Bastard of Liège (his father having been Prince-Bishop of that city); he, though, was a Knight of St John of unimpeachable merit, and had fought in the siege of Rhodes, of which he wrote the history.[31] François de Lorraine (1548–63) obtained the Priory at the age of fifteen in the same wave of favour that brought his family the dukedom of Guise; he became General of the Galleys of France and was killed fighting the Huguenots. Alexandre de Vendôme, son of Henry IV and Gabrielle d'Estrées, qualified for his tenure (1619–31) by professing as a knight and had previously held the Priory of Toulouse.

An outstanding Grand Prior was Jacques de

132

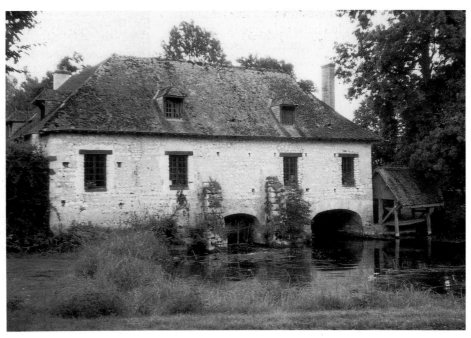

Water-mill of the commandery of Le Lieu-Dieu-du-Fresne (now L'Hôpital).

Below: Seventeenth-century prioral palace of the Temple, Paris. The gate-tower built by the Templars can be seen beyond, and the Temple church to the left.

Souvré, who before his brief time in office (1667–70) had administered the Priory for many years as Bailiff of Saint-Jean-Latran and ambassador of the Order in France. He was an accomplished figure of contemporary Parisian society and built the sumptuous prioral palace. His successor, Hugues d'Estampes-Valency, was the last to hold the office through normal promotion, being followed in 1678 by Philippe de Vendôme, great-nephew of Alexandre. In 1719 this prince sold his office to the Regent for the benefit of the latter's seventeen-year-old bastard, Jean-Philippe d'Orléans, who made his vows in the same year; if he had kept any of these he would have been a perfect ornament to the Order, for he fought in many campaigns, was made Général des Mers du Levant, and filled the prioral residence with such a glittering society as prompted the young Voltaire, his protégé, to salute it as the 'Temple of Good Taste'.

The appointment of the Prince de Conti (1748–76), a married man who had to be dispensed from vows, took royal caprice still further; nevertheless he proved a good administrator and continued the patronage which made the Temple for so long the home of the most brilliant society of Paris. At his invitation the boy Mozart played in its salons. Corbeil at the same period attracted the aristocratic society of the capital by the splendour of the liturgy, where the Prior officiated with mitre and crozier amid the chaplains of the collegiate church. In its last years the Grand Priory enters a second childhood with the appointment of the one-year-old Duc d'Angoulême (1776) and his eleven-year-old brother the Duc de Berry (1789).★

Lest such scenes of worldliness should seem to overshadow this later period, it is right to recall the lives of professed knights who remained true to the highest ideals of their vocation. Gabriel du Bois de la Ferté (1644–1702) retired to the rustic little commandery of Le Breil-aux-Francs, in the Priory of Aquitaine, and lived there a life of such saintly self-denial that he habitually slept in a small hayloft. He devoted himself to the poor and the sick, on one occasion remaining by the death-bed of a dropsical man whose condition made the attendant priest physically sick. His commandery is virtually unchanged today and its owners still show the bedchamber to which the commander was at last prevailed upon to come down from his garret to die. A later knight who combined the life of the Parisian salons with profound devotion to his vocation was the Bailli de Froullay (1694–1766) who was for twenty-four years ambassador of the Order at the court of Louis XV. He was a friend of the leading literary figures of his day and the protector of Voltaire, but held himself aloof from the fashionable irreligion and died almost in the odour of sanctity.

THE FRENCH REVOLUTION

In the late eighteenth century the Order in France was notably well administered. The prioral Receivers performed their duties with a dedication of which the Revolution itself was to elicit the most striking examples. The Order retained lawyers to protect its interests and printed reports on the management of its affairs. The respect it earned from those concerned for good administration partly explains why attacks were not made earlier on an institution which so quintessentially embodied noble and ecclesiastical privilege.

From such connexions the Grand Master strove to dissociate the Order on the summoning of the Estates-General. Wishing to rest its status on the pillars of sovereignty and international law, he instructed his subjects not to seek election to the Estates-General, but some of them disregarded him, including the Turcopolier, Flachslanden, who represented Alsace, and the Bailli de Crussol, administrator of the Grand Priory of France for the young Duc d'Angoulême. The attempt to shelter the Order from the attack on privilege proved impractical, since the bulk of its revenues were in the feudal dues abolished by the National Assembly. The Receiver in Paris, the Commander d'Estourmel, calculated that the Priory of Toulouse – though this was evidently an extreme case – thereby lost 36,000 *livres* of its annual income of 40,000. Moreover the six Priories of the kingdom found it politic to display their patriotism by donating a quarter of their revenues to the national treasury, necessitating a six-month delay in the payment of responsions, and the abolition of tithes threw the multitude of parish priests on the charity of their Priories. Against this we have to consider that the huge debts of the previous fifteen years had just been paid off and that the investment in the lands of St Anthony would in normal circumstances have begun to yield a profit.

Despite the official stance of neutrality, the Knights of Malta were closely identified with the royalist party. The Comte d'Artois, who had lived in the Temple during the nominal tenure of his sons as Grand Priors, initiated the Emigration in July 1789, followed by Crussol and other dignitaries. On the sudden death of the ambassador Brillane – who had incurred odium as a favourite of Marie-Antoinette – Estourmel was left as *chargé d'affaires* and was to show himself more responsible but no less firm

★ He may be considered to have forfeited the dignity on his morganatic marriage in 1807.

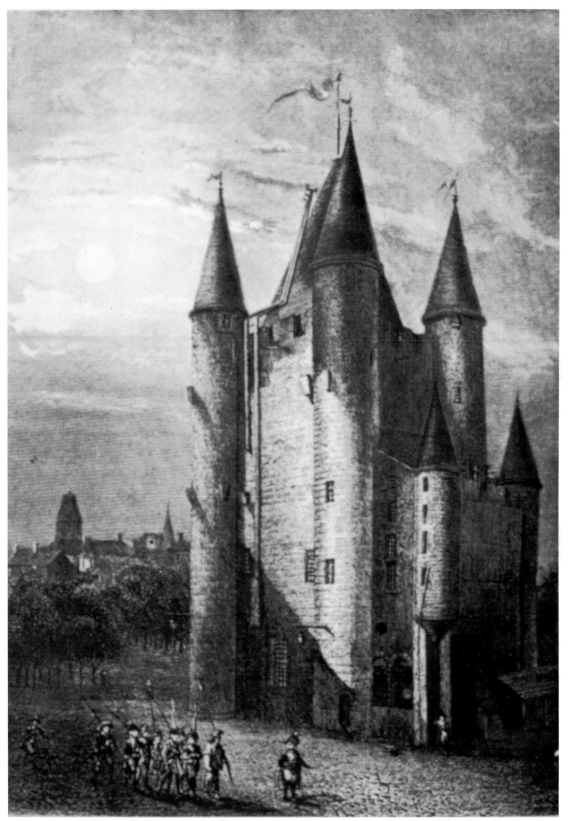

The Tower of the Temple, prison of Louis XVI and his family.

in his devotion to the throne. The Grand Prior of Saint-Gilles, the Bailli de Tulle-Villefranche, was an active counter-revolutionary in Provence, and Flachslanden called for the knights to mount a naval expedition to the same region. Yet the revolutionaries held back from attacking the Order directly; even after the royal family's flight to Varennes, which Estourmel financed out of the Order's funds, their response was surprisingly muted: in July 1791 the knights were stripped of their French citizenship and declared subjects of Malta, but were left in possession of their commanderies. Despite the rhetoric against their Order realists were sufficiently conscious of Malta's international role to permit its 'citizens', though unworthy of the status of free men, to continue drawing revenues from 240 estates in France.

This period of prudence was of short duration. With the September Massacres of 1792 the Revolution entered its phase of blood, and in the same month a new law confiscated all the Order's properties in France. It is evidence of the extraordinary ability of its servants that the Receiver in Marseilles, the Bailli de Foresta, contrived just at that moment to ship 156,000 francs (£6,500) to Genoa. In Paris Estourmel abandoned a diplomatic and a financial post that had both been deprived of substance. At Beaulieu the nuns were ejected from the convent in February 1793; the seventy-five-year-old Prioress, Françoise d'Estresse de Lauzac, who had preserved it from earlier closure by stoutly maintaining the sovereignty of the Order, died within a month. At Lyons the Grand Prior Savary-Lancosme, like most of his *confrères*, had already fled the country, but the prior of the church, the *abbé* Servier, perished as one of the many innocent victims of the guillotine.

The last act of the tragedy was played in the grim fortress of the Templars, where the crime of Philip the Fair against their Order was expiated by his descendants. In August 1792 Louis XVI and his family were imprisoned in its tower, from which he and Marie-Antoinette went to the scaffold. Their son, after suffering the basest ill-treatment, died in 1795 at the age of ten years, and later the same year the seventeen-year-old Madame Royale was released after three years' captivity. The Temple church was sold to a hairdresser in 1796 and demolished, and the tower disappeared in 1808 in the anxiety of the Napoleonic regime to sweep away the memories of royal Paris.

MAP KEY

The Tongue of Aragon

Castellany of Amposta

(Founded as the Priory of Aragon 1149;
Castellany of Amposta founded 1154)

- ⚥ Amposta 1154, ceded to the Crown 1280
- ⚥ Saragossa from *c.*1285
- ⊙ Caspe late fifteenth century
- ⊙ Novillas sixteenth century
- ☐ Caspe 1394
- △ Sijena 1188
- △ Tortosa (founded at La Rápita *c.*1290, moved to Tortosa 1579)
- ● 30 commanderies

Priory of Navarre 1185

- ⚥ Cizur Menor fourteenth century
- ☐ Puente la Reina fifteenth century
- △ Puente la Reina 1307
- ● 18 commanderies

Priory of Catalonia 1319

- ⚥ Barcelona from 1561
- ⊙ Majorca 1428
- △ Alguaire (founded at Cervera 1193, moved to Alguaire 1264, to Barcelona 1699)
- ● 29 commanderies

The Tongue of Castile (and Portugal)

Priory of Castile and Leon *c.*1149

- ⚥ Consuegra 1183–*c.*1287 and 1517 onward
- ⚥ Alcázar de San Juan *c.*1287–1517
- ⊙ Lora 1523
- ⊙ Santo Sepulcro de Toro sixteenth century
- ☐ Santa Maria del Monte 1451
- △ San Juan de Acre, Salinas de Añana, late thirteenth century?
- △ Santa Maria de Orta, Zamora (founded at Fuente de la Peña fourteenth century, moved to Zamora 1534)
- △ Seville 1490
- △ Tordesillas (founded fifteenth century, affiliated to the Order of St John 1545)
- ● 37 commanderies

Portugal or Crato
(independent from Castile late twelfth century)

- ⚥ Crato 1232
- ⊙ Leça (titular Bailiwick of Acre attached to it *c.*1570)
- ☐ Flor da Rosa 1541
- △ Estremoz (founded at Evora 1519, moved to Estremoz 1541)
- ● 21 commanderies

The titular Bailiwick of Negroponte was common to the Langues of Aragon and Castile.

Four prioral territories are marked on the map as follows: I Crato, II Castile and Leon, III Castellany of Amposta, IV Sijena (royal convent).

Franco-Spanish frontier in Navarre (after 1512) and Catalonia (after 1659):

The Tongues of Aragon and Castile.

CHAPTER X

The Tongues of Aragon and Castile

Early Foundations in Spain

THE DONATIONS TO the Hospital which appeared in southern France early in the twelfth century took only a few years to be reproduced on the other side of the Pyrenees. In 1108 a farm was given at Sarroca in the County of Barcelona; four more followed in the next year, and by 1111 a preceptory existed at Cervera.[1] In 1113 the Blessed Gerard sent Pelayo Arulsiz (who to judge from his name and later career was a native of northern Castile) to receive endowments to the Order in Spain.[2]★

In Aragon the royal donation of Aliaga (without its castle) has been dated to 1118, and other bequests are recorded in the 1120s.[3] In Castile the Hospital benefited from the favour of Queen Urraca, who in 1113 gave it the village of Paradinas, near Salamanca; a grant at Atapuerca in 1126–27 initiated the Order's work of hospitality on the road to Compostella. The volume of royal and private gifts grew until in 1130 we find five donations, including the monastery of San Vicente del Villar near Benavente.[4]

The same year sees the first mention of a military presence of the Hospitallers, when Alfonso *el Batallador* of Aragon granted the right to a yearly dinner to two brethren travelling *cum suis armigeris*.[5] There is evidence that at this time the Hospital and the newly approved Order of the Temple were associated in Spanish minds as military orders of equal standing. When in 1133 the Count of Urgell bequeathed his castle of Barberà to the Temple he erroneously described

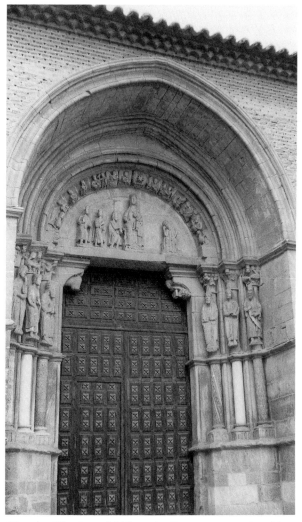

Church of San Juan del Mercado, Benavente, *c.* 1180; this commandery was one of the Order's hospices on the pilgrim-route of Compostella, of whose iconography the portal is a typical example.

★ A more eminent Spanish Hospitaller at this time was Peter of Barcelona, whose career unfolded in Provence and the Holy Land. See p. 117.

it as *hospitalis de Jerusalem*.[6] The most striking instance is the singular will made by the childless Alfonso *el Batallador* in 1131 for the succession to his dominions of Aragon and Navarre; he bequeathed these to the Holy Sepulchre and the Knights of the Hospital and the Temple. Although none of those orders had yet taken an active part in the Spanish Reconquest, the most plausible explanation of this testament by a king who had spent the thirty years of his reign fighting against the Moors is that he believed that all three would be capable not only of defending their territories but of pressing on with the leading role in the *Reconquista* with which he had himself associated them.★ That his expectations were in all three cases far too sanguine is partly the reason why on his death in 1134 the barons rejected his testament; Navarre elected Garcia Ramirez, the restorer of an independent dynasty, and Aragon passed in 1137 to the Count of Barcelona through his marriage to the niece of Alfonso, with the consequent union of the Catalan and Aragonese states.

The three orders had to be compensated for their disappointment. The Templars' strong military role enabled them to be given in 1153 the important castle and frontier territory of Miravet; it seems, on the other hand, that Raymond du Puy (who travelled to Spain in 1140 to negotiate the terms of compensation) was in no hurry to respond to this incentive to a rapid militarisation of his Order. Alfonso had intended to enfeoff the Hospitallers with the powerful fortress of Tortosa, then still in Moslem hands; when it was finally taken in 1148 with what appears rather a token Hospitaller presence, such a grant was still out of the question. Instead the Order received the sea-port of Amposta at the mouth of the Ebro,† an indication perhaps of the importance of the Hospital's work in shipping goods and pilgrims to the East. Although as a port it was strongly fortified it was not a position of special significance on the land frontier. It was nevertheless the Order's first military enfeoffment under the Crown of Aragon and its grant seems to have prompted the creation of an Aragonese priory

(1149) which from 1154 became independent from Saint-Gilles under the title of the Castellany of Amposta.

The subsequent military role of the Hospital in Aragon continued to be weak; its most important centre was probably Aliaga, where the castle was given in 1163, when the Aragonese were preparing themselves for the drive southward to Teruel.[7] The Hospitallers took second place to the Templars in the work of reconquest, and the grant of the Castle of Sollavientos in 1205 is a rare example of a royal wish to use them as a frontier force. The Aragonese brethren possibly preferred the pull of the Holy Land, where they may have enjoyed a temporary prominence; after the fall of the Master des Moulins at Hattin the Order was apparently governed by two Catalans: the Grand Commander Borrell, who assumed temporary control in 1187, and Ermengard d'Asp, who hurried out to the East at his request and after ruling the Order provisionally for a year or two returned to his old post as Castellan of Amposta.

Castile and Portugal (1)

Personalities may likewise explain why the early military initiative seems to have passed to the Castilians. The first two generations of their Priory are dominated by the careers of two men: Pelayo Arulsiz, who after arriving in Spain in 1113 appears constantly in positions of authority until we last see him as Prior of Portugal in 1157; and Pedro Arias, who began as Prior of Portugal in 1140 and as Prior of Castile received the King's grant of the Castle of Consuegra in 1183. The emergence of Pedro, who was almost certainly a knight, is perhaps responsible for the rapid militarisation of the Priory. Until then donations had been located safely out of harm's way in central Leon and Castile, but the year 1144 brings a change of place and function. The Order was invested with the castle of Olmos, strategically situated on the road leading south

★ The Canons of the Holy Sepulchre were in fact never a military order, but there had been a plan to attach such a branch to them earlier in the century. Alfonso may have been under the impression that this had taken place, or he may have believed that the plan was still capable of being realised.

† The Ebro delta has been built up mainly since the fourteenth century.

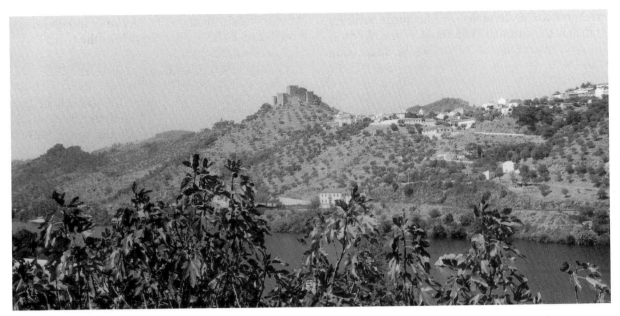

Castle of Belver on the River Tagus, Portugal.

to Toledo.[8] Though it was not strictly a border castle, the proximity of the Moslem frontier to the east and the importance of the road it guarded show that the King of Castile could now trust the Hospitallers with the charge of a sensitive point of the kingdom's communications.

The efficacy shown by the Templars and Hospitallers in the war against the Moors is proved by the rapid development of their imitators, the Spanish military orders. Whatever the early balance of martial honour between Temple and Hospital, in 1158 it tilted sharply in favour of the latter when the Templars gave up as indefensible the frontier castle of Calatrava and withdrew to the quieter task of protecting pilgrims on the road of Compostella; from that date the Templars cease to play a significant part in the Leonese and Castilian *Reconquista*. Calatrava was given to a group of knights who founded the military order of that name; those of Santiago and Alcantara were added over the next twenty years. The Knights of St John seem to have been entrusted with a series of castles which they relinquished as the frontier advanced; in 1183 they received what proved to be the definitive grant of Consuegra, with a wide territory which came to be known as the Campo de San Juan, a central piece in the block of border fiefs in La Mancha which the Crown conferred on the Orders of Calatrava, St John and Santiago.* The castle of Consuegra, placed on one of the long ridges that rib the plain of La Mancha, was developed by the Hospitallers from its Moorish core into a strong fortress. But the orders had scarcely established themselves here when the Christian advance was reversed by the Almohads, who defeated Castile at Alarcos (1195), swept through the barrier of military fiefs, and pushed their frontier well to the north of Toledo. For seventeen years Consuegra was a beleaguered outpost of Christian rule, though the Campo de San Juan itself was never conquered. At this period (1157 to 1230) the kingdoms of Castile and Leon were separate, and we have occasional mention of a Prior of Leon, but there is no evidence of any special Hospitaller role on the short Leonese frontier with the Moslems.

The same advance of the Almohads was responsible for the first military grant to the Hospitallers in Portugal. Their earliest endowment there was at Leça, a monastic house which was given to them by the Countess of Portugal probably in 1128.[9] At first Portugal (which had not yet shaken off its vassalage to Castile) was governed together with Galicia as a dependent Priory, and its heads were the Castilians Pelayo Arulsiz and Pedro Arias. There were a number of royal donations, but there is no sign of any military role until the last decade of the century.

* The Order of Alcantara had not yet acquired sufficient strength to qualify for comparable grants, and when it did so these came principally in Extremadura.

After the Almohads had reconquered as far as the Tagus, the Portuguese priory – by now independent – was granted in 1194 a large territory on the north bank, and on the river itself, where the surrounding hills narrow almost to a gorge, the Hospitallers built the castle of Belver, a smaller and less elaborate fortress than Consuegra but by its position almost impregnable and a key point of the kingdom's defences.

The militarisation of the Hopitallers in Portugal may have owed something to an illegitimate son of King Afonso Henriques, Dom Afonso de Portugal, whose career in the Order culminated in his election as Master in 1202. He was obliged to abdicate for unknown reasons four years later and returned to his country, where he died in 1207. By 1211 the Prior of Portugal ranked as one of the five principal prelates in the kingdom.[10] The flow of donations continued for a time after that date, seven new preceptories being founded in the north, besides larger grants following the conquest of the south.

In 1212 the power of the Almohads was broken by an alliance of the Spanish monarchs at the battle of Las Navas de Tolosa, in which the Hospitallers fought under the Prior of Castile, Gutierre Ermegildez. To consolidate the victory the recovered fiefs of Calatrava and Santiago were extended into a great belt of territories along the new frontier, with the holdings of the Knights of Alcantara added in the extreme west. In this distribution, though, the Hospital received only an insignificant south-eastern appendix to the Campo de San Juan. This loss of favour reflected no decline in the Hospitaller contribution to the reconquest but merely the preference of the Kings of Castile for the native orders which they could control more completely. Hence the map of the Hospitaller possessions in Castile remained virtually what it had been in the twelfth century, reflecting both the economic centre of gravity and the military frontier of the kingdom at that period.

The only significant new grant was made in 1240, when the frontier of Castile was extended to the Guadalquivir; in recognition of its work in conquering them, the Order of St John was given the castle and fortified village of Setefilla

Castle of Setefilla. The pilgrimage church of Our Lady in the background is all that remains of the extensive fortified village that once existed between it and the castle.

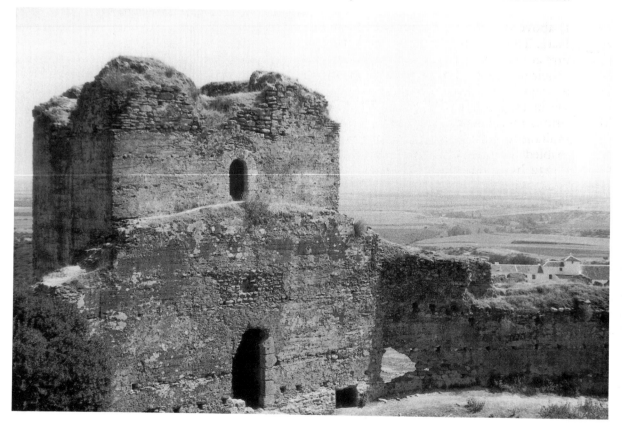

Tower of the prioral palace at Alcázar de San Juan (1287).

when he distributed a large part of Murcia among them, the Hospitallers were established as junior partners to the Knights of Santiago, receiving two commanderies in the kingdom, and these represent the last military gifts to the Hospital in southern Spain. This interlude of royal favour is perhaps what encouraged Ferrán Perez to transfer the capital of the Campo de San Juan to Alcázar and to build there (1287) the great prioral palace of which one tower survives as an impressive relic.[12]

In their vast empty estates of central Spain the military orders evolved over the centuries the methods of cattle-farming on horseback which were taken by the *Conquistadores* to the pampas and prairies of the Americas. The Hospitallers for their part introduced the eastern style of windmills which they found on the harbour mole of Rhodes, and which became current in Spain about the fifteenth century. The line of windmills that shares the hill of Consuegra with its castle must have been the prototypes of those for which the region is famous; but windmills and La Mancha evoke special associations: in a later age when chivalry was a less serious business they were to inspire one of the most famous *jeux d'esprit* in European literature.

Navarre and Aragon

A Priory of diametrically opposite character was that of Navarre. A few donations may have been made here before 1131, and in that year Alfonso *el Batallador* gave a splendid start to the Order's possessions by granting it his palace at Sangüesa, together with properties at Sos and Uncastillo. A second preceptory was created at Cizur Menor, just outside Pamplona, about 1181, and the Priory of Navarre shows a continuous existence from 1185. Its establishment evidently reflects a substantial consolidation of the Hospitaller properties in the kingdom, since by 1189 a further ten preceptories are listed. The Hospital was the only military order (if indeed one may call it such in this Priory) with important possessions in Navarre, and its Prior ranked as one of the four prelates of the kingdom with the two

in the hills above the river, together with Lora and Almenara. The knights made their administrative centre at Lora, on the Guadalquivir itself, and under their management it became the most prosperous town of the area, the commandery being raised in 1523 to the rank of a bailiwick, with enormous revenues attached to it.

The simultaneous advance of the Portuguese frontier enabled the prioral territory to be extended in 1232 by a long tongue to the south of the Tagus, with its centre at Crato, which became the residence of the Priors.★ At this time the Portuguese knights played an equal role with those of the Temple, Santiago and Aviz (the Portuguese branch of Calatrava), taking part in conquests such as that of Faro in 1249.

In Castile, however, royal neglect worsened to active hostility. The absolutism of Alfonso X weighed heavy on the military orders, and when his son Sancho rose in rebellion in 1282 they ranged themselves with his supporters. Their reward came in Sancho's own reign (1284–95);

★ The grant was the reward for the Hospitaller conquest of Moura and Serpa in the south, where a large territory was also given to the Priory. Both towns, however, were given up to King Alfonso X in 1281 during the temporary Castilian sovereignty over that region.[11]

Church of Cizur Menor (Pamplona), seat of the Priors of Navarre.

bishops and the Prior of Roncesvalles. With the death of the *Batallador* Navarre ceased to play any part in the *Reconquista* and the military element among the Hospitallers was minimal; only twenty-two knights have been identified among the brethren in the whole of the twelfth and thirteenth centuries. Nor did the Order play any part in colonisation or founding *salvetats*, or receive important manorial fiefs. The Navarrese preceptories were quiet, modestly endowed little communities, some of the larger ones numbering a dozen brethren or more. Bargota offers an example of a house with women inmates, and this element of the community was developed into a separate nuns' priory at the neighbouring town of Puente la Reina, a stopping-place on the road to Compostella. In the fifteenth century a pilgrims' hospital and a community of priests was added.

The marriage of the Queen of Navarre to Philip the Fair in 1284 brought her kingdom strongly within the French orbit, and from 1297 we find Provençal knights appointed Priors of Navarre. The formal attachment of the Priory to the Langue of Provence seems to have been made in 1314, and was accompanied by a promise that the prioral dignity would be reserved for Navarrese;[13] this was observed between about 1317 and 1340, but then three more Provençal knights succeeded. The advent of Charles II to the throne in 1350 led to a Spanish reorientation of the kingdom, and on the death of Austorge de Caylus (Prior 1349–58) Navarre was restored to

the Langue of Spain.[14] It was perhaps due to this Provençal influence that the Priory began to grow more military in the fourteenth century. The acquisition of the Templar property (which consisted of only two houses in Navarre) took place without difficulty; the Priory continued to prosper, increasing its number of preceptories from 21 to 28 in the fourteenth century, and the Prior Monteolivo de Laya (1358–83) was a significant figure at court who served as Governor of the kingdom.

In Aragon, although the national military orders scarcely had a presence, the role of the Hospitallers in the *Reconquista* continued to be weak in comparison with their activity in Castile and Portugal; they took no part in the conquest of Majorca (1229), where the bulk of their future possessions was to come from the spoils of the Templars. On the other hand they fought in the conquest of Valencia (1239) and received five preceptories in the kingdom. Subsequently Aragonese expansion was directed towards Sicily and Greece.

In 1280 the Priory suffered a marked reverse in its territorial position when the King – presumably with a view to controlling the crossing of the lower Ebro – obliged it to give up Amposta in return for 'fatter revenues' in Valencia and elsewhere. Although the Hospitallers moved their headquarters to Saragossa, the loss of their most important town and castle seems to have weighed heavy on their minds, for they continued to style their

Tower of La Zuda and church of San Juan de los Panetes in Saragossa, the remains of the prioral palace of the Castellans of Amposta.

Prior Castellan of Amposta for the next six centuries.

This loss should not make us believe that royal favour was slipping away from the Hospital; its prestige had other than military pillars to support it. A special feature was the diffusion of women's convents; Grisén, near Saragossa, was given to the Order in 1177 for the establishment of a convent – the first such foundation in Europe – but there is no evidence of the presence of nuns here till 1240.[15] The foundation was perhaps superseded, or at least completely overshadowed, by that of the royal convent of Sijena, which was planned by Queen Sancha in 1183. The monastery was completed and occupied in 1188, and became one of the most illustrious convents of the kingdom, both Queen Sancha and her daughter Doña Dulce taking the veil in it; it was the burial-place of several members of the royal house, including King Peter II when he fell at Muret in 1213. During the first century of its existence the convent acquired a domain of nearly four hundred square miles, over which the Prioress exercised full jurisdiction. The superb painted chapter hall, whose frescoes have been described as perhaps the greatest series of early thirteenth-century paintings anywhere in Europe,[16] were among the earliest expressions of its splendour.

In 1192 Sijena founded its first daughter house at Cervera, but in 1264 this community transferred itself to the new monastery at Alguaire built for it by Doña Marquesa de Guardia, whose daughter Gueralda was the first Prioress. This house, second in magnificence to Sijena, acquired the barony of Alguaire and indulged in private

wars with the city of Lerida and the Count of Urgell, the latter of whom atoned for his conduct by granting the nuns the title of Baronesses of Portella. Around 1290 a further convent was founded (perhaps by nuns fleeing from the fall of Acre) at the coastal town of La Rapita, which belonged to the Castellany of Amposta. The existence of these three convents★ contrasts with the absence of women's houses in Castile and Portugal, and exemplifies the less exclusively military character of the Aragonese priory.

The nuns of St John enjoyed their high point of royal favour in the reign of James II (1291–1327). The King's great-aunt Constance of Hohenstaufen took the veil at Valencia in 1306. James conferred on Sijena the right of coinage in its dominions and had his daughter Doña Blanca (1302–48) appointed Prioress at the age of nineteen. She built a new prioral palace with a throne room of magnificent timberwork, and converted Sijena into a splendid royal residence. The choir nuns rose to the number of one hundred, ladies of the highest families in the kingdom who entered with their retinues of servants and built themselves private apartments, crazily perched on the structure of the monastery itself; with their jumble of balconies and façades these came to give the cloister a highly picturesque appearance, reminiscent of the square of a Spanish country town. In the choir the nuns wore rochets and gloves of fine linen and carried silver sceptres, and the costume of the young *escolanas* who were brought up in the convent vied with theirs in elegance. Doña Blanca conducted the house with boundless extravagance, enjoyed frequent absences at court and allowed her nuns to travel with the same freedom, so that the monastery is to be compared not so much to an ordinary convent as to a *chapitre noble*, the nuns (as their title *dueñas* suggests) enjoying independent prebends which consisted in the dowries that enabled them to keep up their proper state. When the Aragonese royal house became extinct in 1410, no fewer than seven ladies of royal blood or of families which claimed the throne were resident in Sijena.[17]

The royal links with the Hospital were further embodied in Don Sancho, an illegitimate half-brother of James II, who after serving as Admiral when the Order began the conquest of Rhodes acquired in 1328 the Castellany of Amposta. The Knights of St John were thus well placed when Pope Clement V ordered the

Sijena: the door of the church, late 12th century.

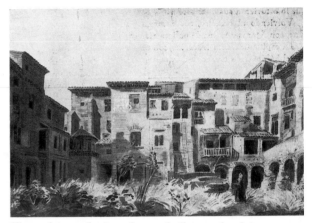
Sijena: the nuns' private houses built over the cloister (19th-century drawing by Valentin Carderera).

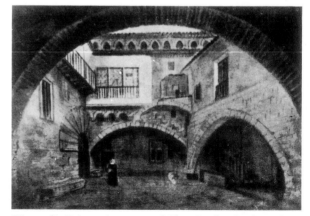
Sijena: the Prioress's courtyard (drawing by Carderera).

★ Preceptories with women religious are also found in the thirteenth century, but it is not known whether these communities or that of Grisén survived to the end of the century.

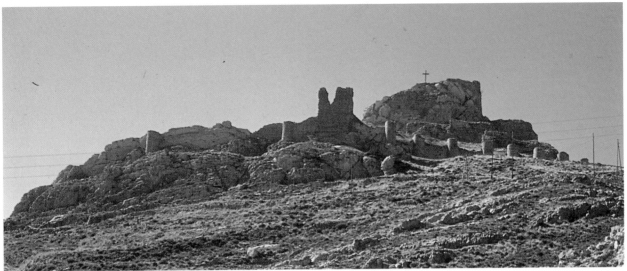

XIII. Aliaga, the most important Hospitaller castle in Aragon, granted to the Order in 1163.

XIV. Castel of Consuegra, the prioral seat of Castile, granted in 1183 and rebuilt by the Hospitallers.

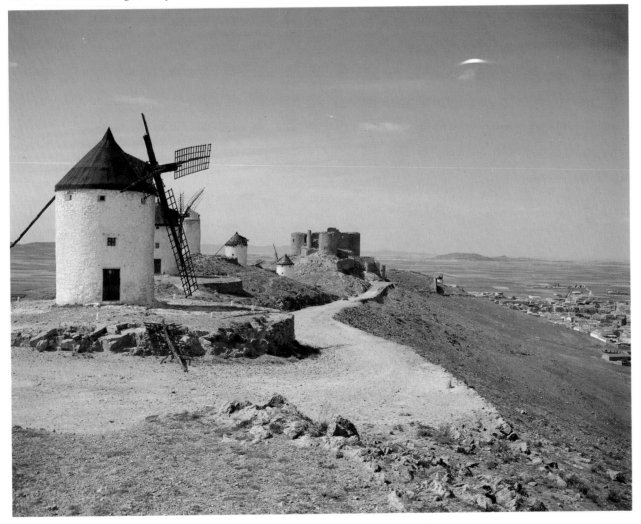

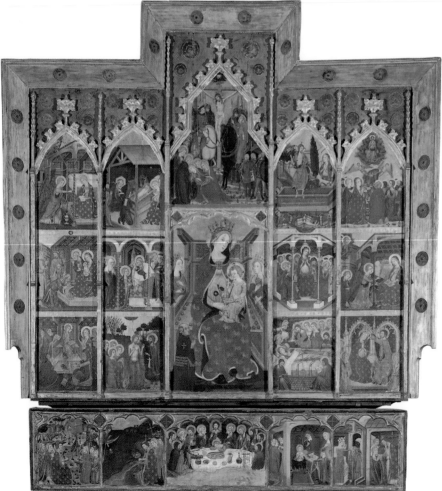

transference to them of the Templar heritage. Royal resistance to such huge accretion of wealth was common in many countries, but it was especially understandable in Aragon and Portugal, where the Templars held great military fiefs. The castle of Miravet was the centre of a Templar province which until 1243 had included not only the whole of Christian Spain but a large portion of southern France as well, and its territory on the Ebro, added to that of Amposta, was to make the Hospitallers lords of almost the whole of Catalonia on the west bank of that river. It is proof of the high favour the Hospital enjoyed that James II permitted these acquisitions in the greater part of his kingdom; only in Valencia did he insist on using the Templar properties to found the military order of Montesa (1319). The Hospitallers gave up four of their five preceptories in the kingdom for the same purpose, but retained next to the capital the important house of Torrente, which gave its holder the right to a seat in the *Cortes*. The Knights of St John also picked up some personal benefits, since the first two Masters of Montesa, Guillermo de Eril and Arnaldo de Soler, were appointed from among their number.

The rich gains outside Valencia prompted the carving out of a separate Priory of Catalonia in 1319, though the part of Catalonia beyond the Ebro remained attached to the Castellany of Amposta, constituting in fact the estate of the Castellan. A bizarre episode of the same year was the brief entry of the heir to the throne, Don Jaime, into the Order of St John to escape his intended marriage to Doña Leonor of Castile. This dynastic renunciation was far from being prompted by an aversion to the pleasures of the flesh, and his reception almost immediately afterwards as a Knight of Montesa relieved the Hospital of a disreputable *confrère*.

Castile and Portugal (2)

In Portugal the Templar lands were used in 1317 to found the Order of Christ; in Castile the government of the infant Alfonso XI promised their cession to the Hospital, but in the disorders of the time they were seized by the Castilian military orders and other powers, nor did papal protection avail to restore them. The city of Seville defied excommunication for many years to avoid giving up a nearby Templar castle, and eventually acquitted the Hospitaller claim in cash. It was of little profit that at this time the Priory produced one of its most powerful figures, Fernán Rodriguez de Valbuena, whom we find as Grand Commander in 1317, only three years before that office was permanently reserved for the knights of Provence. In 1328, as Prior of Castile, Valbuena raised a rebellion against the boy King's powerful minister, Alvar Nuñez de Osorio, and it may be due to his ascendancy that Toro, the centre of his power, was the only place in Castile where the Order succeeded in acquiring the Templar property. Valbuena remained at the centre of royal intrigues for the last five years of his life, but there is no other sign that his influence benefited the claims of his Priory.[18]

The capture of Gibraltar by the Moroccans at this time, after a brief Castilian tenure, raised the ghosts of the Almoravid and Almohad incursions, which had centuries before reinforced Moslem Spain and reversed the tide of Christian conquest. The Spanish kingdoms combined against the danger; the Prior of Castile, Alfonso Ortiz, was entrusted with command of the fleet that patrolled the Straits of Gibraltar in 1340, while the Christian armies – among whom the Prior of Portugal was present with his kingdom's forces – won a great victory at the nearby River Salado, closing finally that avenue of Moorish invasion. These interventions did little to attract royal benevolence in Castile, the prospects of which became even slighter in the reign of Peter the Cruel (1350–69). Rejecting the nomination of Fernandez de Heredia as Prior of Castile, the King imposed Gutier Gomez de Toledo in that office, from which he elevated him in 1361/2 to the Mastership of Alcantara. His successor withdrew the Order from its enforced loyalty to the violent monarch and supported Henry of Trastamara, whose victory in 1369 strengthened the fortunes of the Hospitallers, and their claims to the Templar lands were finally settled to the benefit of the Castellany of Amposta.★

The military character of the Priory began during this period to yield to softer influences: the women's convent of Salinas de Añana existed by 1396 and is credited with an origin in the

★ For these events see also pp. 42 and 43.

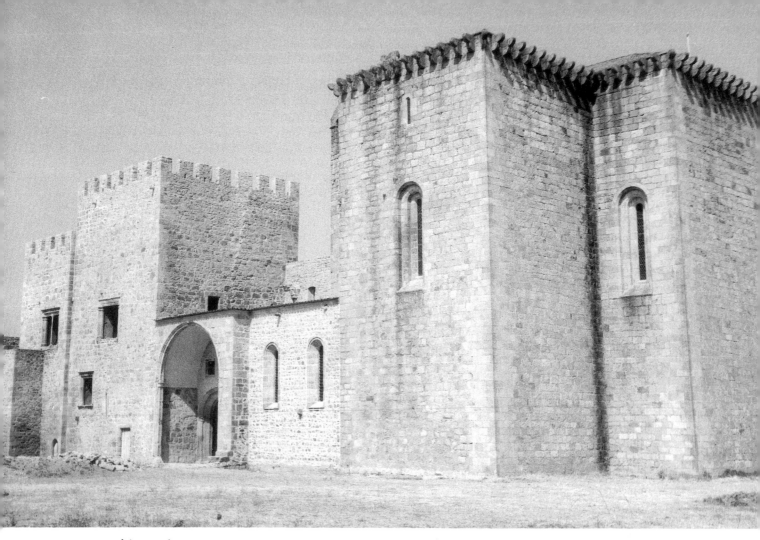

thirteenth century; its name of San Juan de Acre suggests that it may have been one of the group founded after the fall of that city. Another convent, established in the fourteenth century at Fuente de la Peña, was transferred in 1534 to Zamora and became the most important in the Priory, the beauty of its church and house leading to its being called 'the pearl of the convents of Zamora'. That of Seville was founded in 1490, and in 1545 an existing convent in Tordesillas was affiliated to the Order, bringing the number of women's houses in the Peninsula (with the other five in Aragon, Navarre and Portugal) to nine; we may compare this with the mere seven that existed at the time in all the rest of Europe.★

A development in a similar line was the foundation near Consuegra in 1451 of a sort of pre-Tridentine seminary to train priests for the Castilian priory, supplemented after 1530 by a small college at the university of Salamanca.

Flor da Rosa, the church and palace of the Priors of Crato (14th century).

Portugal, which always followed Castile step by step, founded a similar community in 1541 at Flor da Rosa in the prioral palace, by then abandoned as a residence by absentee incumbents; but otherwise the only counterparts of these houses were those of Strasbourg and Prague for the German and Bohemian priories, which had a strongly marked ecclesiastical character.

The palace of Flor da Rosa, next to Crato, was built by Alvaro Gonçalves Pereira, who held the Priory from 1340 to 1383. It was the most meritorious act of a man who lived with scandalous extravagance, fathered thirty-two illegitimate children and was eventually excommunicated for failing to pay his dues to Rhodes. The large but truncated church which he left behind, with the fine palace beside it, might stand as a symbol of his imperfect spiritual and

★ It is also a high number in the context of the peninsular military orders. While most of these had women's houses, the only one in which they reached comparable prominence was the Portuguese Order of Santiago, which had seven convents.

unbounded worldly aspirations. At this time the Priory of Crato reached perhaps the apogee of its independent glory; the Prior held the rank of a Count and (when that concept gained currency) a grandee of Portugal; the Vicar General of Crato was a mitred prelate with episcopal jurisdiction in the prioral lands, a virtual principality including ten towns and twenty-nine parishes.

But Pereira left, unintentionally, a more shining legacy to Portugal and the Order of St John. One of his numerous illegitimate sons was Nuno Alvares Pereira (1360–1431), the 'Holy Constable'. He was a Knight of Rhodes by 1383 when King Ferdinand I died, leaving an only daughter, Beatrice, who had been given in marriage to the King of Castile; but her succession was contested by Ferdinand's illegitimate brother, the Master of the Knights of Aviz. Nuno ensured the proclamation of the Master by the Portuguese people, who detested the prospect of Castilian domination. The new King appointed him Constable, and at only twenty-five he won a resounding victory over a much larger Castilian army at Aljubarrota. His continued military services against Castile consolidated the rule of the House of Aviz, and Nuno's daughter married the Duke of Braganza, the

Leça: monument to Chancellor Cristovão de Sernache, early 16th century.

legitimised son of the King whom he had raised to the throne. The blood of the 'Holy Constable' was thus fittingly enough at the origin of the dynasty which assumed the crown of Portugal in 1640, when the nation again rose against Castilian rule. Royal service was particularly common among the Portuguese Hospitallers: in the thirteenth century we find two Priors of Crato who served as chief ministers of the kingdom, and a third, Vasco de Athayde, fell commanding the army with which Afonso V attempted in 1475 to assert his claims to the Castilian throne.

Aragon

The towering figure in the history of the Castellany of Amposta was Fernandez de Heredia, who revolutionised the standing of his countrymen in the Order. His management of the vast estate of the Castellany raised it to a peak of productivity and caused it to be regarded in the fifteenth century as a uniquely valuable endowment of the Order. Two Catalan knights climbed the ladder Heredia had built for them: Antonio de Fluviá served as Lieutenant under Naillac and succeeded him as Master (1421–37); Raimundo Zacosta* was Castellan of Amposta when he was elected Master in 1461. The King of Aragon was at that time attempting to suppress a rebellion of the Catalans, and the Castellany with its great possessions was a key post; he therefore imposed in that office a knight devoted to his own cause, Bernardo de Rocaberti, who played a strong military role in re-establishing royal authority. The Master, however, supported his fellow Catalans, a stance which the King punished by sequestrating the Order's commanderies, and it was not until after Zacosta's death that relations were mended and the Order recognised Rocaberti as Castellan.

Before the breach became open, in 1462, Zacosta contrived an important gain for his country, dividing the Langue of Spain into two, Aragon and Castile; the first comprised the three priories of Amposta, Catalonia and Navarre, and the second embraced Castile and Portugal. The division is curious evidence of the fact that only

* The modern spelling is Sacosta, but Zacosta seems to have been common in the Middle Ages.

Church of St John, Vilafranca del Penedés (14th century).

a few years before the political union of Spain Castile appeared to have stronger political and cultural affinities with Portugal than with Aragon.

A later Catalan knight, Hugo de Montcada, was a prominent royal servant and the author of an epic poem which is noteworthy for the introduction of Italian influence into Catalan verse. He was a kinsman of the Borgias, some of whose character he shared, and this connexion directed his steps to Italy. After receiving the Priory of Messina, he was appointed in 1509 Viceroy of Sicily. His arrogant conduct infuriated his subjects, but when they complained to Charles V, alleging that Montcada had deflowered a thousand virgins and was seeking to make himself King, Montcada replied: 'As to the first, might God send me the vigour for it; and as to the second, let His Majesty consider whether he is not worthy to be served by a man with aspirations of royalty.' The Sicilians were not amused, however, and their rebellion occasioned Montcada's removal in 1516. He was enfeoffed with Tripoli (anticipating his Order's possession of the town), conquered the island of Gerba for Spain and was killed fighting the French in 1528.

The privileges of Sijena declined after the extinction of the royal house that had founded it, and even more when the centre of power shifted to Madrid. They appeared threatened from another quarter when the Council of Trent insisted on the rule of enclosure for all monastic orders; but the Prioress staunchly defended the principle that the vocation of her noble sisters included the right to absent themselves at pleasure from the remote and dreary landscape that Queen Sancha, unfortunately, had chosen for their dwelling, and in 1573 the Pope conceded her point. A similar development had taken place at Alguaire, where the Prioress Margarita de Urrea (1505–25), an illegitimate daughter of the Archbishop of Tarragona, introduced considerable relaxation, and the *comendadoras*, like the *dueñas* of Sijena, began building themselves private houses. By the late seventeenth century all the nuns were so accommodated and the monastery was falling into ruin; this was taken as a pretext to move the convent in 1699 to Barcelona, where the nuns shared the palace of the Prior of Catalonia. The convent of La Rapita,

which was less luxurious, had dwindled almost to extinction when it was re-founded in 1579 in Tortosa, but subsequently it flourished, building in the eighteenth century a fine church of which the battered baroque façade survives in the Plaça de Sant Joan.

Castile and Portugal (3)

The Priory of Castile became an appanage for over a century of the ducal house of Béjar, Don Alvaro de Zúñiga gaining possession of the office in 1482. His nephew Antonio expected to succeed him, but when the time came his family's influence was countered by that of the Duke of Alba; through the favour of King Ferdinand and the acquiescence of Pope Leo X, he had Don Diego de Toledo appointed, overriding the wishes of the Order. Zúñiga refused to give up his claim, and at the time of King Ferdinand's death Cardinal Cisneros was moving a royal army to eject him from the prioral lands. The dispute was resolved by the young Charles V, who ordered the Campo de San Juan to be divided between the two claimants (1517); Consuegra became the residence of Zúñiga as Prior of Castile, and Toledo enjoyed the palace of Alcázar de San Juan as nominal Prior of Leon, a division that continued until the death of the last of three successive Toledo brothers in 1566. As far as the Order was concerned the genuine

Prior was Zúñiga, and he took care to retain royal favour by playing a leading part in suppressing the *Comunero* rebellion, reconquering the city of Toledo for the King in 1521.

A worse example of royal intervention was shown in Portugal, where in 1516 the King imposed a Knight of Santiago as Prior of Crato. After the fall of Rhodes the threat to the integrity of the Priory became even graver, but it was averted by the diplomacy of Villiers de l'Isle Adam, and in 1528 King John III paid the Order 15,000 crusadoes for its consent to seeing his brother Luiz installed as Prior. Dom Luiz (1506–55) was the most admirable of four royal brothers; he administered the Priory well and kept the rule of celibacy, being noted in his later years for his piety. In 1541 he founded a seminary of chaplains at Flor da Rosa and established at Estremoz the convent of nuns which had been founded at Evora in 1519. It took the rule of Sijena and occupied a fine building on the spacious square of St John, the main market-place of the city.

Unfortunately the product of Dom Luiz's less regular youth was his bastard son Antonio (1531–95), who succeeded him as Prior. On the extinction of the House of Aviz in 1580 he attempted to gain the throne against the claims of King Philip II. The Prior of Crato was an unprepossessing individual of licentious life, whose principal military exploit to date was to have been taken prisoner at the battle of Alcacer Quibir. The King of Spain had little difficulty in

Convent of Estremoz (16th century).

Leça: the Bailiff's church, *c.* 1335.

making good his title; Dom Antonio fled to England and in 1589 landed with Drake on the Portuguese coast in a further attempt to conquer the kingdom.★ When this failed he withdrew to the protection of Henry IV, in whose dominions he ended his days.

His successor as Prior of Crato was the Cardinal Archduke Albert, known as 'the Pious' (1559–1621), who when only twenty-three was appointed Viceroy of Portugal. The ten years of his government did much to reconcile the Portuguese nation to Castilian sovereignty. He resigned the Priory, together with his cardinalate, on his marriage in 1599, and was succeeded by two princely absentees, Victor Amadeus of Savoy and the Cardinal Infante Ferdinand, famous for his leadership of the Spanish armies in the Thirty Years' War. When the latter died in 1641 the Portuguese revolt against Spain had begun, and it was the House of Braganza which appropriated the right of nomination. The new King conferred the Priory on his third son, who was to seize the throne as Peter II in 1668. Three professed knights nominated by the King then held the Priory, and from the end of the seventeenth century it was reserved to a series of Infantes.

In view of the exclusion of the Portuguese knights from the prioral dignity, the titular Bailiwick of Acre was reserved for their nation about 1570 and was attached to the commandery of Leça, which, after Crato, had always been their most splendid possession. The fine church had been built about 1335 by Estevão Vasques Pimentel, one of the most distinguished Priors of the fourteenth century, and the adjoining palace became the residence of the Bailiffs, who were the real administrators of the Priory while princes enjoyed the revenues of Crato. The same circumstances may account for the prominence of the Portuguese in the government of the Order. Luis Mendes de Vasconcellos held the Grand Magistry for a few months (1622–23) after a career of great distinction, and in the eighteenth century Portugal produced two of

★ This expedition, which involved a larger fleet and resulted in almost as complete a disaster as that of the Armada the previous year, sinks out of sight in the patriotic glow of ordinary English historiography.

the most notable holders of that office, Antonio Manoel de Vilhena and Manuel Pinto da Fonseca.

In Castile the sixteenth century was the golden age of the Order of Malta. While the national military orders went into decline after the ending of the *Reconquista* and the annexation of their Masterships to the Crown, the grant of Malta and Tripoli by Charles V and the strategic co-operation of Spain and Malta gave new prominence to the Knights of St John. The Grand Mastership of the Aragonese Homedes came at an opportune time to assist the advance of his compatriots, but it was the Castilians who chiefly took advantage of it. This was especially true in the great surge of recruitment after the siege of 1565, when the Castilians came to exceed in numbers not only their Aragonese *confrères* but also the Knights of Calatrava and of Alcantara, and perhaps even those of Santiago, which otherwise held pride of place among the military orders of the kingdom.[19]

The tenure by the Zúñigas of the Priory of Castile ended in 1598, when Philip II nominated his grandson Prince Filiberto Emanuele of Savoy (1588–1624), younger brother of the contemporary Prior of Crato. The princes had been brought up in Spain but had been withdrawn when their father decided to follow the anti-Spanish star of Henry IV. The assassination of that monarch in 1610 caused the Duke of Savoy to send Filiberto Emanuele on a hasty diplomatic mission to assuage the displeasure of the King of Spain, a task in which he was so successful that he was appointed Captain General of the Spanish navy. On this death the Priory was briefly held by two ordinary Knights of Malta, including another Zúñiga, but then reverted to royal possession.

An incident of this period was the reception into the Order of Lope de Vega. The playwright's vast *oeuvre* already assured him an unshakable position in Spanish letters, but he hankered after a less immortal distinction. He coveted the title of *frey* which was borne by the knights and chaplains of the military orders, and whose prestige is a sign of the position those orders held in the society of the time. Lacking the qualifications of nobility, he approached the papal nephew Cardinal Barberini on his visit to Spain in 1626, and two years later a dispensation from Pope Urban VIII enabled him to be admitted as a chaplain of the Priory of Castile.

Tomb of the Knight of Malta Juan-Luis de Vergara (1575) from Valladolid Cathedral, now at St John's Gate.

In 1642 Philip IV had the Priory conferred on his thirteen-year-old bastard, Don Juan José de Austria, who professed as a knight and grew up to be one of the most significant statesmen of the century. At the age of twenty-two, after four years' proconsular experience in Naples, he was appointed Viceroy of Catalonia, where Spain was reimposing her rule after the serious revolt of 1640. The Catalans had delivered themselves to French sovereignty, but after eleven years' experience of their liberators they received with joy the return of the House of Austria. During his five years there Don Juan pacified the principality and won the popularity which later made it the base of his political strength. From 1661 to 1665 he commanded with great skill the Spanish forces in Portugal, the only part of his father's dominions whose rebellion had not been overcome. There can be little doubt that if he had not been starved of resources by the jealousy of Queen Mariana, who resented any glory won by her husband's illegitimate son, this kingdom too would have been restored to the Spanish monarchy. On the death of Philip IV a struggle for power developed between Don Juan and Queen Mariana, who exercised the regency. He withdrew to Aragon, and his remembered popularity made him the first statesman in Spanish history to base his power on the eastern regions, from where he issued his *pronunciamento* against the Queen's government. He failed to exploit his advantage, however, and con-

tented himself with the government of Aragon. As the afflictions of the monarchy continued Don Juan became the idol of a swelling party which looked to him as the saviour of the nation, and whose clamour enabled him to return, banish the Queen Mother and assume full power. His ministry from January 1677 to September 1679 was marked by valuable financial reforms, but his political projects outstripped the capacity of his exhausted country, and when he died, aged only fifty, he left the great hopes that had been held of him disappointed.

Don Juan's successors as Grand Priors were the Marqués de Tejada and, from 1687 to 1715, Francisco Fernando de Escobedo, a former Governor of Guatemala. He had devoted the greater part of his fortune to founding the hospital of Belén, but being accused of misgovernment he was dismissed, in the stringent fashion of Spanish administration, and was left so destitute that he was unable to return to Spain to answer his accusers; the Order of Malta sent a ship to bring him back (1678) and the charges against him evidently failed, for he was appointed to the Council of the Indies, from which position he continued to render good service to Central America.

A more important political career was that of the Order's ambassador in Madrid, Manuel Arias (1638–1717), who after serving as Pilier of the Castilian Langue took holy orders in 1690. His proposals for administrative reform caused Charles II, in a rare moment of independent decision, to appoint him in 1692 President of the Council of Castile. His honesty and ability struggled with some success against the political sickness of his age, and on the accession of Philip of Anjou (1701) he was called to second Cardinal Portocarrero in proposing sweeping reforms by which it was hoped to regenerate the Spanish monarchy. That this ambition failed is due to the twelve years' war that the new King had to fight to defend his title, and partly also to the influence of the royal favourite the Princesse des Ursins, whose enmity for a time excluded Arias from government. Before that he had been placed second in rank in the Council of Regency, was appointed Archbishop of Seville (1702) and immediately offered the entire revenue of his see to confront the crisis of the war. He was restored

Balì Antonio Valdés (1744–1816) by Goya.

to ministerial office in September 1704 and eight years later received the cardinal's hat.

After the death of Escobedo the Grand Priory of Castile again became reserved for royal nominees. Charles III, whose despotic conduct towards the Order of Malta had already been shown when he was King of Naples,★ appointed his second son, Don Gabriel, Grand Prior of Castile in 1766, and in 1785 he had that dignity, with its vast revenues of half a million *reales*, turned into a hereditary appanage of the cadet line, its connexion with the Order being thus severed in all but name. Four years later this measure was copied by the Portuguese royal house in regard to the Grand Priory of Crato.

Numerous knights distinguished themselves in the royal service, and the names of Jorge Juan, Amat, Bucareli, Guirior, Taboada, Grua Talamanca and Malaspina indicate that a student of the role of the Knights of Malta in the life of

★ See pp. 222–3.

Spain in the late eighteenth century would have a wide field of research before him. The most eminent representative of this generation is Antonio Valdés, who for thirteen years (1782–95) held with great ability the office of Minister of the Navy. He later incurred the enmity of Godoy and was excluded from public service until he took up arms against the Napoleonic invasion of Spain. On the fall of the French regime Valdés was made Lieutenant of the Grand Priory of Castile and was one of the figures on whom the Lieutenancy of the Order could have depended, if its incapacity had not prevented it, to aid the restoration of the Spanish priories.

The Eclipse of the Order

The legacy of enlightened despotism that Charles III imported into the Spanish monarchy – in other words the policy of anti-clericalism and unprincipled self-interest – was fully maintained by his son, Charles IV. During the whole of his reign (1788–1808) the government was dominated by the favourite Godoy, whose ascendancy was limited only by his incompetence. The King took advantage of the fall of Malta to impose his rule on the four priories of the kingdom; when the provisions of the Treaty of Amiens threatened to restore the independence of the Order, he annexed the Spanish priories to the Crown by decree (January 1802), converting them into the royal Order of St John, and the commanderies that had been won on the galleys of Malta were distributed as courtiers' favours.

The life of the Order, as of all Spain, was interrupted by the French invasion. At the Restoration the Prior of Castile was the Infante Sebastian (1811–75), grandson of Don Gabriel, for whose benefit the office had been made hereditary; as administrator of this Priory the King appointed his first brother, Don Carlos (who was Sebastian's step-father), while his younger brother Don Francisco (1794–1865) received the Castellany of Amposta.[20]

Before his death in 1833 the King changed the law of succession in favour of his infant daughter Isabella, overriding the rights of his brothers, but Don Carlos refused to accept his relegation and rose in revolt, taking his stand on the tra-

ditional laws of Spain and the defence of the Catholic religion. His step-son the Grand Prior supported his cause and fought for him in the first Carlist war (1833–39). The anti-clerical government of Isabella immediately confiscated the property of the Church. The convents of the Order of St John were expropriated; that of Sijena lost its immense possessions, the monastery itself was sold, and although the purchaser allowed the nuns to remain they were reduced to the sustenance of their own dowries. With the knights the liberal regime was less stringent, lest they should flock in support to Don Carlos, and it was not until 1841, when the Traditionalists had been defeated, that it began the expropriation of the commanderies. In 1847 the Order of St John was turned into a civil order without qualifications of nobility, and the Concordat of 1851 provided for the abolition of its extensive ecclesiastical jurisdictions.

This last measure provoked a reaction from the Castellan of Amposta. He had seen no profit in supporting the claims of his brother Don Carlos, and had sought a more direct dynastic advantage by marrying his own son to his niece, Queen Isabella; he was thus in an influential position to check attempts against his prerogatives. He was allowed to keep his prelacy over the convents of the Order and to annex the Priory of Catalonia to the Castellany, and it was not until after his death that these bodies were dissolved by the republican government of 1868. For his part Don Sebastian achieved a reconciliation with the regime of Queen Isabella to the extent of marrying her aunt, and returned from exile to resume the empty title of Grand Prior of Castile. The Knights of St John thus continued a tenuous existence, and took a prominent part in the establishment in Spain of the Red Cross (1867), whose founder Henri Dunant was a personal friend of Don Sebastian.

In Portugal the Order followed a remarkably similar development: although there was no formal annexation to the Crown the appropriation of the Grand Priory of Crato as a royal appanage placed it in a very similar position. The last holder of the office was the absolutist Dom Miguel, who was proclaimed King in 1828 but had to go into exile in 1834. That event may be considered the end of the Order in Portugal, since the new Liberal government, following a parallel policy to that of Spain, confiscated the

Sijena: the Prioress and her personal court of seven nuns (an institution established by the Infanta Blanca in the 14th century and which survived until the destruction of the convent in 1936).

properties of the military orders. The convent of Estremoz passed to the State on the death of its last nun in 1878.

In Spain a few knights had taken vows by papal dispensation after 1802, but none seems to have survived by 1885, when a royal decree 'restored' the Tongue of Spain to the unity of the Order under the Grand Master Ceschi a Santa Croce.★ There were then some 250 knights who had been received before 1868, often without nobiliary qualifications,[21] but the Spanish assembly thenceforth reacted strongly against such liberalism, demanding the strictest proofs of nobility from both knights and their wives. This union did not apply to the women's convents, which the disappearance of the old prioral jurisdictions had converted into independent

communities. The nuns of Sijena recovered possession of their house (though not their land) and continued their traditional life until the outbreak of the Civil War, when a party of Republicans arrived from Barcelona and burnt down the convent, destroying the royal and monastic sepulchres; only the prompt escape of the nuns prevented their massacre from crowning this all-too-common example of barbarism. Since the war two attempts have been made to renew conventual life in the ruins of Sijena, but they have had to be abandoned and the nuns have been absorbed into the community of Barcelona.

The vicissitudes of the other convents are exemplified by the case of Barcelona, and by the long career of one of its nuns, Doña Raimunda de Pont, whose life was almost coextensive with the nineteenth century. This noblewoman entered the convent of Barcelona before the expropriation of 1835, which confiscated the

★ The Tongues of Aragon and Castile had been fused by the decree of 1802 nationalising the Spanish priories.

Salinas de Añana, the only convent of nuns of St John which still occupies its original buildings.

house. In 1860 she was able to return with a lay sister, the only other survivor of the old convent. During the revolution of 1868–74 the thirteen nuns of the restored community were again dispossessed, and after a brief return they had to abandon the house for the last time in 1880 when the rebuilding of Barcelona entailed the destruction of the old palace of the Grand Priors of Catalonia. In the new convent in the suburb of San Gervasio the Prioress died in 1893, at the age of ninety-three.

The Civil War brought renewed disruption, and the convent was used for the torture chambers of the Republicans. The nuns recovered pos-

session after the war, but in 1973 they moved to a new house at Valldoreix, outside the city. Of the other convents, that of Tortosa, where the Prioress was shot by the Republicans, left its ruined house for Gandia in 1956, and that of Zamora is relodged in a modern building; the community of Salinas de Añana is the only one that still occupies the house that has been its home since the fourteenth century. These four are the survivors of the once-flourishing conventual life of the Order in the peninsula.

MAP KEY

The Tongue of Italy

Priory of Lombardy, -1186

(expropriated *c.*1800, restored and combined with Venice 1839)

- ✠○ Asti -1186
- ⊙ Pavia -1563, transferred to:
- ⊙ Cremona 1631, transferred to:
- ⊙ Turin 1762
- ☐ Genoa 1501
- △ Genoa 1230
- ● 36 commanderies

Priory of Venice, -1180

(expropriated 1806, restored and combined with Lombardy 1839)

- ✠○ Venice -1180
- ● 29 commanderies

Priory of Pisa, -1236 (expropriated *c.*1800)

- ✠○ Pisa -1236
- ✠○ Florence from seventeeth century
- △ Pisa *c.*1200
- △ Florence 1391
- ● 12 commanderies

Priory of Rome, 1214

(expropriated 1808, restored 1816)

- ✠○ Rome 1214
- ⊙ San Sebastiano del Palatino 1632 (*jus-patronat* of the Barberini family, still in existence)
- △ Penne 1291 (or before 1230?)
- ● 19 commanderies

Priory of Capua, -1223

- ✠○ Capua -1223
- ⊙ Sant' Eufemia -1289
- ⊙ Naples -1294

The Bailiwick of La Roccella was founded in 1614 as a *juspatronat* of the Carafa family, but became an ordinary commandery by the end of the seventeeth century.

- ● 17 commanderies

Priory of Barletta, -1170

- ✠○ Barletta -1170
- ⊙ Santa Trinità di Venosa 1297
- ⊙ Santo Stefano di Monopoli 1435 (moved to Fasano seventeenth century)
- ● 11 commanderies

Priory of Messina, -1136

- ✠○ Messina -1136
- ☐ Messina (existed in seventeenth century)
- ● 11 commanderies

The priories of Capua and Barletta were expropriated in 1806 (restored 1815–26) and that of Messina in 1826, and the three were restored as the single Grand Priory of Naples and Sicily in 1839.

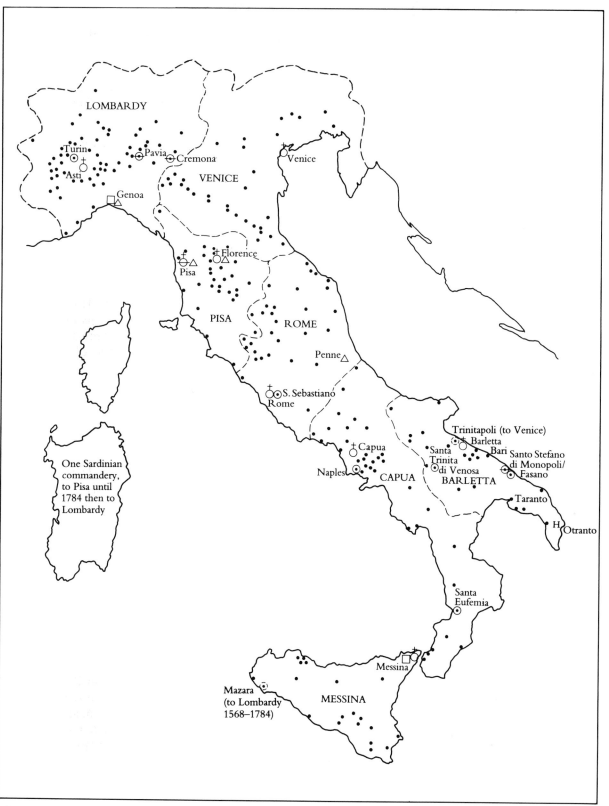

LOMBARDY

Turin
Asti
Pavia
Cremona
Genoa

VENICE
Venice

Florence
Pisa

PISA

ROME

Penne

S. Sebastiano
Rome

One Sardinian
commandery,
to Pisa until
1784 then to
Lombardy

Trinitapoli (to Venice)
Barletta
Bari
Santo Stefano
di Monopoli/
Fasano

Capua
Santa
Trinita
di Venosa
Naples
CAPUA
BARLETTA

Taranto

H Otranto

Santa
Eufemia

Mazara
(to Lombardy
1568–1784)

Messina

MESSINA

The Tongue of Italy.

CHAPTER XI

The Tongue of Italy

The First Foundations

THE EXISTENCE IN 1113 of six hospices of the Order in Italy and one at Saint-Gilles might suggest that the wealth of donations found in Provence from the beginning of the twelfth century was more than replicated on Italian soil. Such an inference however is overturned by the fact that there is virtually no record of any further Italian foundations before 1150. The conclusion to be drawn is that the hospices of 1113 were not originated by donors in their own localities but were trading depots maintained by Amalfitan merchants in the principal ports, adapted to the provisioning of the Hospital of Jerusalem and extended in use, like the cargo ships themselves, to the service of pilgrims. That is stated to have been the origin at least of the house of Messina.[1] It would also explain the omission of Amalfi from the list, since that was a city in which Brother Gerard's foundation required no factor.★

The exception among the early houses was Asti, which was not located in a sea-port, and this may be an early example of Provençal influence.[2] The same is suggested by the few donations known before 1150, those made in 1136 at Confiengo and Candiolo near Turin.[3] Further research would surely bring to light more donations in this period, but probably not in sufficient numbers to warrant a different conclusion.

The Norman lands of southern Italy were the main area from which the crusader states drew their vital supplies; all four of the southern ports where the Order of St John had its houses in 1113, Otranto, Taranto, Bari and Messina, were leading centres of that traffic and remained so until the fall of Acre. Moreover the rulers of this territory (which in 1130 became the Kingdom of the Two Sicilies) were the dynasties with the closest interest in Outremer; that link was established from the first through the creation of the Siculo-Norman Principality of Antioch, and it became closer when Frederick II acquired in 1225 the crown of Jerusalem, a claim that was assumed likewise by the Angevins. It is not surprising therefore to find the Hospital benefiting from the interest of the successive ruling houses. As early as 1100 the Duke of Apulia made a splendid gift of 1,000 *besants* to the Kingdom of Jerusalem, one third of it destined to the Hospital of St John. The House of Messina enjoyed the favour of Roger II, Grand Count of Sicily (1105–30) and first King of the Two Sicilies (1130–54). By 1136 it was a rich foundation with prioral jurisdiction over the whole kingdom and offering medical care as well as lodging in its houses. The first subordinate hospital in Sicily itself was probably that of Piazza, founded by Count Simone Aleramico in 1147.[4]

The house of Bari disappeared in 1156 when the town was destroyed in consequence of a rebellion. That of Barletta was presumably set up at this time, and it became the headquarters of the Priory of Apulia, which appears by 1169/

★ Amalfi began to decline after submitting to the Normans in 1073, and with the First Crusade Pisa, Genoa and Venice gained an increasing lead over it in trade with the Holy Land; it may be that the connexion of the Amalfitan merchants with the Hospital of St John became their principal link with Jerusalem after 1100, and that their apparent generosity in giving or lending their depots for the use of pilgrims was an attempt to cling to their sole remaining advantage in the eastern trade.

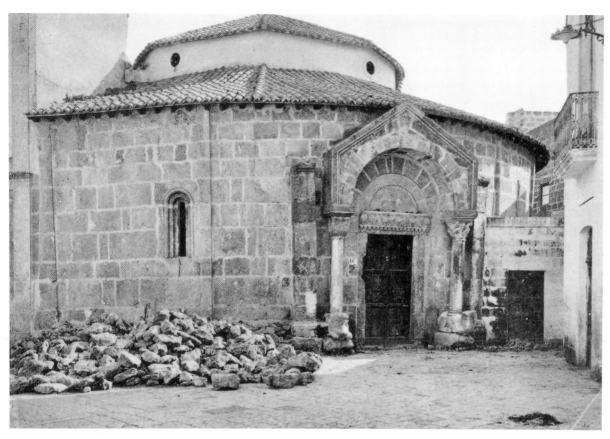

Church of San Iacopo in Brindisi, one of many round
churches built by the Order in the 12th century.

Hospices and Saints

70. Its jurisdiction probably covered most of the
continental part of the kingdom, the rule of
Messina being reduced to Sicily and Calabria.
The importance Barletta acquired as a centre of
trade with the Holy Land is reflected in a charter
of King William II in 1179 permitting the Hospital
there to possess warehouses and to ship goods to
the East. When the Emperor Henry VI conquered
the Two Sicilies he continued the same royal
favour, enfeoffing the Priory with the castle of
Guaragnone in 1197, and his son Frederick II in
1215 added grants of such importance as to
make the prioral house perhaps the richest in
Italy at the time. Nevertheless we know of no
Italians who rose high in the Order's government
in this period, and for news of other preceptories
we have to wait until the late twelfth century:
that of Troia and a church at Montepeloso are
mentioned in 1182; the preceptory of Naples
(though a donation here is known as early as
1119) does not appear until 1186.[5] At about the
same time the Count of Abruzzo laid the foun-
dations of the preceptory of Fermo.[6]

By that date Italy seems to have been divided
into five priories: those of Lombardy, Venice
and Pisa are mentioned respectively in 1176,
1180 and 1182, when the first had five principal
houses under its jurisdiction. The foundation of
pilgrims' hospices under the care of the Order
had begun in earnest in the middle years of the
century. The hospital of Cremona was estab-
lished in 1151; various others probably founded
about the same time are known from slightly
later mentions: Milan (1152), Verona (1157),
Lodi (1161) and Imola (1180, but thought to date
from the first half of the century). In 1160 the
Marquis of Montferrat had just built the hospice
at Felizzano; one at Gamondio was founded in
1172 and that of Pavia likewise belongs to the
second half of the twelfth century. These grew
into a network along the roads followed by the
palmieri on their way to the Holy Land. Crossing
the Alps from the west, they made their way
through Piedmont (or if they came from Germany
descended by way of Lake Como and Milan),

joined the Via Emilia and followed it down the east coast of Italy, taking ship, after a journey of about two months, in one of the Apulian ports. Although the sea route gained favour after the First Crusade, most pilgrims still preferred the old land journey, which involved a short crossing to Durazzo and then continuing through the Byzantine Empire.

As these itineraries indicate, the routes taken by the pilgrims relied heavily on the road-building initiative of ancient Rome, and the distribution of stopping-places bears the millennial imprint of the imperial system. On the Via Emilia especially one can trace the regular spacing of small towns that grew up round the old *mutationes* or staging posts, placed at intervals of seventeen to twenty Roman miles. Typically the hospices of the Order of St John were built at the east gate of the town and bore the name of St John *de Ultramare*, to signify that they served the travellers to Jerusalem, rather than the growing number who sought the tomb of St Peter. Others were in the country, at difficult points on the road such as bridges, and here the obligation of the hospice included keeping the route passable and in good repair. The Templars played an equal role with Hospitallers in this work, and the houses of both orders were outnumbered by the great multitudes of hospices that sprang up in Italy during the twelfth century. Ravenna came to boast twenty-nine hospitals, of which that of St John was among the most important. The memory of these refuges is preserved by the term 'Masone' or 'Magione' which survives frequently as a place name along the old routes.

Though a comparative late-comer, the hospital of Genoa soon acquired special importance. The city emerged in the twelfth century as a strong rival to Pisa in trade with the East and later advanced to challenge the splendour of Venice. At the beach of Capo d'Arena on the west side of the city, where the pilgrims embarked, the hospital and church of St John were built about 1180. The early growth of the house was enriched by the example of St Hugh, who is first mentioned as a brother in 1191 and died in 1233. He devoted his life to the service of the poor, and the note of charity runs through the miracles ascribed to him, such as when he saved a ship from being wrecked by a storm. For centuries the sailors of Genoa were to pray at his tomb for a safe journey, and a fifteenth-century commander

Bridge built by the Hospitallers at Dolcedo (Liguria) in 1293 and still in use, an example of the role of the Order in maintaining roads.

founded a confraternity to foster his cult.

The large, two-storeyed hospital of Genoa was a foundation of a wholly different scale from the little hospices that dotted the pilgrim routes. By the thirteenth century it housed a thriving community of a dozen brethren; noblemen of high rank took the habit here, and around 1230 the preceptor was one of the most considerable personages of the city, Guglielmo da Vultaggio, who in 1228 conducted Genoa's embassy to the Venetian Republic.

By 1230 a separate women's priory had been founded next to the Hospital, one of many instances of the nursing work being performed by the Italian sisters of the Order. It had had a predecessor in the convent of San Giovannino at Pisa, which originated about 1200. Like the Hospital of Genoa, this house benefited in its first years from the presence of an exceptional figure, St Ubaldesca of Calcinaia, whose life of service to the sick was ended by a painful malady in 1206. At Verona the Blessed Toscana Crescenzi,[7] a daughter of one of the noble families of the city, served as a sister in the Order's hospital; no feminine community developed here, but the commandery church was re-dedicated to her in the sixteenth century. The foundation of the priory of Penne has traditionally

XVII. Ranuccio Farnese, grandson of Pope Paul III as Prior of Venice, 1542, aged 11, by Titian.

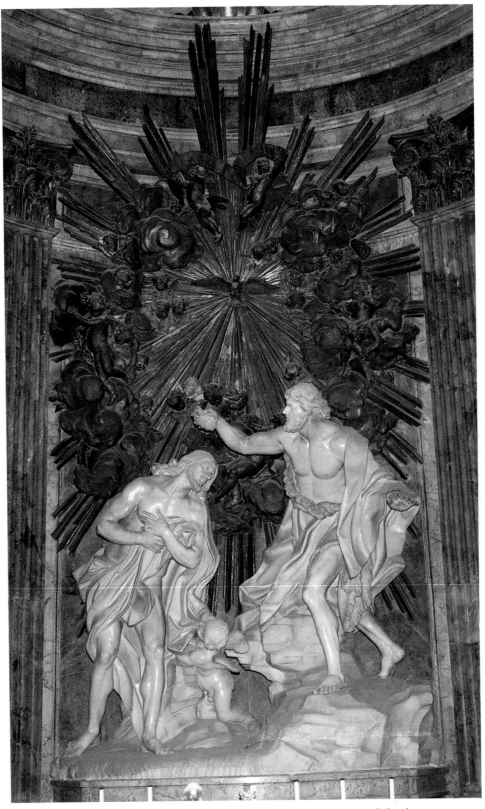

XVIII. The Baptism of Our Lord by St John, carved by Giuseppe Mazzuoli for the sanctuary of the conventual church Valletta.

been dated 1291, but evidence has been found of a community of Hospitaller sisters in the town before 1230.[8] In 1391 the anti-Master Riccardo Caracciolo established the fourth Italian convent in Florence.★

The Italian Tongue was particularly rich in saints, and among the male brethren, alongside St Hugh of Genoa, we may find St Gherardo of Villamagna, who after fighting in the Holy Land as a sergeant of the Order became one of the early followers of St Francis of Assisi. Of the life of St Gerlando d'Alemanna (died *c*.1315), preceptor of Piazza in Sicily, nothing whatever is known, but great devotion to him developed among the people of Caltagirone, who attributed miracles to him after his death. The same force of popular piety is responsible for the cult of the Blessed Pietro da Imola, Prior of Rome from 1320 to 1346, which developed at his tomb in Florence in the seventeenth century.

The Hospitallers are not known to have had a house in Rome before the early thirteenth century, when the Basilian monastery located in the Forum of Augustus was handed over to them; it became the seat of the Priory of Rome, first mentioned in 1214 and often subsequently combined with those of Venice or Pisa. The latter, whose hospital was one of the seven confirmed to the Order in 1113, first appears as a Priory in 1182. The Priory of Capua was the last to emerge, in 1223, but the prioral divisions were at this time very fluid; a Grand Commander held authority over the whole of Italy in the last two decades of the twelfth century and his office continues to be found until the end of the thirteenth.

By that date the Order managed well over fifty pilgrim hospices in the north of Italy. At Milan the great Archbishop Ottone Visconti, who founded the *Signoria* of his family, bequeathed the Hospitallers his entire property in 1295, and the house there became an exceptionally rich one (briefly supplanting Asti as the prioral seat in the late fifteenth century). In 1296 it received as a *confrater* Buonvicino della Riva, the most eminent Lombard poet of his time.

Southern Italy

The conquest of Naples after 1265 by Charles of Anjou, ejecting the Hohenstaufen dynasty, brought a host of Provençal noblemen to replace the Norman governing class. The invasion was strongly supported by the Prior of France, Philippe d'Egly, who committed the Order's revenues to the venture,[9] and the chief commanderies of the kingdom began to be distributed among his countrymen. We find a Pierre d'Avignon as Prior of Barletta in 1269 and three successive Frenchmen held Messina from 1267; the last of these, however, had to be transferred to Barletta after the Sicilian Vespers (1282), which gave the sovereignty of the island to Peter of Aragon, and that Priory was jealously reserved thenceforth for the Sicilian nobility.

One consequence of this revolt was to cut off Messina from its dependencies across the Strait. These were consolidated into the Bailiwick of Sant'Eufemia, which first appears in 1289,[10] and is the earliest instance of a European commandery being created a capitular bailiwick; it remained independent of the Priory of Capua and differed from a priory only in having no subordinate commanderies. The bulk of its possessions consisted of three huge estates along the northern shore of the Gulf of Sant'Eufemia. The town of the same name stood at the mouth of the River Bagni and was an active port in the Middle Ages (*nunc tantum sinus et statio male fida carinis*), its dues providing the Bailiffs with a rich source of revenue.

This *latifundio* became the model for several more in southern Italy, which gave its priories a very different character from those in the north. In contrast to reactions in the rest of Europe, the fall of Acre seems here to have produced a strengthening of support for the military orders: the region's close ties with the East evidently permitted a continuing awareness of such needs as the rescuing of refugees and the provisioning of Cyprus. In 1297 Pope Boniface VIII made over to the Hospital the Benedictine monastery of Santa Trinità di Venosa, whose vast possessions were scattered over the whole of southern Italy. Even when they had been dismembered to

★ Two other women's communities appeared in the fourteenth century at Perugia and Monteleone di Spoleto, but they enjoyed only a brief history.

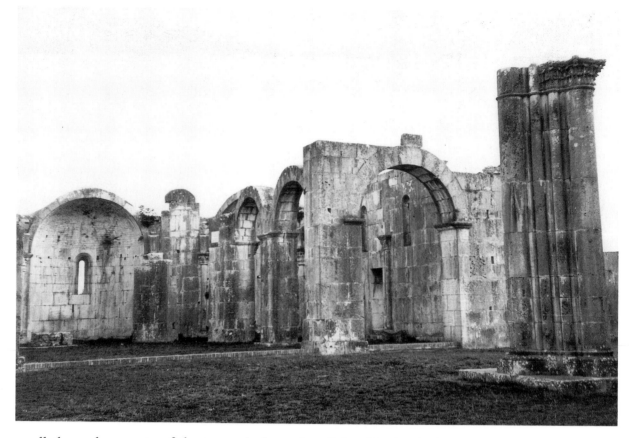

swell the endowments of the two priories and Sant'Eufemia, the nucleus remained one of the Order's richest properties. Also in 1297, King Charles II gave to the Templars the large fief of Alberona in Capitanata, which sixteen years later was passed on to enrich the Priory of Barletta.

Another opulent and decayed Benedictine abbey was Santo Stefano di Monopoli, where the monks had come to blows before Pope John XXII subjected it to the Knights of Rhodes in 1317.★ The usurpation of the Count of Lecce prevented them from taking possession until 1358, but when they did so Monopoli, with the annexed towns of Fasano and Putignano, became one of their greatest possessions. This prize was chosen for the convenience of its location for embarkation to the East, a connexion whose memory Monopoli maintains with its Ospedale Gerosolimitano and the diminutive church of St John beside it, on which a faded cross of Malta is still to be seen. At Sant'Eufemia, Venosa,

Ruins of the church of Santa Trinità di Venosa, a Benedictine abbey granted to the Hospitallers in 1297.

Alberona and Fasano the Bailiffs and Priors exercised full temporal and spiritual jurisdiction, appointing vicars *nullius* who ranked as prelates of their ecclesiastical provinces.

In 1332, in return for allowing the Pope and his nephews to keep various Templar properties in Provence, the Grand Master Villeneuve obtained for the Order the rich county of Alife, north of Capua. King Robert of Naples and Provence was reluctant to give up the Templar lands in Italy, and kept most of them in his hands until after 1324. There was no such difficulty in the papal states or in the north, where there was no royal power to intervene. In any case the transference was a very different matter in northern Italy, where Hospitallers and Templars alike had no important feudal holdings. Their property consisted largely of the little hospices that sheltered the pilgrims – a service whose continuation nobody could grudge. The number of

★ At the same time he confirmed the Order's possession of the fortified Benedictine Abbey of Alberese, in the Priory of Pisa.

Courtyard of the commandery of Faenza, one of the
Order's pilgrims' hospices on the Via Emilia.

the Hospitallers' houses was probably doubled
by this change.

It was not until the middle of the fourteenth
century that the sevenfold prioral structure of
the Italian Langue was consolidated. Appreciable
differences existed between the regions: In
Lombardy the Priory was controlled by a close
circle of great families such as Grimaldi and
Del Carretto;★ in Venice the acquisition of the
Templar Priory did nothing to sweeten the dis-
favour with which the Order of Rhodes was
viewed by the patriciate, and recruitment was
mainly from the nobles of the *terraferma*. Pisa

was an exceptionally poor priory, its properties
consisting mainly of roadside hospices which
brought more expense than revenue. As Florence
rose to commercial greatness in the fourteenth
century we find its merchants joining those of
Genoa as friends of the Hospitaller domain in
the Aegean; Bartolomeo di Lapo Benini, who
had represented in Rhodes the Florentine banking
house of the Bardi, later placed his financial
expertise at the service of the Order and in 1351
became Prior of Pisa and Rome.†

In the Roman priory the use of Hospitallers as
papal *cubicularii* became especially common at
this period, but the knights were recruited from
a very modest nobility, only the prioral dignity

★ Prince Amadeus V of Savoy favoured the Order of St John but was not the hero of the legend that has long flourished
within it, to the effect that he made an expedition to Greece, helped the knights to conquer Rhodes, and was rewarded with
the right to bear the Order's arms with the motto FERT (interpreted as *Fortitudo eius Rhodum tenuit*). Though it is true that
Amadeus V adopted the cross argent on a field of gules, these were the arms of the County of Asti, with which the Emperor
invested him in 1313. The expedition to Greece was made (without touching Rhodes) and the motto FERT adopted by his
great-grandson Amadeus VI. The motto is the Latin word and had a meaning connected with courtly love.

† Even in Italy, however, the reception of men of mercantile family into the Order was rare, a fact which accounts for the
relative scarcity and lack of prominence of Italians at Rhodes during this period when the rest of the Latin East was virtually
an Italian preserve.

itself coming to be reserved for scions of the papal families. In the Kingdom of Naples the characteristic feature was the control of the Provençal knights; although in 1373 Italian protest obliged them to give up the two Priories, they retained the right to the powerful commanderies which distinguished this region and which paid their responsions directly to Rhodes.

The record of responsions paid in the year 1374–75 gives us an idea of the relative weight of the Order's possessions.[11]

Table 3 Responsions paid, 1374–75 (florins)

Priories		Bailiwicks	
Venice	1,182	Naples	1,059
Lombardy	–	Alife	1,382
Pisa	1,210	Sant'Eufemia	1,659
Rome	1,210	Venosa	807
Messina	1,182	Monopoli	1,182
Capua	1,406		
Barletta	3,024		

In the middle years of the century the Priory of Capua was held by Isnard d'Albar, a trusted minister of Queen Joanna. Through his protection, the Bailiwick of Naples was conferred on his nephew, Montreal d'Albar, who is known in Italian history as Fra Moriale. When Joanna reputedly had her husband murdered, his brother King Louis the Great of Hungary invaded the kingdom and Moriale attached himself to his party; in reward he was given the Priory of Hungary (1348–50). This invasion brought upon Naples the scourge of the fourteenth century created by the Hundred Years War, the roving private armies which had already plundered their way through France and northern Italy. One of these, under Malatesta of Rimini, ousted Fra Moriale from his governorship of Capua and turned him too into a mercenary captain. In 1353 he entered Romagna to take his revenge, defeated Malatesta and extorted 40,000 gold florins in indemnity. Swollen with plunder and with the fame of having defeated the man hitherto the most feared of the *condottieri*, Fra Moriale was joined by thousands. His army became a moving

state, with judges, a Grand Council, four Constables of infantry, four Captains of cavalry and a General of Finance; he made and unmade alliances, demanded 150,000 florins from Venice to fight Milan and exacted huge ransoms from Florence, Pisa and Siena. But in 1354 he went to Rome unguarded to receive the return of a loan from his supposed ally Cola di Rienzo, who had proclaimed himself Tribune of the sacred Roman Republic. The fat little lawyer outwitted him, put him in irons and after torturing him put him to death within twenty-four hours.

The troubled reign of Queen Joanna was followed by a more anarchic war of succession between Louis of Anjou and Charles of Durazzo, who took opposite sides in the papal schism.★ The Order of St John, or at least its Provençal magnates, were clearly identified with the Angevins and the pontiffs of Avignon; Jean de Savine was a henchman of Louis in his invasion of Naples (1383) and acquired the Bailiwick of Sant'Eufemia. But Louis died the following year and Charles of Durazzo retaliated by confiscating the Order's county of Alife.[12] As anti-Master, the

The Hospital and commandery church of Genoa.

★ See also p. 121.

Prior of Capua Riccardo Caracciolo was trying to unite the Italian knights against Avignon, holding a Chapter in Naples in 1384, but the political situation in that kingdom limited his success. Dominique d'Alemagne seems to have retained control of Santo Stefano di Monopoli on the Adriatic coast; in 1392–95 we find him in Rhodes as Pilier of Italy, or rather of the fragment of the Italian Langue which remained faithful to the Convent.★

In the mean time Pope Urban VI was busy ranting away the support that was undoubtedly due to him; for fifteen months in 1385–86 Antonio Grimaldi found himself playing unwilling host to him in the commandery of Genoa, which had just been magnificently embellished with its double loggia. Urban brought with him in chains six of his cardinals who had conspired against him, and departed leaving them all dead except the Bishop of London, who was saved by the intercession of the King of England.

A further conflict developed in Sicily through the rebellion which began in 1390 against the Aragonese King Martin. Roberto Diana, who had received the Priory of Messina – evidently very young – in 1383, was one of the leaders of the rebellion, and he likewise declared for Pope Urban VI and the Italian anti-Master. In the course of his tumultuous career he twice lost his Priory to Catalan knights (1392–97 and 1408–16), but was later named Councillor to King Alfonso, aptly named the Magnanimous. He resigned his Priory at last in 1434, subsequently holding those of Venice and Rome and the Lieutenancy to the Grand Master Lastic, and died in 1439.

After the death of Caracciolo the Italian knights were governed successively by two Lieutenants, Bartolomeo Carafa (1395–1405) and Niccolo Orsini (1405–9), appointed by the popes; but after the Council of Pisa most of them submitted to Philibert de Naillac. Such resistance as remained disappeared after Joanna II succeeded Ladislaus on the throne of Naples in 1414. Her consort Jacques de Bourbon had friendly relations with both the Order of St John and the Angevin dynasty, and the Provençals continued to retain their hold of the Neapolitan commanderies for a further generation. Their star waned as René of Anjou and Alfonso the Magnanimous battled for the right to call themselves the Queen's heir. The Provençal commander of Monopoli was replaced in 1436 by an Italian; Alfonso then installed one of his supporters, Marino Malatesta, who was apparently not a Knight of Rhodes, but he was ousted for a while (1437–39) by Angevin partisans. In 1441 Alfonso seized Alberona from the Prior of Barletta, and his definitive victory the following year brought an end to the fortune of the Provençals, whose right to the Neapolitan dignities was formally abolished by the Chapter General of 1466.

In the north politics likewise impinged on the Hospital's affairs. The conquest of Genoa by the Duke of Milan enabled his ambassador to the Pope, Raccello dell'Oro, to acquire the commandery there (1425–36), and the Order obligingly received him as a knight; but the expulsion of the Milanese permitted the house to return to its tradition of native commanders. In Venice by contrast the Priors were nearly always strangers: patricians who took the habit of St John lost their political rights, and few cared to do so. The strained relations between the Republic and Rhodes produced an outbreak of hostilities between the two in 1460; nevertheless the importance that Rhodes gained in the East after the siege of 1480 caused Venice to look at the Order with more respectful eyes, and when in 1489 the Serenissima brashly annexed Cyprus from its Queen, Caterina Cornaro, the need for friendly relations was further strengthened.†

The importance of the Priory of St John in Venice probably reached its peak during the tenure of Sebastiano Michiel (1492–1535), an ambitious man very conscious of his precedence, who took a prominent part in the affairs of the city. He remodelled the prioral palace, embellished the church, and was probably the patron for whom Carpaccio executed his paintings in the Scuola di San Giorgio – the old hospital which had been turned into a refuge for Dalmatian

★ Although Dominique d'Alemagne belonged to the Langue of Provence, his family (a branch of the Castellanes) settled in Naples, and it is possible that he was Italian by birth.[13]

† The rise of Caterina Cornaro to that throne had enabled her family to acquire a hereditary right to the Grand Commandery of Cyprus; even after the loss of the island to the Turks the Cornaros continued to bear the titular dignity until their extinction in 1798.

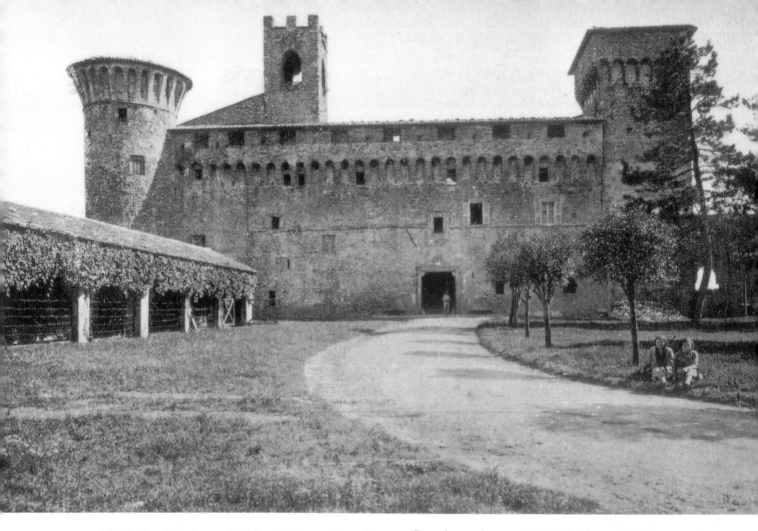

The Castle of Magione, rebuilt by the Priors of Rome in the 15th century and today an official residence of the Grand Master.

sailors. The position to which he raised the Priory may be judged from the fact that on his death the Signoria endeavoured to have another Venetian appointed, but Pope Paul III conferred the dignity on his young grandson (*sic*), Ranuccio Farnese.

The Renaissance

With the Renaissance we enter an age of notable figures. About 1440 Giovanni Orsini became Prior of Rome, and when the Grand Master Raimundo Zacosta died in Rome in 1467 Pope Paul II Barbo took the opportunity to arrange his succession to the office. His illegitimate son Cencio Orsini followed him as Prior, but the Priory was in fact administered till 1491 by the Pope's nephew, Cardinal Marco Barbo, a cultivated man who rebuilt as his private residence the original Hospitaller prioral house, now known as the Casa di Rodi. This fine palace with its airy frescoed loggia, crazily perched on the ruins of the Forum of Augustus, became again for a century the seat of the Priors of Rome.

A cluster of names associated with the intellectual life of the time adorns the lists of the Order. The titular Prior of Hungary Pietro Bembo (1470–1547) brought to Italian literature the canons of Cicero and Petrarch. Gabriele Tadini da Martinengo (1480–1543), Prior of Barletta, was one of the leading engineers of an age when that profession was headed by Michelangelo and Leonardo da Vinci. Antonio Pigafetta (1491–1534) sailed in Magellan's circumnavigation of the globe, keeping a diary to record the features and languages of the lands he saw and composing from it a unique account of the voyage. Annibale Caro (1507–66), a dedicated humanist and antiquarian, won renown for his translation of the *Aeneid*. Another Prior of

Hungary, Gabrio Serbelloni (1509–80), following in the footsteps of Tadini as a military engineer, contributed to the design of Valletta and built the fortifications of the Vatican.

A fine example of the Hospitaller tradition enriched by grace and learning is offered by Sabba da Castiglione (1484–1554), who after serving the Order in Rhodes retired to a modest but happy life in the commandery of Faenza. He formed an outstanding library to which he admitted the public, founded a school for poor children, softened the bare little church with beautiful frescoes, collected works of art such as the exquisite bust of the boy St John now

Head of the boy St John, attributed to Antonio Rossellino, bought by the Commander of Faenza, Sabba da Castiglione.

Tomb of the Knight Luigi Tornabuoni from the commandery church of San Giacomo in Campo Corbolino, Florence, early 16th century.

attributed to Antonio Rossellino, and devoted himself to writing the *Ricordi . . . di tutte le materie honorate che si ricercano a un vero gentil huomo*; this work, which recalls the *Courtier* of his kinsman Baldassare Castiglione, reinterpreted the medieval ideal of the knight in the light of Renaissance culture.

By the sixteenth century nearly all the pilgrims' hospitals of the Order had ceased to function, becoming mere commanderies, and the move of the Convent to Malta prompted a much stronger military interest in it. The Grand Masters Pietro del Ponte – who had distinguished himself as a naval commander – and the energetic Pietro del Monte were worthy representatives of this trend. Of the 448 knights who fought in the Great Siege, 151 came from the Italian Langue, which also provided well over 40 per cent of the Order's recruits in the remaining thirty-five years of the century.[14] Subsequently the proportion declined, but it remained substantially higher than it had been at Rhodes. The Langue thus underwent a very marked change from a Hospitaller to a military character, and the veterans of the galleys

reposed under the modest roofs which had sheltered the medieval palmers.

In 1562 Duke Cosimo I of Florence founded the Order of Santo Stefano in close imitation of that of Malta, with the principal aim of fighting at sea against the Turks. To some extent it was a response to the stiffening of nobiliary qualifications at Malta, and with its parvenu dynasty and the privilege ennobling any family that founded a commandery it was a paradigm of the way in which the Italian mercantile class bought its way into the nobility. In Tuscany the Grand Dukes frowned upon entry into the rival order, and comparative lists for the period 1600 to 1718 show 1,983 knights of St Stephen against 356 of St John; within the same state the imbalance was much smaller at Siena, which had always distinguished itself for the purity of its nobility, and we find 282 knights of Santo Stefano, 123 of Malta. The Florentine order's easier conditions of membership gave it considerable recruitment even outside the Grand Duchy, where during the same period it attracted 605 knights, against 1,592 who entered the Order of Malta.

Papal and Princely Predators

The unfortunate trend towards royal appropriation of the Order's dignities was initiated by the popes. Two nephews of Julius II, Sisto and Giovanni della Rovere, successively held the Priory of Rome (1509–17) and were followed by Pietro and Bernardo Salviati (1517–68), nephews of Clement VII de' Medici – himself a former professed knight and Prior of Capua. Bernardo Salviati served as Captain of the Galleys of Malta but subsequently took holy orders, went to France and became Grand Almoner to his cousin Queen Catherine de' Medici, through whose favour he received the cardinal's hat.

On his death Pope Pius V conferred the Priory on his Dominican nephew Michele Bonelli (known as Cardinal Alessandrino), exempting him from paying responsions. When La Valette tried to protest, the Pope refused to receive his ambassador, and the chagrin is said to have hastened the Grand Master's death. That such high-handedness should have been shown by a saintly Pope, and precisely at the moment

Arnolfo de' Bardi, the Order's ambassador to Rome in the 1630s.

when the importance of the Order's work to Christendom had been most signally demonstrated, shows us how deeply engrained the habit of papal nepotism had become. In fact Cardinal Alessandrino proved an excellent and popular administrator, restoring the old Templar church and palace on the Aventine which had been from 1312 to 1467, and now became again, the residence of the Priors of Rome.

The list of Bonelli's successors for the next two centuries shows us a cameo of the clerical laxity of their age: typically the Grand Prior of Rome was the scion of a papal family, appointed to that dignity at an early age, later promoted to the purple, and waiting several years more before taking even minor orders. Thus the sacerdotal impression conveyed by a succession of cardinals is a misleading one.

The last holder of the office to have made a genuine knightly career was Aldobrandino Aldobrandini, who succeeded his brother in 1612; after serving as General of the Galleys of both

Malta and Rome, he left the city in well-justified disgust on the election of Urban VIII Barberini (1623) and took service in the imperial army. Pope Urban made his pontificate glorious by his patronage of artists such as Bernini, and scandalous by his patronage of his own family. Within a short time of his elevation he had conferred the purple on a brother and two nephews; of the latter, the second and more worthless, Cardinal Antonio the Younger, was a boy of sixteen when in 1624 his doting uncle bestowed on him four of the richest commanderies of the Priory of Rome, to which he added two more the following year. When the Italian knights raised a tumultuous protest at seeing their hopes of preferment dashed, they were assured that the Pope was watching over their interests with a most holy mind.[15]

Aldobrandini's departure from this scene of corruption only served to play into Urban's hands, for when he fell gloriously at Nördlingen in 1634 the Pope lost no time in giving the

Church of the Grand Priory of Rome on the Aventine, by Piranesi.

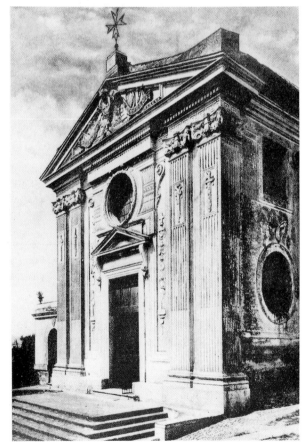

Priory to Cardinal Antonio. Not content with this, he founded for his family the Bailiwick of San Sebastiano, which he assured for his posterity with indecent foresight, granting remainder, if legitimate heirs failed, to 'illegitimate children however born, even of incest or of unions of priests or religious . . . or issuing from any coition soever that may arise from human frailty and the permission of God'.[16] On the death of his uncle the apt creature of this shameless patronage suffered a measure of the retribution due to him, for he was obliged to flee to France and was stripped of all his emoluments; nevertheless it was not until 1658 that Cardinal Antonio was formally obliged to give up the Grand Priory to the nine-year-old Sigismondo Chigi, whose matured wisdom was likewise soon afterwards recruited to the Sacred College.

Of the later Grand Priors of Rome one of the most distinguished was Benedetto Pamphili (1653–1730, appointed in 1678), a poet and 'Prince' of the *Accademia degli Umoristi*. His cultivated example was followed by Giovanni Rezzonico (appointed as a young man by his uncle Clement XIII in 1763; died in 1783), who left behind the memory of a worldly but gifted and well-loved prelate; he engaged Piranesi to rebuild the church of the Aventine and enclose its gardens, a work of superb crisp elegance and inventive symbolism, and the only architectural design of that artist ever to have been executed.

The example of the popes was imitated in Tuscany, where an illegitimate Medici was granted the Priory of Pisa in 1595; he was followed by Cardinal Gian Carlo de' Medici (died 1663), who refused to pay any responsions to Malta but condescended in 1654 to donate a galley built at his expense. Fortunately the supply of both bastard and legitimate Medicis subsequently gave out and the Priory reverted to professed knights. An exactly parallel case of patronage was seen in the Duchy of Modena, where Prince Ippolito d'Este was succeeded in 1648 by Cardinal Rinaldo d'Este in the commandery of Reggio, a benefice which seldom escaped appropriation by ducal courtiers.

These usurpations combined with the decline of the Turkish menace to curtail the zeal for the cross of Malta that had been so notable in the late sixteenth century. The figures of Italian receptions, divided by quarter-centuries, show a sharp fall from 886 in 1576–1600 to 333 in

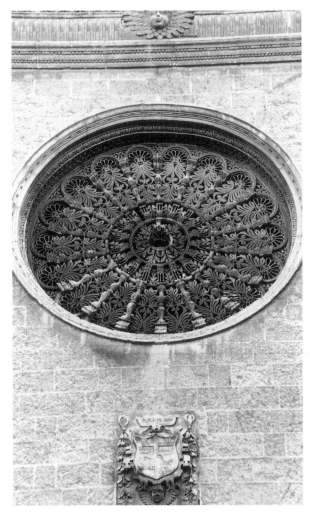

Church of the Bailiffs of Santo Stefano, in Fasano, early 17th century.

martyrdom in China. Arrigo Rondinelli (1659–1708), equerry to the Duchess of Modena and preceptor to her children as well as commander of Modena, whose church he enriched, lived outwardly the splendid life of a courtier but slept on the floor in a cell carved out of his sumptuous bedroom and rose early to make the prayers and mortifications of a Franciscan tertiary. Marcantonio Zondadari (1657–1722) was an accomplished man who, though his reign as Grand Master was too brief to make any mark on the Order, left a handbook in which he intelligently reinterpreted the vocation of a Knight of Malta in the light of the conditions of his age. Gioacchino Portocarrero (1681–1760), after serving as General of the Galleys of Malta and Viceroy of Sicily, took holy orders and received the cardinalate; his magnificent library passed to the Bailli de Tencin, who donated it as the public library of the Order.

The growing number of knights in the Order caused a reorganisation of the Italian Langue in the later eighteenth century: twenty-two new commanderies in the Kingdom of Naples were carved out of the richer endowments between 1768 and 1791, and a similar increase seems to have taken place in the other Priories.[18] Dissatisfaction with the prioral structure was exploited by the King of Sardinia in 1781 to demand another change: he insisted that the Piedmontese commanderies be reserved to his own subjects. The other Italian princes naturally stipulated the same rule for their own territories. After complicated diplomatic transactions a *Piano Conciliativo* was arrived at in 1784 whereby – with the exception of the Neapolitans, who had Capua, Barletta and Messina in common – Italian knights would be entitled to commanderies only in the Priory to which each was native. The diplomacy of the Order contrived to exempt the prioral dignities, bailiwicks and magistral commanderies from this manifestation of selfish nationalism.

1651–75. A recovery later took place, especially in the papal states (though here recruitment from the lesser nobility was still very much the rule), but admissions from northern Italy continued to dwindle. By 1789 more than half the Italian knights came from the Kingdom of Naples, compared with a proportion of one third in the period 1600–1718. The Langue at that date numbered 652 knights, probably a little less than 30 per cent of the whole Order. In relation to the censuses of 1631–5 absolute numbers were higher but the ratio to other Langues had slightly declined.[17]

The spiritual tradition of the Order of St John, in no way fostered by the silken prelates imposed on the Priory of Rome, was being upheld by other figures. Ludovico Buglione di Mineo, after fighting gallantly as a Knight of Malta, became a Jesuit missionary and suffered

Revolutionary and Royal Spoliation

Confiscation of the Italian commanderies began in 1797 in the puppet republics set up by the French in northern Italy. It was not at first universal; in Parma the definitive confiscation did not take place until 1811, and the commander

of Piacenza in that duchy died in his commandery in 1814. The hospital of Genoa was closed in 1798 (its capacity had already dwindled to only four beds) and its dependent confraternity of St Hugh became extinct eight years later. The Grand Priory of Venice, having been transferred to Austrian sovereignty, survived until 1806, when its territory underwent a second conquest by the French, while the simultaneous installation of Murat as King of Naples swallowed up Capua and Barletta. The year 1808 saw the suppression of the Priory of Rome when France annexed the Papal States.

Messina succumbed to the curse of royal appropriation, from which the Neapolitan priories had hitherto been free: in 1801 Paul of Russia repaid the King's recognition of his title as Grand Master by allowing him to confer the Priory on his son, Prince Leopold. The residence of the Convent in Sicily gave the monarchy special opportunities for control which the prime minister Sir John Acton was not slow to exploit, and the commanderies of the island were sequestrated in 1811.★

With the fall of the Napoleonic client states a partial recovery began. Ferdinand I returned to Naples in 1815 and, reversing his ungenerous policy in Palermo, permitted a restoration of the Order's endowments at least to such of their incumbents as were still living. His son, however, confiscated everything in 1826. The Grand Priory of Rome was revived in 1816. With the installation of the Lieutenancy in that city and the subsequent material recovery the history of the Italian Langue becomes virtually subsumed into that of the Order, in which it henceforth played the dominant role.†

When Austria reinstated the Grand Priory of Venice in 1839, the old prioral palace was also returned, and it is now, with the Casa di Rodi and the Aventine villa in Rome, the only one of the historic prioral residences in Italy still in the Order's possession. In the Two Sicilies the new Grand Priory of that name was founded in Naples in the same year, but the old bailiff's palace and church of San Giovanni a Mare were not restored; the prioral residence is a former convent which was granted by the King in 1856. The commanderies founded in the nineteenth century were nearly all family *juspatronats*, and their value today is little more than nominal, none of them exceeding about £3,000 in annual income.

In Rome the popes continued to confer the Grand Priory on cardinals, who were now more clerical than in the past but just as aristocratic. Perhaps the most distinguished was Luigi Lambruschini (1839–54), who had already rendered long service to the Order before his appointment.‡ Flavio Chigi (1876–85) comes the closest to having had a knightly career, since he had served as a young man in the *Guardia Nobile*. In 1961 the office was restored,

High altar of the present prioral church in Naples.

★ See pp. 245–6.

† See p. 251.

‡ See pp. 250–1.

like the other Grand Priories of the Order, to professed knights.

Since 1877 the three Grand Priories have been backed by the Italian Association, initially founded to conduct the Order's army medical services. With 3,000 knights in its membership it is now by far the largest of the forty national associations, and its medical services are principally civilian. These remain closely linked to the life of the Order itself: in Rome, Naples and Venice, for example, the dispensaries and diagnostic centres occupy part of the magistral and prioral palaces respectively. The Knights of Malta in Italy have devoted their efforts especially to diabetic care: they have fifteen such centres all over the country, as well as a hospital, blood clinics and children's homes, which maintain its charitable presence in twenty-one towns.

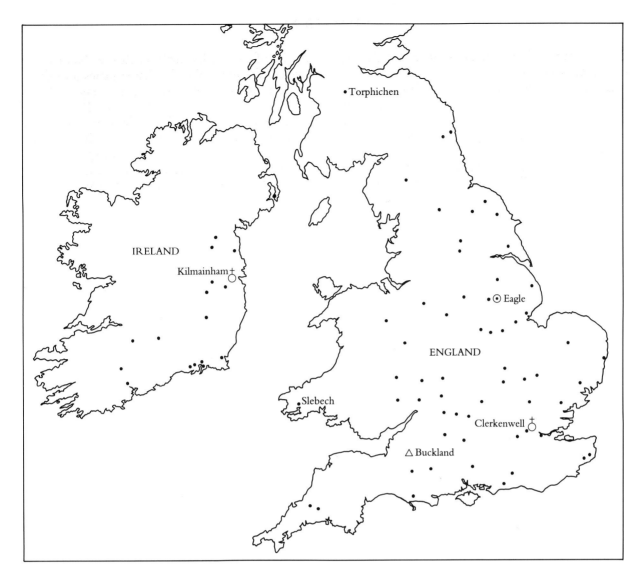

The Tongue of England.

MAP KEY

The Tongue of England

Priory of England, 1144 (independent from *c.*1185)

- ✝⃝ Clerkenwell (London) 1144
- ☉ Eagle 1433
- △ Buckland 1180
- ● 59 commanderies *c.*1350, reduced to 19 by sixteenth century

Priory of Ireland or Kilmainham, –1202

- ✝⃝ Kilmainham –1202
- ● 18 commanderies *c.*1350, much reduced by sixteenth century

CHAPTER XII

The Tongue of England

The Priory of England (1)

THAT KING HENRY I (1100–35) favoured the Order of St John we know from his foundation of the preceptory of Villedieu in Normandy, *regiâ munificentiâ exornatum*; but he does not seem to have made any grants in England. The fashion for endowing the Hospital evidently only reached northern France and England in the last years of his reign, by which time the Templars had established themselves in the contemporary mind as the chief defenders of the Holy Places, and the royal preference they enjoyed under both King Stephen (1135–53) and King David I of Scotland (1124–53) gave them at least as great an advantage in wealth and recruitment as are evident over most of France.

The first news we have of a Knight Hospitaller in England is that of Gerard Jebarre, who in 1135 was sent on a secret mission to the country to bring back Raymond of Poitiers as a consort for the heiress of Antioch. Perhaps in reflexion of this diplomatic glitter, the Order of St John began about this time (there is very little in the way of precise dating) to receive gifts from the highest nobility of Norman England: Gilbert, first Earl of Hertford, Robert, first Earl of Derby (died 1139), Robert d'Oiley, Castellan of Oxford (died 1142), Adeliza, the mother of the first Earl of Pembroke. The preceptory of Godsfield in Hampshire was founded by the brother of King Stephen, Henry of Blois, who as Bishop of Winchester (1129–71) was the pole star of the English ecclesiastical firmament. Especially rich patronage was to be lavished by the family of Clare, Earls of Striguil (in Essex) and Pembroke; the Hospitallers began to acquire extensive pos-

sessions at Slebech in Pembrokeshire in the 1140s if not before, and the preceptory may have been a centre of the Flemish colonisation promoted by the Clares.

The prioral lands of Clerkenwell, just outside the walls of London, began to be given in the 1140s by the Bricett family in a process that culminated in the grant of the whole manor in 1211. A chaplain named Walter held office here from 1144 to 1162 and was apparently, like his immediate priestly successors, Prior of all England, a responsibility which at that time remained of little consequence. England was at least partially under the authority of Saint-Gilles until 1184/5.[1] A more active role may have been that of Brother Roger Simple, who was engaged in receiving donations throughout the country between 1150 and 1178.[2] By 1154 the Hospital in England already possessed nine houses,[3] whose heads were designated *conservus* or *custos* rather than Preceptor.

In Scotland the Order owed its first possessions to David I, who granted it the house of Torphichen. Contrary to the traditional dating of 1124, this donation is now ascribed to the last decade of his reign, but we have no knowledge of any Hospitaller brethren in the country; certainly they did not enjoy the prominence of the Templars at that time. Malcolm IV (1153–63) granted the Order a house in every burgh in the kingdom, and these remained dependencies of Torphichen, for no other preceptory ever developed in Scotland.

By 1180 there were six Hospitaller houses in England in which women had received the habit, and Henry II made the grant of Buckland in Somerset to enable all of them to be gathered in a single community. This was one of the

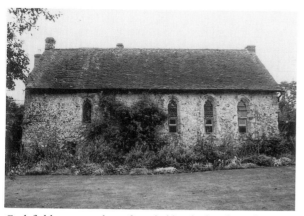

Godsfield commandery, founded by the brother of King Stephen in the 12th century.

Jerusalem visited England in 1185 and presided at the consecration of the church at Clerkenwell, one of a number of round prioral churches that the Order was building at this time. From 1189/90 Garnier de Naplous[†] was Grand Commander of France and Prior of England, an office from which he was raised to the Mastership; the independence of the English Priory probably dates from these years.

The Hospitallers' recruitment doubtless benefited from the Master's visit, and although Henry II was unable to satisfy his visitors' plea for military aid they received much more substantial favour from Richard the Lionheart (1189–99), who worked closely with Garnier de Naplous in the Third Crusade. Robert l'Anglais was Grand Commander from 1195 to 1201, the first English knight to rise so high in the Order. He typifies both the crusading prestige that Richard won for his nation and the ordinary career of a great officer of the Order, for he then retired to serve for ten years as Prior of England (1204–14).

When King John came to the throne (1199) the Hospitallers had twenty-eight preceptories in England. The royal exactions of that year required of them a payment of £500, exactly half the sum demanded from the Templars. In spite of this disparity the Priory was increasingly well endowed, and we learn from a magistral letter of 1268 that it was by then one of the Order's richest sources of revenue.[5] One of the more notable priors of the thirteenth century was the German Dietrich von Nussa (1235–47). Matthew Paris describes the success of this 'most elegant knight' in raising an expeditionary force with the Templars, which he led through the city from Clerkenwell, to the enthusiastic admiration of the crowd, to embark for the Holy Land.

Native English knights also achieved respectable careers. Roger de Vere, a scion of a great family from which the Hospitallers received extensive donations, served as Drapier (1262–65) before being Prior of England (1265–72). Joseph de Chauncy held the office of Treasurer for a quarter of a century at a most critical time (1248–73), and must be credited with an important part in the financial reforms with which

earliest convents of the Order in Europe, and if we are to believe the census of 1338, which speaks rather loosely of fifty nuns there, it became one of the largest.[*] It was also among the best endowed, its revenue of £223 in 1505 making it the fourteenth-richest women's house in England.[4]

It was in the 1180s that England advanced to a less peripheral role in the Order's affairs. The Master Roger des Moulins and the Patriarch of

Seal of Walter, the first Prior of England, *c.* 1143.

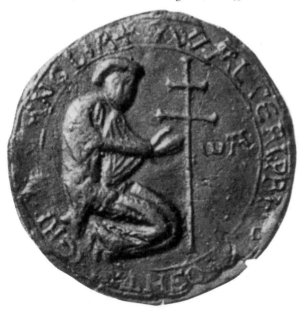

[*] At the Dissolution it had only fourteen nuns, but such a decline would not be untypical. The staff of two brother chaplains and one secular priest in 1338 is consistent with a fairly large community.

[†] He is thought to have belonged to the family of the Lords of Naplous in the Kingdom of Jerusalem.

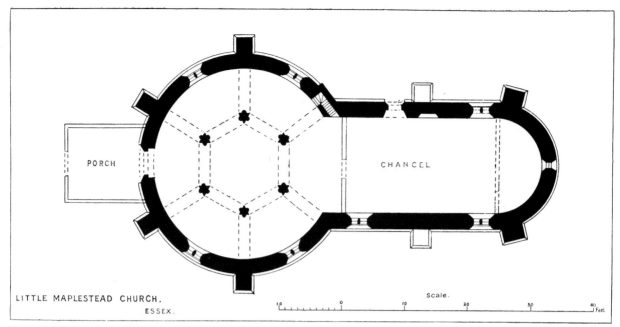

LITTLE MAPLESTEAD CHURCH,
ESSEX.

PORCH

CHANCEL

Scale.

Plan of Little Maplestead church.

Round Hospitaller church of Little Maplestead, 12th century.

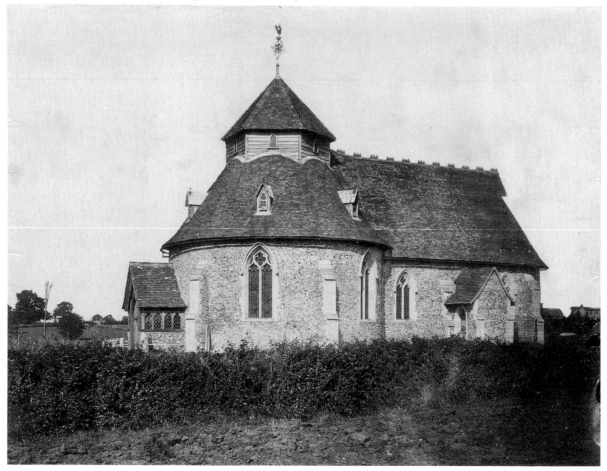

178

Chapel of the commandery of Swingfield.

the Master Hugues de Revel met the disasters of the crusader kingdom. His ability recommended him to Edward I as royal Treasurer during his tenure as Prior of England (1273–81). The Prior William de Hanley is likewise found as a royal minister in the 1280s and his successor William de Tottenham was the first holder of his office to be summoned to the House of Lords, sitting in the parliaments of Edward I and Edward II. The 'Prior of St John' was later to be accorded precedence between viscounts and barons.

When the Order of the Temple was suppressed in 1312 it owned forty-five preceptories in England, including its splendid headquarters outside Ludgate overlooking the Thames. Its patrimony would have more than doubled the wealth of the Hospitaller Priory, but in no country perhaps was the transference blocked by a heavier weight of royal and noble obstruction. The Temple itself was immediately seized by the favourites of Edward II, the Earl of Pembroke and Hugh le Despenser. The Prior to whom it fell to solve these problems was Sir Thomas l'Archer (1318–28); this hapless veteran, 'weighed down by age and corpulence', had entered office no doubt looking forward to a dignified retirement, and found himself out of his depth in the legal and financial morass of the

Templar legacy.★ Although an Act of Parliament in 1324 ordered the Templar properties to be handed over, he was unable to make its terms effective. In these circumstances the Master Hélion de Villeneuve sent to England the Umbrian knight Leonardo de Tibertis de Monteleone, who had been active since 1312 on the Order's general commission for the recovery of the Templar lands. De Tibertis found a situation of such disorder that he was obliged to mortgage his own jewels, and, raising a loan of £2,337, he set about attacking the problems before him. Not for nothing was he a native of the most sophisticated commercial society of his age, and his worldly-wise methods are evidenced in the lavish retainers which the inquest of 1338 reveals the Hospital as paying to prominent judges to smooth the passage of its claims. So successful was De Tibertis that in 1329 the English brethren entreated the Master to confirm him as Prior, relegating l'Archer to thankless obscurity.

In 1331 De Tibertis, having resigned his charge to Sir Philip de Thame, was visiting Scotland in the hope of repeating his successes. The preceptory of Torphichen belonged to the English Priory, but the Hospitallers had enjoyed only scanty recruitment in Scotland, and that mainly

★ He was equal, however, to the spiritual duty it created, ordering a list to be compiled of the Masters of the Temple in England so that the Hospitallers might remember them in their prayers.

St John's Gate: gatehouse of the prioral palace in
Clerkenwell, built in the early 16th century.

confined to priests and sergeants. The subjection
of this branch to England was made more com-
plete when Edward I claimed the Scottish crown,
and in 1291 the English knight Sir Alexander de
Welles did homage to him for the preceptory of
Torphichen. That was a dangerous association
when Scotland began to rise against English
rule, and in 1314 we find Sir Ralph Lindsay in
possession, the first of a line of native preceptors
that continued for most of the century. In theory
the Hospitallers had received the Templar pro-
perty immediately in 1312, but in practice the
devastation caused by the English war had
deprived them even of their own, and the in-
quest of 1338 declares that Clerkenwell was still
unable to extract any revenue from Scotland.
By the later fourteenth century however
some measure of English control had been
re-established.

The Priory of Ireland

It was a seminal circumstance for the fortunes
of the Hospital in Ireland that the Norman
conquest of that country took place under the
leadership of Richard de Clare, second Earl of
Pembroke, known as Strongbow, the head of a
family which distinguished itself beyond all
others in the extent of its donations to the Order.
After seizing Dublin, Strongbow made to
the Hospitallers about 1174 a rich donation at
Kilmainham on the outskirts of the city, where
the prioral seat was fixed. An earlier dona-
tion had appeared two years previously at
Wexford, the first foothold of the Normans
in the country; the town had originally been
granted to Richard FitzStephen and the Fleming
Maurice de Prendergast, who appears in 1202 as
first Prior of Kilmainham. If the fief of the
Clares in Pembrokeshire served as a model for
their Irish colonisation, it is easy to under-
stand the prominence of the Hospitallers, whose
preceptory of Slebech had already acquired sub-

stantial wealth and doubtless corresponding prestige in the life of the Norman-Welsh colony. By 1212 the Priory of Ireland or Kilmainham possessed at least twelve further preceptories, distributed among all the Irish provinces except Connaught. Compared with the mere six houses accumulated by the Templars, this wealth of endowment reverses the position of England and Scotland and reflects the exceptional favour the Hospital received from the Norman aristocracy, whose grants were the chief source of foundations.

The Order of St John was unmistakably an arm of the Anglo-Norman ascendancy. In the reign of Henry III the royal tax-collectors were ordered to hand over their proceeds to the Prior of Kilmainham, whose experience in passing on such sums to London evidently recommended him for the task. A glimpse of the economic role of the military orders is given by the fact that at this period they were the main distributors of flour throughout the whole of Ireland. Preceptories generally took the form of fortified manor houses and stood as strongholds of Englishness in the surrounding Gaelic world.★ In 1274 the

★ But not necessarily cut off from it: when Richard II visited Ireland his interpreter was 'a certain Hospitaller learned in the Irish tongue'.

Prior William FitzRoger was captured and many of his companions killed in battle against native rebels; he escaped and was given command of the castle of Rindown and of the army which the King intended for the conquest of Connaught. A later Prior, Sir William Boss, served in 1299 as Lord Deputy of Ireland, the first of four Priors of Kilmainham to head the island's government, while a further seven appear as Lord Chancellor.

A consequence of this colonial usefulness was that the Hospital encountered less difficulty than in England in laying its hands on the Templar legacy; here the strengthening of Hospitaller influence was a development which the monarchy welcomed. Difficulties came more from the resurgence of Gaelic power, and in particular the ravaging of Ireland by the Scots between 1315 and 1318. As the English colony contracted, the preceptory of Ards was virtually lost in the early fourteenth century, because it lay in the lands of the McGuinesses and O'Neills in which the King's writ no longer ran.

At the same time the Priory of Kilmainham began to pass from English to Irish hands. From 1311 to 1340 the office was held by the Irish

Kilmainham Hospital, Dublin, showing the original chapel of the prioral palace (right).

S.R.LAIRD

knight Sir Roger Outlawe, who was also Lord Justice of the kingdom. The Priory came under the increasing control of the great Irish families. Sir Thomas Butler, who held it from 1404 to 1418, was an illegitimate son of the Earl of Ormonde; he served as Lord Deputy (1409–13) and in 1418 led a strong Irish force to France, where he distinguished himself at the siege of Rouen and died on active service. In the middle years of the century the prioral dignity was being fought over by two knights of the houses of Fitzgerald and Talbot, who alternately ousted each other and found themselves deposed for maladministration.

They were succeeded by Sir James Keating, not himself a magnate but a henchman of the Earl of Kildare, who was then Lord Deputy; when he was removed, Keating as commander of Dublin Castle prevented his replacement from taking up his office, and the King was obliged to reinstate Kildare. Keating dealt in similar fashion with the English knight sent later to replace him as Prior, descending upon him with a force of armed men and destroying his commission of appointment. Excommunication did not prevent this pugnacious son of Erin from clinging on to office until 1494, when Henry VII began a ruthless imposition of royal power in consequence of Lambert Simnel's rebellion. Keating was replaced with Sir Thomas Docwra and the King ordered the Priory to be confined to Englishmen, chosen from among 'sad, wise and discreet' knights, an association of qualities which it was thought would effectively exclude any candidate from the sister island.

Sir John Rawson, the son of a London mercantile family with landed connexions, held the Priory of Ireland from 1511. Commanderies had been so accumulated by that time that there were only four commanders in the whole Priory, two of them chaplains who are thought to have been resident at Kilmainham. That concentration of income enabled Rawson to maintain an establishment second only to the Lord Deputy's, and he served as Privy Councillor and Treasurer of Ireland. His loyalty was important in preserving royal control in the rebellion of the Earl of Kildare in 1534. The Priory of Kilmainham thus ended as it began, as an instrument of English royal rule in Ireland, but more sadly as a servant of despotism, for there was no such opposition as among the English knights to Henry VIII's imposition of a state religion. Rawson surrendered Kilmainham in 1540, receiving the Viscountcy of Clontarf and a lavish pension of £333 a year. One of the turbulent Irish incumbents of the fifteenth century would surely have given the Priory a more honourable end.

The Priory of England (2)

The general inquest ordered in 1338 by Hélion de Villeneuve offers us a picture of the Priory of England at its height. The recovery of the Templar property was still spinning out its laborious processes, and the annual income of the lands already secured was estimated at just over £1,000 – little more than a quarter of that provided by the old Hospitaller estates.★ Nevertheless the returns of 1338 show us the Priory before the depredations of the Black Death and after a decade of good administration by Leonardo de Tibertis and Sir Philip de Thame.

In that year there were 116 professed Hospitallers in England and Wales, of whom 34 were knights, 34 chaplains and 48 sergeants. Besides these the houses of the Priory maintained three donats, about 48 corrodaries, 55 clerks and squires and some 400 servants and dependants of every kind, while 70 secular priests served the Order's churches.[6] The prioral house of Clerkenwell had revenues of £400 a year, and its lordly precincts sheltered a household which numbered the Prior himself, a preceptor, five other professed brethren including three chaplains, together with 11 corrodaries, 13 secular priests, 5 clerks in minor orders and 22 other officials and servants.[7]

The Priory had 37 preceptories, of which 14 were held by knights, 7 by chaplains and 16 by sergeants. By far the richest preceptory was Slebech, whose estates were scattered all along the Welsh coast from the south-east to the north-west, and it may be regarded as the preceptory

★ The Temple itself was not recovered until 1340; it was immediately leased to the lawyers of London and began its long history as the Inns of Court.

Commandery church at
Madron.

of Wales as Torphichen was that of Scotland.★ Its income of £307 bore comparison with the Prior's and far exceeded the £192 of its nearest rival, Carbrook in Norfolk, while the average of all the preceptories was under £100. Even so, Slebech seems to have been less valuable than the Templar house of Eagle in Lincolnshire, which had not yet been assimilated into the list of preceptories, but which in 1433 was erected into the capitular Bailiwick of the Langue. The acquisition of the Templar lands for a time brought the number of preceptories to 59, but as in other countries this superfluity was stringently docked and by the early sixteenth century the number had been reduced to a mere 19.

Carbrook, the greatest of the English preceptories in 1338, was governed by a knight, supported by a chaplain and a sergeant. It was the custom here to give a meal to thirteen poor people every day and to any stranger who asked for it. The dependent house of Chippenham served as the infirmary for the Priory's members; its establishment in 1338 consisted of ten brethren with a chaplain at their head, and the staff assigned to the service of the sick included a knight, two chaplains and three sergeants, besides three male nurses, a steward and three servants. Hospitals for the laity were maintained at Carbrook, Skirbeck and Torphichen.

A large element mentioned among the residents of the preceptories were the corrodaries;

these were a feature common to the Order's houses in most of Europe but nowhere, it would seem, taken to such a degree of development as in England and Ireland. The corrodaries were lay people who in return for a benefaction were granted the right of residence in a particular house. They shared in the spiritual benefits of the Order, received burial in its consecrated ground and were assured the prayers of the brethren. This institution, which was a marked feature of the Hospitaller houses as early as the twelfth century, was one of the means by which the Order of St John extended its support among the laity, enabling men and women to live the life of a religious house without the need for celibacy or vows. While the poorer houses sheltered people from humble walks of life, the richer ones and the prioral palaces were evidently in favour with men of substance. One of the corrodaries at Clerkenwell in 1338 was William de Langford, who had the right to dine at the preceptor's table, while his chamberlain ate at the second and three servants at a third, and there was provender too for the horses he kept in the stables. At Kilmainham we hear of one corrodary who after lending the Priory £400 was promoted from the sub-Prior's to the Prior's table, where the company and the fare were alike more exquisite. With their combination of comfort, *bon ton* and spiritual benefit the houses of the Hospitallers offered a range of advantages

★ The border preceptories of Garway, Dinmore and Halston also had some properties in Wales.

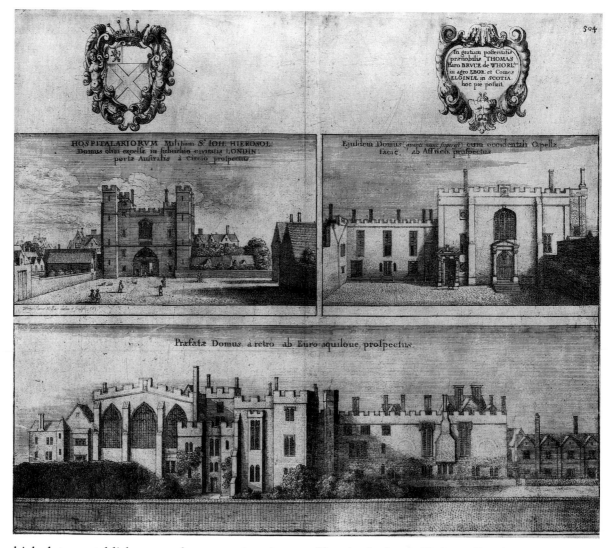

The prioral palace in Clerkenwell, 17th-century engraving by Wenceslas Hollar (only the gate-house remains today).

which later establishments for genteel retirement have scarcely equalled.

Two Priors of England, Robert Hales and John Redington, served Richard II as Admirals of the Western Fleet; but the former received a thornier appointment as Treasurer of the kingdom. He took office in 1380 when the government was attempting to enforce a swingeing poll tax, and his predecessor had resigned to escape the odious duty. It was Hales who, with the Lord Chancellor Archbishop Sudbury, became the chief object of the mob's hatred when the Peasants' Revolt broke out a year later. The personal enmity of one Thomas Farringdon, who led a section of the rebels into London, directed the anger of the peasants to the destruction of Clerkenwell and other Hospitaller houses. Then, marching on the Tower, where Hales and

Sudbury had taken refuge, the peasants dragged them from the chapel and beheaded them both on Tower Hill.

Clerkenwell was rebuilt, and the new palace was splendid enough by 1400 to lodge the Emperor Manuel II of Byzantium. The papal schism of these years, in which England took the opposite side to the leadership of the Order,★ served to demonstrate the essential unity of the Hospitallers, for the English knights continued to send their responsions to Rhodes. When Sir Peter Holt was appointed Prior of Ireland after serving as Turcopolier, his personal rival Sir

★ See pp. 45–7.

Thomas Butler contested his claim, calling him a schismatic for having served in Rhodes, but Henry IV upheld Holt's appointment and ordered the Hospitallers to acknowledge no superior but the Master of Rhodes.

The schism nevertheless complicated relations between Clerkenwell and Torphichen, since the Scots belonged to the opposite camp. The Prior's authority over Torphichen had been drastically enforced in 1376, when Edward III sequestrated the English preceptories to persuade the Master that Scottish appointments were not to be made without reference to Clerkenwell. During the first decade of the schism (1378–88) the problem was simplified by the fact that there were apparently no Hospitallers in Scotland at all, but later the Scots regained Torphichen and a measure of independence; the attempt of Sir Alexander de Leighton to perpetuate this after the restoration of papal unity was rebuffed, however, and in 1422 the Scottish brethren were again declared subject to London.

Torphichen had acquired the rich property of the Templars in Scotland and found itself in possession of six baronies,* an estate that was described to Queen Mary as 'equal to any earl

within your Realm'.[8] Sir William Knollis, who held the preceptory from 1466 to 1510, played a correspondingly large role in public life, serving as royal Treasurer, ambassador and Privy Councillor, and was the first Preceptor of Torphichen to be summoned as a Lord of Parliament. Perhaps as a counterweight to the rule of Clerkenwell the Scottish knights cultivated a strong attachment to the Crown which was to develop into secularism and the betrayal of religious vows.

The Priors of England were even more consistently prominent as royal servants. This was the case of Sir Robert Malory (1432–39/40), though more interesting is his relation with his kinsman, the Arthurian author; it has been pointed out[9] that Thomas Malory's retelling of the chivalric legend shows influences from the ethos of the military orders which may be due to his connexion with the Prior.[10] Sir John Langstrother's Lancastrian loyalties caused King Edward IV to reject him as Prior of England until Warwick the Kingmaker forced him to give way and even to appoint him Treasurer; Langstrother held that office during Henry VI's brief restoration (1469–71) and commanded the

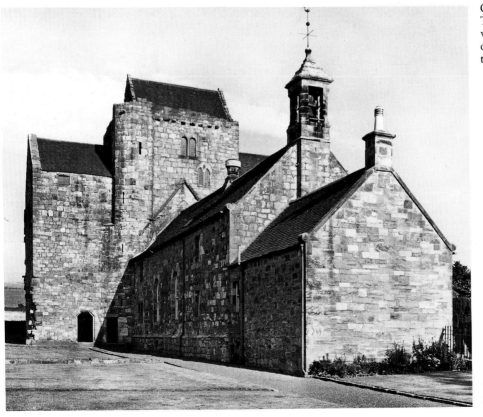

Commandery church of Torpichen, Scotland, which included a hospital on the upper floor of the transept.

* A technical term of Scottish land tenure.

centre of the Lancastrian army at Tewkesbury. After the defeat he took refuge in Tewkesbury Abbey but was seized on Edward IV's orders and executed.

Martyrs and Catholic Exiles

Henry VIII was named Protector of the Order in 1511 (a title first conferred on his father), but even before the breach with Rome he revealed clearly enough the quality of his protection. When the Order lost Rhodes he tried to divert the English knights to the task of garrisoning Calais on the plea that they had nothing else to do, and in 1527 he exacted a 'benevolence' of £4,000 from Sir William Weston as the price for allowing him to take possession of the Priory of England. The visit of Villiers de l'Isle Adam in the following year converted him momentarily to a less covetous disposition and he made a gift of nineteen bronze cannon to replace those which the Order had lost at Rhodes.

The King's assertions of supremacy over the Church were reflected in the conduct of Sir Clement West, who on arriving in Malta as Turcopolier in 1531 placed the lion of England over the Order's arms and had an officer march before him bearing a mace with the royal arms. A hidden but diplomatic hand caused his symbol of provocation to disappear, to the fury of Sir Clement. After insulting representatives of his Langue at the Chapter General he was imprisoned and deposed, but had to be reinstated on the orders of Henry VIII, who maintained that the true reason was his use of the royal symbols. Further insults and provocation to duel brought his second dismissal in 1539.[11]

After his dissolution of the monasteries, Henry VIII turned his rapacity on the Order of St John, and confiscated the property of both the English and Irish priories in 1540. Sir William Weston died at the very moment of suppression; the conduct of his followers forms an honourable contrast to the meekness with which the rest of the Church submitted to Henry VIII's claims. Thomas Fuller remarked of them: 'The Knights Hospitaller, being gentlemen and soldiers of ancient families and high spirits, would not be brought to present to Henry VIII such puling

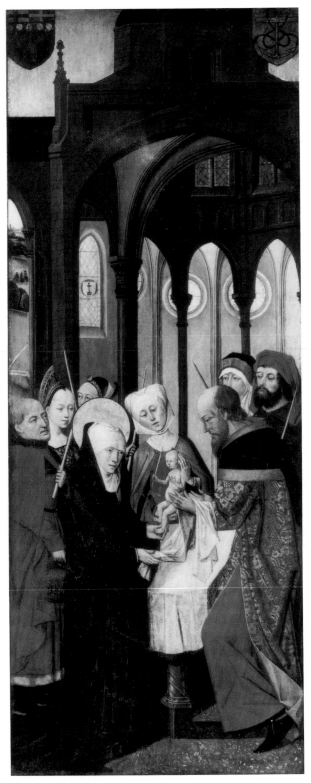

Diptych made for the Prior of England, Sir William Weston, 1527–40.

petitions and public recognition of their errors as other Orders had done.' Sir Thomas Dingley (a nephew of Sir William Weston) and the Knight of Devotion Sir Adrian Fortescue were executed in July 1539, and Sir David Gonson won the same crown two years later.

A dwindling band of Catholic exiles kept their Langue alive in Malta. The Turcopolier Sir Nicholas Upton led the cavalry charge that repelled Dragut's invasion of Malta in 1551; it was a very hot day and Upton, who was a large and corpulent man, suffered a stroke in his armour and fell dead from his horse. Unfortunately the disreputable Oswald Massingberd was titular Prior of Ireland when the accession of Queen Mary enabled him to take possession of Kilmainham in 1554; he ignominiously surrendered it to Elizabeth five years later. The Priory of England, restored in 1557 with the Bailiwick of Eagle and nine commanderies, was conferred on Sir Thomas Tresham, who had proclaimed Queen Mary at Northampton in 1553 and escorted her on her march to London. His death came like Weston's at the very moment of the suppression of the Priory, in March 1559.

Since 1540 the Langue of England had retained one commandery, that of Torphichen. It was conferred in 1547 on Sir James Sandilands, who on arriving in Scotland began to associate with John Knox and the Lords of Congregation. By 1560 he was deemed to have become definitely a heretic, and the commandery was nominally transferred to his cousin. Its real fate was that Sandilands surrendered it in 1564 to the Crown and received it back with the title of Lord Torphichen. Though he married he had no children, and it is the descendant of his brother who now holds the house as 15th Lord Torphichen, his family and estate constituting the most direct historical link with the Order in the British Isles.

After suppressing the English and Irish priories a second time, Queen Elizabeth gave the palace of Clerkenwell to her Master of the Revels, and it was therefore here that Shakespeare's plays were licensed and some of them acted. Elizabeth's imposition of royal supremacy was less bloody than her father's but was not without its victims among the knights created in the short-lived

restoration. Sir Edward Waldegrave died in prison in 1563, Sir Thomas Mytton in 1583, and Sir Marmaduke Bowes was hanged, drawn and quartered in 1583 for sheltering Catholic priests. One of the leaders of the English Catholics under Elizabeth was Sir Thomas Tresham's son, of the same name, who built the triangular lodge at Rushton in honour of the Trinity. In Scotland Sir James Irving, who had left the country to avoid subscribing the Confession of Faith, returned in 1573 and was immediately imprisoned and tortured, and it was about the same time that Sir David Seton, the last titular commander, left Scotland and retired with the remaining brethren to Germany.

Sir Richard Shelley (c.1513–89), who had been active in the restoration of the Order and had been created Turcopolier, left England on Elizabeth's accession. He received a pension from Philip II of Spain, but the growing enmity between the two countries caused him to change his position. He exemplifies the class of English Catholics, whose existence the government refused to admit, who wished to remain loyal to both their country and their faith. From about 1569 he lived in Venice and acted as an informer on plots against Elizabeth, but her government's suspicion prevented him from realising his desire to return to England. His family remained Catholic until the eighteenth century and shortly after its apostasy produced in the poet Shelley its most famous member.

In the siege of 1565 the English Langue was represented in Malta only by Sir Oliver Starkey, Lieutenant Turcopolier and Latin Secretary to the Grand Master La Valette.★ Other Catholic exiles entered the Order from time to time; Sir Andrew Wyse was received in 1582, lived on a Spanish pension and had himself appointed Prior of England in 1593, a dignity he enjoyed until his death in 1631. Edward Crisp was received on the recommendation of Cardinal Allen in 1589. Sir Nicholas Fortescue became a knight in 1639 but was killed five years later in the Civil War, which dispelled his dream of restoring the English Priory. The same plan was aired again under James II, only to be similarly smothered by the Revolution. The King's illegitimate son by Arabella Churchill, Henry FitzJames, was

★ The Turcopoliership was resigned by Shelley in 1561 and was left vacant until it was fused with the office of Grand Master in 1582.

made titular Prior of England in 1689 and fought under that name in Ireland, seeking to restore his father to the throne. He resigned the office on his marriage in 1701, and it was later conferred at the request of the Old Chevalier on Jacobites and other scions of the illegitimate branch. Such were the Irishman Nicholas Gerardin (appointed in 1726), Peter FitzJames (1733), son of the second Duke of Berwick, and his brother Anthony (1734), who held the title until his marriage in 1755.

The Anglo-Bavarian Langue

The utility of the English Langue even as an occasional source of dignities for Jacobite exiles was already extinct when it was refurbished as a convenient portmanteau for two new foundations of the later eighteenth century. The first of these was the Priory of Poland, which the Order had long been endeavouring to create from a seventeenth-century bequest of Prince Janus of Ostrog; that nobleman had intended to endow the Order with his great estate in Volhynia,★ but a succession of heirs pressed their family claims, and by the 1750s the property was in the hands of eleven aristocratic families. At this point the intricacies of Polish politics gave reason to hope that the matter might be settled, and the Grand Master Pinto held out the bait of instituting a separate Polish priory. A new factor was introduced when Poniatowski, the former lover of Catherine the Great, became King of Poland, and Russian power became an influence in Polish affairs. Pinto welcomed Catherine's overtures to the Order and in 1769 sent his ablest diplomat to St Petersburg, the Marchese Sagramoso, who was an old friend of the Empress. In 1772 the First Partition of Poland brought Prussia too into looming imminence on the disintegrating kingdom, and Sagramoso dangled the threat of interesting the *Herrenmeister* Prince Ferdinand in the Order's claims.[†] Resistance rapidly crumbled; Prince Adam Poninski was the first to turn his inherit-

Elector Charles Theodore of Bavaria (1724–99), the restorer of the English Langue in 1782.

ance into a commandery and was created Grand Prior. The other occupants of the Ostrog estate followed suit, founding commanderies of which they themselves became the commanders with dispensation from celibacy, and retaining for their families the right of nomination for the future. The agreement was ratified in 1776.

The favour shown to the Order by the Northern Courts was eclipsed by that of the Elector Palatine Charles Theodore, who inherited Bavaria in 1778. He had no legitimate children and no affection for his heir, the Duke of Deux-Ponts, one of the most odious petty tyrants to stamp on the divided face of eighteenth-century Germany. On inheriting Bavaria he tried unsuccessfully to exchange the country for the Austrian Netherlands, where he hoped to found

★ At the time of writing, this region of south-eastern Poland forms part of the Republic of the Ukraine.

† This was shortly after the Grand Bailiwick of Brandenburg had been nominally restored to unity with the Order of Malta: see p. 204.

a hereditary kingdom for his eldest bastard. Not surprisingly this attempt caused the Deux-Ponts line, who subsequently governed Bavaria, to cover him with obloquy, but Charles Theodore's reputation in the Palatinate, which he had governed since 1742, was a high one; his gallant character caused him to be known in youth as 'the First Cavalier of the Holy Roman Empire.' When he came into his Bavarian inheritance he found the government in possession of the extensive property of the Jesuit Order, which had been suppressed in 1773, and he decided on a characteristically chivalric and traditionalist use for it. For reasons which no historian has explained, the whole of Bavaria had only two commanderies of the Order of Malta, in the imperial city of Ratisbon and in the Prince-Bishopric of Eichstätt; the Electorate itself had none at all. Charles Theodore remedied this lack at one stroke by turning the Jesuit properties into a Grand Priory with twenty-four commanderies, a Bailiwick at Neuburg, and a prioral palace in the magnificent college of Ebersberg near Munich.

Rumour, presumably of Bavarian origin, credited Charles Theodore with a thousand illegitimate children, which would no doubt explain why in later years he suffered from dizzy spells that prevented him from hunting or riding; but the mathematical truth is that he had five. The eldest son, Charles Prince of Bretzenheim (1768–1823), was appointed Grand Prior of Ebersberg through the indulgence of Rohan. The German Langue, however, refused to admit either the Polish or the Bavarian Priory, and hence it was that in 1782 the Langue of England was revived as the Anglo-Bavarian to incorporate both foundations. With that recherché courtesy which distinguished it, the Order took the trouble to seek approval for this measure from George III, whose interest in the matter could hardly have been slighter.

Charles Theodore was succeeded in 1799 by the Duke of Deux-Ponts, who came to the throne filled with vindictive hatred of every aspect of his kinsman's policy. He immediately tried to suppress the Bavarian priory, but was prevented by the Emperor Paul of Russia, who was then governing the Order as *de facto* Grand Master.★ Two years previously Paul had transformed the Polish priory, raising its number of commanderies to twenty and its responsions to 32,200 florins (£800). The partition of Poland had brought its estates within the Russian Empire and it was now renamed the Priory of Russia. In 1799 Paul added a second Priory for the Orthodox nobility of his empire and endowed it with numerous commanderies funded from the postal revenues, while several families founded *juspatronats*. When the treaty of Amiens excluded British subjects from membership of the Order it was thought fit to rename the Anglo-Bavarian Langue the Bavaro-Russian.

This highly anomalous body had a brief and unquiet existence. On the dissolution of the Holy Roman Empire in 1806 the Elector of Bavaria, now King Maximilian I, united the German and Bavarian priories as an appanage for his infant second son, dispossessing both the Grand Priors. Perhaps the little boy misbehaved, for two years later this plaything was abolished. The former Turcopolier, Baron Flachslanden, lived on a Bavarian pension until 1822. The two Russian priories enjoyed a momentary importance as almost the only remaining possessions from which the unfortunate Lieutenancy in Sicily drew any revenues, but in 1810 Alexander I confiscated their commanderies too; in 1817 an imperial decree confirmed this graceless abolition by declaring that the Order of St John no longer existed in Russia.

★ For the wider context of these events see pp. 243–5.

MAP KEY

The Tongue of Germany

Priory of Germany or Heitersheim, -1187

- ♁ Heitersheim 1428 (Prince-Priory from 1548)
- □ Cologne thirteenth century
- □ Steinfurt thirteenth century (to *c.*1615)
- □ Wesel fourteenth century (extinct, sixteenth century)
- □ Küsnacht 1358 (suppressed 1528)
- □ Strasbourg 1371
- □ Heimbach fifteenth century
- ● 27 k, 4 cs commanderies

Priory of Bohemia, -1182

- ♁ Prague 1192 (transferred to Strakonitz 1420, restored 1684)
- ♁ Strakonitz 1420–1684
- □ Mailberg 1244 (extinct 1544, continues as a commandery)
- □ Breslau *c.*1273? (extinct 1548)
- □ Prague fourteenth century
- △ Manetin 1183 (extinct by fifteenth century)
- ● 20 k, 4 cs commanderies

Priory of Dacia, 1266 (suppressed 1530–80)

- ♁ Antvorskov 1266
- ● 9 commanderies

Priory of Hungary, 1217 (virtually suppressed *c.*1538)

- ♁ Vrana *c.*1345 (lost 1538)
- ⊙ Carlstadt 1689
- ● 5 commanderies before 1526

Grand Bailiwick of Brandenburg, 1382 (Protestant after 1538)

- ⊙ Sonnenburg 1428
- ● 13 commanderies before the Reformation, 8 by the late seventeenth century

The Anglo-Bavarian Tongue

Priory of Poland 1776 (expropriated 1810)

9 *juspatronat* commanderies 1776, 20 further commanderies added in 1797

Priory of Bavaria or Ebersberg 1780 (expropriated 1808)

- ♁ Ebersberg 1780
- ⊙ Neuburg 1780
- ● 24 k, 4 cs commanderies

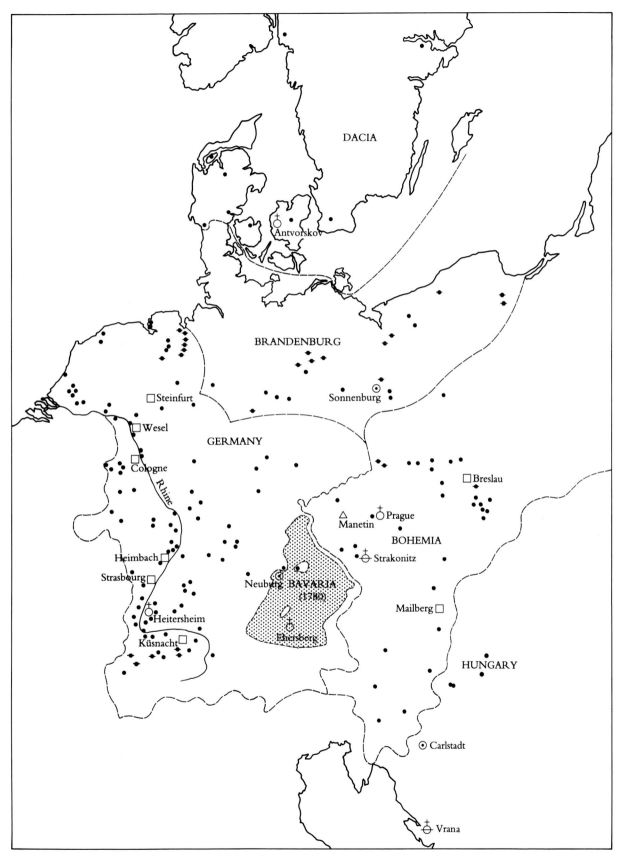

DACIA

⚥ ⦶ Antvorskov

BRANDENBURG

□ Steinfurt

⊙ Sonnenburg

□ Wesel

GERMANY

□ Cologne

Rhine

□ Breslau

△ Manetin ⚥ ⦶ Prague

BOHEMIA

⚥ ⦶ Strakonitz

□ Heimbach

Strasbourg □

Neuburg BAVARIA
(1789)

Mailberg □

⚥ ⦶ Heitersheim

Küsnacht □

⚥ ⦶ Ebersborg

HUNGARY

⊙ Carlstadt

⚥ ⦶ Vrana

The Tongue of Germany.

CHAPTER XIII

The Tongue of Germany

The Hospitallers as Colonisers

WHEN WE SEE how slow the Order of St John was to establish itself in northern France and even in Italy, where its network of hospitals did not begin to be created till about 1150, it is not to be wondered at that in Central Europe no evidence exists of its presence during the first half of the twelfth century. Not until the Second Crusade (1147–48), in which the Emperor Conrad III and his successor Frederick Barbarossa took part, did Germany participate significantly in the crusading movement; when that door was opened, however, the development of the Hospital in the Empire was rapid. The special interest here was evidently the land route to the Holy Land through the Byzantine Empire; by 1163 the Order possessed a Priory in Constantinople which had been governed for some years by Peter the German, a figure of some importance who served as ambassador of the Emperor Manuel to the King of France.

Foundations in Central Europe itself also followed soon after the Second Crusade. At Duisburg on the lower Rhine the Order built its hospital and church before 1153/4; Albert the Bear, Margrave of Brandenburg, had by 1160 founded the preceptory of Werben, having witnessed the work of the Hospitallers on his pilgrimage to Jerusalem; the house of Mailberg in northern Austria existed by 1156; and the royal foundation of Prague is first known in a document of 1158/69.★ By the end of the century there were at least nine further preceptories on German soil, including the present territories of

Holland and Switzerland. A Prior of Germany had been appointed to govern them by 1187, the corresponding office being known in Bohemia five years earlier.

A particular interest attaches to the eastern foundations, which appear as typical agents of the German colonisation of Slavonic lands. At Gröbnig in Upper Silesia the first donation was received in 1169, and the name itself marks the place as the dwelling of the 'gravemen', the guardians of the Holy Sepulchre. This preceptory played a leading part in the colonisation of the Troppauer Land, clearing the forest edge, founding eleven out of the 83 villages planted between 1200 and 1380, and building their churches. Gross-Tinz was another centre, from which developed the subordinate preceptories of Lossen, Striegau and Beilau; of these, Lossen itself founded three villages and Striegau established the new town of that name after the Mongol devastation of 1241. The preceptor built the town walls and shared with the townsmen the building of the church.

On the Baltic coast the Hospitallers played a similar role in the work of Germanisation, which was soon to be taken up much more strongly by the Teutonic Order. Several preceptories in Mecklenburg and Pomerania performed this work; in Pomerelia Prince Grimislav in 1198 laid the foundation of the preceptory of Liebschau, which itself later founded the town of Schöneck; but when the duchy passed to the sovereignty of the Teutonic knights they bought the Hospitaller preceptories here.

These settlements commonly received both German colonists and German law. Preceptors

★ Doubtless it marks the gratitude of King Ladislaus, to whom Raymond du Puy had offered Crac des Chevaliers as a residence when he took part in the Second Crusade.

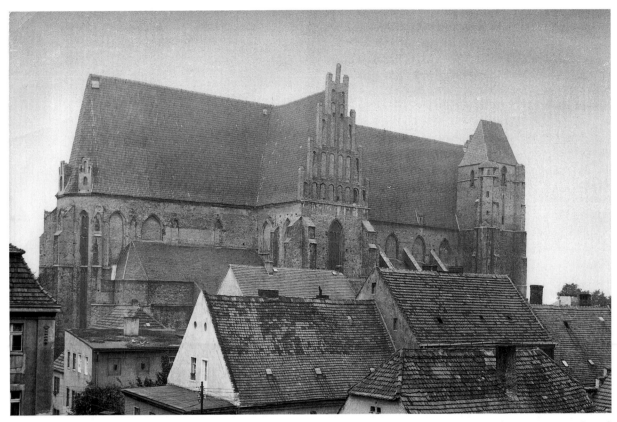

Church of Striegau, built jointly by the town and the Hospitaller commandery.

were often knights, perhaps because of the need for armed protection, or we may see these dignitaries simply as the institutional equivalent of the many German noblemen who went east in search of new lordships. The prosperity and stable society that such colonists introduced soon came to be welcomed by the native princes, and the reception of Duke Mesco of Oppeln as a *confrater* in 1240 is a sign of the acceptance of an Order that came essentially in the guise of a German institution.

The task of bringing security to a savage land left its mark on the foundations of the Hospital. Travellers' hospices were common here, the most important being that of Prague, built on the west bank of the Moldau next to the bridge giving access to the city. The military style of the church's towers suggests that it was built with an eye to protection. The Priory had here an extensive enclosure, recalled by the church's name *Unsere Liebe Frau unter der Kette* (Our Lady within-the-chain), and this grew into a ward under the Prior's temporal jurisdiction, numbering fifty-eight dwellings in the seven-

teenth century. Prague provides an example of the characteristic double-storey houses of the Order which served as both church and hospital. Of this arrangement, very frequent in Central Europe and sometimes found elsewhere, the best surviving specimen is the commandery of Nieder-Weisel in the Rhineland, which offered its travellers protection in the upper floor above the church.

German Particularism

By 1249 the German priory had been divided into two, Upper and Lower Germany, and a Grand Commander governed all the lands that were to be included in the German Langue; yet the prioral structure was perhaps less important than the division of the country among a few head preceptories which founded subordinate ones, appointed their preceptors and received their responsions. Thus Gröbnig had authority over Upper Silesia and northern Moravia; Gross-Tinz over lower Silesia; Prague over Bohemia;

Commandery of Nieder-Weisel, an example of a two-storey church with a hospital above; now the property of the Johanniterorden.

Mailberg over Austria and southern Moravia; Bubikon (founded in 1192 by a crusader who had been healed by the Hospitallers) over Switzerland; Werben over Brandenburg and north-eastern Germany; Steinfurt over Westphalia, Friesland and part of the Netherlands; Utrecht (a rather later foundation, of about 1250) over Holland; Burg over the lower Rhine. The heads of such houses were generally knights and were distinguished by the title of *Meister*, which at Mailberg was retained until 1519.

A special case among these regional groupings is Scandinavia. The Hospitallers arrived here

Commandery of Nieder-Weisel, an example of a two-storey church with a hospital above; now the property of the Johanniterorden.

in the second half of the twelfth century as preachers of the crusade, and in 1219 they helped the Danes defeat the pagan Estonians; as a consequence the Danish kingdom adopted the Order's flag as its own. The Templars held little or no property in Scandinavia. The Priory of Dacia was created in 1266;★ the prioral residence was fixed at Antvorskov, and there seems to have been a deliberate policy of establishing a preceptory in each of the eight Danish dioceses. Norway and Sweden had one preceptory each at Vaerne and Eskilstuna; the former, founded in the late twelfth century, had a special connexion with the royal bodyguard, the *hird*, whose members had the right to retire there as corrodaries. There were very few knights among the Scandinavian brethren, and the Priors until the fifteenth century were always German or Dutch.

The first Polish donation to the Order was made by Duke Henry of Sandomierz in Zagosc

Bubikon, the chief Hospitaller commandery in Switzerland.

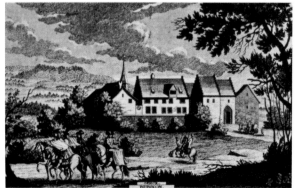

★ The name Dacia (which properly belongs to Romania) is an example of pretentious and erroneous medieval Latinity, originating apparently in a confusion between *Danica* or *Danici* and *Dacia* or *Dacii*.

194

in 1153, and the preceptory of Posen was founded in 1170; until 1610 it was the only Polish preceptory. Poland was included in the title of other priors (usually the Bohemian) from 1252, but there was no separate Polish priory until 1775. In Hungary royal favour towards the Order began to be shown as early as the reign of Geza II (1141–61) and here too the policy of encouraging German colonisation may have been an influence. By the end of the century there were five Hungarian preceptories. Larger benefactions followed the participation of Andrew II in the Fifth Crusade in 1217. He stayed at Crac des Chevaliers, was received as a *confrater* and invested the Hospital with the entire county of Somogyi, one of the finest territories in the kingdom. The creation of a separate Hungarian Priory dates from the same year, though its first head (like most of his successors) was a foreigner, Pons de la Croix.

The building up of a centralised Priory of Bohemia out of the autonomous groupings of Silesia, Bohemia, Austria, Carinthia, Styria and Carniola began in the period 1253–78 when those lands were united under the crown of Ottocar II. The chief promoter of the process was Hermann von Hohenlohe, councillor to successive Bohemian and Austrian rulers, a nobleman who accumulated such power that the Order was eventually constrained to discover that his illegitimate birth disqualified him from the Priory he had held for fourteen years (1282–96).

In Germany the regional preceptories also began to lose their position, but more to the advantage of their subordinates, whose independence increased. A distinctive example is to be found in Friesland, where the Hospitallers arrived at the time of the Fifth Crusade (1217–21) and developed a special type of mixed houses of lay brethren and sisters who lived by tilling the land. The number of Frisian preceptories reached twenty in the fourteenth century, a remarkable proportion of the 45 religious communities of all orders found in Friesland at the time; in 1319 these houses demanded and obtained their emancipation from the head establishment at Herrenstrunden, with the right to elect their own preceptors from among native brethren.

After 1320 similar fissile tendencies developed in Brandenburg, during the confused period that followed the extinction of the Ascanian dynasty. There was difficulty in securing any sort of government at all; finances deteriorated, some preceptories were sold, and there were irregular alienations of property. Yet the strivings for independence were directed against the Priory of Germany, not against the Order's government; responsions were sporadically sent to Rhodes, and when the lands in Pomerania and Pomerelia were sold off to the Teutonic knights it was with the permission of the Chapter General (1366). Eventually Fernandez de Heredia, with characteristic skill, achieved the compromise of Heimbach (1382), which established the north-eastern preceptories as a distinct group, nominally subject to the Prior of Germany but in practice a separate priory: it appointed its own preceptors and was ruled by its own head, known to his subjects as the *Herrenmeister* and to the Order as the Grand Bailiff of Brandenburg, whose election was subject only to the formality of confirmation by the Prior.

Schism and Florescence

In the early years of the fourteenth century the Langue of Germany appeared to be in a very strong position; at home it was distinguished by populous and prosperous communities, in the Convent it was represented by an outstanding figure, Albrecht von Schwarzburg, Grand Commander and virtual ruler of Rhodes in the years around 1320.★ The relatively scanty Templar possessions in Bohemia and the Rhineland were easily acquired; in Brandenburg, where their wealth was greater, the Margrave Waldemar the Great at first seemed inclined to offer resistance, but his assent too was secured in an agreement of 1318. It might have seemed as if Germany were about to assume a prominent place among the newly formed Langues.

Yet such happy expectations were destroyed by the disputed imperial succession, when Charles IV of France, supported by Pope John

★ He belonged to the family which ruled as Counts and later Princes of Schwarzburg-Sondershausen and Schwarzburg-Rudolstadt until 1918.

XXII, attempted to gain the crown against the claims of Lewis of Bavaria. The ordinary policy of the Hospitallers was closely linked with that of France; the Grand Master Villeneuve (then governing the Order from Provence) was a councillor of Charles IV; and the need to secure the Templar properties tied the Magistry especially closely at this time to papal policy. In 1326 the Prior of Toulouse, Pierre de l'Ongle, went as papal legate to Coblenz to urge the election of the King of France, and as Lieutenant of the Master in Germany he held a provisional chapter and collected responsions from some of the brethren. But the most prominent of the German knights, Gebhard von Bortfelde, who held authority as general preceptor of Brandenburg, espoused the cause of the Emperor, and in 1329 was rewarded with the rank of an imperial abbot. The secession of the north-eastern preceptories was thus given visible status, and the policy of the Master against the German King alienated loyalties throughout the country. The result was that by the 1340s the Langue of Germany at Rhodes had completely disappeared, and although individual Germans continued to be found at the Convent it was not until 1428 that the Langue was restored to full official footing. The reign of the Emperor Charles IV (1347–78), when the German brethren were fully integrated into both imperial and papal policy, failed to recall them to Rhodes, and during the Great Schism they gave their allegiance to the papal nominees in Italy.

Yet in direct contrast to this weakness in the Convent, the Order in Germany showed a florescence comparable only to its palmy state in Provence. Substantial priests' communities were well established at Cologne, Steinfurt, Wesel, Prague, Breslau and Mailberg, and new foundations were made at Küsnacht and Strasbourg. Steinfurt, with 45 residents of all classes in 1345, compares with the most flourishing Provençal houses. Herrenstrunden, which took the place of Burg as head preceptory of north-western Germany, became the second-richest religious house in the circle of Rhineland and Berg. Strasbourg was founded in 1371 as a priestly community, its prior becoming the general ecclesiastical superior of the German chaplains; about 1448 it carried out a reform of the decayed chaplains' preceptory of Breslau in Silesia. The prior of Strasbourg was a mitred

Wesel, an example of a German commandery with a large community of priests.

prelate ranking second among the abbots of the diocese. There were also many houses with substantial communities of knights: at Steinfurt four was the usual number, and some preceptories had more. It is clear that the Langue of Germany, having virtually turned its back on Rhodes, was training its own novices and supporting them throughout their careers in a type of conventual life unknown in other countries.

Bohemia showed even greater prosperity, of which the prioral House of Prague was the prime example. The community in the fourteenth century included ten knights and nineteen priests. The prior became a mitred prelate in 1395 like the prior of Strasbourg, with jurisdiction over all the Bohemian chaplains. Many priests were university graduates, and Zittau was notable for its library and the writings of its preceptor, Heinrich von Warnsdorf. At least thirteen schools existed in the different houses, of which Prague had 27 pupils in 1373 and Strakonitz 21. At Manetin (1183) and Prague (1187) the Priory had established two of the

earliest women's convents of the Order, though these were of short duration. The fourteenth century was the period when Bohemia shook off its subjection of German knights, and from 1337 the Priory was regularly held by native noblemen; above all it was a time of great architectural and artistic enrichment, when many fine churches were built, enlarged and embellished.

Crusades and Heresies

In spite of the papal schism, two successive Priors of Germany distinguished themselves by their service to the Order: Frederick Count of Zollern* (1392–99) and Hesso Schlegelholz (1399–1408). The former commanded the Hospitaller force that marched with Sigismund of Hungary to the Battle of Nicopolis and when well over seventy took part in the expedition that seized Halicarnassus about 1405. In 1428, after the ending of the schism, there seems to have been a deliberate attempt to restore the Langue to a firm footing; an eighth great office, that of Grand Bailiff, was created for its Pilier and the prioral seat was fixed at Heitersheim.

The latter measure gave recognition to a de-

velopment that had begun with the patronage of the margravial House of Baden and Hachberg in the late thirteenth century. Henry of Hachberg became a Hospitaller in 1290, having already endowed the preceptory of Freiburg-im-Breisgau with the lordship of Heitersheim; further members of his family were preceptors of Heitersheim and Priors of Germany in the next two centuries. By 1505 a large castle had been built at Heitersheim and the estate had grown into a fief of 25 square miles; in 1548 the priors were raised to the rank of princes of the Empire.

The separateness of Germany perhaps accentuated the isolation of Dacia, whose responsions reached Rhodes so irregularly that around 1433 the Order was contemplating disposing of the entire Priory to the Teutonic Knights in return for their four commanderies in Sicily. The plan proved politically impossible, but an exchange was successfully negotiated with Hospitaller possessions in Germany and the Teutonic commandery in Spain in 1423, and with the Teutonic properties in Italy and Greece some thirty years later.

Hungary suffered the same dearth of native knights as Scandinavia, and by the fourteenth century the Priory was habitually held by Italians. The accession of the Angevin dynasty in 1308 benefited the standing of the Order, and about

* His family were then Counts of Zollern (later Hohenzollern) in Swabia; their elevation to electoral status as Margraves of Brandenburg took place in 1415.

Castle of Heitersheim, seat of the Prince-Priors of Germany, in a 17th-century engraving.

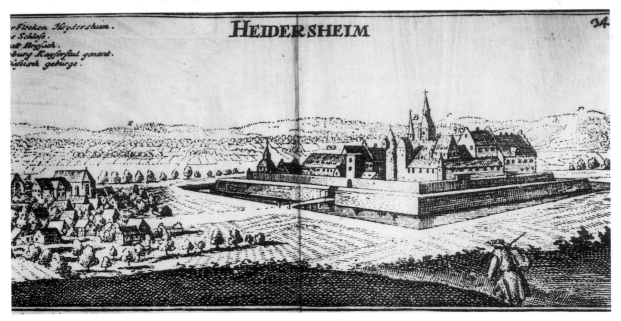

1345 Louis the Great invested the Priory with the Templar Castle of Vrana, in Dalmatia, which became for a century the prioral headquarters.[1] At the same time began the succession of Provençal Priors, but from 1378 native Priors started to be appointed. The death of Louis the Great in 1382 favoured more nationalistic attitudes, and during the Great Schism, in 1404–5, we find Hungary refusing the prioral nominees of both Naillac and the Italian anti-Master. In 1409 Venice recovered possession of Dalmatia and Italian knights again monopolised the Priory. When the Turks conquered Vrana in 1538 they took it from the Venetians; the greater part of Hungary had already fallen to their sword in 1526.

The prosperous Priory of Bohemia was struck down by the Hussite wars, which destroyed the house of Prague in 1420; the Prior Heinrich von Neuhaus was killed in battle and the church was reduced to ruins, leaving only its two towers. Although the priests' convent was rebuilt in 1442, the Priors moved to Strakonitz, where the imposing castle became their residence. Nine of the Order's commanderies were lost until the Catholic recovery in the seventeenth century, but fortunately Silesia and Austria were spared the destruction. The Catholic cause was upheld by the Prior of Bohemia, Jobst von Rosenberg (1451–65), who was also Bishop of Breslau and an energetic writer against the Hussites. The preceptory of Zittau continued its scholarly tradition with a school of illumination. In Silesia the schools still flourished, that of Breslau attaining particular importance; in the early sixteenth century the chaplain of Breslau Barthel Stein (himself a pupil of the preceptory school at Brieg) described the geography of Silesia and

Castle of Strakonitz, the prioral seat of Bohemia 1420–1684.

was the first scholar to lecture on geography in a German university, teaching at Wittenberg between 1508 and 1512.

In Austria and the German priory the internal life of the commanderies continued to flourish in the fifteenth century. The commandery of Mailberg, whose *Meister* sat as a prelate in the Diet, enjoyed such importance that the Emperor Maximilian was invested with it (1492–99) before his election to the throne. Steinfurt in 1495 contained more than fifty brethren, including five knights and ten priests. Cologne had a similar number, including seventeen priests, one of whom governed the house as commander; the convent boasted a magnificent church and extensive buildings spreading around five courtyards. Strasbourg was the third-largest house, with fifty residents, including the commander, the prior and fourteen other priests, besides lay brethren and eighteen lay sisters. A new priestly foundation was made at Biel in the diocese of Basle in 1455.

The Impact of the Reformation

The religious upheaval that caused so many throughout Germany to desert their vocations was not without effect among the brethren of St John. The chaplain Johannes Stumpf became a friend of Zwingli in 1522 and handed over the commanderies of Bubikon, Wädenswil and Küsnacht to the city of Zurich. Although the Order recovered the three properties it was not until after their conventual life, including that of the priestly community of Küsnacht, had been irretrievably destroyed by Protestant intrusion. Münchenbuchsee and the priests' convent of Biel were confiscated by the government of Berne in 1529.

In Strasbourg an attempt to close the church to Catholic worship was resisted in 1526, but the atmosphere in the city was so hostile that the priests and students – for the house was the novitiate for the chaplains of the Priory – moved for a time to Séléstat, while six members of the community sought secularisation. At Duisburg the church was given over to Protestant worship by 1554 and the commandery was administered from Herrenstrunden, for here too the once-flourishing community was in rapid decline. A

Statue of St John, 1547, and commandery church of Fribourg.

As it bled from these wounds, the German priory was at least given prestige in the middle years of the century by one of its most distinguished heads, Georg Schilling von Cannstadt (1546–54), who had commanded the Order's forces when Charles V took Tunis and had served as Governor of Tripoli. To strengthen Catholic representation in the College of Princes Charles V raised the Prior of Heitersheim to princely rank, and Schilling's personal standing justified and gained acceptance for the act. Schilling made efforts to retrieve the Priory's material losses, but the Order still had many blows to sustain before circumstances improved.

In Scandinavia a chaplain of Antvorskov returned from Wittenberg a Protestant in 1521 and was expelled from the Order; in 1530 the King of Sweden began giving the commandery of Eskilstuna to laymen, Vaerne in Norway was confiscated two years later, and the Danish commanderies suffered the same fate in 1536, though the brethren were not ejected. In 1552 a Prior still ruled at Antvorskov and was expected to give hospitality to travellers, but in 1580 the castle was appropriated by the Crown.

The Grand Bailiff of Brandenburg, whose seat had been at Sonnenburg since 1428, found himself a subject of the Margrave of Neumark during the separation of that territory from the Electorate (1535–71). When the Margrave became a Protestant in 1538 he could not remain indifferent to the allegiance of a dignitary who was in fact the richest vassal of the reduced principality. He soon imposed his authority, while leaving the structure of the Bailiwick outwardly intact; some commanders married, knowing that their Protestant princes would bar any intervention from Heitersheim. In 1564 the Margrave had his Chancellor, Franz Neumann, elected *Herrenmeister*, but he took his responsibilities to the Bailiwick more seriously than suited his prince and was obliged to flee to Prague. Finally in 1594 the office began to be given to members of the electoral house, while commanderies in Mecklenburg and elsewhere were surrendered to their princes; by the middle of the seventeenth century the Grand Bailiwick retained only seven of its thirteen medieval commanderies, though an eighth had been bought at Schivelbein in 1540.

The case of Brandenburg illustrates the survival of Catholic institutions in Protestant Ger-

comparison of the strength of the German priory in 1495 and 1540 shows what blows it had been struck even in the first stages of the Reformation. The number of knights had fallen from 40 to 26, while the loss among the chaplains was catastrophic: from 322, they were now reduced to 132. The case of Steinfurt, which had exactly the same number of knights and chaplains at the two dates, shows that in Catholic territories houses could maintain their strength, but the respite ended when the Counts of Bentheim became Protestant; in 1564 the church of Steinfurt was confiscated, and after two successive commanders had apostatised and been deposed the community transferred to Münster about 1615.

In Friesland all but three of the houses were confiscated around 1530; ten years later there were still sixteen aged sisters to be found there, half of them at Dünebroek, but the Reformation soon made a clean sweep. A lawsuit enabled the Order to recover Hasselt and Langholt in 1609, and these two commanderies remained a unique survival of Catholic institutions in East Friesland.

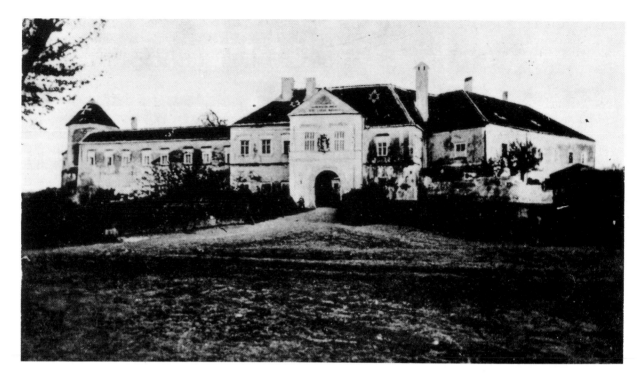

Mailberg, the chief Hospitaller commandery in Austria, still in the Order's possession.

many where their usufruct had passed into the hands of the nobility. It also exemplifies the principle *cuius regio eius religio.* Wietersheim, the most westerly possession of the Grand Bailiwick, was held by Catholic knights till 1582, when a member of the ducal house of Brunswick-Wolfenbüttel was elected Prince-Bishop of Minden and imposed Protestantism on the principality and the commandery. In this region the imperial commissioners were able to enforce the Edict of Restitution and introduce a Catholic commander in 1630, while French influence placed another Catholic there in 1641. Not until the Peace of Westphalia gave Minden to the Electorate of Brandenburg was Wietersheim definitively restored to the jurisdiction of the Grand Bailiff.

Catholic Recovery

In the Bohemian Priory Protestant attrition extended the ravages of the Hussites into the hitherto immune areas of Silesia and Austria. The once-flourishing priestly house of Zittau was given over to knights after 1538 when the town became Protestant, and was sold in 1570.

At Gröbnig the chaplain became Protestant in 1534; prolonged disputes followed between the commanders and the town, and the commandery likewise passed from priestly to knightly possession. At Striegau Catholic worship survived only until 1542, and at Breslau the last chaplain of what had been a community of eighteen priests died in 1548.

Even in Austria the priestly community of Mailberg became extinct in 1544; material recovery began in the years 1594–1608, when the commander rebuilt the castle in its present form and founded a school for the village. At about the same time the restoration of Catholicism began at Lossen in Silesia, where the Priory had had to negotiate with the Duke of Brieg to avoid the expulsion of the chaplain. The long tenure of the Grand Prior Matthäus von Lobkowitz (1590–1620) saw the beginning of visitations to enforce the Tridentine decrees.

As a well-known Catholic dignitary, Lobkowitz only narrowly escaped the Defenestration of Prague. He did not live to see the restoration of Catholic and imperial authority that followed the Battle of the White Mountain. Commanderies that had long been lost to the Hussites or the Protestants were recovered and

in 1628 a new one was founded at Maidelberg. Poland also showed a revival of interest in the Order, the family commandery of Stolowitz having been founded by Duke Nicolaus Radziwill in 1610; in 1622 there were four Polish knights, three of whom were living abroad.

As the Catholic tide swept over Germany, even Brandenburg seemed for a while about to return to the bosom of the Order. The intimidated Elector allowed an Austrian, Adam von Schwarzenberg, to be appointed Grand Bailiff in 1625; for sixteen years Schwarzenberg exercised his office with respect for established Protestant rights but with a wish to restore the Bailiwick to its ancient duties. In 1637 the knights of Brandenburg began for a short time to arm and maintain galleys at Malta in lieu of the responsions denied for so long;[2] but the accession of the Great Elector and the retreat of Catholic power in the Empire put an end to this brief renewal of relations.

Another swallow in the fleeting Catholic summer was Prince Frederick of Hesse-Darmstadt (1616–82), who after visiting Malta at the age of twenty was filled with such enthusiasm for the Knights of St John that he immediately resolved to become a Catholic and enter the Order.★ To compensate for the damage that his anti-imperial policy was doing to the Catholic cause Pope Urban VIII sought to use this seemingly frivolous young man as a bell-wether to lead a flock of putative princely converts into the Roman fold. He granted Frederick the succession to the German Priory even before his reception into the Church, let alone the Order. The prince was made General of the Galleys and surprisingly, at twenty-three, vindicated the Order's apparently capricious notions of merit, for he discharged his duties well, and in 1647 he succeeded to the Grand Priory of Heitersheim.

The Peace of Westphalia largely confirmed the loss of Catholic endowments in Germany, and thus the attention of the Grand Prior, in his zeal to serve the Order, turned to its expropriated commanderies in Holland. He demanded the restitution of the rich house of Utrecht with its four 'members', together with the commandery of Arnhem and Nymegen. In 1662 he went so far as to have some Dutch ships

in the Port of London seized to compel the United Provinces to give way, and though he was not wholly successful the Republic in 1667 paid for Utrecht the handsome indemnity of 150,000 florins; Arnhem and Nymegen were also eventually restored and continued to pay responsions throughout the eighteenth century.

On being appointed Cardinal and Bishop of Breslau, Frederick showed equal zeal in negotiating the recovery of the commandery in that city. Another knight-turned-prelate was coming to prominence under the same Habsburg sovereignty: Leopold von Kollonits (1631–1707), after serving strenuously on the galleys in Crete and at the Dardanelles, took holy orders and was promoted to a bishopric and to the presidency of the imperial *Hofkammer*. During the Turkish siege of Vienna in 1683 he was active in encouraging the defenders and founded a hospital in the Mailberger Hof. As the Christian counter-attack swept the Ottoman frontiers back to the Carpathians, Kollonits was in 1695 appointed Prince Primate of Hungary, where he led the restoration of Christian rule. It has been said of him, 'He must be reckoned one of the greatest representatives of militant Catholicism in the later seventeenth century.'[3] The Priory of Hungary enjoyed a partial restoration and the Bailiwick of Carlstadt was created in 1689.

Prague recovered its status as the seat of the Prior of Bohemia in 1684. A fine baroque church

The baroque palace of the Grand Priors of Bohemia in Prague.

★ He bore the title of Landgrave of Hesse-Darmstadt, but his conversion in fact obliged him to renounce the succession to that important principality.

201

was built over the ruins of the medieval one, and an equally sumptuous prioral palace added in 1727–38. The priestly community and novitiate renewed the work of training the Priory's chaplains,★ and new commanderies were founded at Miecholup (1691) and Doschütz (1745).

The Germany of the Princes

Between 1500 and 1600 the character of the German Langue underwent a very substantial transformation. Apart from material losses, the conventual life that had distinguished it almost wholly disappeared; the multitude of priests and lay brothers and sisters became a thing of the past; commanderies left isolated in Protestant lands lost their once-flourishing religious life; everywhere priestly commanderies were given over to the government of knights.

The Priory of Dacia and Grand Bailiwick of Brandenburg became titular dignities for Catholic knights, and Hungary was similarly transferred from Italian to German tenure in 1600. With two Grand Priories, one of them with princely jurisdiction, and three titular bailiwicks at their disposal, the lot of the small club of German knights might appear enviable. Only untimely death could prevent any of them from accumulating three good commanderies and a Grand Cross with a modicum of effort.

Yet these perquisites could not prevent the Order of St John from labouring under a national disadvantage. One reason was that Germany was the only country in which its qualifications for knighthood were not among the strictest of any order of chivalry: that distinction belonged to the Teutonic Order, which demanded thirty-two quarters of nobility and was thus regarded as the touchstone of German pedigree. The proof of sixteen quarters, which no other nation dared to exact, was a mere commonplace among German nobiliary bodies.

Further, the Grand Prior of Heitersheim ranked only about twenty-seventh among the ecclesiastical princes and held much the same place in territorial consequence. By contrast the High Master of the Teutonic Knights enjoyed precedence over Prince-Archbishops and ruled a respectable territory at Mergentheim; even after 1680, when that dignity became a Wittelsbach and Habsburg appanage, the order retained two fiefs at Coblenz and Altshausen whose commanders ranked as Counts of the Empire.

But the more pertinent comparison was with the wealth of ecclesiastical endowment open to the German nobility. Celibate younger sons could accumulate three or four canonries in neighbouring prince-bishoprics, similar in income to knights' commanderies and with more valuable rights, including that of electing the Prince and being oneself eligible for the mitre of those principalities, compared to most of which the Priory of Heitersheim was a state of very local importance. It is therefore not surprising that knights of the German priory tended to be drawn from baronial families of Swabia whose names are also commonly found among the Prince-Bishops of Basle.

In Brandenburg the prestige of the Grand Bailiwick increased in the seventeenth century. The *Herrenmeister* from 1652 to 1679 was Prince Maurice of Nassau, who had been Governor of the Dutch possessions in Brazil;† after 1693 the dignity was reserved again to Hohenzollern princes. It carried with it the command of the Electress's Life Guard, which bore the eight-pointed cross on its banner, and the *Herrenmeister* received investiture in a splendid ceremony held in his Berlin palace.

The Hohenzollerns acquired an interest in Catholic commanderies when Frederick the Great annexed Silesia in 1740, virtually depriving the Bohemian Priory of more than half its endowments. The Silesian commanderies were conferred at the King's pleasure, often on men without vows or without the necessary quarters of nobility. It became a point of national loyalty not to pay responsions to Prague, and this was often an excuse not to pay them at all.

★ A similar revival took place of the German novitiate at Strasbourg, which moved into the old monastery of St Marx in 1687. The half-dozen commanderies in Alsace continued to be attached to the German Priory even after the French occupation of the region, which began in 1635.

† The magnificent Gobelins tapestries made for the Council Chamber of the Grand Master Perellos were based on paintings of native life which he had executed and presented to Louis XIV.

The sixteen quarters of nobility of a German knight, Heinrich Ludger von Galen.

Heitersheim, the Chancery building and castle entrance built in the late 17th century.

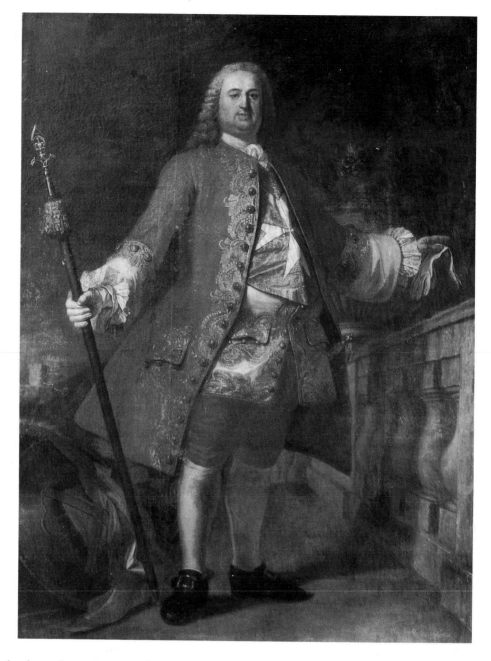

Grand Bailiff Johann von
Schauenburg, by Antoine
de Favray, 1752.

By contrast Frederick chose in 1763 to seek the Grand Master's confirmation for his appointment of his brother Ferdinand as *Herrenmeister* of Brandenburg, proposing a nominal reunion of the Grand Bailiwick and its parent Order which Pinto accepted in a magistral bull of the following year.★ The *rapprochement* failed to impress the Silesian commanders, whose Receiver challenged to a duel the envoy sent by Rohan to collect their responsions. The King imprisoned this ill-tempered official and ordered responsions to be paid not only by the Silesian commanders but even by those of Brandenburg.[5]

★ A consequence of this reconciliation is revealed in the memoirs of a Protestant Alsatian noblewoman, the Baroness d'Oberkirch, who relates that when her husband was appointed to a Brandenburg commandery in 1775 he went to pay his respects to the Grand Prior of Heitersheim, as the chief dignitary of the Order in Germany. Madame d'Oberkirch writes of this Grand Prior (Remching): *Il était très-riche, dépensait beaucoup d'argent, et son luxe étincelait sur toute l'Allemagne.*[4]

An opposite disposition was shown by Joseph II of Austria and his minister Kaunitz. When the Chapter General in 1777 decreed the much-needed increase in responsions they saw the opportunity they had long been seeking to strike at the Order. Joseph refused to allow the increase to be applied to the German Langue; he found a willing tool of his policy in his ambassador to Malta, Hompesch, and especially in his secretary, the *abbé* Boyer, whose intrigues with anti-magistral trouble-makers provoked Rohan to put him under arrest. This attempt to enforce discipline played into the Emperor's hand, in which all the aces were concentrated. After Joseph had retaliated by sequestrating the Austrian commanderies, Rohan was obliged to apologise abjectly, release Boyer and compensate him with a magistral pension, confer a commandery on the sycophantic Hompesch and accede to the Emperor's demand that he alone should decide the level of German responsions, an arrangement which reduced the intended levy by 32,000 *scudi* (£3,200).[6]

The French Revolution and its Sequel

The commanderies of Alsace and German Lorraine were confiscated by the National Assembly in 1792; all the others west of the Rhine succumbed in the French annexation six years later. The losses similarly suffered by the German princes were to be made good by the wholesale confiscation of the ecclesiastical states, but the two military orders were exempted from this spoliation, and indeed enriched. During the first stage (1803–6) of the transformation of the Holy Roman Empire into the German Confederation, the Grand Prior of Heitersheim was granted the property of the Abbey of St Blaise, whose domain included the imperial county of Bonndorf with some 200 square miles and 180,000 guilders (£18,000) in revenue. These years therefore saw the curious scene of the German prior strengthened in his status as a reigning prince while the head of his Order lived almost a refugee existence in Catania.

This interlude was brought to an end by the Napoleonic conquest of the Empire. As the spoils were divided among the jackal princes of Germany, Heitersheim was awarded to the Grand Duchy of Baden (January 1806), and its last prince died the next year on a pension. Other rulers likewise confiscated the remaining German commanderies. The French onslaught gave rise in Prussia to the programme of harsh retrenchment that enabled the kingdom to counter-attack effectively in 1813; but among its victims were the commanderies of Brandenburg and Silesia, which were expropriated in 1810.

In Austria the properties of the Bohemian priory were saved from a similar fate by the diplomacy of their Prior, and the fall of the Napoleonic empire set the Order on the path of recovery. The Congress of Vienna confirmed the ill-gotten gains of the princes, but by a quaint survival one commandery of the German priory, that of Frankfurt, was preserved as an Austrian sovereign enclave, its commander at the time being Ritter Edmund von Coudenhove. Metternich, in his plans to control the Order, was contemplating moving its seat of government to Vienna. The result of his meddling was that neither the Grand Prior of Bohemia nor the Lieutenancy was in a position to keep hold of the disappearing fragments of the German Langue. One of these was the chaplains' commandery of Fribourg in Switzerland, which had enjoyed a prosperous history under six successive commanders from the local family of Duding, two of whom had also been Bishops of Lausanne. Its last commander, evidently adrift from any prioral control, surrendered the commandery in 1825 to the city government. The only remaining Silesian commandery, Breslau, which had survived because it was a *juspatronat* of the Kollowrath family, was claimed by its patrons on the death of its last incumbent in 1828. A similar fate seems to have befallen the Radziwill *juspatronat* of Stolowitz in Poland, whose last commander was appointed in 1813.

Genuine recovery only began in the second half of the century. With the efforts to restore the Hospitaller character of the Order are pre-eminently associated three Austrian Knights of Justice: Gottfried von Schröter, who initiated the moves to found the hospital of Tantur in the Holy Land, Bernhard von Caboga, whose generosity brought the plan to fruition, and Othenio von Lichnowsky (Grand Prior of Bohemia 1874–87), who represented the Sovereign Order at the second international conference of the Red

Cross.★ The establishment of a military hospital, a voluntary nursing service and a hospital train for the Army Medical Corps extended these endeavours in Austria itself in the last third of the century.

In 1881 Francis Joseph raised the Grand Prior of Bohemia to the rank of Prince of the Austrian Empire, with the style of Serene Highness. After 1860 Vienna remained the only European capital, other than the Vatican, in which the Order preserved diplomatic representation, the ambassador being normally the Grand Prior; and the Austro-Hungarian Empire was the state in which it enjoyed the highest prestige and the most visible presence. The Grand Priory retained its commanderies and its traditional ecclesiastical jurisdiction, and the novitiate of Prague continued to train a numerous clergy for the Order's churches. For fifty-two years the restored Grand Mastership was held by representatives of two of the most illustrious families of the Austrian nobility.

After the First World War – during which the Austrian knights performed notable work in the service of the wounded – the Grand Priory's properties were scattered in three different countries, and the founding of the Polish and Hungarian Associations reflected the frag-mentation of the cosmopolitan aristocracy of the empire. In 1938, in the brief interval between the Nazi annexations of Austria and Czechoslovakia, a new Grand Priory of Austria was created, in the fear that an institution that proclaimed itself Bohemian would invite expropriation. Despite this precaution the commanderies of both Priories were confiscated during the war, only the priestly community of Prague remaining. That too was suppressed by the communist rulers of Czechoslovakia in 1950.

In Austria the Grand Priory recovered its status after the war; its principal possession, Mailberg, is still administered by a professed knight and is the only commandery of the Order that has enjoyed a virtually continuous existence since the twelfth century. Diplomatic relations were restored when Austria regained full independence, and this example was followed by Czechoslovakia on the fall of the communist regime. The new Czech government also returned to the Order's possession the magnificent prioral palace and church in Prague. The human renewal, after a period of abeyance, had already taken place in 1980, when the Grand Priory reconstituted itself in exile with three Knights of Justice.

★ For these events and the contemporary attempts to revive the Grand Priory of Germany see pp. 251–2.

PART III

A Princely Charity

CHAPTER XIV

Our Lords the Sick

Obsequium Pauperum

IT WAS A rare gift of providence, and one to which the Order of St John has owed its greatness and its longevity, that granted to the Amalfitan hospice in Jerusalem a Rector worthy of both its place and its exceptional time: no mere administrator but 'the most humble man in the East and the servant of the poor' – the words in which the Blessed Gerard's epitaph expressed the potent vocation he taught his brethren. William of Tyre recalls the same character when he describes Gerard as 'a man of venerable life, renowned for his piety', who 'long rendered devoted service to the poor'.[1] Gerard had the gift shared by other founders of religious orders of formulating his own devotion so as to speak to the hearts of his age and turn a local work of charity into a universal and perennial vision. The task of the Hospital of St John was to serve the indigent pilgrims whom Gerard taught his followers to think of as 'Our Lords the Poor'. As more and more travellers arrived in Jerusalem after their hard and dangerous journey, the Hospitallers had to give special care to the wounded and ill, and 'Our Lords the Sick' became the needy ones to whom the brethren of St John pre-eminently vowed their service.

To give effect to this vocation the Blessed Gerard fashioned an instrument in some respects very typical of his time: in the late eleventh century religious communities following the Augustinian rule became popular as a less enclosed alternative to the Benedictine model. To this tendency Gerard gave a markedly practical twist: his intention was to form a group of lay brethren whose service to God was to be expressed less in corporate prayer than in active works of mercy. He gave his infant Order a wholly unprecedented flexibility, enabling brethren to undertake whatever tasks the service of the pilgrims required: to travel all over the world receiving donations and founding daughter houses, to organise, as it seems, the transport of pilgrims across the seas, and even to answer, sword in hand, the needs of security on the Palestinian roads. The same practical talent permitted the central but skilfully delegated government of a universal Order which became the model for the most effective religious orders of the Middle Ages.

Our knowledge of the first Rule of the Hospitallers,[2] like our knowledge of its military work, goes no further back than the time of Raymond du Puy, and historians have easily ascribed both initiatives to that Master. Nevertheless the paucity of early records is not a sufficient basis for such a conclusion; it is unlikely that Raymond made innovations in any aspect of the vocation he inherited from the Founder, whatever his greatness in expanding it. Whether or not, therefore, Gerard left any written Rule, the religious vision revealed in the twelfth-century Rule and statutes is here attributed to him. We cannot say how much it owes to his own individual genius – the 'noble heart' that shone under his humility – and how much to the crusaders who entered the Hospital and became his coadjutors, but whatever its source the vocation described is one of masterly inspiration, harnessing the crusading and chivalric ethos to the Hospitaller ideal. One sign of this is the use of the Cross on the brethren's habit – a mark not of monastic orders such as the Benedictines but of the crusaders who adopted that symbol at Clermont. A similar

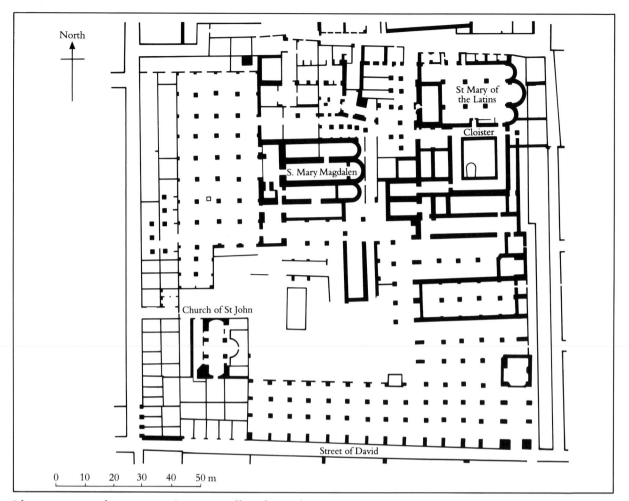

North

0 10 20 30 40 50 m

St Mary of
the Latins

Cloister

S. Mary Magdalen

Church of St John

Street of David

Plan of the Hospital of Jerusalem, 12th century.

idea seems to be present in a grandly phrased letter that Raymond du Puy addressed to benefactors, probably shortly after his election.[3] He speaks of himself and his brethren who serve (*militamus*) for the honour of God, and assures those who enter the Order in Europe that they gain the same merit as if they served (*militent*) in Jerusalem. The word chosen, though not exclusively military in meaning, had obvious overtones of the service of a *miles*, a knight.

Later in the century the Hospitaller statutes present the idea of 'Our Lords the Poor' in the language of chivalrous devotion. 'Les freres de l'opital doivent faire de ardant et de devot corage as povres malades com a seignors.'[4] The feudal concept of loyalty and zealous service to one's lord becomes the inspiration for the service of the poor. We thus see almost from the earliest years the chivalric ethos not merely appended but fully integrated into the ideal of the Hospitaller vocation.

If this synthesis was fruitful in teaching humility to the great, it was no less so in giving grandeur to the service of the poor. From the time of the rebuilding of the Hospital under Raymond du Puy, travellers unite in wonder at its size, its beauty and the unheard-of munificence of its work for the poor. Theoderic wrote in 1172:

No one can credibly tell another how beautiful its buildings are, how abundantly it is supplied with rooms and beds and other materials for the use of poor and sick people, how rich it is in the means of refreshing the poor, and how devotedly it labours to maintain the needy, unless he has had the opportunity of seeing it with his own eyes. Indeed, we passed through this palace, and were unable by any means to discover the

number of sick people lying there, but we saw that the beds numbered more than one thousand. It is not every one even of the most powerful kings and despots who could maintain as many people as that house does every day.

John of Würzburg put the capacity of the Hospital at 2,000, and asserted that an equal number of poor were daily fed by the brethren. It was a hospital far larger than those that were appearing in Western Europe at this time and is comparable only to the imperial hospitals of Constantinople, that of St Sampson, founded in 1136, offering the closest parallel both in time and in the splendour of its planning.

Whereas western hospitals rarely had resident physicians before the fourteenth century, the Statutes of 1181 ordered four physicians to be attached to the Hospital of Jerusalem; they were required to be expert in urinalysis – a preferred diagnostic tool of the period – and in the prescription of medicines. Each of the many aisles of the Hospital had nine brethren assigned to it, whose duties were to wash and feed the patients and make their beds. Every bed was provided with its own sheets and coverlet and with a sheepskin dressing-gown and slippers for when the patient went to the privies. With regard to meals, the rule of Raymond du Puy orders: 'Each day before the brethren go to eat, let the sick man be refreshed with food as if he were a lord.' As the ordinances of 1181 show, the patients of the Hospital enjoyed a diet such as few except the rich could expect in the life of the time. Thrice a week they ate fresh meat: pork and mutton for the robust, chicken for the frail; they were also assured the luxury of white bread, the revenues of two *casalia* being set aside for this purpose.

What tradition of medical science was uppermost in the Hospital of Jerusalem is a matter for speculation. Given the origins of the Hospital, it is significant that Salerno, the immediate neighbour of Amalfi, emerged in the late eleventh century as the leading medical school in Western Europe; but it may be that the brethren of St John were not long satisfied with this example. Western doctors in general were regarded with derision by their Byzantine and Arabic counterparts. Arabic medicine in Syria must have been at least an indirect influence; a concrete instance is the use of medicinal syrups, which is attested

The Hospital of Jerusalem shown in a 12th-century map.

in the Statutes of 1181. The example of Constantinople was surely of greater weight, since most pilgrims came to Jerusalem after passing through the imperial city, and from the middle of the twelfth century the Hospitallers themselves had a permanent house there.

The Hospital of Jerusalem proved an essential inspiration to the *Maisons-Dieu* that appeared in France in the thirteenth century. The medieval concept of a hospital as a religious institution attained its highest expression in a religious order whose vocation was centred round the service of the sick; but by their emphasis on the ideal of 'Our Lords the Sick', the brethren of St John drew the patients in a particularly intimate way into the life of their Order. Reception into the Hospital was viewed as entry into religious jurisdiction and discipline. It was the rule that each patient on admission should confess and receive Communion before he was allotted a bed. An altar stood in the main ward so that the daily life of the patients should be sanctified by the celebration of the Mass and by the constant presence of the symbols of spiritual comfort and protection.

The Order of St John concentrated its nursing work in its successive centres of government; it did not set up a network of medical hospitals in Europe, and though its houses might go by the name of 'Hospital' this expressed their affiliation, not their function. Preceptories which were

pilgrims' hospices doubtless did what they could for sick travellers, but only the largest of them, such as Bargota on the Compostella road, or Genoa, gave regular medical care. Leper hospitals were a fairly common feature, examples being Launay-les-Sens, Bellecroix and Chagny·in France, Rignadello and Corbucci in Italy, Melaten in Germany; but their existence must be attributed to the idiosyncrasy of their founders who chose to place such houses under the care of the brethren of St John. The members of the Order themselves were the only systematic beneficiaries of its Hospitaller vocation, for a house was set aside in many priories for the care of their sick brethren, for example Chippenham in England or Cizur Menor in Navarre.

Tuitio Fidei

The salient characteristic of the vocation created by the Blessed Gerard was, as has been said, its practical emphasis, and this is what enabled it to assimilate the military service, at first linked to the vocation of protecting pilgrims but soon extended to functions that might appear incongruous with the religious life. Yet under that seeming incongruity was a harmony of vision: not merely because of the marriage of the chivalric and the hospitaller ethos that has been described, but because the two tasks were pre-eminently the new needs of the time and place, and therefore natural objects for a young order to address itself to.

Both the Hospitallers and the Templars began their military work in the service of pilgrims, and Brother Gerard at least cannot have envisaged any other function for the soldiers who wore the habit of St John. It is therefore to Raymond du Puy that we must attribute the addition of *tuitio Fidei*, the protection of the Faith, to the original duty of *obsequium pauperum*, the service of the poor. By the end of his magistry the two had reached approximately equal importance in the Order's work. Raymond, like Gerard, is honoured among the Blessed of the Order, and it is significant that a man of his saintly character should have turned the Hospitallers to a warlike role. The ideal of the soldier dedicated to Christ

and to the protection of the weak was just emerging to take hold of men's imaginations and to discipline the lawlessness of the feudal nobility; it was an ideal akin to Brother Gerard's vocation of service, and could appeal to the same men of active instinct and pious aspiration. In their double vocation implanted by Raymond du Puy the Hospitallers came to exemplify the best elements in the age of the crusades.

By the middle of the twelfth century the Hospitallers and the Templars stood as examples of a new military and religious vocation which the crusades contributed to the tradition of the Roman Church. Writers only tenuously acquainted with ecclesiastical matters are inclined to describe the military orders as 'fighting monks', thus giving a misleading idea of their character. The Hospitallers (still less the Templars) were never a monastic order; they began as a lay brotherhood and developed into a religious order of a wholly new kind. The Knights of St John were not monks who fought but soldiers who took vows. Their origins and training were those of warriors, and it was to be expected that the view they took of their calling was military rather than religious. They no more doubted that they honoured God by dedicating their craft to Him than did those master masons whose handiwork, equally vigorous and often equally marked by a robust sense of earthly reality, glorifies the great churches of medieval Europe.

At the same time the knights of the crusading orders devoted themselves in a special fashion to the service of the faith. They took vows which were the common standard of Christian abnegation for all religious men, but which punished especially the normal expectations of their rank: poverty, when a nobleman's consequence derived from the breadth of his acres; celibacy, when his glory was in the long continuance of an ancient name; obedience, when it was his prerogative to go into battle as a commander of men. The Hospitaller vocation carried the ideals of chivalry to their most generous expression: service became an undertaking of perfect self-dedication; the knightly obligation of protecting the weak found its fulfilment in a life of humble service to the poor and the sick.

The young man who wished to embrace the life of a Hospitaller was taught his obligations in these words:

Good friend, you desire the company of the House and you are right in this, for many gentlemen earnestly request the reception of their children or their friends and are most joyful when they can place themselves in this Order. And if you are willing to be in so excellent and so honourable company and in so holy an Order as that of the Hospital, you are right in this. But if it is because you see us well clothed, riding on great chargers and having everything for our comfort, then you are misled, for when you would desire to eat, it will be necessary for you to fast, and when you would wish to fast, you will have to eat. And when you would desire to sleep, it will be necessary for you to keep watch, and when you would wish to stand on watch, you will have to sleep. And you will be sent here and there, into places which will not please you, and you will have to go there. It will be necessary for you therefore to abandon all your desires to fulfil those of another and to endure other hardships in the Order, more than I can describe to you. Are you willing to suffer all these things?

When he had expressed his acceptance the novice laid his hand on the missal and made his solemn undertaking: 'I vow to God, to the Blessed Mary ever Virgin, Mother of God, and to St John the Baptist, to render henceforth and for ever, by the grace of God, a true obedience to the Superior whom it shall please Him to give me and whom our Religion shall choose, to live without property and to guard my chastity.' The knight who performed the investiture, before clothing him with the habit, pointed to its white linen cross and asked, 'Do you believe that this is the Holy Cross upon which Jesus Christ was nailed and died for the redemption of our sins? This is the sign of our Order, which we command you to wear always on your garments.' The novice kissed the Cross and received the habit, fastened by a cord around his neck: 'Receive the yoke of the Lord, for it is sweet and light, under which you will find rest for your soul. We promise you no delicacies, but only bread and water, and a modest habit of no price.' When the ceremony was over the new knight, in token of the poverty he accepted, sat on the floor of the refectory and was served by this brethren with water, bread and salt.

Acre, Cyprus and Rhodes

When Saladin conquered Jerusalem he permitted the Hospital to remain open for twelve months to allow the sick to be cured, and we may thus assume its continuance, with the staff of ten nursing brethren to which it was limited, until 1188. Most of the Order's other hospitals in the Holy Land – for example at Bethgibelin, Naplous and Acre – were likewise lost; but in 1191 the Hospitallers were able to regain possession of their house in Acre. Once a mere port of arrival, the city grew as the new royal capital, and though it was not to receive the multitudes of pilgrims who had once flocked to Jerusalem the old hospital became too small for its needs. It had been built in the first half of the twelfth century and was, as far as we know, much the largest of the Order's hospitals next to that of Jerusalem itself. It was presumably after 1191 that a separate *domus infirmorum* was built to the

Hospital of Acre: the Refectory, *c.* 1148.

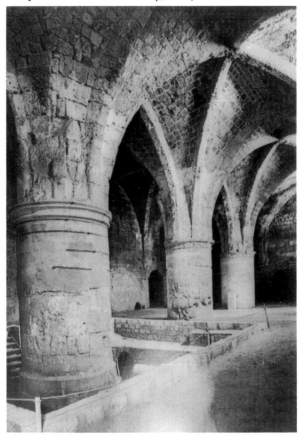

213

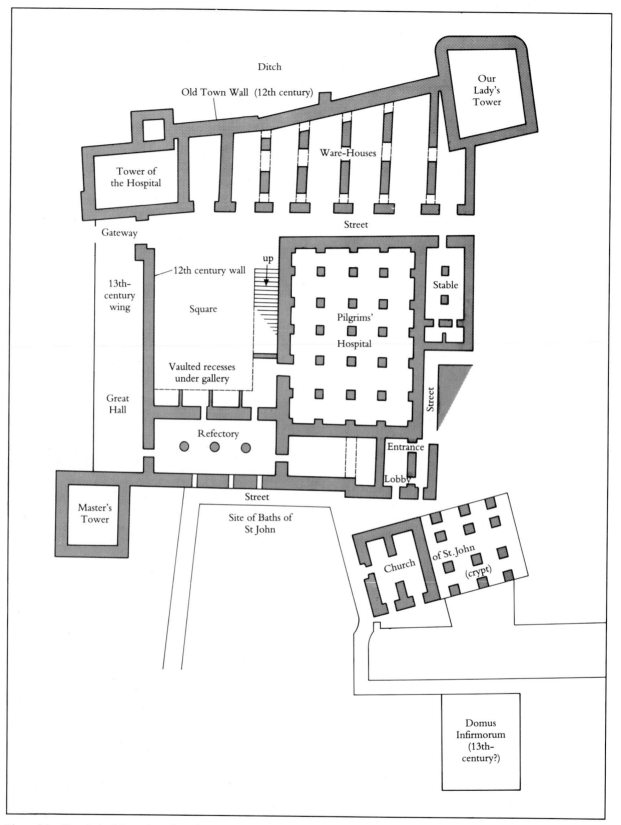

Plan of the Hospital of Acre, based on the current excavation plans of the Israel Antiquities Authority. The function assigned to the different buildings is conjectural.

south of the church, a sign both of expanding needs and of the increasing specialisation in medical care that is a feature of the Order's history; the original hospital was no doubt reserved for the use of healthy travellers.

The brethren were able to return to the old Hospital when Frederick II recovered Jerusalem in 1229, but after fifteen years the city fell finally to the Turks. Antioch, where the Order had another hospital, was lost in 1268. It is recorded that as the Saracens breached the walls the nuns of St John, resigned to death, lacerated their faces with knives so that their disfigurement should preserve their chastity from the lust of the invaders. When Acre suffered a similar fate thirty years later the inmates and servants of the Hospital had probably made good their escape before the city fell.

Whatever the uncertainties about the Order's future as it gathered its sad remnants in Cyprus, its primitive duty was still imperative, and a new Hospital was founded at Limisso in 1296. It had no opportunity for great development and has left no architectural trace. In Rhodes a Hospital was founded soon after the conquest, a building with spacious halls at the bottom of the Street of the Knights, located near the harbour so that the wounded or sick could be transferred to it quickly. It was a much more modest building than the hospital of Acre, let alone that of Jerusalem, but it evidently sufficed for the numbers who dwelt and passed through Rhodes at the time. The Order's medical specialisation was taken a step further at Rhodes, for there was no pilgrims' hospice at all, and when Dominique d'Alemagne founded the hospice of St Catherine at the end of the fourteenth century it was to provide lodging for rich visitors to the city. 'Our Lords the Sick' had definitely replaced 'Our Lords the Poor' as the objects of the Order's charity. The change only made the brethren's care of the sick all the more lavish, and in the fifteenth century the Grand Master Fluviá ordered the construction of what was to be the most beautiful of all the Order's hospitals, and one of the finest of medieval Europe.

The new Hospital of Rhodes was built between 1440 and 1489, opposite its predecessor at the foot of the Street of the Knights. Its design, which encapsulated the Order's long medical experience, was as distinguished for its splendour as its convenience. It was built round a courtyard

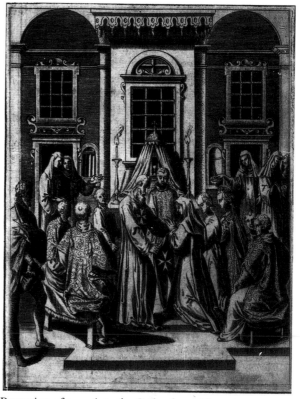

Reception of a nun into the Order, late 16th century.

Knights serving the sick in the Hospital of Malta.

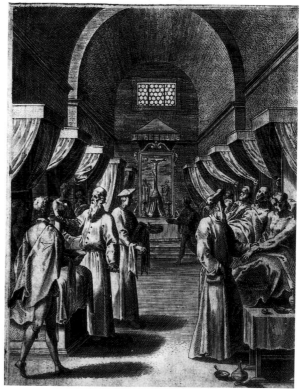

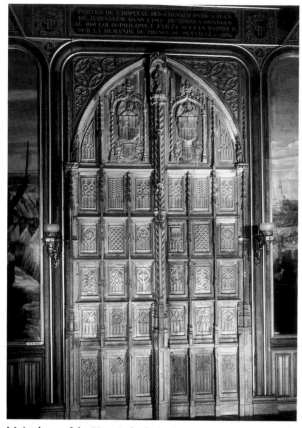

Main door of the Hospital of Rhodes, no in the Salle des Croisades, Versailles.

with arcaded cloisters on both the ground and the first floor. The upper floor was evidently reserved for the care of the sick; the east range is entirely filled by the great ward, over 150 feet long and divided lengthways by pillars whose arches carry the roof. In the centre of one side an elegant oriel window overhanging the main door from the street formed a niche in which the altar stood. In the thickness of the walls were built small windowless alcoves containing individual privies.★ Along the north range, overlooking the Street of the Knights, are seven spacious rooms; the grand staircase that gives access to them from the street suggests that they may have been wards reserved (perhaps by Langue) for the members of the Order. A similar number of rooms along the remaining two ranges were perhaps designed for the separation by diseases that the Hospital, in advance of its time, is known to have practised. At one end of the great ward a door gives access to a large

★ The same arrangement is found in the Malta Hospital.

room whose neighbourhood to what is obviously a kitchen identifies it as the refectory; two doorways lead from it to a terrace onto which one can imagine patients strolling with a leg of chicken in hand to enjoy the sun. Add to these comfortable arrangements the masculine beauty of the stonework, and it is a hospital in which one would give an arm to be treated.

An account by a French visitor to this hospital describes how the patients were fed: 'for each sick man they poured wine into beautiful silver cups and the food in beautiful silver plates. . . .

Reception of knights into the Order, late 16th century.

The beds are like a little tent, very fine.'[5] The use of silverware, which distinguished the hospitals of the Order until the fall of Malta, reflects not only the lavishness thought fitting for the service of 'Our Lords the Sick' but also a concern for hygiene (for the implements were smooth and unadorned so as to be easily cleaned) and a knowledge of the antiseptic properties of silver.

The rules of the Hospital in the fifteenth century required the doctors to visit the sick at least twice a day and to write down their opinion.

An overseer visited the wards with a servant at Compline and early in the morning to talk to the patients and put them in good spirits. Mass was said in the great ward every day, the Prior officiating three days a week and a chaplain on the others, and it was their duty to hear the confessions of the inmates, give them Communion and attend the dying.

Malta

When the knights arrived in Malta they found a small population whose needs were already served by a hospital in Notabile. For the first time, therefore, the hospital which they built in 1533 in the Borgo made no provision for women;* it was evidently intended not for the local population but for sailors and soldiers, a service which Malta's character as a crossroads of the Mediterranean made particularly useful. After the move to Valletta the new Hospital was not built until 1575, so that for three years the knights had to cross the Grand Harbour to perform their duties. The *Infermeria* was built next to the harbour's edge, as those of Rhodes had been, though this position had the double disadvantage of being less central and exposed to the African sirocco.

Like the other buildings of Valletta, the Hospital was very much more functional than that of Rhodes. It consisted of a single long ward, to which others were added later. Its closest model seems to be the great hospital of Santo Spirito in Rome, and it reflects the Order's continuing determination to provide a hospital equal to the largest and best in Europe. A house for foundlings was soon added and provision was later made for the insane, while the Hospital provided several isolation wards for sufferers from contagious diseases. The lazaretto for ships undergoing quarantine came to be regarded as the most important mechanism for protecting Italy from infection brought from Africa or Asia.[6] In the 1660s the great ward of the *Infermeria* was extended in length to more than 500 feet.

The regulations of the seventeenth century laid down that three doctors including a surgeon must sleep in the Hospital every night. Five physicians and five surgeons were employed; their service lasted one month, overlapping three days with their successors' team. A general consultation was obligatory once a week for all the doctors, and their salary was docked if they failed to attend it. A medical school was begun by the Jesuits in 1595, a school of anatomy was added in the 1660s and students were also sent to schools abroad.

Service in the Hospital was obligatory for the novices once a week, and each Langue had a day of the week appointed for that attendance. Ceremonial visits of the whole Convent took place on Maundy Thursday and on the Sundays between Easter and Ascension, but the Grand Master and the great officers laid aside their symbols of rank when they entered the Infirmary.[†] Although there were knights who voluntarily nursed the sick, the regular visits seem to have been confined to feeding them, a duty that was discharged in the following manner: a small table, covered with a cloth and with water and salt upon it, was placed beside each bed; the food was brought into the middle of the ward, a superintendent read out the name of each patient and the diet he had been ordered, and the corresponding meal was served out and carried by a knight to the bedside. Broth and vermicelli were staple dishes, served in the silver bowls of which the Hospital had several hundred for the more privileged patients, the remainder being fed from pewter.

In the eighteenth century efforts were made to strengthen the scientific basis of the Order's medical work in Malta. The Hospital pioneered operations for cataract and the Maltese oculist Joseph Barth attained a European reputation. Chairs of surgery and dissection were founded at the university, and two Maltese doctors published psychological treatises. In Michelangelo Grima (1731–98) the Hospital of Malta produced one of the most eminent surgeons of his age. He studied at Florence and Paris and gained practical experience in the Seven Years War. Returning to Malta in 1763, he introduced the practice of su-

* A separate women's Hospital was founded in the early seventeenth century.

† Some writers allege that the Grand Master had ceased to visit the Hospital by the eighteenth century, but a manual of court usage in 1762 treats such visits as a normal part of the prince's routine.[7]

The Grand Master attending the sick, 17th-century painting.

furnishings were such as would cause a modern hospital matron to sniff, or avoid sniffing. Historians have therefore wrongly spoken of a decline reflected by the criticisms of John Howard on his visit in 1786, when he found fault especially with the smell of the Hospital and the bad character of the nurses. One writer goes so far as to suppose an improvement when the next non-specialist visitor came four years later and gave a favourable report.[8] Howard was unique in being an expert with ideas far in advance of his time, and if we are to judge from his strictures there was not a single passable hospital in Europe. The truth is that the Hospital of Valletta, whatever its shortcomings, was in most respects ahead of contemporary European standards; the very practice of allowing one bed to each patient, which the Order had maintained since its time in Jerusalem, did not become general until after the eighteenth century; the expenditure per patient was higher than average for the period; and it was not until the middle of the nineteenth century that any appreciable improvement was made by the British administration of Malta.

Service in the Hospital was an integral part of the twelve months' novitiate undergone by all the knights. The novices met for instruction in a house opposite the conventual church, and for devotions in the church's beautiful oratory, but they lived in their respective Auberges. Their Master, who was always a Grand Cross, was assisted by other knights and chaplains of different Langues, as the nationalities of the novices required. Their duty was to teach the novices the statutes, customs and history of the Order, to lead them in the recitation of the office of the Virgin and the rosary, which were to be said every day, to guard over their behaviour, and to ensure that they attended the required sermons and instructions, confessed to the appointed chaplains of the Order and took Communion together on the eight principal feasts of the year. If the soldierly and courtly qualities of the knights seem to us more immediately obvious, we should not overlook the religious devotion instilled by this training, exemplified by heroic and devout deaths in battle against the enemies of the Faith, by the many rich gifts to the conventual church and the beautiful churches of the Auberges, and by other churches such as that of Our Lady of Liesse which the Bailli de Bellay built in 1620

turing wounds which he had observed at Cassel, he was appointed chief surgeon to the Hospital and Professor of Anatomy and Surgery; his treatise on traumatic medicine gave him a reputation which attracted students to Malta, while the Maltese themselves were encouraged to enlarge their knowledge at Montpellier.

Despite these efforts a hospital run by traditional methods developed over two hundred years naturally suffered from a certain *vis inertiae*. It is easy to see that a system which confined the offices of Grand Hospitaller and Infirmarian (the latter was the knight with direct charge of the Hospital) to knights of a single Langue, neither of them with medical training and both holding their posts as stepping stones to other appointments, was not calculated to produce efficiency. There are many laudatory descriptions of the Hospital throughout its history, but they are written by laymen who compared its practice with that of other hospitals of their time, a standard which it was not difficult to surpass. Thus when a visitor of 1675, Henry Teonge, describes the beds as 'extremely neate, and kept cleane and sweet', it may well be that these

Jars from the Malta Hospital.

and which embodied the particular devotion of the French knights.

In every age there were knights who raised their vocation to the level of sanctity. Gaspard de Simiane la Coste, who was received in the Langue of Provence in 1622, first devoted himself to the work of converting the Huguenots of his country, sending out missionaries and sharing their task of evangelisation. He then began to work in prisons and hospitals, and in 1643 his compassion was stirred by the plight of the *forçats* in the galleys of Marseilles, to whom he organised a mission. He built a hospital in Marseilles for sick galley slaves and lived in it himself, dedicating himself to the sick with a devotion to which he soon fell victim, succumbing to the plague in 1649.[9] In the 1690s we hear of a group of five or six knights, former captains of galleys, who under the leadership of Gabriel du Bois de la Ferté lived in community in Valletta and devoted themselves to prayer and to the care of the sick.[10] Others made an effort to view their walk of life as more than a nobleman's career and wrote books explaining their vocation, such

as the seventeenth-century *Trattato del debito del Cavaliere* by Pompilio Torelli, the *Instructions sur les principaux devoirs des Chevaliers de Malte* (1712) attributed to the Chevalier Pouget, and the *Istruzione del Sacro Ordine Militare degli Ospitalieri* of Grand Master Zondadari.

How those precepts were put into practice in the late eighteenth century may be illustrated by the careers of two French knights: uncle and nephew, Jean-Baptiste and Alexandre de Freslon de la Freslonnière. In 1776 the former was appointed Colonel of the Guard Regiment which the Grand Master Ximenez had unwisely ordered to be raised from foreign mercenaries. Freslon found this regiment an ill-assorted body of ne'er-do-wells, and immediately set about imposing discipline; in a few years he had under his command a force as efficient as any regiment in the French army, and he saw to it that his men received education and were taught a trade. At the same time Freslon imposed on himself the duty of visiting the Hospital three times a week, and in 1786 he died a victim to his charitable devotion, for in attending the sick-bed of a dying man and persuading him to make his confession he himself caught the mortal fever and died within five days.

His nephew Alexandre was General of the Galleys in the years 1782–84, when he commanded the two expeditions sent against Algiers, but it also fell to him to uphold the Order's hospitaller tradition when Messina was devastated by an earthquake in 1783. Freslon immediately embarked with his galleys full of doctors, medicines, beds and tents, and found the hillsides round the city crowded with refugees. The Neapolitan government, true to its character as an enlightened despotism, was more concerned for its *amour propre* than for its people, and when Freslon offered to set up a field hospital he was told that the royal government had amply provided for the sufferers. The knights were entertained to a sumptuous meal while the famished and half-naked Sicilians crowded round the door begging for food. Freslon insisted on landing his surgeons and setting up a food kitchen on the quay, where the press of starving people came near to toppling their rescuers into the sea. Returning to Malta, Freslon advised the Grand Master to send shipments of grain and biscuit to fill the needs left by the incompetence of the local authorities, and eventually the King of Naples was moved to send a grudging message of thanks.[11] When the French Revolution stripped the Order of its wealth and splendour it was straightforward and devoted men like these who enabled it to survive into a harsher age.

CHAPTER XV

The Closed Crown

Pomp and Prosperity

SINCE 1581 THE Grand Masters of Malta en-
joyed the precedence of cardinal deacons and the
use of the ducal coronet on their arms. In 1607
Wignacourt received the rank of Prince of the
Holy Roman Empire, to which the style of
Serene Highness attached; this was not to the
liking of Pope Urban VIII, who was no friend
of the Empire, and when in 1630 he ordained the
style of Eminence for cardinals he expected the
Grand Master to prefer it. It was Manuel Pinto
da Fonseca, elected in 1741, who joined the
two styles into 'Eminent Highness', a conflation
already employed by the cardinals of the House
of Rohan who succeeded each other as Prince-
Bishops of Strasbourg. The Grand Master further
adopted for his arms the closed crown of royalty
which, excessive as it appears to English heraldic
eyes, had already long been in use by the other
sovereign princes of Italy.

Pinto's ambitions led him into a preposterous
scheme to acquire the island of Corsica, which
he coveted for its royal title. Here he was blocked
by France, which annexed the island for itself; in
matters of pomp and precedence, however, the
sovereigns of Europe seemed only too willing to
oblige him. Under Pinto's reign the ambassador
of the Order received in France the *honneurs
du Louvre* (the right to enter the Great Court in
a carriage), in Rome the use of the *sala regia*,
and royal honours likewise in Spain. Pinto also
began to confer titles on the Maltese, thus creating
a nobility well affected to the Order, unlike the
perennially jealous baronage of Notabile. His

autocratic temper made him refuse to summon a
Chapter General, in the fear that it might limit
his power, even though the responsions last
assessed in 1631 were now inadequate for the
needs of the Order. As a result, by the end of his
long reign there was a debt of nearly two million
scudi, and the annual deficit, including interest
on this sum, ran at 120,000 *scudi*.★

Pinto, however, did not behave like a prince
who was short of money. He remodelled the
magistral palace, rebuilt the Auberge of Castile
with a grand façade and a beautiful arcaded
courtyard, founded the University of Malta, and
built the magnificent warehouses alongside the
port. It was these last that were the key to his
confidence, for the Malta over which Pinto ruled
enjoyed one of the most thriving economies in
Europe. Despite the tradition of enmity with
Turkey, which continued to produce moments
of tension, Malta was the natural staging post
for trade between Turkey and France, a status
accentuated by the knights' 'special relationship'
with the latter. So thoroughly had Maltese navi-
gation penetrated the Ottoman Empire that Paros
and its neighbouring islands in the central Cy-
clades were becoming informal Maltese colonies.
A flourishing export trade in cotton with France
and Catalonia was gathering momentum, and in
1765 the grant by Louis XV of the privileges of
French citizenship to the Maltese put the finish-
ing touch to the partnership. Malta's trading
position was improved by measures making
Valletta partially a free port, and by the excel-
lence of Manoel's quarantine arrangements.

A conflict with Charles VII of Naples illustrated
the strength of Pinto's position. That prince, a

★ The *scudo* was valued at ten to the pound sterling or *louis d'or.*

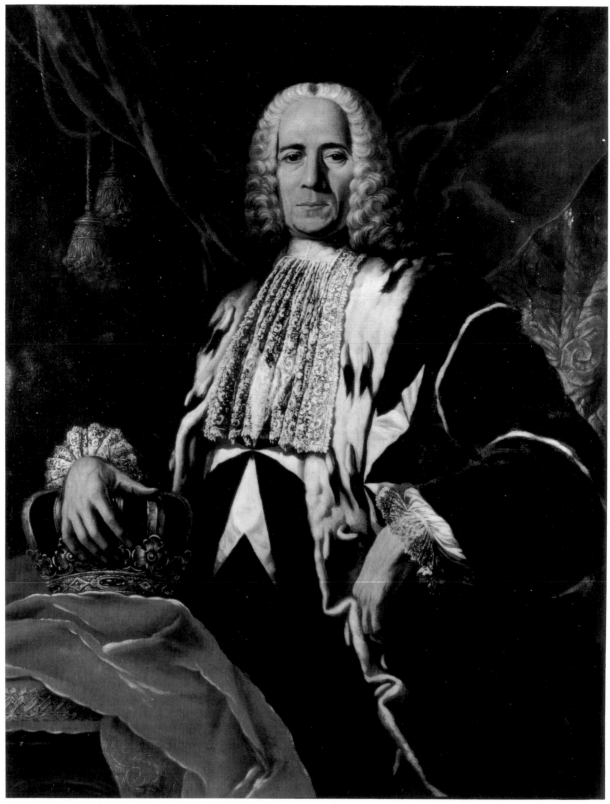

Grand Master Manuel Pinto da Fonseca.

The Auberge of Castile rebuilt by Grand Master Pinto.

member of the Bourbon dynasty of Spain, had taken advantage of Austria's involvement in the War of the Polish Succession to conquer Naples and Sicily in 1734–35. In the same predatory vein he endeavoured to turn his feudal suzerainty over Malta into outright control; where the Habsburgs had scrupulously respected the rights of the Order, Charles VII lost no opportunity to add this apparently slight fragment to his domain, and in 1754 matters came to a head when he imposed an eleven-month embargo on Maltese trade to enforce his claim. But Pinto remained resolute. Malta was too valuable to France as a trading post and to Sardinia for protection against Algerian corsairs, and the intervention of both kingdoms instructed Charles VII in the realities of Mediterranean politics.

Pinto's policy of prestige was responsible for many of the advances the Order made in the second half of the eighteenth century; nevertheless his preference for autocracy delayed necessary reforms, and matters were not improved by his uninspired successor, Ximenez; his brief reign witnessed a 'rebellion' by a group of Maltese priests, who resented limitations that the Grand Master had placed on their hunting rights. Despite its comic-opera character, an incident of this sort was damaging, and gave a handle to the Order's enemies in Europe.

A French Grand Master

The election that followed Ximenez's death in 1775 was won by Emmanuel de Rohan de Polduc, the first Frenchman to attain the Grand Mastership since 1697, and under his rule a distinguished period opened in the history of Malta. The name of Rohan is perhaps the noblest in France, originating in the ancient Kings of Brittany, and the great magnates who held it boasted the motto, 'Roy ne puy, duc ne daigne, Rohan

Auberge of Castile, the courtyard.

suy.'[1] The Grand Master's family, however, traced only the remotest connexion with that princely race; they had enjoyed for many generations a purely local importance as Counts of Polduc, until in 1720 Emmanuel's father had to flee the country for plotting against the government of the Regent Orléans. This contretemps made his fortune; he was received by Philip V of Spain, in whose interest the conspiracy had been made, and married a rich Flemish lady whose father had been an officer in the Walloon Guard. Emmanuel was able, in spite of his father's exile, to attend the Jesuit college of La Flèche. At the age of eighteen he was chosen as Gentleman of the Bedchamber to the Infante Philip, five years his junior, who was soon afterwards given an independent court as Duke of Parma. After conducting a special embassy to Vienna Rohan returned to France, where he was taken up by Prince Constantin de Rohan-Montbazon, who was a Knight of Malta, and by the Princesse de Marsan, a Rohan-Soubise by birth; either they did not realise how very much *à la mode de Bretagne* he was their kinsman or else they were motivated by the extraordinary jealousy their family displayed for the honour of their name.★ Through their patronage he was admitted into the Order of Malta and later received a gift of 100,000 *scudi* from Louis XV to enable him to carry out the office of General of the Galleys; during his tenure of that command he found himself in Naples when the Emperor Joseph II and the Grand Duke of Tuscany arrived on a visit to Ferdinand IV, and distinguished himself by the splendour of his entertainments to them. Probably few Grand Masters had come to the throne with such wide experience of the courts of Europe.

★ In 1782, when the Prince de Guémenée (a Rohan-Montbazon) went bankrupt, Madame de Marsan gave up all her fortune to pay his debts and retired to a convent.

Partly through Rohan's ability, partly through fortunate inheritance of his predecessors' plans, his first seven years saw an extraordinary series of improvements in the affairs of the Order. He began by attacking the financial deficit, appointing as Secretary of the Treasury Jean de Bosredon de Ransijat, a young knight of Auvergne with advanced views and a talent for mathematics; he promptly threw the antiquated accounting documents on the fire and rebuilt his department from the ground. Despite this valuable service, Ransijat was one of a radically minded party among the French knights who set out to use the Chapter General summoned by Rohan in November 1776 to push forward their own policies; these were to strip the Grand Master's power of the accretions of a century and a half of absolute rule, to prevent the proposed increase in responsions, and to reform the Order's government in the interest of a knightly oligarchy. Although their initial weapon was a strict appeal to the letter of the ancient statutes, their ulterior object was to abolish the Order's character as a religious institution and turn it into a purely military and nobiliary body, thus ending its dependence on papal authority. With the contempt for the common herd characteristic of progressive opinions, they tried to exclude the chaplains and sergeants from participation in the Chapter General, at the same time bitterly resenting Rohan's breaking down of the old exclusiveness that had kept the Maltese out of magistral society.

The Chapter General opened with a sharp trial of strength between the reformers and the Grand Master. The attempt to limit voting to the knights was defeated, with the chaplains and sergeants forming a solid magistral party. The reformers' legalism broke down on their irreligion, one of them being rejected as representative of Provence when he failed to take Communion as the statutes required. Ransijat, seeking to challenge the capitular nominations which tradition allowed to the Grand Master, took refuge in an appeal to papal authority, of which he was generally no assiduous advocate; he protested to the Inquisitor, and the other champions of humanity associated themselves with his action. The Chapter General rejected the plans of

the advanced party, reaffirmed the religious discipline of the Order, promulgated new rules to enforce the duty of caring for the sick, and voted an increase in responsions so as to double their yield to half a million *scudi* per annum. Thus assisted, and with Ransijat's reforms in the Treasury, the Order's revenues advanced from a deficit to a surplus of nearly 80,000 *scudi* in 1788.

That this result was not achieved sooner was due to the enormous undertakings currently being shouldered in Europe – part of a great expansion of the Order's possessions which went some way towards making up the losses suffered at the Reformation. Already in 1763 Frederick the Great of Prussia had arranged the nominal reunion of the Grand Bailiwick of Brandenburg with the parent Order, and Rohan even induced the Protestant knights to resume the payment of responsions. In 1775 the Order of Malta completed the absorption of the ancient hospitaller order of St Anthony of Vienne, whose possessions lay mainly in France.★ The benefits of the agreement were curtailed by the intervention of the Comte de Provence (the future Louis XVIII) in favour of his own Order of St Lazarus; nevertheless Malta acquired new revenues of 195,600 *livres* a year, and although the bulk of this was

Gold coin of Grand Master Rohan, 1778, with the Order's arms incorporating the double-headed eagle of the Order of St Anthony, recently absorbed.

★ As a result of the union the Order of Malta in 1777 adopted as supporter in its arms the double-headed imperial eagle which had been granted to the Order of St Anthony by Maximilian I. Unfortunately this design, so appropriate on both historical and artistic grounds, has since been forgotten and replaced by the nondescript mantle.

Bailli Johann von Flachslanden (1739–1822), the last Turcopolier of the order. An active royalist during and after the French Revolution, he was proposed as Grand Master in 1802 and had the distinction of being the only candidate to be vetoed by the First Consul Bonaparte.

absorbed, until the outbreak of the Revolution, by compensation payments, there was a concrete achievement in the foundation of a new priory of *Dames Maltaises* in the old Abbey-General of Saint-Antoine-en-Viennois.

In 1776 an agreement was ratified for the institution of a Grand Priory of Poland, with six family commanderies created from a bequest of the Prince of Ostrog which had hitherto been usurped by various noble families. Though of limited value, the Grand Priory represented a creditable solution to a problem which had eluded the Order's efforts for a century. A much more valuable foundation was that made in 1780 by

the Elector Charles Theodore of Bavaria, one of the most cultivated of the German princes of his day; he formed the Grand Priory of Ebersberg, or Bavaria, with a Bailiwick and twenty-four commanderies, from the property of the dissolved Jesuit Order. To group these two new priories it was decided in 1782 to revive the defunct Langue of England as the 'Anglo-Bavarian'. An imposing palace was assigned as its Auberge in Valletta, and the long-dormant office of Turcopolier was conferred on the Alsatian Baron de Flachslanden, who had already proved his worth as a servant of the Order and was to confirm it amply in the hard days of the Revolution.

The Grand Master's Court

With these advances in the efficiency and dignity of the Order, Rohan attained the eighth year of his reign in such good fortune as merit seldom receives from fate. In Malta his direction had been fruitful. In place of Pinto's somewhat provincial grandeur, Rohan introduced the habits of taste and breeding of the European courts. Fleeing from the gaunt mass of the magistral palace in Valletta, he preferred to spend his days in Paule's country mansion of Sant'Antonio, driving out in his coach-and-six with his equerry riding ahead and two carriages following him, and returning to Valletta only in the evening. In the gardens, already famous for their multitude of orange and lemon trees, he laid out lawns in the French style, and embellished the grounds with rose trees, pools and fountains. From these pleasances came the gifts of blood-oranges – reputedly the most exquisite in Europe – of lemons, pomegranates and orange-flower water which were sent to the Queen of France and the great ladies of Europe. In Valletta the Château, as it was known to the French knights, also felt Rohan's civilising hand. He loosened the stiff etiquette that had formerly governed all, lunched with his friends, held *conversazioni*, opened the doors to the Maltese nobility who had been so rigorously excluded, and was the first Grand Master to admit ladies to his levees.

Rohan heard Mass in the Château every morning, and at midday would emerge into the audience room, dressed in the short velvet robe of ordinary wear; it was here that the ambitious assembled to pay court to him, and the officers of the household waited to attend him in the *promenade*. At luncheon and dinner he was entertained by an orchestra which he had formed from the Regiment of the Guard. A hundred of the finest wines of France figured in his cellars, and he also received tribute from the vineyards of the Order's commanderies from Portugal to Hungary. Music and the theatre were his passions, and he followed Pinto in lavishing his favour on the performances; the knights themselves formed two companies, the French for comedies, the Italian for operas, and gave celibate entertainments in which the Pages and younger knights took female parts and sang the soprano roles.

On Sundays and feast days the Grand Master processed to the conventual church with the attendants known as the *Compagnia di Maestro*. He sat on a throne on the gospel side of the high altar, under a canopy of crimson velvet, with four Pages standing at his side. In the middle of the church the Grand Crosses in their ample gowns occupied a separate enclosure. The Prior of St John was enthroned opposite the Grand Master, trailing yards of scarlet moiré like a cardinal; or if he officiated he used the mitre and crozier, and his gloves were laid on a superb tray of baroque silverwork; two acolytes fanned him alternately with huge gold-handled peacock-feather fans. Behind the altar in their sumptuous stalls sat the chaplains in the violet *mozzetta* and *cappa magna* which they were privileged to wear. The Feast of Our Lady of Victory on 8 September, the anniversary of the raising of the Great Siege, was celebrated with exceptional pomp; in the morning the Grand Crosses assembled in the palace in full dress and processed with the Grand Master to the church; amid martial music and the discharge of artillery the standard of the Order was carried in by a knight of Auvergne, followed by the entire Langue; and a Page dressed in white and gold bore the jewelled sword and dagger which Philip II had given to La Valette, and which were presented to the Grand Master and borne upright during the singing of the gospel.

The magistral household was composed exclusively of knights, chaplains and sergeants of the Order.[2] At its head was the Seneschal of the Palace, a Grand Cross, who presided staff in hand when foreign dignitaries were entertained. Next to him came three great officers who enjoyed the honours of Grand Crosses even without holding that dignity: the first was the Steward of the Household (*Premier Maître d'Hôtel*), who presided at meals and directed three *sous-maîtres d'hôtel*, one for each of the three palaces; while the houses of Valletta and Sant'Antonio were those most frequently used, Rohan also went eight or ten times a year to the Boschetto (tradition prescribed this venue for the festivities of St John's Day), and gave banquets of forty to eighty people. The next great officer was the Master of the Horse (*Cavalerizze Major*), who gave the Prince his hand when he entered his carriage and had charge of the stables, where a staff of forty gave royal care to Rohan's fifty-two horses; in

Silver glove tray with the arms of Grand Master Pinto.

the small realm of Malta these had little travelling to do, but it was the Grand Masters' custom to lend their carriages to distinguished visitors. The third great officer was the Receiver of the Revenues.

First of the lower officers was the Grand Chamberlain (*Chambrier Major*), who presented the shirt at the Prince's *coucher*; his department consisted of four chamberlains, sergeants at arms, to whom one applied for audiences. The Equerry (*Sous-Cavalerizze*) had more detailed charge of the magistral stable. The Falconer supervised the exiguous hunting of the island and bred the famous Maltese falcons which were sent in token of fealty to the King of Naples, and, as was by now the custom, to other sovereigns who favoured the Order with their protection. The last of the knights of the household was the Captain of the Guard. There was an Almoner at the head of a staff of four chaplains, and a more numerous body of sergeants at arms included the Master of the Wardrobe, and the Butler, who supervised the buffet and poured the Grand Master's wine. All these attendants formed a perfectly disciplined staff who, together with the less official frequenters of the palace, impressed visitors by the obedience and respect shown towards their Prince, for it was by paying court to him that one could hope to attain the higher ranks and richer benefices of the Order.

A special group of the Grand Master's attendants was constituted by the Pages, usually numbering sixteen, though Pinto seems briefly to have had twenty-four.[3] Competition for admission as Pages was strong; they were drawn on average from an even more distinguished nobility than the mass of the knights; and their three years' service next to the person of the Prince made them something of a *corps d'élite* from which many of the Grand Masters themselves were drawn. Their livery (which seems to have changed with each Grand Master) followed the fashion of the time, with no concession to boyhood in cut or coiffure and Rohan's pages looked extremely smart in a white tail-coat with scarlet waistcoat and breeches. The cross was worn on a broad black ribbon round the neck or in a bow over the heart. Two of the Pages were in attendance on the Prince at every moment, and are often included in official portraits, evidently being considered as much a part of the Grand Master's *tenue* as a pair of wig-ribbons. They waited in the ante-room known as the Pagery, next to the sovereign's suite, and had

the task of carrying the Grand Master's hat and stick, fans to keep him cool in summer, or torches to light his way at night. They waited at meals, all of them together on ceremonial occasions, serving the guests on silver plates, or at Rohan's evening buffets, when the guests were allowed to give them sweetmeats or pièces of partridge from the table.

Malta on the Eve of the French Revolution

The charm of the society over which Rohan reigned is displayed to us in the memoirs of Ovide Doublet, who in the 1780s was the deputy to the Grand Master's Secretary for French affairs. Although, as an actor in the betrayal of 1798, Doublet is concerned to paint the blackest picture of the Order, his narrative cannot help giving us more pleasant glimpses, such as the time when he was convalescing from an illness, and so many knights, from the Grand Master downward, sent him presents of wine that he still had bottles left ten years later.

Doublet's immediate chief, the Chevalier de Varrax, was a lunatic who took it into his head to forbid Doublet's marriage to a Maltese girl, which therefore had to be celebrated in secret. When Varrax was sent off home, completely insane, Doublet asked his successor, the Chevalier de Loras, to disclose his marriage to the Grand Master. It turned out that Rohan had known about it all along; he immediately doubled the secretary's salary and sent a carriage to bring him and his wife to the Château. They entered the ante-chamber packed with the great officers of the Order, who looked them good-humouredly up and down, and as they passed through Doublet heard one of the noble celibates murmur to his neighbour, 'Elle est, ma foi, jolie à croquer', to which the other replied, 'Oui, si elle ne l'était déjà.'[4] Rohan received them in his cabinet with great kindness, to which Doublet's wife was too young and too shy to answer, but when they left she showed her husband a beautiful amber rosary which the Grand Master, as she kissed his hand, had pressed into hers under cover of her *faldetta*.

Another picture of the island's society is given by Patrick Brydone, who visited Malta in 1770.

'Knights and commanders,' he tells us, 'have much the appearance of gentlemen and men of the world. . . . The French skip, the German strut, the Spanish stalk are all mingled together in such small proportions that none of them is striking.' Yet national differences were important. The French knights tended to dress in black, in contrast to the gaudier Spaniards; one spotted the German by his red heels and the corner of handkerchief hanging from his pocket, the Italian by his long sword. The French even kept their own time, an hour behind the official one, seeing no reason to adjust their watches in the fact of being six hundred miles east of Versailles. The rivalries springing from this variety were among the factors that made Malta, in Brydone's words, 'one of the best academies of politeness in this part of the globe', for any knight who failed to learn an exquisite consideration for the sensibilities of his neighbours might find himself atoning for his error in a duel. That it was strictly forbidden made no difference to its vogue in a society that was the quintessence of the military and aristocratic ethos.

With the middle class and the newer magistral nobility (as distinct from the baronage who kept to their mansions in Notabile) the knights had easy relations. Paradoxically, celibacy was not a barrier but a bond, for the knights had no families to create a colonial style of society, and it was the custom for a knight to attach himself to a Maltese family, to whose domestic circle he could retire in search of feminine company. Less innocently there were the numerous mistresses and prostitutes of the island. Contemporaries thought that sexual morality was higher, at least on the surface, than in earlier times, but that was a very relative virtue. Brydone, watching a group of ladies waving farewell to the galleys setting out for Tunis, discerned, with the peculiar penetration conferred by a Protestant conscience, that they were all the mistresses of the departing knights; on the other hand Roland de la Platière, who was in Malta six years later, rebutted such slanders and affirmed that Malta was quite as decent in sexual matters as France itself – a testimonial which, from the age of the Marquis de Sade and the *affaire du Collier*, may be felt as less than overwhelming. It is significant, however, that such varying judgments were made, since the truth is that the knights, like their observers, brought with them the different *mores*

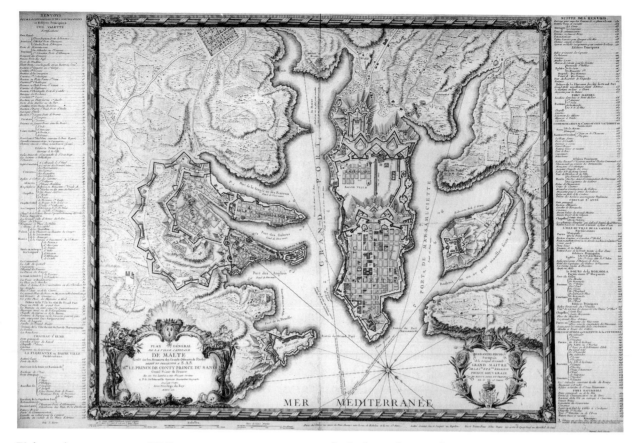

Eighteenth-century map of Valletta.

of their respective countries. Rohan himself, though devout, was no puritan, and in the later 1780s we find him in a discreet affair with Marie de Rohan-Montbazon, when she was in her early twenties and he forty years older.★ Rohan's attitude to such matters was of the eighteenth, not the twentieth century; when a Maltese woman came to him to complain that her daughter, a child of ten or twelve, had been raped by a young French knight, he considered that an indemnity of 1,500 *scudi* from the culprit satisfactorily atoned for the offence.

In 1785 a prominent Bohemian knight, Count Kollowrath, founded a masonic lodge in Floriana; although Freemasonry had been officially condemned by the Church, the nobility of those pre-revolutionary days were inclined to take such prohibitions with a pinch of snuff, and membership was not necessarily a mark of anti-clerical or advanced opinions. Rohan was himself an adept, having been initiated while in the household of the Duke of Parma, and when the Inquisitor tried to have the lodge closed he ignored the protest; but according to Doublet the Inquisitor was also a Freemason, and had only acted under compulsion from his auditor (who had been alerted to the existence of the lodge by the mistress of one of its members, a chaplain of the Order). Not until the French Revolution had awakened fears of the dangers of Freemasonry was the lodge closed, in 1792.

Historians in search of an easy explanation for the débâcle of 1798 have imposed a view of the eighteenth century as a period of decadence, and have laboured to discover symptoms of decline, some of them mutually contradictory, many of them quite fictitious. In reality, if one were to seek a period of imminent disintegration in the Order of St John it would not be the eighteenth but the fourteenth century, with a Grand Master

★ She was the daughter of the Prince de Guémenée, whose bankruptcy has been alluded to, and great-niece of Prince Camille de Rohan-Montauban, one of the Grand Master's leading supporters. Neither she nor any of the other Rohans whom historians refer to as the niece, nephew, uncle etc. of the Grand Master were, in the normal sense, related to him at all. Marie died shortly after the fall of Malta and was buried with her former lover in his tomb in the church of St John.

deposed, Fernandez de Heredia lording it over Provence and Aragon, Gonçalves Pereira debauched and insubordinate in Portugal, and Germany in open schism. The knights of the eighteenth century were far better behaved; it was a reflexion of their age that they were courtiers, diplomats, connoisseurs, more polite, more cultivated, and admittedly less pious than their predecessors. Yet in the last respect too we should judge them against the standards of their time, and remark not that they obeyed them but that they resisted them so strongly. In 1776 proposals to secularise the Order had been decisively rejected; most Knights of Malta regarded their vocation with respect, some of them with profound devotion, and it is significant that, while the great monastic houses such as Cluny and Saint-Denis were dwindling towards extinction, entry into the Order of Malta in the late century was experiencing a brisk revival.[5]

The facts of this period show us an Order giving unmistakable signs of vigour and renewal, undertaking its own reform, eliminating the abuses that had cheapened its dignities, improving its administration, adding to its commanderies and priories, and adapting itself to the new seriousness of the age. From no less an observer than Montesquieu it merited the judgment: 'C'est l'Ordre peut-être le plus respectable qu'il y ait dans l'univers, et celui qui contribue le plus à entretenir l'honneur et la bravoure de toutes les nations où il est répandu.'[6] Far from seeming an anachronism, it was acting very much as an institution of its time, the classic expression of that ethos of the *noblesse d'épée* which was showing a strong revival in the later eighteenth century. Malta, in full consonance with that development, had become the finest officers' academy for the fleets and armies of Europe. The French navy still drew thence its most illustrious names – Suffren and de Grasse stand at their head; even more important were the Knights of Malta to the navies of the southern European states. A more unexpected example is Russia, where Catherine the Great, wishing to create a galley fleet in the Baltic, called on the services of the young knight Giulio Litta, who formed the new force and by his decisive action at the Battle of Svenskund in 1790 saved the Russian fleet from disaster.

Above all, the show-piece of the Order was Malta itself. Magnificently defended, sumptuously built, efficiently regulated and astonishingly prosperous, eighteenth-century Malta was a prodigy state as surely as seventeenth-century Holland or sixteenth-century Venice were. The energy of the knights communicated itself to the inhabitants and created an industrious population in strong contrast, as Brydone found, to the character of neighbouring lands. 'We found ourselves in a new world,' he writes. 'The streets were crowded with well-dressed people, whereas at Syracuse there was scarce a creature to be seen and even those few had the appearance of disease and wretchedness.' 'The police,' he also tells us, 'is very much better regulated than in neighbouring countries, and assassinations and robberies are very uncommon.' Law and administration were thoroughly reformed by the *Code Rohan* of 1782 and by the *Diritto Municipale*; Rohan improved the care for the poor and the sick, re-endowed the university, stimulated learned studies, and housed a magnificent collection of books in the stately building, with its fine arcaded portico, which still forms the library of Malta. In its combination of benevolence and efficiency the Malta of Rohan had few rivals in Europe, and his government deserves the name of an enlightened despotism more truly than those of European princes who made their countries bleed for their ambition.

Enemies and Malcontents

Yet if the Order of St John preserved important strengths on the eve of the French Revolution, it also suffered from weaknesses, one of which came to the surface, like a suppurating wound, in the Auberge d'Auvergne. In May 1783 the Langue elected as its acting head and Vice-Marshal Déodat de Gratet de Dolomieu, and the malaise that had been growing under absentee Piliers was brought to a head. Dolomieu was an abrasive man who had been deprived of his habit for killing a man in a duel, but had been pardoned through the intercession of Louis XV – a grace which did nothing to reconcile him to the Order – and with his election the school of rebellious, free-thinking reformism that had seemed defeated in the Chapter General was pricked to new life. He began by attempting, in the name

of his own authority as Vice-Marshal, to undermine Freslon's attempts to reform the Guard Regiment,★ and when he failed in this resigned in high indignation against the 'sycophants' who believed in obedience to the Grand Master. He retired to Naples, where he found scope for further trouble-making in the secret negotiations between that court and Catherine the Great to transfer the suzerainty of Malta to Russia – a plan to which Dolomieu alleged the Order was party.

Charles VII had left the Kingdom of Naples to his third son, the proletarian Ferdinand IV, to whom nothing so intricate as a policy could be imputed; but his marriage in 1768 to Caroline of Austria revived the malicious vigour of his monarchy and its harassment of the Order of Malta. Caroline held similar views to those of her brother Joseph II, who even while their mother Maria Theresa still ruled in Austria began to prefigure his own brief reign of priggery, bullying and blundering. He was seconded by the anti-clerical minister Kaunitz, who had seen fit to warn the Order's ambassador in Vienna that the Grand Master had better reform his knights 'if he does not want to oblige us to reform them ourselves'. When the Chapter General increased the responsions, Joseph and his minister were delighted at an opportunity to attack the Order while preserving the support of the German knights. They refused to let the new levy be applied to Germany, and forced Rohan to accord the Emperor the right to determine himself the responsions to be paid by his subjects.

These pin-pricks against Malta were the product of the fashionable anti-clericalism of the time, but an equal danger emerged from the Holy See, to which the knights owed religious obedience. Frustrated by the growing secularism of the European courts, the papacy sought compensation by meddling in the one state where its authority was still paramount, and fostered the indiscipline of disaffected knights. Dolomieu returned to Malta in 1786 and sought a place on the *Consiglio Compito*; in the election, which reflected his own virulent character, one of his supporters publicly insulted his opponent, Charles-Abel de Loras, the leader of the magistral party in the Langue of Auvergne – a proved diplomat and a man of honesty and sufficient charm to overcome the disability of a slight hunchback. Loras was elected by thirteen votes to seven, and the offender was imprisoned for his insolence, though Loras interceded to have him pardoned. To Dolomieu's liberal zeal, however, rejection by a majority of his own Langue was an injustice that demanded an appeal to sacred authority; for the next three years he pursued an attempt to obtain a brief from the Pope reversing the election and appointing him to the Complete Council. His case became bound up with an even more outrageous appeal, which the Inquisitor in Malta chose to support, by which a young novice attempted to evade a punishment imposed by the Grand Master.

The situation in which the Order found itself was well summed up by Loras:

> Our principles and maxims are wise, our chiefs are impartial and just. But Rome and Naples undo the good we do by protecting trouble-makers. Yet despite obstacles, agriculture and commerce are on the increase, our political system is solidly and nobly united, our army, our navy, our magazines, our workshops are in better condition than our means really permit. The Treasury . . . is now nearly out of the wood. What then are the urgent reforms we must carry out? It is not we who must reform, it is the arbitrary jurisdiction of Rome that tyrannises over us, to whom the virulent detractors of law, order and obedience fly at the first sign of trouble.[7]

Within a few months Loras was to find himself the chief victim of the evils he denounced; in August 1788 he was summoned to Rome to answer Dolomieu's accusations, and here events took a disastrous turn. Like Rohan and his Roman ambassador Brillane, Loras was a Freemason, and in Rome he was introduced by Brillane to Cagliostro, who was posturing about Europe as 'Grand Copht of the Egyptian Lodge'. Loras, although he described Cagliostro as 'ce fameux charlatan', seems to have regarded him as a useful ally in gaining the support of Brillane, and invited him to hold séances in the Villa Malta for the aristocracy of Rome. When in 1789 Brillane was transferred to Paris, Loras hoped to strengthen his own position by succeeding him as ambassador, especially since his rival for the post, Prince Camille de Rohan, was

★ See p. 221.

a friend of Dolomieu's. Cagliostro, who had his own reasons for wishing to see his ally promoted to diplomatic status, wrote to the Grand Master in tones of inflated pomposity and darkly hinted menace, demanding the embassy for Loras 'by virtue of the authority in us invested to make known to you the wishes of Eternal Providence'. This nonsense helped Rohan to decide in favour of Prince Camille, but it also shook his confidence in his hitherto trusted servant Loras.

While these events were unfolding the French Revolution was in its first months, and one of its immediate effects was to complete the downfall of Loras. The papal government, believing that the French were planning to use the Freemasons to export the revolution to Rome, ordered the arrest of Cagliostro. Dolomieu improved the occasion by spreading word that Loras was about to be arrested also, and the unfortunate Bailiff had to withdraw rapidly to Naples. It would have gone worse for him but for the fact that just at that point the knights of Auvergne elected him to the vacant office of Marshal, thus enabling him to return to Malta and assume the headship of the Langue. Nevertheless, the events of the past year had destroyed his authority, and Rohan, to whom he would have looked to restore it, now regarded him with insuperable aversion. This state of affairs, as will be seen, became a not unimportant cause of the fall of Malta.

CHAPTER XVI

Ruit Alto a Culmine Troia

The French Revolution

WHEN THE ESTATES GENERAL were summoned in France in 1789 Rohan was concerned to dissociate the Order, as a sovereign and independent body, from the classes on whose privileges a fierce attack was foreseen.* Nevertheless the nature of that attack was such that no separation was possible: in August the National Assembly abolished all tithes and feudal rights; since the bulk of the Order's revenues were in dues of this kind, the blow was a very grave one. Inescapably, the Knights of Malta were closely identified with the royalist party; many of them joined the emigration, and the Chevalier d'Estourmel, the *chargé d'affaires* in Paris, lent Louis XVI 12,000 francs (£500) out of the Order's funds for his attempted escape from France in June 1791. When this resulted in his capture at Varennes and return to Paris in the hands of a revolutionary mob, it was the end of effective monarchism in France, and Rohan, on hearing the news, suffered a stroke which left his right side partly paralysed for the six years of life that remained to him. It was thus the calamity of the Order that in these most critical years its fortunes were in the hands of an invalid.

The beginning of the end came in August 1792, when the King was imprisoned in the Temple. Estourmel protested against this violation of the Order's property, but the revolutionaries had passed the stage of diplomatic respect, or even recognition. In October a new law confiscated the entire property of the Order in France, valued at 112 million *livres* (nearly £5,000,000). Three-fifths of the revenue that the Order had drawn from its European estates was thus wiped out, and the knights of the French Langues were left penniless. In Malta the deficit was partly covered by such expedients as selling silver and dissolving trusts, but Rohan's reluctance to suppress institutions to save money dismayed his secretary, Doublet. In particular the subsidy on corn, which assured cheap bread for the Maltese poor, was maintained, building up a debt of one-and-a-half million *scudi* by 1798. The contempt for penny-pinching that the Order showed in these years of adversity was truly aristocratic: it was the spirit of the Chevalier d'Estourmel, who as he prepared to leave Paris in the catastrophe of 1792 turned aside from the spoliation which robbed him of his livelihood to help out of his own pocket some dispossessed nuns of the Order. In the same manner Rohan sold all his jewels and gave orders to his household: 'See that I have one *scudo* a day for the expenses of my table and distribute the rest to my distressed brethren.'

For the Knights of Malta as for the rest of Europe, the guillotining of Louis XVI in January 1793 deprived the Revolution of the last vestige of moral right. Rohan refused to recognise the Republic and maintained the accreditation of the royal envoy in Malta. When in August a rebellion at Toulon gave the town to the royalists an opportunity was presented to intervene. Rohan offered six hundred knights and the Maltese navy to help hold the town, but the English, on whose support the rebellion relied,

* It was at this time that the expression 'sovereign Order of Malta' came into use to affirm its distinction from other religious orders.

234

refused the offer, and the most hostile action taken by the Grand Master was to close Valletta to French ships when Naples entered the war against France, as the terms of Charles V's donation required of him. One must attribute it to the illness of Rohan and the disgrace of the Marshal, Loras, that no stronger lead was given, and that these weak gestures marked the high point of Malta's counter-revolutionary vigour. From these years of nerveless leadership and mounting adversity flowed the demoralisation that led to the disaster of 1798.

As the European struggle against France faltered, Maltese policy lapsed from weakness to incoherence. In 1795, the year that Prussia, Holland and Spain dropped out of the war, Rohan forbade his subjects to enlist in Condé's *émigré* army; but at the same time the Chevalier de Thuisy proposed a secret agreement to Britain opening Valletta to British ships, while a Maltese contingent was to help garrison Corsica, which had just accepted George III's sovereignty. Nothing resulted from this proposal, and in the following year Rohan accredited an ambassador to the French Republic, recognising the failure of the counter-revolution.

The conquests of the French were striking further blows at the Order in Europe, so that at the end of 1797 Etienne Poussielgue reckoned the value of German revenue lost at 40,954 *scudi* and the Italian at 235,335; but suddenly the clouds were lightened by a sun-burst in the East. Paul I, who succeeded to the Russian throne in November 1796, was an ardent admirer of the Knights of Malta, and summoned to his side the Balì Litta, who had so distinguished himself in the Russian navy six years before.★ He proceeded to overwhelm with his patronage the Polish Grand Priory, which had passed under his sovereignty by the Second Partition of Poland, paying its arrears and increasing its responsions to 53,000 florins (£1,200). One of the Order's least valuable possessions thus became a significant source of revenue.

Until 1797, whatever confiscations might strike the priories in Europe, no-one (not even the French) had any thought of the capture of Malta. The rising at Toulon had cost France her Mediterranean fleet, sunk in the harbour as the English sailed out, and there had not been time

to rebuild it. When in October 1796 Spain entered the war on the French side, obliging the British navy to relinquish Corsica, the most Bonaparte could propose was that Spain should control Malta, with French backing. But by the following May his own army gave France the means of more direct possession; the conquest of Venice put the Republic's fleet at France's disposal, and the consequent annexation of the Ionian islands brought French power into the central Mediterranean. Then, in July 1797, Rohan died.

The death of the Grand Master could not have fallen at a more unlucky moment. Of Rohan, Doublet wrote, 'S'il eût vécu un an de plus, tout valétudinaire et souffrant qu'il était, il aurait péri sur la brèche, plutôt que de signer la reddition de Malte, comme l'a fait son successeur'.[1] We may believe this, yet it is also true that if Rohan had succumbed immediately to his stroke in 1791, or within two or three years of it, the Order could have elected a successor of competence and vigour, and would have been spared the disorientation of Rohan's last years and the disgrace of 1798. Now, in 1797, that freedom was denied to it. The fall of the French Langues made a French candidate out of the question; neutrality required a choice from a country that was not at war; but, more than this, it was imperative to find a patron capable of giving the Order some effective protection, and the choice was thus reduced to Austria and Naples. There was in fact a Neapolitan (Frisari) who put himself forward, but given the unvarying policy of the dynasty he served there was still ample reason to fear that patronage from that quarter would bring more danger than security. That is why weeks before Rohan's death it was already considered a certainty that a German would succeed him. To these considerations we should add that just at this moment the chances for peace in Europe seemed particularly fair: the elections of spring 1797 in France had proved so favourable to the conservatives that a monarchist restoration was being talked of. Thus even the most principled legitimist might feel that a policy of diplomacy was the one best calculated to end the nightmare raised by the Revolution.

No German had ever been elected to rule the Order of St John; the smallness and isolation of the Langue had militated against it. Yet there had frequently been, as there were in 1797, knights of that nation who could most fittingly

★ See p. 231.

have held the office. Unfortunately the only German in a position to present his candidature on the death of Rohan was Ferdinand von Hompesch, who since 1775 had held the post of imperial ambassador in Valletta. Hompesch was the typical minor diplomat of the eighteenth century: empty-headed, with a shrewd sense of whom it was valuable to cultivate, much attached to pomps and ceremonies, ingratiating and spineless. He had held no naval or military command in the Order, but represented the class of knights who made their careers by influence and royal favour. When Joseph II refused to accept the increased responsions of 1777, Hompesch had lent himself to that policy and had profited from the dispute to acquire a commandery as 'compensation' for the insult to the imperial majesty. He had since turned his attention to winning popularity in Malta by a liberal use of other people's money, and at the time of his election he owed eight years' rent for his *palazzo* in the Strada San Giovanni, 21,000 *scudi* to the late Grand Master, 12,000 to the Monte di Pietà and sundry debts to members of the Maltese nobility. Though he held a pension from Rohan and a collection of the best commanderies in Germany, he had not disbursed a penny to help the destitute French knights since the Revolution. In 1796 he had succeeded the Bailli von Schönau as Pilier of Germany, and was thus the only German Grand Cross resident in Malta. A malign convergence of circumstances focused the choices of the Order on the one man who could be trusted to dishonour it.

Hompesch spent the eleven months of his reign cultivating an impression of unruffled normality, and scattered privileges in place of the money that was so uncomfortably lacking. There is no doubt that he remained highly popular with the Maltese throughout his rule in the island, and even after the ignominy of his departure. In international affairs he looked to Russia for his chief support, and named the Emperor Protector of the Order. Like Rohan's brief anti-revolutionary acts, these policies have been blamed as provocations to France, but such criticisms are beside the point. The notion that the Republic's lust for annexation depended, for action or restraint, on the behaviour of its victims is a piece of historical naivety. The real failings of Hompesch's policy were different, and showed the disadvantages of rule by a diplomat instead

Grand Master Ferdnand von Hompesch.

of a soldier. While cultivating political support in Europe, Hompesch took no action to secure Malta's military position. Six weeks before his election the French seizure of the Ionian islands placed the possibility of an attack on Malta unmistakably on the chessboard of war; and if France held back there was the prospect of a preventive blow by Britain or Naples to be considered. These were threats to which no diplomatic defence existed, yet Hompesch had one strategic card to play: the impregnability of Valletta. His course was to make sure of loyalty and morale, and to ensure so firm a defence that no power could have attempted conquest without a disproportionate expenditure of military effort. On both these counts Hompesch's failure was abysmal; although the appearance of seventeen ships under Admiral Brueys off Malta in March 1798 gave early warning of France's intentions, dispositions for defence were allowed to lapse until the very day that the vanguard of

Bonaparte's fleet was sighted off Malta. The Grand Master's inactivity destroyed any sense of common purpose among the knights, and full liberty was allowed to those French and Spanish residents who in the event of an attack could be expected to act in the interests of the invader.

The loss of Malta

Bonaparte had been urging on the Directory the conquest of Malta since May 1797, but found no hearing for his views until the Jacobin *coup d'état* of September that year, which replaced the moderate, pro-royalist government with one dedicated to an aggressive prosecution of the revolutionary war. Bonaparte at once repeated his advice, pointing out: 'With the island of San Pietro, which the King of Sardinia has ceded to us, Malta, Corfu, etc., we shall be masters of

the whole Mediterranean.' Talleyrand's reply authorised him to give instructions to Admiral Brueys, and an ambitious expedition was planned for the following spring.

In December 1797 Bonaparte sent an agent, Etienne Poussielgue, to Malta with a list of possible republican sympathisers supplied by Dolomieu, who was living in France and was to arrive in Malta as scientific attaché of the Egyptian expedition. Poussielgue's mission was to seek out friends of the republican cause, and he found them among the men who had formed the anti-magistral circle of the seventies and eighties: Jean de Fay, Dolomieu's friend and correspondent; Bosredon-Ransijat; Rouyer, who held the office of *Maestro Scudiere*; and a handful of others inside and outside the Order. In the great majority of the two hundred French knights in Malta Poussielgue identified, on the other hand, the main fighting strength of the island. They

General Bonaparte lands in Valletta, June 12th, 1798.

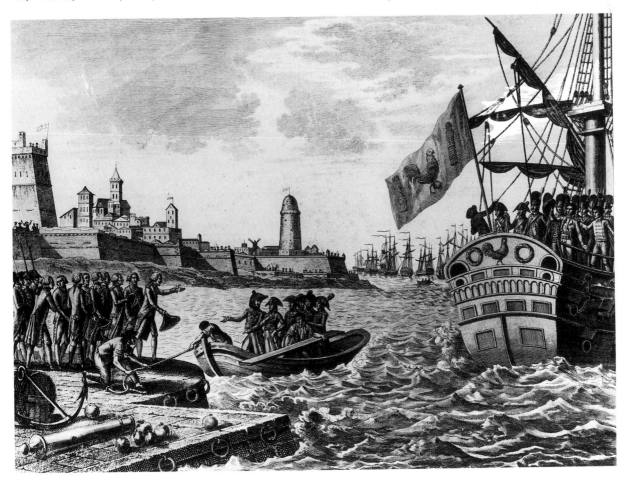

Louis-Ovide Doublet, Secretary for French affairs to Grand Master Rohan. In the 1790s he led the party opposing action against republican France, and played a part in the betrayal of Malta to Bonaparte in 1798.

the powers friendly to the Order who are here are informed of it as I am, but they know also that the fortress of Malta is impregnable, or at least in condition to resist for three months. May your Eminent Highness take guard: it is a matter, Monseigneur, of your own honour and the preservation of the Order; and if you yield without having defended yourself, you will be dishonoured in the eyes of all Europe.

This letter is of especial significance from a man who, having served as Grand Bailiff in Malta from 1787 to 1796, knew equally well the strength of the island and the weakness of his compatriot, Hompesch; it is also eloquent of Schönau's fear that the Order had chosen as Grand Master the man least competent to face the approaching danger. It reached Malta on 4 June, a few days before Bonaparte's expedition, but Hompesch preferred not to believe it. 'Let us pray to God', he said, 'that we shall not be attacked.'

Not until 6 June, when the first frigates of the French armada appeared off Malta, were preparations made to defend the island. A plea for help was sent to the British fleet, but did not reach Nelson until 20 June, when he replied that he was making all possible despatch 'to preserve your island from falling into the hands of the common enemy'. By then he was a week too late. In Malta the command of the defence was apportioned between six of the Grand Crosses, most of them men of ability; but what stands out is the want of central direction. Loras, who was still Marshal, was loyal and efficient; he organised a sally of three ships which attempted to oppose the French landing at St Julian's Bay, but broken by the humiliations of the past nine years he lacked the authority to exercise his proper command.

Hompesch frankly admitted his ignorance of military matters, and left the defence wholly to the Congregation of War; unfortunately his non-intervention did not permit him even to ensure that this body was reliably composed. By a singular aberration it counted four out of its eleven members who were favourable to the cause of France: Bosredon-Ransijat, the Financial Secretary, Fay, Commissary for Fortifications, and the Directors of Artillery and Engineering, Bardonenche and Toussard. Whether any treachery, apart from Ransijat's open defection, is attributable to these men cannot be certainly

were, he said, 'des royalistes inabordables', and with the desperate intransigence burnt into them by the disasters of the past eight years they would defend Malta to the last breath.

At the Congress of Rastadt, summoned in 1798 to decide the fate of the Holy Roman Empire, the Order had a *locus standi* through the Grand Prior of Heitersheim, as a German prince. His delegate, the Bailli von Schönau, soon discovered that a French attack on Malta was being widely talked of, the Directory having issued a secret decree on 12 April 1798 ordering Bonaparte to seize the island on his way to Egypt. Schönau wrote to Hompesch:

I advise you, Monseigneur, that the considerable expedition that is being prepared at Toulon has as its object Malta and Egypt. I have it from the very secretary of M. Treilhard, one of the ministers of the French Republic at the congress. You will certainly be attacked. Take all measures to defend yourself suitably. The ministers of all

discovered, although accusations were later made against Bardonenche and Toussard. What is obvious is that this Trojan Horse was fatal to any coherent strategy of defence.

A fallacy that has often been repeated in connexion with the fall of Malta is that the French knights at heart sympathised with the invaders; as we have seen, this is the reverse of the truth. Poussielgue arrived at a very exact estimate of the number of knights favourable to the Republic: fifteen (a figure he repeats several times), of whom only three or four had what he called the energy to work actively for France;* the remainder he recognised as the most resolute element of the defence. The received view, while casting undeserved suspicion on the French, has distracted attention from the genuine responsibility of the Spanish for the surrender. Spain was in active alliance with the French Republic, and the Spanish minister, Don Felipe de Amat, forbade his fellow subjects to take part in the fighting; they therefore spent the siege in their Auberges, from which the knights of Castile, observing the Chevalier Anthony O'Hara in danger of being massacred by a mob of demoralised soldiers, issued out and rescued him, thus rendering the only service given by their nation in the siege. In administration, Bardonenche may have used his position in the artillery to hamper the defence, and the contribution of the Commander Vargas, a member of the Council, was to urge the acceptance of Bonaparte's demand that the French fleet should be admitted to Valletta.

The forces at the disposal of the Order consisted of some 300 knights and about 7,000 soldiers, between regulars and militiamen. The fortifications were in excellent condition, the defensive ring having been completed with Fort Tigné as recently as 1793, and were defended by 1,400 cannon. Against them there sailed into view between 6 and 9 June a French fleet of five to six hundred vessels carrying an army of 29,000 men. These were formidable odds but, given the strength of Valletta, by no means hopeless ones. On 7 June General Desaix sent a request that the eighty ships with which he had arrived that day be admitted into the harbour to take on water. The Council resolved to apply a regulation of long standing, intended to safeguard Malta's neutrality, that only four should be admitted at a time. This answer was taken on the evening of 9 June to General Bonaparte, who had by then arrived with the bulk of the armada.

Early on the morning of the 10th Bonaparte dictated his reply: he declared himself indignant that such a condition was imposed, and viewed it as constituting Valletta an enemy city. Before this communication was delivered the Council had received, at seven in the morning, a letter from the Financial Secretary to the Congregation of War, Bosredon-Ransijat, declaring: 'When I became by vow a member of Our Institution I did not contract any other obligation beyond that of warring against the Turks', and begging to resign his office and observe a strict neutrality. He was immediately consigned to a cell in Fort Sant' Angelo.

The French attack, organised into three landings on Gozo and at St Paul's and St Julian's Bays, began without loss of time. An important tactical error made by the Order was the decision to oppose the invasion throughout the archipelago, instead of withdrawing all available forces behind the walls of Floriana and Cotonera; besides ensuring that the fighting opened with a series of defeats, this decision deprived the central defence of courageous leaders, who made isolated and useless stands at Gozo and Fort Rohan while the French overran the rest of Malta. The division of General Vaubois, which had been entrusted with the landing at St Julian's Bay, was opposed by three vessels of the Order which dashed out and succeeded in sinking a landing boat before they were forced back. Part of the Malta Regiment also opposed this landing but quickly withdrew into Valletta. With no further hindrance, Vaubois marched on Floriana, where the defenders, observing an advance party take up an exposed position, sallied out. The French fell back and the inexperienced Maltese troops were lured forward into an ambush; in the retreat they lost their colour ('the Standard of the Order', said Bonaparte in his report, as if it had been snatched from the height of the Grand Master's palace).

* His caution was more than justified; when Bonaparte expelled the French knights from Malta he exempted only three (Ransijat, Fay and Rouyer) on the grounds of their assistance to the French cause; the rest of the fifteen had evidently been insufficiently energetic.

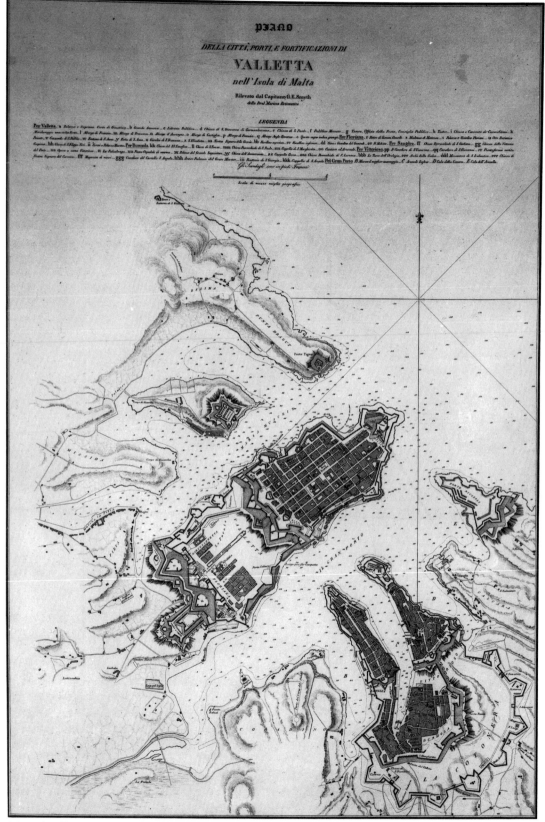

Map of Valletta in 1798.

Despite accusations of cowardice made by commentators devoid of military knowledge, these forays demonstrated a verve which good sense, let alone caution, would have repressed. And other examples of the ancient courage of the knights were not wanting: of the eighty-year-old Bailli de Tigné, who had himself carried onto the ramparts by his soldiers to be where an officer ought to be, leading his men; of Giovanni Tommasi who attempted to hold the hopeless position of the Naxxar lines with 400 raw militia-men against the division of General Baraguey-Hilliers. Yet as that forlorn defence collapsed there were already signs of the defection that was to bring the Order down. Notabile was surrendered without resistance by its Maltese governor; that evening the Spanish minister Amat dined Generals Vaubois, Marmont and Lannes at his house on the south coast.

His guests sat down in some security, for by the evening of the 10th the French troops had occupied the Sliema peninsula and set up their artillery against Fort Tigné; the investment of the Four Cities was complete. It was the situation that the Grand Master ought to have chosen as the first defensive position, one which might have presented the French with an impasse for weeks if not months; but the useless alarms and losses of the day turned the atmosphere among the Maltese into one of panic and defeat. Shortly after midnight a deputation of notables went to Hompesch and urged him to ask Bonaparte for an armistice. 'If I were Grand Master,' raged the Balì Carvalho Pinto, 'I would see you hanged.' But Hompesch, ever the slave of popular regard, sent them away with vague words.

As doubt and indecision increased, the sense of treachery propagated itself through Valletta. The simpler Maltese, who had not quite grasped how the French could be both their officers and their enemy, yielded to the whispers of republican agents that the French knights were out to betray them. When the morning of 11 June dawned desertion sapped the walls of Cotonera more effectively than the besiegers; two knights were murdered by their mutinous men, and Suffren de Saint-Tropez (the brother of the great admiral) fled from his command at Senglea to bring news of the collapse of discipline; very different was the conduct of the Bailli de la Tour du Pin Montauban and sixteen of his knights, who when their men deserted carried powder to the guns with their own hands in a desperate defence of the position entrusted to them.

Their courage was wasted; Hompesch had already decided to yield to the Maltese pleas and seek an armistice. In vain Loras entreated him on his knees to hold out in Valletta till the English fleet should arrive. Hompesch did not know that Nelson was at that moment off Toulon and that, summoned by the news of Bonaparte's dash to Malta, he would reach Syracuse by 22 June, neither did he know that Bonaparte had orders to abandon Malta if its resistance should threaten the success of the Egyptian expedition. Nevertheless it was plain that the report of the French attack on Malta must bring English intervention within a few weeks at the outside. The Bailli de la Tour du Pin believed that Hompesch was ordered to surrender Malta by masonic lodges in Germany, and he might be forgiven for thinking the Grand Master's pusillanimity beyond the reach of cowardice or incompetence to account for. One might say that Hompesch, as a diplomat, considered not the military possibilities of Valletta's resisting Bonaparte but the political impossibility of Malta's resisting France. Or, perhaps more realistically, one might say that his behaviour was what was to be expected of a man who had spent his life toadying to the powerful in detriment to the interests of his Order.

One small acquittal Hompesch is entitled to: he had not, at this stage, formed the purpose of surrendering Malta to the French; his object was to seek some compromise that would satisfy Bonaparte's demands. At six in the evening a ceasefire, negotiated by Dolomieu, was declared, and intermediaries were sent to discuss terms of agreement on Bonaparte's flagship. They were chosen for their innocuousness to the most aggressive French scrutiny: Amat, whose Francophile zeal had been made amply apparent; the Balì Frisari, minister of Naples; Bosredon-Ransijat, whose well-timed refusal to serve his Order established him as *persona gratissima;* and four members of the Maltese nobility and bourgeoisie. Amat and Frisari, as accredited diplomats, ought to have been the decisive members of this delegation, but as Frisari spoke very poor French and remained silent throughout the discussions, Amat was in practice the arbiter of the negotiation, and he assumed the purpose of serving his country by handing over Malta to its

ally. Here again the role of Spain in the betrayal of the Order was important.[2]

The sea was so rough that the delegates did not reach *L'Orient* until after midnight. Bonaparte briskly dictated to them the capitulation of Malta, but, much as his demands exceeded their brief, they were seasick enough to have signed away an empire, even to a less forceful adversary. They were sent back to Valletta with a document that surrendered Malta with compensation in the form of pensions to the French knights and the promise of a German principality for the Grand Master. Hompesch, appalled, refused to ratify the treaty, but made ready to receive the conqueror in Valletta, again demonstrating his faultless diplomatic sense allied to complete ineffectiveness in action. When La Tour du Pin came to him, blazing with outrage from his useless stand at Cotonera, Hompesch greeted him with a weak smile: 'What would you, my dear Bailli? All was lost.' 'It is now, Monseigneur, that all is lost – and honour above all.'

Bonaparte landed on that morning of 12 June and made his way on foot into the city. His General of Engineers remarked to him as they passed through the massive fortifications, 'It is well, General, that there was someone within to open the gates to us. We should have had trouble in working our way through had the place been empty.' Hompesch was permitted to leave the island, taking away, of the riches of the Order, only the Hand of St John and the icon of Our Lady of Filermo. All the other valuables – the treasures of the Grand Master's palace, the sacred ornaments of the churches, including the inestimable treasure of St John's, the silver utensils of the Hospital – were seized by the French and packed aboard *L'Orient* to accompany Bonaparte to Egypt. In the week before he left he issued a multitude of decrees to eradicate the traces of the Order's rule and remodel Malta as a democracy on the French pattern. He set sail on 19 June, leaving Vaubois behind with 3,000 men and a civil government headed by Ransijat. On the night of 1 August Nelson destroyed his fleet at anchor in Aboukir Bay, and the flagship, rent by a tremendous explosion, took the Order's treasure with her down into the shallow waters of the anchorage, where it lies to this day.

Some fifty French knights accepted Bonaparte's invitation to join the army of Egypt. They included the republican sympathisers whom Poussielgue had found six months earlier,

Icon of Our Lady of Filermo, from Rhodes. This relic was brought away from Malta by Grand Master Hompesch and sent to Czar Paul of Russia. After the 1917 Revolution it was taken to Yugoslavia and is now lost. Its vicissitudes inspired the story of *The Maltese Falcon*.

but the motives of the majority, who saw their last hopes annihilated by the surrender of Malta, were fairly judged in the comment of the Chevalier de Boisgelin: 'Pity is the only sentiment they inspire in my breast; yet I cannot help remarking that no situation, however desperate, can ever justify the commission of a dishonourable act.' The remaining hundred and fifty French knights preferred beggary to the service of a regicide republic. Some of them made their way to Russia, where the barely credible tale of Hompesch's disgrace seemed to speak of nothing other than treachery. On 26 August the Russian Priory, many of whose members were themselves French exiles, issued a manifesto declaring that they regarded Hompesch as deposed, and invoking the protection of the Emperor of the Russias; the Priory of Germany immediately seconded their action, repudiating its own unworthy son.

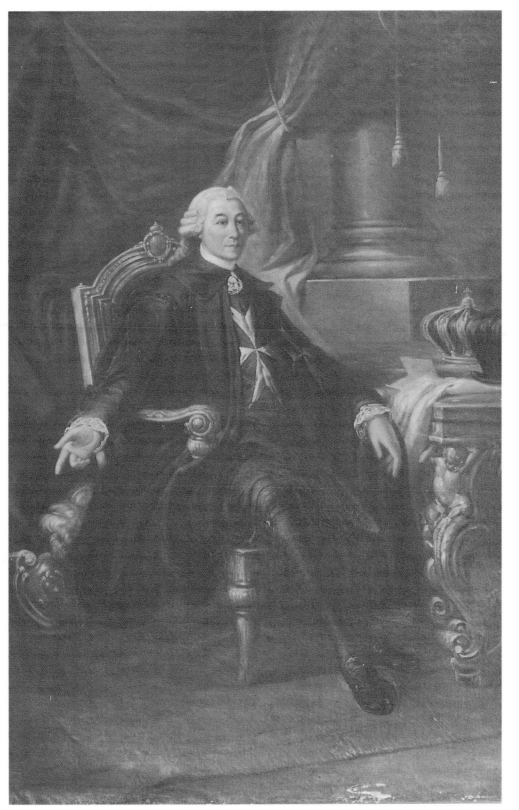

XIX. Grand Master Emmanuel de Rohan.

XX. Gobelins tapestries in the Council Chamber of the Grand Master's Palace.

The Czar as Grand Master

The outrage of the knights was justifiable; but the Emperor's impatience to see himself at the head of the Order he so cherished next pushed his followers to an indefensible absurdity. On November 7th the Russian Priory, assisted by sundry adherents from elsewhere, took it upon itself to elect Paul I Grand Master. His favour was ever more lavish; at the beginning of the new year he created a second Grand Priory for the Orthodox nobility of Russia, as well as special squadrons of the Baltic and Black Sea fleets entrusted to the Knights of St John. Yet even if the whole Order had acclaimed him nothing could have legitimated the choice of such a head: a man who was not a professed knight and was, by religion and marriage, irremediably disqualified from being one.

Paul proceeded to enforce recognition of his title with a brisk insolence of diplomatic method surpassed only by the French. The Spanish minister, for failing to attend his 'coronation', was given a few days' notice to depart; the Bavarian almost suffered the same fate, until the assent of the Elector was made clear. Charles Theodore, however, died in February 1799 and his revengeful successor lost no time in suppressing the Priory of Ebersberg. A threat to devastate Bavaria with an army of 50,000 Russians instantly called him to heel. When in March the Pope signified his disapproval of the election, the Nuncio was ordered out of St Petersburg. Louis XVIII authorised the French knights to recognise the Czar; the Kings of Naples and Portugal followed, and when the German Emperor reluctantly accepted the usurpation Paul had almost the whole Order under his control. Only the four Spanish priories repudiated him. In June 1799 Hompesch yielded to the pressure of the German Emperor and abdicated his office.

The consequence of the Czar's claim was to make him in his own eyes the rightful sovereign of Malta, and here the means had already appeared to make good his title. Within seven weeks of the French annexation the Maltese had risen against the new government, goaded by the exactions and sacrilege of the conquerors (as Vaubois expressed it, 'the priests have fanaticised the people'). For two years the Maltese endured enormous privations while they kept the French

Giulio Litta, after Wigny, by I.S. Klauber.

garrison besieged in Valletta, with feeble support from Britain and Naples. During all this time it would have been open to the Russian Emperor to clinch the siege with forces of his own and take possession of the island; yet, although a squadron was ordered through the Dardanelles in December 1798 and remained in the Mediterranean until 1800, it did everything but head for Malta. Official British policy at that time supported Russia's claim to the island, but its idiosyncratic agent in the Mediterranean was Nelson, who considered that the fate of Malta should be decided by Britain and Naples, and it was partly his influence at the Neapolitan court which frustrated the intentions of his own government and diverted the Russian forces from their goal.

The increasingly unbalanced Emperor was exercising his power by showering the Cross of Malta on all who took his fancy; his mistress Madame Lapoukhine was one of the recipients. When she fell from favour the Emperor used to call nightly upon her successor, Madame Chevalier, attired in the habit of the Grand Master. In the political field Paul began in 1800 a flirtation with France, where Bonaparte had

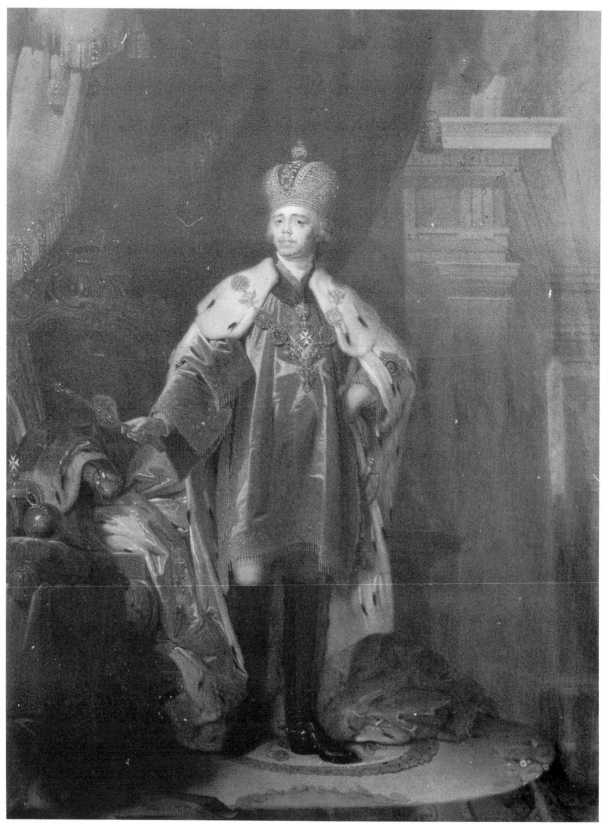

Czar Paul of Russia as Grand Master of the Order.

seized power as First Consul; the consequence was to cool British zeal for a Russian presence in Malta. When Nelson's fleet at last secured possession of Valletta in September 1800 the Czar, still ostensibly Britain's ally, demanded the cession of the island, and receiving no reply responded by forming the League of Armed Neutrality and planning to recover Malta through alliance with the French. Isolated day and night in his moated palace of Mikhailow, the Emperor was living his last months in an atmosphere such as Tacitus describes surrounding another doomed tyrant: 'He returned to the empty and desolate Palace, where even the lowest of his household had fallen away or avoided his approach. Terror lurked in the deserted and silent halls; he tested the locked doors and trembled in the empty rooms.'[3] On the night of 23 March 1801 Paul was strangled by a group of his courtiers, among whom were four of his Knights of Malta. The most bizarre episode in the history of the Order ended in a fitting key.

Principes persecuti sunt me

Paul's son, the young Alexander I, appointed the Bailli Soltykov as Lieutenant of the Order, but renounced both the Grand Mastership and the claim to Malta, with a view to a regular election and a legitimate claimant. The same ends were envisaged by the Treaty of Amiens, signed a year later, which stipulated that Malta should be returned to the knights, though on the condition that French and English members should be excluded from the Order. It only remained to find a Grand Master to take possession. With notable disinterest the Russian council decided to relinquish its control and, in order to circumvent the difficulties and delays of a Chapter General, proposed that the Pope should appoint a Grand Master from a list of candidates nominated by each Priory. Even this solution, however, was not proof against the Order's enemies. The King of Spain made official the *de facto* schism of his four priories, subjecting them to his own rule, and thus (with the exclusion of the French Langues) reducing the Order to only eleven of its priories. Bonaparte, having described the plans for Malta as 'a romance that

could not be executed', urged Bavaria to a second attempt at abolishing its Grand Priory, though Russian protection proved strong enough to protect it for the moment; he succeeded, on the other hand, in putting pressure on Pius VII to override the Order's nominations and attempt (September 1802) to confer the Grand Mastership on the Roman knight Bartolomeo Ruspoli. Although Ruspoli refused the offer the delay was fatal; it was not until February 1803 that the place was filled by the appointment of the Balì Giovanni Tommasi, who had played a courageous part in the ill-fated defence of Malta.

Tommasi was living at Messina, from where he immediately sent an envoy to Malta to demand the cession of the island promised at Amiens. Unfortunately in the twelve months that had elapsed since the treaty the international situation had changed for the worse; French annexations had shown that Bonaparte had no thought of letting the treaty inhibit his expansionist aims, while his projects in Tunis and Egypt pointed the danger especially at Malta. It was the elegance of French policy to make the Treaty of Amiens unworkable in practice while leaving to Britain the odium of breaking it in the letter. The military governor of Malta professed to regret that none of the four magistral palaces was in a state to receive its proper occupant, and advised that he would be more comfortable where he was. In fact the British government was making up its mind to prevent France from obtaining a foothold in the central Mediterranean – an intention that was made all the clearer when Bonaparte offered to let Britain keep Malta in return for France's acquisition of Taranto and Otranto. In May 1803, after a year of uneasy peace, the two countries resumed the war, and the return of the knights to Malta receded from the field of practical politics.

Tommasi reconstituted the Convent in Messina by summoning a Chapter General, which ratified his appointment. He refused Bonaparte's attempt to suborn him with a pension of 300,000 francs, and when it was feared that the French fleet might appear at Messina he left abruptly for Catania, where the Duke of Carcaci put an elegant *palazzo* at his disposal. When he died in June 1805 the Convent confirmed the Balì Guevara Suardo as Lieutenant, and on 17 June the thirty-six members present in Catania elected to the Grand Mastership, subject to the

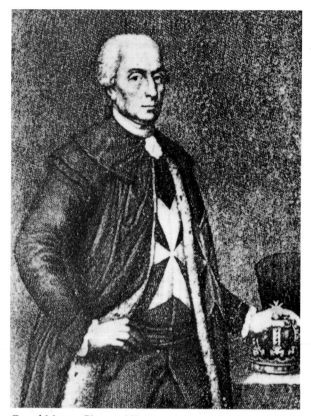

Grand Master Giovanni Tommasi.

confirmation of the Pope, the Balì Giuseppe Caracciolo dei Marchesi di Sant'Eramo. As a Neapolitan, Caracciolo was considered an instrument of that court, and therefore of England; and Pius VII, who was continuing the policy of subservience to France that ended in the annexation of the Papal States, refused to confirm him. The government of the Order thus devolved upon the Lieutenant. When we consider that France's attitude could hardly have been more hostile if the Duke of Wellington himself had been Grand Master, we may regard the Pope's policy as one of the more unnecessary disadvantages the Order laboured under in these and subsequent years. The Czar, however, recognised Caracciolo's title and granted him a pension of 12,000 roubles from the revenue of the Russian priories.

With the death of Tommasi ended the brief respite given to the calamities of the Order; the French invasion of Italy forced the King of Naples, in January 1806, to take refuge in Sicily, and made him a helpless vassal of British sea-power. Guevara Suardo tried to move the Convent to Rome, where its neutrality would be less compromised, but the government blocked this attempt by refusing passports and transferring the Order's treasury to royal keeping in Palermo. It was never returned. A further consequence of the invasion was to put the restoration of Malta out of the question, by making the island an essential base for the defence of Sicily. In August 1806 there were peace negotiations between England and France, in which it was proposed that the former should keep Malta as a permanent possession, and this is the first evidence that such a prospect was envisaged by the British government. The work of hindsight historians, who suggest that as early as the 1780s the days of Maltese independence were numbered, has obscured this point. We have seen that Britain passed over two opportunities, in 1793 and 1795, to bring Malta within its sphere of influence; and after 1798 it was ready to hand back the island to Paul of Russia, the Neapolitans or the knights. Nelson himself, who favoured a more vigorous policy than his own government, urged that Britain's only interest was to keep the island out of the hands of France: 'The possession of Malta by England would be a useless and enormous expense . . . I attach no value to it for us.'[4] The need to retain Malta was only gradually impressed on the British government by the ever-widening aggression of the French in Italy.

The Napoleonic Wars completed the destruction of the Order in Europe. Between 1805 and 1810 the commanderies of Germany, Italy, Bavaria and Russia were swept away; Portugal was ravaged by the yearly invasions of the French; in Sicily Lord William Bentinck tried to have the Order dissolved, and though he did not formally achieve that end, the commanderies were sequestrated for the benefit of the royal Treasury. Only the Priory of Bohemia remained, protected by the Habsburg monarchy, and even that precariously, for in 1813 there was an attempt – foiled only by the diplomacy of the Order's ambassador – to fuse it with the Order of Maria Theresa. That this project should have been conceived by the most conservative, and one may say the most generous, dynasty in Europe shows to what an extent the Order of St John was by then regarded as a thing of the past. After a nine-year government in a period of unmatched disasters, the Lieutenant Guevara Suardo died in Catania on 25 April 1814.

CHAPTER XVII

Resurgence

An Age of Lost Opportunities

THE GOVERNING COUNCIL at Catania had petitioned Pius VII four times to recognise the Grand Master Elect, Caracciolo, but without success, and in 1809 Russia withdrew its recognition of his title. Although he had scrupulously refrained from interference in the Order's government, Caracciolo insisted on his right to grant crosses of Devotion, and a breach developed between himself and the Convent.[1] On hearing of Guevara Suardo's illness he left Messina and was present at the Lieutenant's death-bed; but the Convent ignored his claims to the succession and conferred the Lieutenancy on the seventy-two-year-old Sicilian Andrea di Giovanni. It is indicative of the very small pool to which the ruling body of the Order had sunk that Di Giovanni was not even a Grand Cross at the time. Perhaps the best that can be said of him is that he was not as bad as his successor, but his handling of events at the Congress of Vienna was outstandingly ineffective, and he was later to allow the affairs of the Order to become submerged in local Sicilian politics.

As the Napoleonic regime collapsed in the spring of 1814, golden opportunities presented themselves for the restoration of the Order. In the Austrian Empire the Priory of Bohemia was still in being, but tact was needed to loosen imperial control; in Portugal a similar situation existed after the royal family returned from exile. Greater difficulty appeared in Spain because of the nationalisation of the four priories in 1802, but in the conservative restoration there was every reason to hope for the reversal of a measure that had stood for only six years before the French invasion; the King's brother, Don Carlos, who administered the Grand Priory of Castile, was in favour of co-operation with the rest of the Order. Above all, the fall of the Empire opened the way to a revival of the three Langues of France. The Grand Prior of Aquitaine, Prince Camille de Rohan, held an assembly of knights in Paris in May 1814; they formed the Commission of the French Langues, which received recognition from Louis XVIII and the Lieutenancy in Catania.

The advancing preparations for the Congress of Vienna found the Commission in an extremely influential position. The French government, while withholding recognition from the Lieutenancy's ambassador in Paris, charged its plenipotentiaries at the Congress with protection of the Commission's interests; and in Spain Don Carlos authorised the Commission to act for the Spanish branch of the Order, and gave it a similar status *vis-à-vis* the Spanish plenipotentiaries. By contrast Di Giovanni's envoy to the Congress, the Balì Miari, failed to acquire any comparable influence with the Austrian or other governments; nevertheless the course of enlisting the aid of the French knights, or even recognising their representatives, did not recommend itself to him. Rohan, who was well aware of Miari's hostility, replaced his original envoy in Vienna with the Commander de Dienne, who made every effort to establish cordial relations, but Miari continued to refuse the opportunity presented. The disastrous failure of the Order's claims at the Congress was the all too natural consequence of his jealousy.

Already in May 1814 the Treaty of Paris had confirmed Britain's possession of Malta, nor was there any realistic hope of reversing that

provision. What could be hoped for, though, was some territorial compensation that would have restored the Order's sovereignty, and it is worth examining why this obvious redress was not obtained. Beyond the incompetence of the Balì Miari there was the disadvantage of the Order's despoiled and divided state, compounded by the fact that it still lacked its proper head. Pope Pius VII had denied Giuseppe Caracciolo the Grand Mastership in 1805 for political reasons which appeared the less reputable in the light of subsequent history; now restored to freedom, he showed no disposition to remedy the injustice. In 1814 Caracciolo was still only fifty-two, and he lived until 1839. It was true that he had fallen out with the Convent, but given the character of the Convent that might almost be esteemed a merit. Apart from the Tacitean principle of *odisse quem laeseris*,[2] it is hard to see any motive for the Holy See's policy, unless it was the wish to preserve a weak, unrepresentative, wholly Italian government dependent on Roman control, and ultimately to reduce the Knights of Malta to a papal order of chivalry. The Order was thus denied not only the advantage of a Grand Master to represent its claims but, equally importantly, the unity and cohesion its regular head would have commanded from its different national sections. As in 1802 Pius VII destroyed the knights' chances of recovering Malta, so in 1814 he was instrumental in preventing them from making good their loss elsewhere.

Inept as the Lieutenancy showed itself at Vienna, it failed equally in promoting the Order's fortunes in the years that followed. Whereas Tommasi had called a general assembly in Messina within four months of becoming Grand Master, no advantage was taken of the fifteen years' peace after Waterloo to summon a Chapter General and restore the unity of the Order. When the Convent was first established at Catania it still had the international composition that Tommasi's action had given it, but by 1814 it was degenerating into a purely Italian body; its members monopolised the high offices of the Order, in 'representation' of the other Langues, despite the existence of numerous knights of those Langues statutorily entitled to them. This state of affairs also seems to have

enjoyed the support of the Holy See, although it cannot have escaped any observer that a man like Camille de Rohan, who had been prominent in the Order's councils well before the Revolution, had far stronger personal claims to take part in its government than the nonentities in Catania, whom any more representative assembly would have despatched in a clean sweep of the Order's offices.

What had not happened in these years, however, was a transfer of the Order's government to the Langue of Italy. The men in Catania happened to be Italians, but their authority even in Italy was merely nominal. The Grand Priory of Rome was restored in 1816 essentially to give a title and a revenue to a curial cardinal; the Neapolitan priories, restored in 1815, were as much under royal control as were those of Bohemia and Portugal. All that upheld the Lieutenancy was the insistence of the Pope on regarding it as the exclusive government of the Order, and thus preventing anyone else from governing it in reality.

In contrast the Knights of Malta in France were giving every sign of the vigour which had historically made that the strongest nation of the Order. On Rohan's death in 1816 the presidency of the Commission was assumed by the Grand Prior of Auvergne, the Bailli de Lasteyrie du Saillant. The Commission had secured government pensions for the surviving professed knights,[*] was raising revenue by the admission of many new Knights of Justice and of Devotion, and was gathering influence for a restoration of the Order's properties; for, although the farmlands had generally been sold to private buyers, the woods – which had yielded the bulk of the Order's revenue – for the most part remained in state ownership, and their value was estimated at 29 million francs. The Commission claimed to have the support of 220 deputies of the Chamber for the return of these properties, on condition that the Order found a way of recovering its territorial sovereignty.

The means to achieve this were readily apparent: Metternich made repeated offers of Elba and various Austrian islands in the Adriatic, but the condition of restoring the Grand Mastership under Habsburg control made them unacceptable. Another aspect of Metternich's policy

[*] There were estimated to be ninety of these in France in 1814.

opened a second avenue of hope: the regular international Congresses, at which the question of the Order's restoration could be aired. Miari represented the Order at Aix-la-Chapelle in 1818, but the offer of Elba under the Grand Mastership of a Habsburg prince had to be rejected. In 1821 an Austrian subject, Antonio Busca, succeeded Di Giovanni as Lieutenant at the prompting of Metternich, of whose baneful influence over the Order he became the principal instrument. When a new Congress was summoned at Verona, Busca announced that he would attend it in person; in the event, he neither went himself nor sent a representative, stating as his reason that, according to Metternich, the Congress had no intention of discussing the affairs of the Order.

It seems fair to describe Busca as the worst head, after Hompesch, ever to have governed the Order of Malta. Where Di Giovanni had been supine, Busca was calamitous; where Di Giovanni had neglected to co-operate with the French Langues, Busca seems to have been merely waiting for the opportunity to sever relations with them altogether. This was not long in presenting itself: in 1821 the Greek rebellion against Turkey broke out, and the rebels began their eight-year struggle for independence, while the European powers looked on unsympathetically. In 1822 a Greek deputation sought a meeting with the Lieutenant Busca in the hope of enlisting the armed help of the Knights of Malta against their ancient enemy; but Busca referred the envoys to the Commission of the knights in France. It is said that he did so to avoid revealing the penury in which the Sovereign Order existed at Catania. To the French knights the Greek approach disclosed glittering possibilities: Malta might be lost, but what if Rhodes could be recovered? And if that conquest seemed formidable for the moment, there remained the myriad islands of Greece, on one of which the Order might establish its precious claim to sovereignty. Their own compatriot, Colonel Jourdain, who had entered the service of the rebels, was one of the negotiators on the Greek side. For the Commission the prime mover was its new Chancellor, the Marquis de Sainte-Croix-Molay. It is due to this somewhat fantastical figure that the affairs of the French Langues take on at this time, as one writer has commented, the flavour of a novel by Balzac.

The treaty signed between the Greeks and the French Commission in June 1823 was an agreement between two parties desperate, the one to recover, the other to gain, its independence. Under its terms the Knights of St John were to be granted immediate sovereignty over some small islands off the Peloponnese, already under rebel control, and were promised Rhodes and its neighbouring islands when these should be liberated. In return the French Langues undertook to raise a loan of ten million francs to subsidise the Greeks and to fit out their own naval squadron for service against Turkey; the security was the property in France whose restoration the Order had been promised once it regained its sovereignty.

Given the policy of the European powers against revolution, complete secrecy was essential. The influence of the French knights assured them of the acquiescence of their own government, which was not averse from its subjects' doing what it could not do itself. Austrian policy was much more unequivocally pro-Turkish, and Busca, though he did not actively oppose a scheme that held such promise for his Order, would take no action that might cause trouble with Metternich. Everything turned on the initiative of the French Commission. But by the end of the year the plan was in ruins: rumours of the treaty leaked out in the newspapers; the French government, under pressure from the other powers, repudiated the knights, and the bankers refused the loan.

It was the pretext Busca had been waiting for to rid himself of the French Langues. At his request, the French government withdrew its recognition from the Commission. In vain Sainte-Croix-Molay resigned the chancellorship, and in vain the Commission – including Sainte-Croix-Molay himself – made repeated attempts over the years to repair their relations with the Lieutenancy. Busca remained deaf to all pleas, satisfied that he had succeeded in expelling from the Order of St John the nation which had for centuries furnished its strongest numbers and its noblest leaders.

Elsewhere the Lieutenant's policy was equally barren. In Spain the Order's property had been confiscated in the revolution of 1820, but the invasion of the country in 1823 by a French army under the Duc d'Angoulême – a former Grand Prior of France – to uphold royal auth-

ority gave hope once more that the priories could be recovered; but the severance of relations with the French knights ruined any chances of influence from that quarter, and the Spanish priories reverted to royal control until their confiscation in 1841. The Priory of Portugal followed the same example of separation. But it was close to home that Busca suffered the full penalty for his incompetence; in 1825 the liberal, anti-Austrian Francis I succeeded to the throne of the Two Sicilies, and relations with the Order became icy. Busca decided in 1826 to move the Convent to the papal city of Ferrara, and as a consequence Francis I immediately suppressed the priories in his kingdom.

A Council of the French Langues reconstituted itself at this time under the presidency of the Bailli de Calonne d'Avesnes; it made renewed efforts to raise a loan to assist the Greeks, now with slimmer chances of success. In 1827 the Greek question was decided at Navarino, when the British, French and Russian fleets destroyed that of the Ottoman Empire, and the ensuing Russo-Turkish war obliged the Sublime Porte to recognise the independence of Greece. If the Knights of Malta had been present at Navarino – so the French Langues urged – the terms of the agreement of 1823 would have been satisfied and the Order would have been entitled to its territorial reward. A last flicker of hope appeared with the French invasion of Algiers. The fertile imagination of Sainte-Croix-Molay seized the occasion to propose the establishment of the knights in that city, from which they would police the Mediterranean against Barbary piracy. The papal nuncio in France, Monsignor Lambruschini, who was a member of the Order, supported the plan, but no sooner were the French troops in possession of Algiers than Charles X lost his throne in the revolution of 1830, and the influence of the Knights of Malta at the French court came to an abrupt end. After the despair over the lost chances of the recent past, this proved the death-blow to the Order in France, and from this date it ceased all further activity.★

★ In 1830 the diplomatic relations that the Lieutenancy had maintained with France were also discontinued, leaving only those with the Holy See and Austria and, for a few years, the lesser Italian states.

The Order revives

The death of Antonio Busca in 1834 ended the worst twenty years in the Order's history: twenty years of opportunity squandered by petty self-interest, which made permanent the temporary disasters of the revolutionary period. Apart from the notion of recovering Malta by maintaining contact with disaffected elements in the island, it is impossible to detect any policy held by the Lieutenancy beyond that of preserving the monopoly of power which chance and papal favour had placed in its hands. In these twenty years no Chapter General was held to reunite the Order, no novitiate was founded to perpetuate its religious life, no hospital was promoted to carry on its original duty. Limited to a purely political concept of the Order, the Lieutenancy demonstrated in the political field above all a prodigious incompetence. Morally speaking, the ruin of the Order of St John was brought about not by revolutionary France but by the wretched clique of Catania and Ferrara; to say that it set back the Order's recovery by seventy years would be to state only the factually obvious,

The garden of the Order's villa on the Aventine with its famous view towards St Peter's.

but it would fall well short of the truth; for although by the end of the century National Associations of knights had been founded throughout Europe, they were only a shadow of what the Order's corporate life would have been if it had not been allowed to die, in the years from 1814 to 1834, in France, Spain, Portugal and the Two Sicilies.

On Busca's death Pope Gregory XVI appointed a new Lieutenant, Carlo Candida, and simultaneously summoned the Convent from Ferrara to take up a new residence in the old embassy of Malta in Rome. It might have seemed that the result of papal policy and the Lieutenancy's feebleness had been consummated, and that the Knights of Malta had been reduced to the condition of a pontifical order. Yet such an interpretation would have been the opposite of the truth: the Pope's act had been that not of a despot but of a friend, and one to whom the Order of Malta owes more than has generally been recognised. Gregory XVI recalled Monsignor Lambruschini from Paris and made him a cardinal and Secretary of State; he was to remain throughout that pontificate the principal architect of Vatican policy. In the Lieutenant Candida, the Pope chose the only surviving knight who had held naval command before the fall of Malta, and his years of office saw a resurgence of the Order's life in singular contrast with what had gone before.

Candida immediately asked the Pope for a hospital in which future novices might perform the traditional service of the sick, and the Order accordingly took charge of the hospice of Cento Preti at the Ponte Sisto. The Pope's own nephew, Giovanni Cappellari della Colomba, was the first to undertake this almost forgotten duty, making his vows as a knight in 1836. Moreover, in the quarter-century after 1834 some thirty family commanderies were created in Italy to replace those which had been lost, Gregory XVI himself leading the way by founding two for his own family. In 1839 the Austrian government, seconded by the rulers of Parma, Modena and Lucca, restored the Grand Priory of Lombardy-Venetia, and in the same year Ferdinand II founded the Priory of the Two Sicilies with the remnant of what his father had confiscated. In 1844 even the King of Sardinia, though a liberal and anti-Austrian, reinstated five commanderies.

Gregory XVI naturally wished to restore the Grand Mastership, but Metternich's plans for Austrian control stood in his way, and his derisory proposal to confer the dignity on the young Archduke Frederick (1821–47) had to be rejected; the granting of the title 'Lieutenant Grand Master' to Candida was the sole result of the Pope's intention. In 1845 the succession of the Austro-Italian Colloredo as Lieutenant opened the way to easier relations with Vienna; unfortunately Gregory XVI died only a few months later, and the long pontificate of Pius IX saw a reversion to an attitude of papal indifference, so that it was not till 1879 that the pointless interregnum in the government of the Order was brought to an end.

Colloredo, who had been received as a Knight of Minority in 1783, constituted a personal link with the pre-revolutionary days of the Order, but he led its adaptation to a wholly new period. The professed knights had come to be heavily outnumbered by Knights of Honour and Devotion, a class which had been insignificant before the fall of Malta. Though without constitutional rights, they became the means by which the Order recovered its social and political influence. Above all, the benefit of Colloredo's rule was the reintegration of the German Langue after its years of virtual independence, and it was Germany which took the lead in the revival of the Hospitaller ideals. In 1857 the Austrian Knight of Justice Gottfried von Schröter went to Jerusalem in the spirit of the Blessed Gerard, to found a hospital and novitiate of the Order. The age of Godfrey of Bouillon was past, however; Napoleon III, who had just fought the Crimean War to assert his protectorate of the Latin Church in the Holy Land, refused to permit the establishment except under French auspices. It was not until 1869 that the zeal of Austrian and German knights fructified in the foundation of a hospital at Tantur, between Jerusalem and Bethlehem.

Schröter's first efforts stirred the imagination of the German nobleman August von Haxthausen, who spoke with him on a visit to Rome in 1858. Haxthausen, who was already well known as a figure of the Catholic romantic revival, conceived the ambition of restoring the German Priory; he became a Knight of Justice, and communicated his enthusiasm to a group of other gentlemen of the Rhineland and West-

The hospital of Tantur, near Jerusalem.

phalia, whose association Colloredo recognised in 1859 as the basis for the Priory. In Germany, however, official approval eluded the knights; as a leader of the active Catholic party, Haxthausen was viewed with suspicion by the very Protestant government of Prussia; there were accusations of ultramontanism and Jesuitical influence. Haxthausen was forced step by step to a plan that would have made the Priory virtually a Prussian national order. From that error he was saved by his chief supporter, the Count von und zu Hoensbroech, who though blind was clearer-sighted than his leader; Hoensbroech denounced the proposed statutes as incompatible with the intention of forming a branch of the Catholic Order of St John. In 1864 Haxthausen resigned his position to Schröter, who came from Rome to seek a remedy for the problem; he recognised the impossibility of founding the intended Priory and reformed the association as a religious sodality, whose presidency he later handed over to Count Hoensbroech.

The burning idealism which brought this first national association into being is reflected in its articles of foundation:

The members bind themselves by special and solemn promises to a Catholic life in every sense, for their own persons, for their families and for those who directly depend on their authority, and will do everything possible to make their homes a mirror of simplicity and Christian living, renouncing all distinctions so as to make themselves known only by their virtues. They will strive in every way to conduct themselves not only as obedient and faithful subjects of the holy Church, but as loving sons of this beloved Mother, fulfilling her wishes punctually and without complaint, loving whatever their beloved Mother approves and wishes, and carefully avoiding whatever she disapproves. They will strive in every way to further the Church's spiritual and secular interests.

Since Our Lord puts Christian love before us as a beacon to our childhood, and since all other virtues must derive their life and their true

worth from this same Christian love, the members of this pious association will open their hearts especially to that spring of Christian life, so as to make Him known to other souls through their example and through the life-giving word.

Within a few years the activity of the Rhenish-Westphalian Association inspired imitation in eastern Prussia, where a group of knights united under the leadership of Prince Hohenlohe-Waldenburg-Schillingsfürst, first Duke of Ratibor, one of the most distinguished Catholic German statesmen of his time; thanks to his influence they had no difficulty in obtaining royal approval in 1867 for the Silesian Association. Even before this, both associations had been active in the Danish war of 1864; at a time when voluntary help in war-time was in its infancy, and while the Red Cross was still in the process of being formed, the Knights of Malta mobilised hundreds of male helpers, nursing sisters and military chaplains, and organised numerous field hospitals. This activity was rapidly developed in the wars of 1866 and 1870, to the extent that nearly a third of all the German wounded in the last-named war were cared for through the services of the Order of Malta. The parallel growth of the Red Cross suggested the advantages of collaboration, and the Lieutenant took care to have the Order represented at the second International Conference of the Red Cross in 1869, his envoy, the Knight of Justice Othenio von Lichnowsky, being received as the delegate of a sovereign power. The field hospital established at Flensburg in 1864 was developed into a permanent civil hospital, to which several more were added in Germany over the years, while the Italian knights maintained since 1859 an operating theatre in the Hospital for Incurables in Naples.

In England the revival of the Order followed the initiative of the convert Sir George Bowyer, 7th Baronet, who became a Knight of Malta in 1858. Through his patronage the community of Sisters of Mercy who conducted the Hospital of St Elizabeth were given the privilege of wearing the cross of Malta, and their establishment developed into the Hospital of St John and St Elizabeth built on the pre-Reformation property of the Order in St John's Wood. In 1876 the British Association of Knights of Malta was formed under the presidency of another young convert, the 7th Earl of Granard.[3] It is significant that the first three national associations were formed in countries where the Catholic community confronted a strongly Protestant national ethos, and their emergence can be seen to form part of the Catholic revival of the nineteenth century.

This aspect came to prominence in the *Kulturkampf* of the 1870s, when the German knights were called upon to bear public witness to their principles. The Rhenish-Westphalian Association, with eleven members in both Houses of the Reichstag, was especially active in resisting the assaults on the Catholic Church, while among the Silesian knights Count Ballestrem suffered imprisonment for his activity.

In 1877 an Italian Association was founded, parallel to the still-existing Grand Priories, for the specific purpose of directing the military medical services of the Order. In 1885 an agreement was signed restoring the 'Langue of Spain', independent since 1802, to the unity of the Order. Since the Langue had neither commanderies nor professed knights its restoration was merely nominal, and in 1891 it was supplemented by a National Association on the pattern of those in other countries. In the same year recognition was granted to the French Association, which had been formed in 1881 under the presidency of the Duc de Sabran-Pontevès.* Thus through the appearance of six associations, each formed with its own aims in response to different circumstances, the direction was marked for the future advance of the Order, which was now re-established in every principal country in Western Europe. Moreover the Holy See at last brought to an end the seventy-four-year interregnum imposed on the Order's government, when in 1879 Pope Leo XIII restored the Grand Mastership in the person of the Lieutenant Ceschi a Santa Croce.

* Attempts to revive the Order in France had been frustrated by the hostility of Napoleon III, even though the Empress Eugénie, who belonged to one of the noblest families of Spain, was a Dame of Honour and Devotion. It was not till the fall of the Second Empire that steps could be taken to rally the French nobility to the Order in which they had once played such an illustrious role.

The Protestant Orders of St John

An interesting adjunct to this historical process is the revival of Protestant orders of St John, which ran parallel to that of the Sovereign Order in Germany and England. The Grand Bailiwick of Brandenburg had been converted in 1812 into the civil Order of St John, but as traditionalist sentiment gained ground in Prussia King Frederick William IV was moved to restore the Grand Bailiwick in 1852, with his brother Prince Charles as its *Herrenmeister* and its eight surviving members constituting the governing council. So scrupulous was Prince Charles in observing ancient forms that he notified the Lieutenant Grand Master Colloredo of his appointment, in default of the Grand Prior of Germany to whom that courtesy was formerly due, and Colloredo replied welcoming the foundation as a bulwark against the baneful principles of the age. The *Johanniter* have been at least as active as their Catholic brethren in promoting the Hospitaller duties of their Order, and early collaborated with the Rhenish-Westphalian and Silesian Associations in providing medical assistance in the wars of German unification.

An odder history is that of the English Order. It originated in the Mediterranean schemes of the French Langues in the 1820s, as a means of securing the indispensable support of Britain for the attempt to recover the Order's territorial sovereignty. Through the agency of the Irish knight Denis O'Sullivan, who had entered the Langue of France in 1783, the Priory of England was 'revived', the Prior being a chaplain of George IV who styled himself Sir Robert Peat. With such sponsors, the Priory had no hope of being recognised by Busca, but it continued unsuccessfully to seek acceptance from the Lieutenant Carlo Candida; the veterans of the old Barbary patrols must have been puzzled by these Quixotes of romantic Toryism, buckling on their armour to tilt at cotton-mills. The group eventually acquired the patronage of the 7th Duke of Manchester, who in turn secured the membership of the Prince of Wales (Edward VII) and opted for the more attainable aim of recognition by the British Crown. The Priory

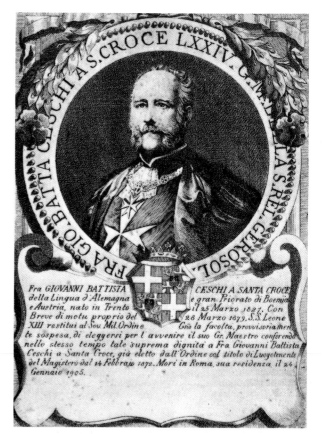

Grand Master Ceschi a Santa Croce.

received a royal charter in 1888 as the 'Venerable Order of St John'. In 1890 the Duke of Manchester was succeeded as Grand Prior by the Prince of Wales, who showed his reverence for the office by choosing the prioral costume invented by the Duke to attend the famous fancy-dress ball at Devonshire House in 1897.* The Venerable Order has maintained the Hospitaller traditions of its ancestor and has rendered sterling service as the organiser of the St John's Ambulance Association.

The Order in Wartime

In 1910 the Duc de Caylus, President of the French Association, founded a hospital for the care of the wounded in wartime, and shortly afterwards the Italian Association distinguished itself by its service in the Tripolitanian war, in

* The choice derived piquancy from the fact that his hostess had previously been Duchess of Manchester, during which time she had been the mistress for over twenty years of her present husband, the Duke of Devonshire.

The hospital ship *Regina Margherita* under the Order's
flag in the Italian-Libyan War, 1912.

which its hospital ship the *Regina Margherita*
transported and cared for 12,000 wounded. The
First World War furnished the occasion for very
extensive activity in all the combatant countries:
in Germany the knights administered two hos-
pital trains, nine hospitals and numerous infirm-
aries, besides organising the collaboration of
some sixty Catholic religious communities and
hundreds of military chaplains; in Austria eight
hospital trains were maintained, besides field
infirmaries, three hospitals and four convales-
cent houses; in Italy the Order's services in-
cluded four hospital trains, a field hospital,
another hospital for the gravely wounded, and
various medical posts; in France the Association's
military hospital functioned for four years in the
most exposed part of the line.

Politically speaking, the course of the war
represented a serious set-back for the Order.
The Grand Master, the Austrian Galeas Thun
Hohenstein, was obliged to withdraw to Swit-
zerland on Italy's entry into the war, and he was
imprudent enough to invest the Order's funds in
Austrian war bonds. The fall of the German
and Austrian Empires deprived the knights of
much of their influence in those countries, even
though Thun Hohenstein was rapidly able to re-
establish diplomatic relations both with the
Austrian Republic and with Hungary. When he
returned to Rome in 1920 dealings with the
Italian government could hardly be cordial, and
matters were by no means improved by the fact
that, as his estates lay in the part of Tyrol
annexed by Italy, he had arguably become an
Italian subject. In fact, despite its loyalty to the
Holy See and its connexions with the Black
aristocracy of Rome, the Order had always
contrived to preserve surprisingly favourable
relations with the Kingdom of Italy, which
recognised its sovereignty in documents of 1869,
1884 and 1923, and accorded the Palazzo Malta
extraterritorial status. When the Fascist govern-
ment set about restoring the city of the knights
in Rhodes, the undertaking was celebrated by an
international assembly of the knights in 1928, at
which the Governor of the island symbolically

Hospital train of the Grand Priory of Bohemia and Austria in the First World War.

handed over to them the keys of the magistral palace and put the knights in possession of the Auberge of Italy.

The prospect of good official relations with Italy was opened up by the Lateran Treaty, which early in 1929 recognised the sovereignty of the Vatican City. Thun Hohenstein immediately discovered that his health incapacitated him from directing the Order, and retired to his castle of Povo, leaving the government in the hands of a Lieutenant, Pio Franchi de'Cavalieri, a man of exemplary life and high reputation, who was able before the end of the year to conclude

a treaty with Italy analogous to that obtained by the Holy See. On Thun Hohenstein's death the Lieutenant declined the Grand Mastership, which was conferred on Prince Ludovico Chigi Albani della Rovere, a widower, hereditary Marshal of the Church and Guardian of the Conclave, whose three princely names represented families from which four popes had been drawn. Under his direction cordial relations with the Italian government were further developed, and on the conquest of Abyssinia the

Procession of Knights of Malta and Teutonic Knights in Vienna in the 1930s.

Order opened a leper-hospital near Adowa, the forerunner of its now extensive nursing work throughout Africa.

Nevertheless the Second World War struck at the Order with new political conditions, in which families for whom loyalty had been the cornerstone of their tradition found that the times required of them a more difficult patriotism. One may instance the courageous stand made against Nazi tyranny by the Grand Cross of the Order Cardinal von Galen, Bishop of Münster. Also of relevance is the conspiracy against Hitler led by Schenk von Stauffenberg, not himself a Knight of Malta but a member of a family whose connexion with the Order goes back at least five hundred years; in the revenge taken by Hitler twelve knights of the Bailiwick of Brandenburg were executed. Neither could the Sovereign Order's roll of honour omit the knights who likewise were executed by the Nazi regime or died in concentration camps, or fell in battle, or the two knights of the Polish Association who lost their lives in the Russian invasion of 1944 while directing the hospital of the Order in Warsaw. Courage in the face of the enemy had become again, as in the past, a concomitant of the Hospitaller vocation of the Knights of St John.

CHAPTER XVIII

An Intrigue in the Vatican

AS THE ALLIED armies marched in over the ruins of Italy and Germany, an immense labour lay open to the Hospitaller Order. The most notable response to it came in Germany, where the knights of the Silesian Association, who had lost everything in the Soviet occupation of the East, joined with their western brethren in a heroic work of assistance to the millions of refugees thrown on the resources of their ruined and truncated country; these efforts were to be crowned with the foundation in 1953 of the *Malteser-Hilfsdienst*, now one of the most important medical and rescue services in Germany and in the world. In Italy, in the twilight days of the monarchy of Savoy, a similar work presented itself, and the knights maintained a refugee camp in the Trastevere. The strange post-war world of rubble, refugees and spivs, of governments newly formed, half formed or falling, offered special opportunities to an institution working with the advantages of sovereignty and diplomatic status, but it also offered pitfalls which the old-fashioned gentlemen of the Palazzo Malta were not always nimble enough to avoid. A scandal was narrowly avoided when 10,800 bottles of penicillin, intended for the hospitaller works of the Order, came close to being diverted by a shrewd operator to the Italian black market.

In the magistral palace there was one man who wished to propel his brethren along more businesslike and more adventurous paths: the Secretary for Foreign Affairs Ferdnand von Thun und Hohenstein, a nephew of the late Grand Master. Unfortunately his skill was not equal to his ambition, and a series of minor errors culminated in June 1949 in a blunder of grave consequence, when he agreed to buy from the Argentine Republic 100,000 tons of grain, to be paid for in convertible dollars, at a price which would yield a profit of $2 million. One detail had eluded his attention: that convertible dollars were an unobtainable commodity; when this was discovered the Order of Malta was faced with the prospect of buying the entire shipment at market price and finding a purchaser for it. The reaction of the Sovereign Council was characteristic of the rarefied honour which was native to Prince Chigi and his *confrères*: Thun Hohenstein's commitments, though unauthorised, were accepted in full; and to spare the Secretary for Foreign Affairs outright dismissal his post was suppressed. Equally characteristic was the Order's response to an opportunity that arose to escape from the predicament: Evita Perón, with her notorious passion for acceptance by the *haut monde*, offered to let the Order have the grain at a very favourable price if she were appointed a Dame of Honour and Devotion – a distinction which, under the Spanish rules applicable to her nation, was reserved for ladies with sixteen quarters of nobility. Rather than debase its honours, the Order preferred to shoulder a burden of nine million dollars, and her offer was refused.

The next concern of the Grand Master was to remove the injudicious ex-Secretary from his place on the Sovereign Council, where he sat as representative of the Grand Priory of Lombardy-Venetia. To avoid this fate Thun Hohenstein presented a secret appeal to the Congregation of Religious, and by doing so he opened the door to intervention by a personage who was to prove the most formidable threat to the Order since Napoleon Bonaparte: the Grand Penitentiary of the Church, Cardinal Nicola Canali, who was at this time consolidating his position as the most

258

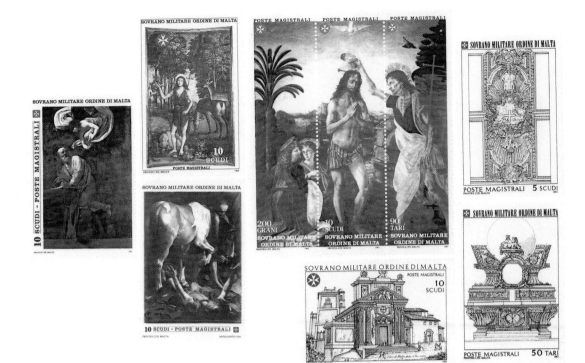

XXI. Stamps of the Order of Malta.

XXII. The Romanian ambassador presents his credentials to the Grand Master in the Palazzo Malta, 1990, after the restoration of diplomatic relations between his country and the Sovereign Order.

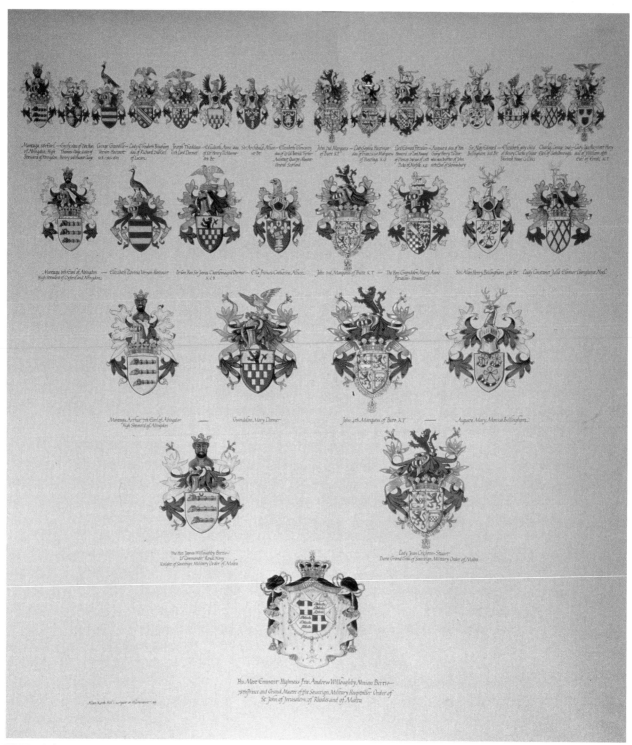

XXIII. The sixteen quarters of nobility of His Eminent Highness Grand Master Andrew Bertie.

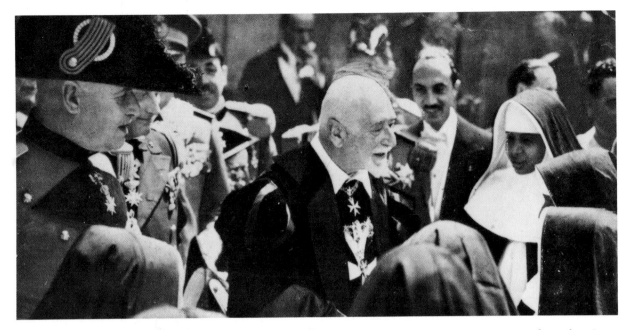

Grand Master Chigi visiting the Order's charitable works in the 1940s.

Grand Master Chigi and Cardinal Canali at the latter's installation as Grand Prior of Rome.

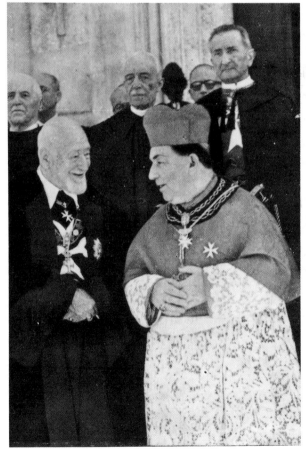

powerful man in the Vatican after the Pope himself.

Canali had been one of the principal artificers of the election of Pius XII; in 1944 he was put in charge of the financial aspects of the Church's administration which had previously been handled by the Secretary of State, and was thus virtually the Vatican's Minister of Finance. Though a member of the Order of Malta of many years' standing, he was not sufficiently well regarded by Prince Chigi to figure on the *terna* of candidates for the Grand Priory of Rome when that office fell vacant in 1948. Bowing to influence, Chigi finally included his name, third on the list, and the Pope overrode precedent to choose Canali as Grand Prior. In the following year he also appointed the cardinal Grand Master of the Holy Sepulchre, a title hitherto reserved for the popes themselves; this Order's dependence on the Holy See may have made Cardinal Canali all the more conscious of the sovereign privileges of the one in which he still occupied only a subordinate office.

Canali's position derived on the one side from his alliance with the Pope's nephew, Prince Carlo Pacelli, whose overwhelming influence was to cause headaches to Pius XII himself, and with the papal financier Count Enrico Galeazzi; they had offices in the same building of the Vatican, and their privileged status led to their being known as 'La Trimurti', after a Hindoo trinity. On the other side Canali was associated with the

leaders of the conservative and papalist party in the Curia, Cardinals Micara and Pizzardo: to these should be added a further name, that of Cardinal Spellman; though outside the Curia as Archbishop of New York, he preserved links with it formed during his eight years in Rome between 1925 and 1933, and his achievements since then had made him a key figure in the Church's affairs. Spellman, who had all the gifts of an American big businessman and political manager, had proved invaluable in raising funds for the Vatican in the difficult war years, and it was due to his financial wizardry that the Bark of Peter, far from labouring in the storm, found itself buoyantly afloat on a sea of American dollars. His chief monetary adviser at home was the Mormon banker David Kennedy, who was to be Secretary of the Treasury under President Nixon, and he was also closely associated with the Vatican financiers Galeazzi, Nogara and Sindona; in 1963 he was to have the distinction of bringing Monsignor Marcinckus to the notice of Paul VI.

To this hard-headed party in the Church the Order of Malta represented a vast and underused potential. It also constituted an independent element which as zealous churchmen they felt could with profit be assimilated to the uniformity of Vatican administration. As a vacancy in the Grand Mastership drew nearer, Cardinal Canali began to speculate on the advantages of having that office transferred like that of the Holy Sepulchre into the Pope's gift, and bestowed likewise on a loyal member of the Roman hierarchy. The beneficiary of that reform would become, not merely in the Vatican but internationally, a figure second in consequence only to the Pope himself. It was this calculation that turned Thun Hohenstein's appeal into a charge of high explosive. The composition of a religious order's governing council would not normally have been a matter for the Congregation of Religious; but Cardinal Canali was himself a member of that Congregation, with special responsibility for the vows of religious, and he may have advised Thun Hohenstein that an appeal lodged in that quarter would have consequences transcending its ostensible motive.

At first, measures in support of the appeal seemed to proceed in a feeble fashion; when the Sovereign Council wished to give Thun Hohenstein's place as representative of Lombardy-Venetia to the Milanese lawyer Angelo de Mojana, the Congregation delayed permission for the latter to take his vows. Thun Hohenstein had finally to be ordered out of the magistral palace, though not until a full year after the blunder that occasioned his disgrace. The Jesuit Father Castellani, a close associate of Cardinal Canali, replied by having Thun Hohenstein appointed to a post which by chance entitled him to offices annexed to the Villa Malta, thus giving the appearance that he still enjoyed official status within the Order; but from this niche too the Grand Master managed to dislodge him. Cardinal Canali's patronage so far seemed of little avail. Confident of his authority, Prince Chigi turned to deal with strange reports he was hearing from America.

The American Association of the Order of Malta had been founded in 1926 by some of the more exclusive members of the society of Knights of Columbus, and had long been flourishing under the patronage of Cardinal Spellman. His connexion with the American knights dated from when he was a young Monsignor in Rome; he was then assistant to Mr Edward Hearn, one of the founding mem-

Bailli Ferdnand von Thun und Hohenstein.

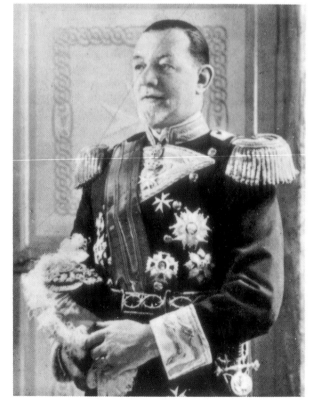

bers of the Association, who had been appointed Commissioner to raise American funds for the Catholic Church. Spellman had not been long in his post when he heard privately that Pope Pius XII was looking for $45,000 for a building project at the Vatican library, and he decided that this was an occasion when he, and not Mr Hearn, might gain the credit for answering the Church's need. Without informing his chief, he persuaded Mr John Raskob (the builder of the Empire State Building) to subscribe the money. It is a proof of Spellman's extraordinary skill that he not only derived kudos from this breach of propriety but was able to use Mr Hearn's resentment of it to bring him into disfavour in the Curia, so that he soon found himself obliged to leave Rome.[1] A short time later Spellman had Mr Raskob directly appointed a Grand Cross of Magistral Grace, thus achieving the double coup of rewarding his ally and snubbing the claim of Mr Hearn and his fellow directors to control nominations.[2]

The passing years detracted nothing from Spellman's touch, and on becoming Archbishop of New York he had himself named 'Grand Protector' of the American Association, distinguishing himself even from the Catholic crowned heads who historically were entitled 'Protectors' of the Order. It was in no sense an empty title, and under Cardinal Spellman's guidance the Association became a focus for the most prominent members of the country's Catholic society, drawn not only by its social prestige but by the Cardinal's extraordinary ease of intercourse with the sources of power. The admission fee for American knights was $1,000, far higher than for any other country, and at their annual banquet at the Waldorf Astoria Cardinal Spellman circulated with a collection plate in which no-one would have dared to deposit less than an equivalent sum for the good works of the Order. What were those good works? Cardinal Pizzardo received a proportion of the gifts for the benefit – so it was supposed in the magistral palace – of the Hospital of the Child Jesus in Rome, which was registered as one of the Association's charities.

Early in 1951 Prince Chigi learnt by accident of the millions of dollars regularly raised in America, and could not contain his astonishment. The Grand Magistry only received some $50,000 a year; the Hospital of the Child Jesus showed no sign of being awash with funds. He decided

that the time had come to recall the Association from the freedoms with which distance and its Grand Protector had endowed it: he wrote to Cardinal Spellman requiring that the American Association should cease to call itself a 'Chapter' and its President a 'Master', and that he should submit the Association's budgets and a list of its works. For several months there was silence. Finally at the end of October the Grand Master received a letter from Cardinal Spellman: it was not to answer Prince Chigi's demands but to request him to give account of the sums which the Grand Magistry annually received from the American Association.

Hard on this came a series of sharp lunges at the Order. The Congregation of Religious ordered the Sovereign Council to keep the Grand Priory of Lombardy-Venetia vacant for Thun Hohenstein, and refused De Mojana permission to take his solemn vows (he was not able to do so until 1957). Then, on Monday, 5 November the Sovereign Council received a message from the Congregation informing it that the Order's organs of government were suspended, that a cardinalitial Commission had been appointed 'to assist and direct the Order, the better to assure the sanctification of its members and the good of their neighbour', and that at 10 a.m. on the following day an emissary of the Congregation would arrive at the magistral palace to seal its offices, at the same time demanding the books of the Treasury and an inventory of the Order's possessions.

Seldom in modern times can such an extreme measure have issued from the Vatican. The key to its severity was to be found in the names of the members of the cardinalitial Commission: Cardinal Canali, Cardinal Pizzardo – the recipient of Spellman's donations from the American knights – and Cardinal Micara, the third member of the curialist triumvirate. Nor was it difficult to suspect that Prince Chigi's recent exchanges with America had something to do with the remarkably material slant to the Commission's moves for the sanctification of the Order: what Peyrefitte calls 'their pious zeal towards budgets and inventories'. The danger was pressing; the Order's Minister to the Holy See, Count Pecci, advised an immediate personal appeal to the Pope, but the Congregation of Religious had left only twenty-four hours in which to act, and a papal audience could not be arranged in

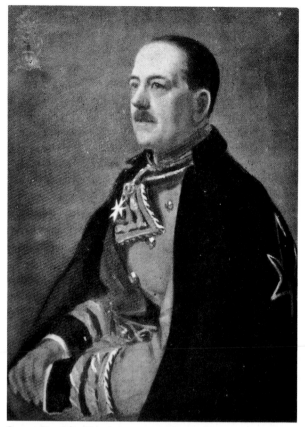

Count Stanislao Pecci, a great-nephew of Pope Leo XIII, the Order's ambassador to the Holy See in the 1950s.

to a secret interview with Prince Chigi and threatened him with excommunication. As Father Castellani left the palace, the Grand Master was found lying on the floor of his office under the effects of a heart attack. After a brief recovery he died on the following day, 14 November.

It was a death perhaps as fateful as that of the Grand Master Rohan in the crisis of the revolutionary wars. The threat of Cardinal Canali's immediate occupation of the magistral palace darkened the tragedy with a double shadow. By the Order's statutes, the government passed automatically to the senior member of the Sovereign Council, Count Antonio Hercolani, who had already served twice as Lieutenant under Prince Chigi; but in the thorny circumstances of the time, would he have the resolution to pre-empt Canali's bid? The doubt had haunted the Secretary of the Chancellery, Count Cattaneo di Sedrano, and he had made plans for the contingency. No sooner had the Grand Master's death been medically pronounced than he closed down the telephone exchange of the Palace, took the sheaf of telegrams he had drawn up announcing the death and Hercolani's assumption of the Lieutenancy, and despatched them immediately to the leading members of the Order and the heads of state with which it had diplomatic relations. Cardinal Canali, when he telephoned the same afternoon to assert his commission's rights, was confronted with a *fait accompli*.

While the Congregation of Religious fought for its ground, ordering that no election for a new Grand Master should take place, the knights awaited the Pope's reply to Prince Chigi's appeal. On 10 December it was made known: Pius XII recognised the rights derived from the Order's sovereign status and appointed a special tribunal to judge between it and the Congregation. Its terms of reference were to study the nature of the Order's sovereignty, its character as a religious order, and the implications of the two for its subordination to the Holy See. Although the chirograph also confirmed the suspension of the election, the Knights of Malta breathed with relief; their case would be heard by an impartial court. Two days later this innocent illusion was destroyed when the names of the members of the Tribunal were published: the President was Cardinal Tisserant, a Grand Cross of the Order; another member was Cardinal Aloisi Masella, an entirely neutral figure; but the remaining

that time. By chance the domestic prelate Mgr Nasalli Rocca di Corneliano, who was related both to Prince Chigi and to Angelo de Mojana, was to see Pius XII the following morning. Through his intervention the Grand Master's letter of protest came to the eyes of the Pope, with an hour to spare, and the visit from the Congregation of Religious did not take place.

The Order thus remained in control of its own government; yet the judgment declaring its subordination to the Congregation of Religious continued to stand, and seemed a comprehensive denial of its sovereign status. Prince Chigi wrote to the Pope pointing out the Sovereign Order's traditional exemption from ordinary tribunals, 'even those of Most Illustrious Cardinals',[3] and asking for a special tribunal to be named to judge the case. Consternation invaded Cardinal Canali's camp; if such niceties prevailed there would be no way of reducing the Knights of Malta to submission. Father Castellani – the Jesuit who had attempted to protect Thun Hohenstein the year before – had himself admitted by a valet

three were the same who formed the Commission of the Congregation of Religious: Cardinals Canali, Pizzardo and Micara. It was apparently the instance of Cardinal Canali, who contended that their omission would be 'an offence to the purple', which had prompted Pope Pius XII to appoint a tribunal to judge a case in which the majority of its members were themselves a party.*

The Grand Magistry named its advocates; Angelo de Mojana was summoned from Milan and remained for the next eleven years the heart of the Order's legal struggle. On the other side, the appointment of Prince Carlo Pacelli as an advocate for the Congregation reflected Cardinal Canali's inclination to depict the dispute as one between the Order and the Pope. He also tried at this time to displace the Lieutenant from his office as representative of the Grand Priory of Rome and claim the right to represent himself on the Sovereign Council, but this attempt was blocked, serving only to raise the temperature of the conflict.

The death of Prince Chigi had caused an outburst of indignation among the high aristocracy of Rome, with which he was so extensively allied; some members of the Chigi family turned their backs on Cardinal Canali when he came to say the first Requiem Mass for the Grand Master. In February 1952, when the papal nobility assembled to pay their congratulations to Pius XII on the anniversary of his election, the Pope treated them to a severe lecture on the need to adapt themselves to the modern age. If he had been better informed he could have added point to his speech by contrasting Cardinal Canali's tycoon ambitions with the antiquated values of the Palazzo Malta, in which a debt of nine million dollars weighed less than a cross of Honour and Devotion.

The cardinalitial Tribunal showed itself disposed to treat the case of the Sovereign Order as briskly as an affair of petty cash. In May 1952 it was preparing to pronounce its judgment before the defence could be heard. Once again the personal intervention of Mgr Nasalli Rocca in presenting a letter of protest to the Pope averted a travesty of justice, and an extension was granted

until the end of the year. For his pains, Mgr Nasalli Rocca was forbidden to act again in the Order's affairs. On 23 December the Order's advocates – mistakenly, in spite of everything – adopted the last resort of withdrawing from the case, alleging 'anomalies of fundamental importance' in its conduct.

The Palazzo Malta had early seen the need to mobilise the Order's international resources to reinforce its Roman base. In July 1952 there took place an assembly of the National Associations which voted for reforms of the Order's religious life and Constitutions, and appointed a Committee to devise them. The assembly also provided strong support for upholding the Order's sovereignty, notably from the Spanish Association, which did not hesitate to threaten secession if that prerogative were diminished. The sequel, though, demonstrated that Vatican diplomacy had lost none of its subtlety since the days of the Renaissance: the Spanish Association had close links with General Franco's regime, with which the Holy See was then negotiating a Concordat. It was intimated that Rome would be willing to give way on certain vexed issues if the knights laid aside their militant attitude. Patriotism was invoked, and the Spanish Association became henceforth a model of docility.

On 19 February 1953 the cardinalitial Tribunal privately made known its findings, which form the basis of the modern political and ecclesiastical status of the Order of Malta. The judgment first acknowledged the Order's sovereignty, but secondly, defined that sovereignty as merely 'functional': that is, based on the Order's international activities and not on the possession of territory; thirdly, it asserted the Order's religious character, and fourthly declared it in consequence subordinate to the Congregation of Religious; fifthly the judgment reserved to the Order, by virtue of its sovereign character, the right to address itself to the Pope through the Secretariat of State, and sixthly all traditional privileges were fully confirmed.

This judgment was by and large a reasonable statement of the Order's position; but the fear in the magistral palace was that it was intended to give *carte blanche* to Cardinal Canali's ambitions.

* One may nevertheless discount Peyrefitte's view that Tisserant was a nominee of Cardinal Canali, to whom he looked to restore his lost favour with the Pope. Cardinal Canali would have been ill advised if he thought that he could use that unpredictable and irascible prelate as a cat's-paw.

Acceptance was only given subject to two 'interpretations': the first stated that the Order's sovereignty was no less real for being merely 'functional', since the possession of territory was not essential to its activities, and the second limited the jurisdiction of the Congregation of Religious to professed members, since otherwise the judgment of the Tribunal would imply that even foreign heads of state who had been invested with the Grand Cross were thereby subjects of the Congregation. These qualifications remained secret, even when the Tribunal's judgment was published at the end of the year.

With the constitutional question resolved, it remained to undertake the Curia's professed objective, the reform of the Order. But here its members had already been active; the committee appointed in July 1952 had in hand a charter of reforms: could these be submitted for approval? No, the Congregation of Religious would only consider proposals jointly drawn up in consultation with itself. A committee was therefore nominated by both sides, and the prospect of the reforms being approved and a Grand Master elected was therefore in sight. This measure of concord upset the expectations of Cardinal Canali and his party. Cardinal Spellman had regarded his friend's installation in the Palazzo Malta as a matter of very little time, and had been treating the Lieutenant's government as non-existent; he admitted sixty-seven American knights in the course of 1952 without informing the magistral palace, and naturally without passing on their reception fees. The fact was discovered in December when one of his recruits innocently appeared in Rome and made himself known to his unwitting *confrères*. The Sovereign Council contented itself with exacting the reception fees and detaching from the Cardinal's flock a new Western Association, based in San Francisco, which came into being in 1953.

In November of that year the Pope appointed Monsignor Ferrero di Cavallerleone Prelate of the Order, an office formerly held by the Prior of St John, and in abeyance since the loss of Malta; its restoration seemed to mitigate the Order's dependence on the Congregation of Religious. It was widely thought that the judgment of 1953, whereby the Holy See recognised the Order's sovereignty and the Order acknowledged the Holy See's authority in the religious sphere, had been a final settlement of the dispute, and that

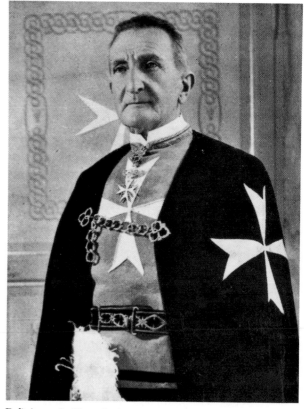

Balì Antonio Hercolani, Lieutenant of the Order 1951–5.

the two parties were discussing in harmony the simple question of religious reform. The Knights of Malta continued to expand their works and their diplomatic representation; recognition by the infant Italian republic had arrived – most opportunely – on the very day before Prince Chigi's death, and in 1954 it was cemented by an exchange of decorations between the Lieutenant and President Einaudi, full diplomatic relations being established two years later.

Unfortunately, behind the movement for reform, which ought to have proceeded openly and to have been fulfilled in its declared purpose, there was an unspoken purpose of control, which could not be satisfied with any degree of reform, and which proceeded by a campaign of underhand tactics against the Lieutenant's administration. A servant who died at this time in the magistral palace was found to have been betraying the magistry's secrets to Cardinal Canali. Newspaper articles and other publications of the most extravagant bias appeared all over Europe; incidents like that of the 10,800 bottles of penicillin were raked up and refashioned to the discredit of the knights; it was recalled as a scandal that old

Prince Chigi while Grand Master used to attend the opera and 'took visible pleasure in the evolutions of the ballet'.[4]

In June 1954, after the prospects of an election had been further and further postponed, the Palazzo Malta got to hear that a brief was being prepared appointing a Lieutenant or a Grand Master on the Pope's direct authority; three days before the threatened date, evidence was presented to the Curia of Cardinal Canali's connexions with a German Protestant who had been responsible for one of the most notorious publications against the Order, and the brief did not appear.

Public awareness of the recrudescence of the dispute was provoked in October 1954, when the Knights of Malta were refused an audience with the Pope to celebrate the Marian Year. This act represented a sharp worsening of diplomatic relations; but what followed was a declaration of war: at the beginning of February 1955 the Pope announced the appointment of a new cardinalitial Commission for the reform of the Order, its members being the same who had composed the Tribunal, with the addition of a sixth, Cardinal Valeri. What was proposed was a renewal of the attempt, foiled in November 1951, to turn over the government of the Order to the Commission. Time was running out for Cardinal Canali, and on this occasion he would allow no judicial niceties to stand in his way. Faced with such a threat, the Sovereign Council played its last card: if the Commission exercised its powers, the Order would publish the whole of its correspondence with the Holy See since 1949. The Commission held its hand.

This well-timed move saved the citadel of the Order, but proved the only success it was to be permitted; from that moment its outer bastions fell rapidly. Cardinal Tisserant presented a solemn 'canonical intimation' requiring the resignation of the Vice-Chancellor Count Cattaneo, who had been the backbone of the Lieutenancy's resistance for the past three years. This was submitted; that of the Chancellor, Baron Apor, followed soon afterwards. De Mojana, who had been named as the third *bête noire*, managed to survive. The Knights of Malta were beaten back from line to line, through assurances informally given, only to be formally repudiated, that a concession here would induce the cardinals to waive a demand elsewhere. In April all the

defences seemed overrun when an election was announced – not for a Grand Master but for a new Lieutenant. Cardinal Canali was confident that the time was ripe to replace Hercolani with one of the few knights loyal to his cause, Don Flavio Melzi d'Eril dei Duchi di Lodi. The Order proposed another candidate, Don Ernesto Paternò Castello di Carcaci, who had been living in Sicily and thus remote from the controversy, but Cardinal Canali was assured that he had no chance of being elected.

On 24 April 1955 the twenty-eight delegates of the Order met in the Priory of the Aventine. It was the first time that the new rules introduced in 1936 for magistral elections were put into effect – a fact whose significance Cardinal Canali may have missed – and the electors included not only seventeen professed knights and chaplains but the representatives of eleven National Associations. These had concerted their policy beforehand, and the forecasts that had been bandied about in Italy were overturned. When Melzi d'Eril's name was balloted he received only two favourable votes: Thun Hohenstein's and Cardinal Canali's. Paternò was then proposed and was elected by seventeen votes to eleven. Antonio Hercolani handed over his office to the new, apparently neutral, Lieutenant. The men who had defended the Order with such tenacity for over three years were out of the Palazzo Malta; but so was Cardinal Canali.

The effect of this *bouleversement* was to destroy Cardinal Canali's chances of gaining control of the magistry. The National Associations had again shown that there was a great deal more to the Order than a handful of professed knights in Rome. All that remained was to proceed along the way of reforms, though at a pace which ensured the control of the cardinalitial Commission for a long time to come. At the beginning of 1957 new Constitutions were adopted, but they were only provisional ones to remain in force for three years, and during that time no Grand Master would be elected. In the same year appeared Roger Peyrefitte's account of the dispute, under the title *Chevaliers de Malte*; though adorned with that author's rich imagination, it was essentially an exact description of everything that had occurred up to the election of 1955, being based on the documents which had secretly been placed in his hands by Count Cattaneo. Nevertheless, the malice in its exposure

of Vatican chicanery and the snobbery in its adulation of the Knights of Malta were too obvious for the book to carry conviction as a chivalrous defence of justice. Perhaps its main effect was to make it impossible for the Vatican, after such devastating exposure, either to advance or to retreat. The Lieutenancy for its part officially apologised to the Holy See for the book's excesses.

The decisive event in this long conflict occurred with the death of Pope Pius XII on 9 October 1958. Although he had more than once intervened to avert obvious injustice, his support for the party seeking the subjection of the Order had placed the latter in the position of seeming to rebel against the personal wishes of the Pope. Two opposite misconceptions had clouded the dispute: on the Pope's side the notion that the Order's attitude sprang from a refusal to reform itself and to submit to the Church's authority; on that of the Knights of Malta the belief that the Vatican was out to destroy the Order's sovereignty. A shrewder calculation would have shown that Cardinal Canali was as concerned as anyone to preserve that sovereignty, from which he hoped himself to profit. But as his intentions required, by their nature, to proceed under disguise, and to invoke the authority of the Church, the Lieutenancy was pushed into an attitude of apparent and unnecessary intransigence.

With the election of Cardinal Roncalli as Pope John XXIII the whole structure of power represented by Cardinals Canali and Spellman began to collapse, and a less hard-headed party advanced to leadership in the Church. On the morrow of his election the new Pope appointed Mgr Nasalli Rocca di Corneliano, whose timely intervention with Pius XII had twice saved the Order from disaster, to the important office of *Maestro di Camera*. What has been called the Order's 'second Great Siege' was over. The removal of the pressure of the curial party allowed the programme of reforms to proceed without the adversarial hindrances of the mid-1950s. The most important of the changes were the abolition of the nineteenth-century abuse whereby unmarried noblemen were admitted as Knights of Justice without making their profession, and the institution of a new category (which Pius XII had been particularly anxious to promote) of Knights

of Obedience, after the pattern of Chaplains of Obedience: members who, without taking vows, committed themselves by promises to special religious duties and obedience to the spiritual guidance of the Order.

The latter innovation disclosed a desire among numerous married knights to share more fully in the spirituality of the Order of Malta; a novitiate for this class was opened in Germany in March 1959, and the following year the first ten Knights of Obedience made their promises to Frà Angelo de Mojana, and shortly afterwards were received in audience by the Pope. By the end of 1961 fifty-three knights had made their promises or begun their probation, and the creation of the new institution of Sub-Priories to group the Knights of Obedience was under way. As in the foundation of the National Associations a century before, the chief impulse in this movement came from Germany and the British Isles, the first Sub-Priories to be founded being those of Germany (1961), England (1970) and Ireland (1972).

In 1961 Pope John XXIII approved the definitive Constitutions of the Order, abolished the cardinalitial Commission, and named a Cardinal Protector of the Order, on the model of those appointed in former times to represent the interests of Catholic countries in the papal Curia. In May 1962 the long interregnum imposed since the death of Prince Chigi was at last ended, and there was held the first legislative Chapter General since 1776, in which the new Constitutions were officially adopted. On 8 May 1962 the Grand Mastership was conferred on Fra Angelo de Mojana dei Signori di Cologna, of the Grand Priory of Lombardy-Venetia, the advocate who had directed the Order's legal defence throughout the long dispute.

The suppression of the cardinalitial Commission was only an episode in the vast revolution which, under Pope John XXIII, deprived Cardinal Canali and his circle of the influence they had built up during the reign of Pius XII. Canali died within a few weeks of that event;[*] Spellman lived on until 1967, by which time the affairs of the Order of Malta had faded into insignificance beside the triumph in the Church of all the tendencies he had so strenuously resisted.

An aspect of interest in the Order's conflict with the Vatican is that – not alone – it illustrates

[*] He was also the last of the line of cardinals who had monopolised the Grand Priory of Rome since the seventeenth century; since 1961 the office has reverted to professed knights.

the way history has of playing tricks on those who propose the adaptation of traditional institutions to the needs of their time. After the fall of Acre advocates of the crusading idea advised the suppression of the military orders and the undertaking of their mission by a Christian warrior king; instead, the policies of European monarchs declined in increasingly selfish and piratical directions, while the Order of St John embarked on five hundred years as the shield of Christendom in the Mediterranean. In the 1770s the progressive party in the Order was calling for the abandonment of its religious character and its remodelling as a purely political and military force; thirty years later its political and military position was in ruins, and it was only its character as a religious order that ensured its survival during the nineteenth century. The events of the 1950s may now likewise be seen as replete with ironies: the first commentary on

them is suggested by the scandals that have since enveloped the Vatican's financial activities. Cardinal Canali and his friends believed that an organisation with the resources of the Order of Malta ought to be removed from the control of the knights and placed in the pious hands of the Curia; in the event, ecclesiastical management has incurred disgrace, and it is the lay administration which has preserved its honour. A second aim was to strengthen religious observance so as to make the professed knights more 'responsive' to the needs of their time; the consequence is that the standard of religious observance in the Order of Malta is now distinctly higher than it has become, under the same plea of adaptation to the modern world, in many other orders. The Knights of Malta would certainly not wish it otherwise; they may only regret that the irony is not more widely savoured.

CHAPTER XIX

The Modern Order

Hospitallers in the Modern World

FRA ANGELO DE MOJANA was Grand Master for twenty-six years, and under the government of this unassuming and affable prince the Order of Malta experienced a growth which has made it one of the largest associations of the Catholic Church and one of the most active hospitaller organisations in the world. The number of knights has increased from 3,000 to over 10,000 and that of National Associations from 28 to 39.

The Order's work as a religious and Hospitaller body is manifested first by its various pilgrimages for the sick and disabled. The most important of these is the pilgrimage to Lourdes, held in the first week in May, an event which was initiated in 1950 and now regularly brings together 3,000 members of the Order with many hundreds of patients. It provides a good corrective to the misconceptions about the Order often held by outsiders. The Lourdes pilgrimage is the principal meeting of the most aristocratic association in the world, and it would be impossible to imagine greater simplicity. Chivalry is apparent in the custom which fits out the ladies in a beautiful red and white nurse's uniform, with the eight-pointed cross resplendent on a black cape; the uniform of the knights, by contrast, is a sort of superior boiler suit, that of the senior dignitaries distinguished, if at all, only by its hoary antiquity. During the five days of the pilgrimage the patients are ferried about to Mass and other devotions and looked after with an assiduity proper to the Blessed Gerard's ideal of 'Our Lords the Sick'.

The National Associations of the Order all direct organisations for the provision of hospital and medical assistance, of which three stand out for their size and international presence. The *Malteser-Hilfsdienst*, founded by the German knights in 1953, runs hospitals and an enormous voluntary ambulance service in Germany and Austria. A sisterhood of nurses, comparable to the Knights of Obedience, was founded in 1965 in connexion with its work; the *Malteserschwestern* are bound by a promise of obedience to their Superior General and have regular meetings for religious and vocational instruction. The *Malteser-Hilfsdienst* has been particularly active in theatres of war and catastrophe; from 1966 to 1970 it maintained a team of about forty-five doctors and young workers in Vietnam, and in 1969 three of these volunteers, aged between twenty and twenty-nine, died of starvation in a North-Vietnamese prison camp.[1]

Equal to Germany in activity stands France, where the *Association des Oeuvres Hospitalières Françaises de l'Ordre de Malte* is supported by

Grand Master Angelo de Mojana at the Lourdes pilgrimage.

268

Hospital of the Order of Malta in Berlin.

the donations of half a million well-wishers. In France itself it has long administered a wing of the Hôpital Saint-Louis in Paris, and one of its recent initiatives has been the opening of a specialised house for the disabled at Rochefort-sur-mer in 1985. Much of the Association's activity is directed to Africa, where in 1968 it arranged the airlift of thousands of tons of foodstuffs during the Biafran war. The work in Africa now takes the form principally of the fight against leprosy which the Association carries on in most of the former French colonies; in all, 140 establishments are maintained in 45 countries. To the support of the French knights especially is due the maintenance of two medical centres in Beirut which pursued their work with exceptional courage throughout the Lebanese civil war. The *Oeuvres Hospitalières* are at present directed by the Bailiff of Obedience Géraud Michel de Pierredon, one of the most outstanding members of the Order at the present day, in whom the vocation of the Blessed Gerard is nobly represented.

In the United States of America the Order of Malta works closely with AmeriCares, especially through Peter Grace and William Simon, who are prominent members of both bodies. Under the symbol of the Cross of St John AmeriCares provides aid to many countries in Latin America and elsewhere in the world.★ Each of the thirty-nine National Associations throughout the world likewise has its own activity. The Irish Association distinguishes itself by its hard work and organises a nationwide ambulance service which yields nothing in completeness to those of the *Malteser-Hilfsdienst* in Germany or the St John's Ambulance Brigade in the United Kingdom.

★ The work of the Sovereign Order in Latin America has won recognition even in a country such as Cuba, which has maintained diplomatic relations with it throughout the duration of the communist regime; the Cuban government ordered official mourning on the death of the late Grand Master de Mojana.

Independently of its hospitaller character, the Order of Malta has been found playing a very representative role in the recent history of many countries. Examples could be multiplied almost indefinitely: in Spain the negotiations for the recognition of the present King as heir and successor to General Franco were conducted by the then President of the Spanish knights, the Infante Fernando; King Juan Carlos, who was christened in the chapel of the Palazzo Malta in 1938 during his family's exile in Rome, was President of the Spanish Association for ten years before his accession to the throne. In Portugal the Conde das Alcaçovas, President of his national association from 1940 to 1960, was one of the leading movers of the Catholic recovery in the public life of his country after the damage done by the masonic governments of the early republic.

In the United States Peter Grace, President of

Georg von Truszczynski, an outstanding figure in the work of the *Malteser-Hilfsdienst*, seen here engaged in the organisation's work in Vietnam.

the American Association since 1977, has long been one of the most influential members of the Republican Party; his links with President Reagan were particularly close, while the advent of the Bush presidency drew the social worlds of the White House and the Knights of Malta even closer together. Austria, southern Germany and France are perhaps the countries in which the Order stands in highest regard. In the last the Order of Malta represents a world of more authentic social prestige than, for example, the milieu of royalist adherence. This is not entirely to do with the difference between a recognised and a phantom sovereignty; it is rather because a gala night of the Knights of Malta at the Paris Opera or similar event, for all its glamour, is organised for the benefit of charitable work whose value is known throughout the country. The fall of communism has opened the door to the Sovereign Order in Eastern Europe; Prince Karl Johannes Schwarzenberg, a Grand Cross of Malta who was President of the International Federation for Human Rights from 1984 to 1990, became Chief of Staff to President Havel of Czechoslovakia on the establishment of democratic government.

Representations and Misrepresentations

Since 1963 the Sovereign Order has maintained formal relations with the alliance of four Protestant Orders of St John which trace their historical roots to it. These are the German Johanniterorden, which is the Grand Bailiwick of Brandenburg as restored by the Prussian monarchy in 1852,[*] and its Dutch and Swedish offshoots, the Johanniter Orde in Nederland and the Johanniterorden i Sverige, which became independent of it in 1946.[†] The fourth non-Catholic order is the Venerable Order of St John in the British Realm. All four have been constituted as orders of chivalry by their respective monarchies and they are the only Orders of St John which their own governments and the

[*] See p. 254.

[†] The Balley Brandenburg also has National Associations for Protestant noblemen in France, Switzerland, Hungary and Finland.

Sovereign Order recognise as legitimate. Their common traditions and Hospitaller aims are reflected in the co-operation they maintain with their Catholic progenitor.

In the past thirty years the Order of Malta has doubled its diplomatic representation, from thirty countries in 1962 to nearly sixty at the present day. Embassies are maintained chiefly in Catholic states, and there are legations in France, Belgium, Germany and Switzerland. Soon after the fall of the Iron Curtain ambassadors exchanged with Poland, Czechoslovakia, Hungary and Romania, and relations have now also been inaugurated with Russia and other successor states of the Soviet and Yugoslav empires. The Order is recognised by all countries as a sovereign entity in international law; it issues diplomatic passports to its accredited diplomats and has also done so in the past to expatriates such as Archduke Otto von Habsburg and the deposed King Umberto of Italy. The Order is likewise represented on international bodies such as the Council of Europe and the World Health Organisation. On the other hand, its right to mint coins and issue stamps is confined to an ornamental level.

The Order of Malta presents a unique case of a body which lost its territorial power two centuries ago, yet still continues to preserve and indeed expand recognition of its sovereignty. Diplomatic relations are of course linked to its international Hospitaller activities, from which in the Order's view they derive their *raison d'être*. Nevertheless, since governments show no inclination to invest representatives of the Red Cross with diplomatic rank, why is there this readiness to extend the privilege to the Knights of Malta? It may be that part of the key to the Order's appeal is precisely its character as a survival. Now that the Golden Fleece, the Saint-Esprit and the Garter are either extinct or conferred under the dour eye of political scrutiny, the prestige that was once distributed among those illustrious bodies is concentrated in the Order of Malta; it is the only genuinely aristocratic institution that retains an effective role in

the modern world. Dare one say that this is what gives it its glamour in the newer republics whose history and founts of honour shine with a more utilitarian light? Somehow democratic politicians, when they withdraw to the sanctity of their presidential palaces, seem to find that a little aristocratic adornment does not come amiss. One may wish to believe that such flames of vanity are being blown out by the spirit of the age, but appearances suggest that they are being fanned to a merry blaze.

A less official sign of the same phenomenon brings increasing disquiet to the historic orders of chivalry. The age of the common man has proved fertile in bodies of private citizens adopting the titles of Knights Templar and similar exciting fraternities; the unique status of the Order of Malta has made it, unwillingly enough, the model for a large number of such imitations. A favourite pretext is to claim descent from the non-Catholic Russian Priory created by the Emperor Paul I in 1799 and suppressed by Alexander I in 1810 – the latter act having apparently had the effect of converting it into a separate chivalric order of rare fecundity.★ One of the earliest personages to make this claim was an American called William Lamb who declared himself a general of Russian descent and thus, obviously enough, empowered to offer membership of the supposed order to citizens of the United States. He registered his organisation as 'Knights of Malta Inc.' in 1911. Apart from moving its headquarters to Shickshinny, Pa, this body experienced an almost humdrum existence until about 1960, since when it has been scattering offshoots like a Catherine-wheel. A Frenchman named Granier de Cassagnac, whose claim to the Grand Mastership was disputed by his brethren, seceded in 1962 and set up a rival group in Europe under the patronage of the deposed King Peter of Yugoslavia; the latter however found cause for discontent and left to enjoy the magistral dignity in America, while Cassagnac led his own faithful in Europe.[3]

A figure who had been prominent in both these factions was the Swiss Otto Schobert, who

★ It is worth noting that from the time of Alexander I all the Czars except Alexander III held the Grand Cross of Honour and Devotion of the Sovereign Order. In 1977 the late head of the imperial house, Grand Duke Vladimir (who held the same decoration), appointed Prince Tchkotoua as his representative before the Order of Malta with the authority to 'intervene in my name and assist the Sovereign Military and Hospitaller Order of St John of Jerusalem, of Rhodes and of Malta, on any occasion that may arise to act against false orders which, usurping the names belonging to the Sovereign Order of Malta, claim to be of Russian Imperial Origin'.[2]

An ambulance boat of the Order on the Amazon.

after being unfrocked as a Catholic priest consoled himself with the compensatory dignity of Baron de Choibert. In 1966 he set up a 'Helvetian Priory' for a group of his friends, by whom he had the misfortune to be murdered in 1970. The tenure of his successor was even briefer, until his reportedly lethal ways with a cup of coffee occasioned his entry into prison. The exact evolution of the variously styled orders sprung from these origins, of which well over thirty have been counted up to the present, would be confusing to trace, but the impressive credentials of their promoters ensure that they seldom want for adherents. One may cite for example Count George King of Florina, a distinguished member of one of the orders who is also a terrestrial representative of the Cosmic Masters of the Solar System. Usually these orders are led by persons of illustrious lineage who have otherwise escaped the notice of genealogists. Thus a 'Priory of the United States' was set up in Malta by His Imperial and Royal Highness Prince Henry III Constantine de Vigo-Lascaris Aleramico Paleologos de Montferrat, Hereditary Emperor of Byzantium and Prince of Thessaly, who formerly hid his light as Enrico Vigo. Another Order of Malta, distinguishing itself by the name 'Ecumenical', counts with the membership of a certain Prince Bruce-Alfonso de Bourbon-Condé.

The prize for plausibility is surely deserved by an American-Italian prince of similar vintage who obtained recognition for his Sovereign Order from the government of the Seychelles, where he set up an embassy in 1985. After a criminal trial in London in March 1987, which disclosed tales of fraudulent property deals, of false titles and of astronomical bills run up at the Ritz by supposed diplomats, the embassy was closed down.[4] More recently soi-disant knights have been drawing profit from the fears of Hong Kong citizens by offering them membership and 'diplomatic passports' for which sums in excess of $40,000 have been asked. Such activities show why the phenomenon of the false orders goes beyond a laughing matter, and the Sovereign Order collaborates with the four Protestant Orders of St John in maintaining a joint committee to help the police in acting against fraudulent use of their names and insignia.

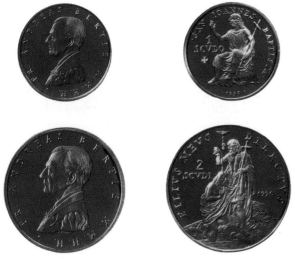

Coins of the Order of Malta.

The Constitution of the Order

The Order of Malta today has three separate natures. It is first, as it has been since the twelfth century, a religious order of the Catholic Church with professed members, the Knights and Chaplains of Justice. In this aspect as a military religious order it is now *sui generis*, since the other surviving members of the same class, the Teutonic Knights and the Spanish military orders, lost either their chivalric or their religious character in the first half of this century. Secondly, since 1960 the Order has been a religious institute comprising laymen (the Knights of Obedience and Donats of Justice), who are bound by promises of obedience to their appointed superiors. Thirdly it is an autonomous order of chivalry conferring the titles of knight or dame chiefly on Catholics but also occasionally on non-Catholics of high rank; its status of international sovereignty is linked with this third aspect of its nature, knighthood being conferred by the Grand Master in his capacity as a sovereign prince.

The Knights of Justice are always recruited from Knights of Obedience or those of Honour or Grace and Devotion, and undergo an enquiry into their suitability which lasts at least three months. They perform a twelve months' novitiate before taking their simple (temporary) vows, and make their solemn and definitive profession between one and nine years later. The vow of chastity limits this class to bachelors and widowers. The vow of poverty is very relative, as it was in the days when the crusader knight had his horses and his squires; a professed knight renounces the freedom to dispose of his property, but he is allowed and indeed required to retain the means to support himself. Nevertheless it is distinctive of this Order which represents the aristocracy of birth and wealth that it is governed by a group of men who are not personally rich. The minimum age for solemn profession is thirty-three years, though in practice the Order discourages such a step until rather later, to make sure that it is a settled decision. Knights and Chaplains of Justice are either members of one of the historic priories, with the Grand Prior as their superior, or are received *in gremio religionis*, being in that case directly subject to the Grand Master.

The Knights of Obedience and Donats of Justice are bound only by religious promises. The class is open to married men and the minimum age is twenty-two years. Candidates undergo a year of probation under a spiritual director and then taken an oath of obedience to their Grand Prior or other superior; the special category of Sub-Priories exists to group Knights of Obedience outside the structure of the Grand Priories, and the Regents of these may be Knights either of Justice or of Obedience. The obligations of this class are to submit to the guidance of a spiritual director, to hear Mass and receive the Sacraments regularly, to perform the spiritual exercises held by the Priories or Sub-Priories at least once a year and to participate actively in the life of the Order. Since the class of Knights of Obedience appeared in 1960 the Order has interpreted its duties in terms of personal sanctification and has so far not attempted, for better or worse, to use it as a cadre for corporate action.

Knights and Dames of the third class have much lighter obligations; their fees and donations support the works of the Order, and obedience to ordinary Catholic teaching is required: a divorcee for example would be excluded from membership. Nevertheless their position as by far the largest section of the Order makes them shoulder a growing responsibility in upholding its religious and Hospitaller character; the pilgrimages and other charitable works owe their existence to the generosity and personal dedication of great numbers of ordinary knights

and dames. There are over 10,000 knights today, grouped in thirty-nine National Associations. An applicant receives his knighthood once his candidature has been supported by four members of the Order and approved by the Sovereign Council in Rome. There are three categories of admission: Honour and Devotion, Grace and Devotion and Magistral Grace, depending on the strictness of nobiliary qualification. While there are many Knights of Honour and Devotion who have made the illustrious proof of sixteen quarters, some National Associations (particularly those outside Europe) are overwhelmingly composed of Knights of Magistral Grace, whose nobility consists only in their knighthood itself. All nevertheless have an equal right to the Presidency and other offices of their Association, since the only distinctions with constitutional significance in the Order are those based on the religious vows and promises. Outside the ranks of the knights themselves there are also numerous holders of the Cross *pro merito melitensi*, awarded for services to the Order's charitable works.

The government of the Order is essentially in the hands of the professed knights, with a certain representation of the other two classes. The Grand Master must necessarily be a Knight of Justice, as most of the ten members of the Sovereign Council are, though some offices may be held by Knights of Obedience. In internal matters they exercise complete authority, but the Order's charitable works are in practice run by the National Associations. The reason for this is largely financial: the Order itself commands very limited funds, and though immense sums are raised by voluntary contributions they go immediately to the hospitaller activities of the Association concerned. In an Order in which everyone gives his services voluntarily, and no-one would be so ill-bred as to tell anyone else what to do, the result until now has been a constitution of very marked local autonomy.★

The heart of the Order nevertheless consists of its professed members, and is to be seen functioning in the magistral palace in Rome. There are generally about seven resident knights, while others who live in Rome come into the palace to work. The Grand Master with the Knights of Justice who live here form the lineal descendant of the religious community founded by the Blessed Gerard in Jerusalem in the last decades of the eleventh century.† They occupy the seventeenth-century palace built as the Order's embassy by Giacomo Bosio. The Palazzo Malta occupies a discreet site in the aristocratic intimacy of the Via Condotti, a few hundred yards from the Spanish Steps. It houses the suite of the Grand Master, with a magnificent tapestried office and other reception rooms, and the knights and servants are also lodged here in patriarchal community. The magistral palace conveys what must have been the tone of the great prince-abbacies or *chapitres nobles* of the eighteenth century; its members unite the urbanity of aristocrats with the discipline of religious. For most of the day the Grand Master and the knights work in their individual offices, but they assemble for daily Mass and evening prayers in the small but stately chapel, and likewise for meals. The language most generally spoken in this cosmopolitan gathering is English, but the palace is a survival of the old comity of aristocratic Europe, in which each individual is at home in three or four languages. Increasingly today the life of the palace is punctuated by ceremonial occasions necessitated by the visits of foreign heads of state and ministers, or the arrival of an ambassador to present his credentials. The footmen's everyday liveries give way to a resplendent eighteenth-century costume and the knights appear in their scarlet gala uniforms. On ordinary occasions, the knights are distinguished only by the small cross of profession worn on the lapel and by the kind of faultless tailoring seldom seen nowadays outside St James's Street.

The ceremonial year of the Palazzo Malta

★ This characteristic sheds an ironic light on the view of the Order peddled by a certain class of commentator. In one recent best-selling book we read: 'Today it is thought that the Order of Malta is one of the main channels of communication between the Vatican and the C.I.A. The proofs of it abound.'[5] Many of its members would often have been satisfied if the Order became sufficiently conspiratorial for one American association to collaborate with another.

† In the nine-hundred-year history of the Order the longest interruption in the continuous life of the Convent was between its dissolution in Malta in 1798 and its reconsitution at Messina in 1803. A similar but shorter interruption occurred after the fall of Jerusalem in 1187, until the Convent was re-formed at Margat.

culminates on St John's Day, 24 June, when a Mass and reception are held for members of the diplomatic corps at the villa on the Aventine, the second of the Order's two palaces whose extra-territorial status is recognised by the Italian Republic. Piranesi's church and the beautiful garden, which is then at the height of its glory, afford a setting to this gathering which the Via Condotti could not provide. The Sovereign Council is then received in audience by the Pope and the knights disperse *ad aquas* until the autumn. In the past the Grand Masters have spent the summer at their fifteenth-century castle of Magione on Lake Trasimene or at the magnificently situated Villa Spinola on the Bay of Rapallo, but the present Grand Master has alternated these stays with visits to Malta, where the government has put an official residence at his disposal.

Strengths and Problems

The modern Order of Malta is the product of a recovery from the catastrophe of two centuries ago into new political and social conditions which might have appeared fatal to it. Its character today is much closer to what it was in the twelfth than in the eighteenth century. There is the same distinctive straddling between the religious and the secular life, the same pragmatism, the same government by a small minority of professed knights, the same reliance on local initiatives and the same consequent diversity of the Order's works. But the differences are also worth noting: in the twelfth century the Hospitallers were a young Order identified with the great inspiration to the religious life of their age – the possession of the Holy Places; today they bear the glory but also the weight of nine centuries of history. In the middle ages the Hospital received a great wealth of endowments which supported its work for pilgrims and the sick but also enabled it to found communities of brethren and form its own charitable and religious activities; today great sums are raised for charitable work but the Order itself remains poor, lacking even the means to support its professed members, who have to rely on private wealth or professional earnings. This both defeats the purpose of religious vows, which is to allow members to devote themselves fully to the Order, and causes

the initiative to pass from the centre to the periphery. While the merit of those individuals who choose the professed life in these circumstances is obviously all the more remarkable, their recruitment has hitherto laboured under a disadvantage unknown to any other religious order.

Another factor is the loss of conventual life since the fall of Malta. One often hears Knights of Malta say, in defence of their present situation, that life in community is not historically part of the Hospitaller vocation. Nevertheless the old statutes required five years' conventual residence for commanders and ten years for higher dignitaries. In practice most brethren had long experience of the life of the Convent with all its influences on their religious formation: a large and continuous novitiate, the Auberges with their chapels and their communal life, the service of the sick, the conventual church as a regular setting for the worship of all the brethren, the distinctive feasts and special devotions, a numerous body of clergy to maintain and interpret the spiritual tradition of the Order. The loss of those things entailed a much greater secularisation than all the change in tone and practice between the twelfth and the eighteenth centuries. The consequence today is that the coherent spirituality of an order such as the Benedictines or the Jesuits is missing. The chaplains in the various countries, thrown back on general resources, often render excellent service to those they direct but are not necessarily in agreement either with each other or with the tradition they are striving to interpret. This is a very heavy disadvantage for an Order that is trying to recover and strengthen its religious character.

Against these difficulties, one has to take into account the undoubted vitality manifested by the Order's recovery over the past century and a half. An institution that relied simply on traditionalism or nobiliary pride would not have been able to raise itself to the status it holds today. The secret of its resurgence has been the Hospitaller vocation itself; it is this which gave the element of idealism and service without which the schemes for revival would have remained at the level of mummery. The vast charitable works born of that impulse have shown the viability of an ancient chivalric ideal in the modern world. The peculiar achievement

of the Knights of Malta is the conjuring trick by which they turn titles and ceremonies into hospitals, ambulances, medical supplies, transport of goods for the needy and services of all kinds – a conjuring trick the more singular because its ingredients are fantasy and its product substance.

The Order of Malta, as it confronts a democratic and secularist world, has been faced with two possible avenues of advance. One is what may be termed the 'modern' option, to relinquish its nobiliary traditions and turn itself into an association of rich and influential people, justifying its pomps by its works; conventional wisdom continually urges it to do this, and to some extent it has been pushed along that path. Yet the strategy is not without its dangers. One of these is suggested by the Order's modern history: it is inescapable that the great strides made since the middle of the nineteenth century are a testimony to the energy and *esprit de corps* of the European aristocracy; and it may be that by weakening its link with that matrix the Order will lose one of its principal sources of strength. A second danger is suggested by more recent events: liberal standards of admission to knighthood inevitably imply offering membership on the one hand to individuals for whom becoming a Knight of Malta may be an object of social ambition, and on the other to very prominent figures in the political and business worlds whose position exposes them, with better or worse reason, to public criticism. Thus the paradoxical consequence of democratising the Order has been to make it more vulnerable to accusations of snobbery and political involvement.

One notorious example was the case of Umberto Ortolani, a financier who was received as a Knight of Magistral Grace in the great expansion of the Italian Association that took place under the Grand Master de Mojana; he was also appointed the Order's ambassador in Uruguay, where he owned a bank. When the scandal of the masonic lodge P2 erupted in 1981, implicating hundreds of the most prominent figures in Italian society, it was disclosed that Ortolani had been a close associate of Licio Gelli, the grand master of the lodge. The criminal trials resulting from this exposure ended in April 1992, with the sentencing of Ortolani to nineteen years' imprisonment as an accessory to fraudulent bankruptcy in connexion with the spectacular crash of the Banco Ambrosiano. Since these are activities in which the older nobility has generally lagged behind the times, the Order of Malta has been left with an unhappy lesson to ponder.

The second option before the Order is to hold fast to its traditional character as a religious order of the Catholic Church, emphasising the role of its professed members and thus, in practice, retaining its reliance on a class by whom the ideal of *noblesse oblige* embodied in that vocation continues to be valued. Difficult as it is, this is the course which the Order has preferred, and it has not been wholly unsuccessful in pursuing it. In 1962, at the end of the long interregnum which had threatened its independence, the number of professed knights had fallen as low as thirty-one. Today there are thirty-eight Knights of Justice. The increase may seem insignificant, but it should be seen against the catastrophic decline in religious vocations that has taken place elsewhere over the same period. The Order of Malta provides an illustration of the truth that the only institutions of the Catholic Church that have prospered in the past thirty years are those which have remained firmly wedded to their traditions. It has contended with a generally difficult religious climate but one which has been particularly unpropitious to an order which links its vocation with the tradition of chivalry. The iconoclastic orthodoxy that prevailed until some years ago in ecclesiastical circles was both hostile to the existence of the Order of Malta and uncongenial to its members, and something of this was reflected in the liturgical sphere. While officially the Order has limited itself to retaining the use of Latin in its religious rites, many of its chaplains preferred to keep the Tridentine Mass for private celebration.

That was the case of one of the Order's chaplains in France, Mgr François Ducaud-Bourget, who in 1955 became known as the author of *La Spiritualité de l'Ordre de Malte*, one of the few modern attempts to lift that subject from oblivion. In the early 1970s his private Mass in the chapel of the Hôpital Laënnec in Paris, where he was chaplain, became the focus of a growing congregation, attracted by word of mouth, and when the Mass was moved to the Salle Wagram in the Rue Montenotte the number of worshippers increased to thousands. The result was a conflict with the episcopate who, having assured the People of God that it was

clamouring for a radical revision of the liturgy, were naturally indignant when the People of God gave evidence of preferring to pray in the old manner. Since this placed Mgr Ducaud-Bourget well outside the policy of the Order of Malta and its scrupulous respect for ecclesiastical authority, he resigned his title of Chaplain in 1976. While it would be a mistake to regard his case as typical, it may be seen as symptomatic of the obstacles faced by the Order of Malta that one of the modern exponents of its spirituality should have been lost to it through the determination of the Catholic Church to turn its back on its tradition. It would equally be a mistake, however, to imagine that the difficulty is a permanent one. We have entered an age whose watchword is conservation, and there is no more fragile life-form in the ecosystem of the Christian tradition than the ideal of religious chivalry of which the Order of Malta stands as the modern exponent. It is now to be seen promoting that ideal in an increasingly sympathetic climate.

Prospects

On the death of Fra Angelo de Mojana in 1988 there was a general determination that the election of his successor should affirm the international character of the Order. For nearly two centuries most of the professed Knights of Malta belonged to the surviving Grand Priories of the Italian and German Langues, and all the heads of the Order had been chosen from those nationalities. The election of Fra Andrew Bertie as 78th Grand Master on 8 April 1988 not only broke with that precedent but gave the Order the first English Grand Master in its history. The elevation of a former Regent of the Sub-Priory of the Blessed Adrian Fortescue may also be said to mark the coming of age of the Order's new constitution. In other respects the choice seems memorably traditional. Fra Andrew Bertie is one of the few Englishmen today who can prove sixteen quarters of nobility; his two years' service in the Scots Guards recalls the 'caravans' that used to be required of the Knights of Malta; and as the pupil of one Benedictine school and a master for twenty-three years at another he has

come to office with a closer knowledge of the religious life than any of his predecessors for many generations. He had been active since 1962 in the Lourdes pilgrimage, for which he organised a group of volunteer *brancardiers* among his pupils at Worth Abbey, and as a resident in Malta for twenty years he established links with the future rulers of the island which have resulted in the unprecedentedly friendly relations that have prevailed since his election. The cession by the Maltese government in 1991 of the historic fortress of Sant'Angelo to the Sovereign Order is one of the fruits of this good understanding.

This acquistion has been conceived as the centrepiece of the new policy currently being developed to improve the efficiency of the Order. These plans, it is fair to say, were promoted by the late Grand Master a year before his death, but the advent of younger men into the key positions of government has given them special strength. The upshot has been the emergence of new institutions such as knights of a generation ago would have regarded with perplexity. A seminar on Future Strategies held in 1988 resulted in the appointment of a Select Council (*Consiglio Ristretto*) which in turn spawned six working groups on various aspects of the Order's needs. Two Commissions, on Spirituality and Strategies, have been working for the past few years with unprecedented determination, and an international committee composed of regional correspondents collaborating with the information officer in Rome is designed to improve communications with the outside world.

In many ways the easy-going methods of the past are yielding to a much better co-ordinated approach. Rationalisation begins to thrust its beam into the world-wide crannies of the Order. Thus the National Associations have been called upon for the first time to carry out an accurate evaluation of their resources and report on them to the Grand Magistry with a view to the replanning of local activities. It has been realised that the Order's unique position can be used to best advantage if its diplomatic representation is employed to co-ordinate the work of the National Associations with government initiatives. These possibilities are especially visible in such regions as Latin America, where virtually the entire continent is in diplomatic relations with the Grand Magistry, and National Associations are well established in nearly every country.

Such a plan in turn implies the need for a more professional diplomatic service, working in collaboration with the National Associations, and courses for its personnel are among the programmes intended for Fort Sant'Angelo, which is envisaged as the new training centre of the Order. The acquisition of that building was by no means an exercise in historical nostalgia; the motivation behind it was that the Order's houses in Rome are simply far too small to be adapted for such a purpose. It was nevertheless a happy stroke to choose a location that gives trainees an immersion in the Order's historic character which Rome itself could not have equalled. The training planned at Fort Sant'Angelo looks to the improvement of the Order's Hospitaller work across the world, with the more successful bodies like the *Malteser-Hilfsdienst* pooling their experience with Associations preparing to set up new services. The success of such courses is clearly going to depend on a very high degree of support from the Grand Priories and National Associations whose young men and women are to attend them, and the Grand Magistry thus has the strongest incentive to promote the policy of co-ordination for which such ambitious hopes are entertained.

From the practical point of view this initiative must be regarded as the most innovative in modern history of the Order, certainly more so than the reforms of the Chapter General of 1962, which were largely juridical; the closest precedent is probably the regeneration of the Order that took place in the years 1834–64. The launching-pad for this change has been the Order's expansion of the past thirty years and the quite unprecedented position it has thereby attained. It has taken a generation for the Knights of Malta to realise the opportunities of that position, and to overcome the attitudes of defensiveness and caution which followed the battering they took at the hands of Cardinal Canali. How far behind that episode has been left is shown by the extent of cordial co-operation with the Vatican in developing the new strategies, and particularly the work of the Commission on Spirituality. It has been noted that the Grand Magistry's relations with Pope John Paul II have profited from the accession of Fra Andrew Bertie, in view of interesting parallels in their position, as foreigners who have come to the leadership of organisations long in Italian hands,

as linguists of legendary versatility and as men strongly concerned for the unity and effectiveness of the flocks they have been elected to govern.

The Grand Master has declared his aim of having above all a working Order, and has himself taken the lead in promoting that objective. His assiduous state visits have been directed towards co-ordinating the work of the local associations both with government policy and with the Order's central organisation. Even more now than at the time of his election, the choice of Fra Andrew Bertie appears increasingly apt for the new age of internationalism that has been opened up; some of the steps he has taken may be of more than symbolic importance. On a private visit to England in 1991 he was received by the Queen, bringing about the first meeting between a Grand Master and an English monarch since 1528. In January 1989 he conferred the Grand Cross of Merit on President Reagan in recognition of his stand against abortion, the first time the Order's honours have been used as an affirmation of Catholic moral teaching rather than as a mere courtesy.

All this new energy is likely to mean that the world at large will come to hear more of the Order of Malta than it has for the past two hundred years. It may be more significant to note the vision of the Order which has stood at the centre of its planning, and which the Grand Master has expressed in particularly unequivocal terms: 'It is an inescapable necessity to safeguard at all costs the pre-eminently religious character which for our Order is supreme, essential, indispensable, and a *conditio sine qua non* of its existence.'[6] It is a reflexion of this that Fort Sant'Angelo will be used as a centre of spirituality; the sturdy church of St Anne, which stands at its heart, aptly symbolises the place of devotion in this projected training school. More particularly the quickening of the religious life of the professed knights has been unmistakable. In the magistral palace the practice has been introduced of saying Lauds and Vespers as part of the community's daily devotional life. The Grand Master's personal example has encouraged several English knights to make their novitiate and take vows, with the result that it is shortly intended to refound the Priory of England with five Knights of Justice leading a strong contingent of Knights of Obedience. If we except

the division of Bohemia and Austria in 1938, this is the first addition to the Order's list of priories for a century and a half, and the Grand Master's declared policy is to extend the policy to other countries. The recent entry of a French Knight of Justice – the first for a generation – is a hopeful sign in that direction.

It thus appears that this ancient order of the Catholic Church is moving back significantly towards its full religious vocation. If that development takes shape, it will confound the trends of the modern world, but will not be out of keeping with the Order's past character. The role of the Knights of St John in some of the most critical moments of history has been in defence of threatened posts against a tide of conquest – garrisoning Belvoir against Saladin and Crac against the Sultan Bibars, resisting the Ottoman Empire in Rhodes and Malta, recovering a chivalric tradition from the ashes of the old world. Some of their stands have turned the tide of history; others have ended in defeat, but not for lack of boldness. Materially the Hospitallers have amply demonstrated the value of their work in the modern world; with the insistence on their religious vocation they are essaying something less predictable. But the Order of Malta is nothing if not surprising; this initiative may yet prove to be its crucial source of strength in the twenty-first century.

APPENDIX I

Grand Masters and Lieutenants of the Order of St John

THE TRADITIONAL NUMBERING of Grand Masters is retained, but names wrongly or doubtfully included are printed in italics. Lieutenants who governed the Order during vacancies are also listed in italics.

Masters of the Hospital in Jerusalem, Acre and Cyprus

Name	Dates
1 The Blessed Gerard[1]	Founder of the Hospital before 1180
	Papal confirmation 1113
	Died 3 Sept. 1120
2 Raymond du Puy	1120–1158/60
3 Auger de Balben	1158/60–1162/3
4 *Arnaud de Comps (uncertain)*	1162/3
5 Gilbert d'Assailly[2]	1163–1169/70
6 Cast de Murols	*c.*1170–*c.*1172
7 Joubert	*c.*1172–1177
8 Roger des Moulins	1177–1187
Lt Borrell ruled the Order as Grand Commander after the death of Roger des Moulins, in partnership with Ermengard d'Asp	1187–1188 *from* Oct. 1187
9 *Ermengard d'Asp, Provisor of the Order until the election of Garnier de Naplous*	1188–1189/90
10 Garnier de Naplous	1189/90–1192
11 Geoffroy de Donjon	1192/3–1202
12 Afonso de Portugal[3]	1202–1206
13 Geoffroy le Rat	1206–1207
14 Garin de Montaigu	1207–1227/8
15 Bertrand de Thessy	1228–*c.*1231
16 Guerin Lebrun[4]	*c.*1231–1236
17 Bertrand de Comps	1236–1239/40
18 Pierre de Vieille-Brioude	1239/40–1242
19 Guillaume de Châteauneuf	1242–1258
Lt Jean de Ronay, Lieutenant during the captivity of Châteauneuf	1244–1250
20 Hugues de Revel	1258–1277
21 Nicolas Lorgne	1277/8–1284[5]
22 Jean de Villiers	*c.*1285?–1293/4
23 Odon de Pins	1294–1296
24 Guillaume de Villaret	1296–1305
25 Foulques de Villaret	1305–

[1] *Geraldus* in most contemporary documents. The names of medieval Grand Masters are traditionally given in their French forms. This does not imply that they were all French.

[2] Abdicated.

[3] Deposed.

[4] The surname, which does not otherwise appear in the lists of Grand Masters, is supplied by J. Raybaud from the Archives of the Grand Priory of Saint-Gilles (*Histoire des Grands Prieurs et du Prieuré de Saint-Gilles*, ed. C. Nicolas, 1904, Vol. 1, p. 139).

[5] The traditional dating of Lorgne's death is taken from a statement in the *Gestes des Chiprois*. According to the Archives of the Grand Priory of Saint-Gilles, cited by Raybaud (op. cit., Vol. 1, p. 205), he abdicated in 1286 and continued to govern the Order till Jean de Villiers arrived from France in 1288.

Grand Masters of Rhodes

	Name	Langue[1]	Date of election
25	Foulques de Villaret	Greater Provence	1305[2]
Lt	Gerard de Pins	Greater Provence	18 September 1317
	Appointed Vicar-General of the Order (after the deposal of Villaret)		
26	Hélion de Villeneuve	Lesser Provence *(County of Provence)*	18 August 1319
27	Dieudonné de Gozon	Greater Provence	7 May 1346
28	Pierre de Corneillan	Lesser Provence *(County of Valentinois)*	8 December 1353
29	Roger de Pins	Greater Provence	August? 1355
30	Raymond Berenger	Lesser Provence *(Dauphiné)*	1? June 1365
31	Robert de Juilly	France	February? 1374
32	Juan Fernandez de Heredia	Spain *(Kingdom of Aragon)*	Appointed by Pope Gregory XI August? 1377
33	*Riccardo Caracciolo*	*Italy*	(1383–95)
	Anti-Master appointed by Pope Urban VI but not acknowledged at Rhodes		
34	Philibert de Naillac	Auvergne[3]	6 May 1396
35	Antonio de Fluviá[4]	Spain *(Kingdom of Aragon)*	c. 1 July 1421
36	Jean de Lastic	Auvergne	6 November 1437
37	Jacques de Milly	Auvergne	1 June 1454
38	Raimundo Zacosta	Spain/Aragon	24 August 1461
39	Giovan Battista Orsini	Italy *(Papal States)*	c. 28 February 1467
40	Pierre d'Aubusson, *Cardinal*	Auvergne	17 June 1476
41	Emery d'Amboise dit Chaumont	France	10 July 1503
42	Guy de Blanchefort[5]	Auvergne	22 November 1512
43	Fabrizio del Carretto	Italy *(Marquisate of Finale)[6]*	15 December 1513
44	Philippe Villiers de l'Isle Adam	France	22 January 1521

[1] The kingdom or state of origin is added where it cannot be presumed from the name of the Langue.
[2] Deposed in 1317, formally abdicated 13 June 1319.
[3] Though he held the Priory of Aquitaine at the time of his election, his first commandery had been in Auvergne. I am indebted to Dr Anthony Luttrell for this information.
[4] The appendage 'de la Riviere' usually added to the name of this Grand Master is evidently some ingenious Frenchman's interpretation of 'Fluvianus'.
[5] Nephew of the Grand Master Aubusson; he died on his way out to Rhodes.
[6] The Grand Master's brother was Marquis of Finale (in Liguria), an immediate fief of the Holy Roman Empire which the family ruled from the twelfth to the sixteenth century.

Grand Masters of Malta

	Name	Langue	Year of Birth	Date of election[1]
44	Philippe Villiers de l'Isle Adam	France	1464	22 January 1521
45	Pietrino del Ponte	Italy (Asti)[2]	1462	26 August 1534
46	Didier de Tholon Sainte-Jalle	Provence	[3]	22 November 1535
47	Juan de Homedes y Coscón[4]	Aragon	1477	20 October 1536
48	Claude de la Sengle	France	1494	11 September 1553
49	Jean Parisot de la Valette	Provence	1494	21 August 1557
50	Pietro Ciocchi del Monte San Savino[5]	Italy	1499	23 August 1568
51	Jean l'Evesque de la Cassière	Auvergne	1503[6]	27 January 1572
52	Hugues Loubenx de Verdale, *Cardinal*	Provence	1531[7]	12 January 1582
53	Martín Garzés	Aragon	1526	8 June (?) 1595
54	Alof de Wignacourt	France	1547	10 February 1601
55	Luis Mendes de Vasconcellos	Castile (*Portugal, under Spanish rule*)	1543[8]	17 September 1622
56	Antoine de Paule	Provence	1551/2	10 March 1623
57	Jean-Baptiste Lascaris de Castellar[9]	Provence (*Duchy of Savoy*)	1560	16 June 1636
58	Martín de Redín y Cruzat	Aragon	1590	17 August 1657

[1] By the sixteenth century Grand Masters were normally elected about three days after the death of their predecessors. Longer interregnums are recorded in separate notes.
[2] Asti was a French possession till 1512; from 1530 it belonged to Savoy.
[3] He died in Provence 'at a great age' on 26 September 1536, before coming to Malta.
[4] Following national custom, the maternal surname of Spanish Grand Masters is added where known.
[5] His family name was Guidalotti, but he had assumed the surname of his uncle Pope Julius III (1550–55).
[6] He died in Rome on 12 December 1581.
[7] He died in Rome on 4 May 1595.
[8] Mendes was, at seventy-nine, apparently the oldest Grand Master ever elected.
[9] Lascaris, who died at ninety-seven, is the longest-lived Grand Master of whom we have record.

	Name	Langue	Year of Birth	Date of election
59	Annet de Clermont de Chattes Gessan	Auvergne	1587	9 February 1660
60	Rafael Cotoner y de Oleza	Aragon	1601	6 June 1660
61	Nicolás Cotoner y de Oleza	Aragon	1608	23 October 1663
62	Gregorio Carafa della Roccella	Italy (*Naples, under Spanish rule*)	1614	2 May 1680
63	Adrien de Wignacourt	France	1618	27 July 1690
64	Ramón Perellós y Rocafull	Aragon	1637	5 February 1697
65	Marcantonio Zondadari[10]	Italy (*Grand Duchy of Tuscany*)	1658	14 January 1720
66	Antonio Manoel de Vilhena	Castile (*Kingdom of Portugal*)	1663	19 June 1722
67	Ramón Despuig y Martinez de Marcilla	Aragon	1670	16 December 1736
68	Manuel Pinto da Fonseca	Castile (*Kingdom of Portugal*)	1681	18 January 1741
69	Francisco Ximenez de Texada	Aragon	1703	28 January 1773
70	Emmanuel de Rohan de Polduc[11]	France	1725	12 November 1775
71	Ferdinand von Hompesch zu Bolheim	Germany	1744	17 July 1797

[10] Nephew of Pope Alexander VII (1655–67).
[11] Rohan was, at fifty, the youngest recorded Grand Master of the Order, though it is likely that some medieval Grand Masters, such as Raymond du Puy, were younger.

Grand Masters and Lieutenants since the fall of Malta

	Name	Langue	Year of Birth	Place & date of election	Date of death
71	Ferdinand von Hompesch zu Bolheim	Germany	1744		[*Abdicated 6 July 1799*]
72	*Paul, Emperor of Russia, irregularly proclaimed Grand Master* *De facto ruler of the Order*			*7 November 1798*	*23 March 1801*
Lt	*Nicholas Soltykoff, appointed Lieutenant by Alexander I of Russia*			*27 March 1801*	[*retired*]
73	Giovanni Battista Tommasi	Italy *(Grand Duchy of Tuscany)*	1731	(Appointed by Pope Pius VII) 9 February 1803	13 June 1805
Lt	*Innigo Maria Guevara Suardo*	*Italy (Kingdom of Naples)*	*1744*	*Catania 15 June 1805*	*25 April 1814*
Lt	*Andrea di Giovanni y Centelles*	*Italy (Kingdom of Naples)*	*1742*	*Catania 26 April 1814*	*10 June 1821*
Lt	*Antonio Busca*	*Italy (Austrian Empire)*	*1767*	*Catania 11 June 1821*	*19 May 1834*
Lt	*Carlo Candida*	*Italy (Kingdom of Naples)*	*1762*	*(Appointed by Pope Gregory XVI) 23 May 1834*	*12 July 1845*
Lt	*Filippo di Colloredo-Mels*	*Italy (Austrian Empire)*	*1779*	*Rome 15 September 1845*[1]	*9 October 1864*
Lt	*Alessandro Borgia*	*Italy (Papal States)*	*1783*	*Rome 26 February 1865*	*13 January 1872*
Lt	*Johann Baptist Ceschi a Santa Croce*	*Germany (Austrian Empire)*	*1827*	*Rome 14 February 1872*	
74	Johann Baptist Ceschi a Santa Croce (appointed Grand Master by Pope Leo XIII)			28 March 1879	24 January 1905
75	Galeas von Thun und Hohenstein	Germany *(Austrian Empire)*	1850	Rome 6 March 1905	
Lt	*Pio Franchi de'Cavalieri* *Lieutenant during the retirement of Grand Master Thun Hohenstein*	*Italy*	*1869*	*8 March 1929*	*26 March 1931* [*retired*]
76	Ludovico Chigi Albani della Rovere	Italy	1866	Rome 30 May 1931	14 November 1961
Lt	*Antonio Hercolani Fava Simonetti*	*Italy*	*1883*	[2]	[*retired*]
Lt	*Ernesto Paternò Castello di Carcaci*	*Italy*	*1882*	*Rome 24 April 1955*	[*retired*]
77	Angelo de Mojana di Cologna	Italy	1905	Rome 8 May 1962	17 January 1988
78	Andrew Bertie	British Sub-Priory	1929	Rome 8 April 1988	

[1] Since 1845 an international assembly has been summoned for the elections of Lieutenants and Grand Masters: hence the longer interregnum on the death of these.
[2] Assumed the Lieutenancy by right of seniority on the death of Prince Chigi.

APPENDIX II

Diplomatic Representation of the Order of Malta

Embassies

Holy See
Argentina
Austria
Benin
Bolivia
Brazil
Burkina Faso
Cameroons
Central African Republic
Chad
Chile
Columbia
Comoros
Costa Rica
Croatia
Cuba
Czech Republic
Dominican Republic
Ecuador
Egypt
El Salvador
Ethiopia
Gabon
Guatemala
Guinea
Haiti
Honduras
Hungary
Italy
Ivory Coast
Lebanon
Liberia
Lithuania
Madagascar
Mali
Malta

Mauretania
Mauritius
Morocco
Nicaragua
Niger
Panama
Paraguay
Peru
Philippines
Poland
Portugal
Romania
Russia
San Marino
Senegal
Slovenia
Somalia
Spain
Thailand
Togo
Uruguay
Venezuela
Zaire

Legations

Belgium
France
Germany
Monaco
Switzerland

APPENDIX III

Institutions of the Sovereign Military Hospitaller Order of St John of Jerusalem, of Rhodes and of Malta

His Eminent Highness the Prince Grand Master

The Prelate of the Order

The Sovereign Council

The Grand Commander
The Grand Chancellor
The Hospitaller
The Receiver of the Common Treasury
Four Councillors
Two Delegates

The Grand Priories, with dates of foundation

Grand Priory of Rome 1214[1]
Grand Priory of Lombardy-Venetia 1839[2]
Grand Priory of Bohemia 1182
Grand Priory of Austria 1938[3]

Sub-Priories

Sub-Priory of St Michael 1961
 Delegation of St Hedwig (Silesia)
 Delegation of St Clemens (Rhineland-Westphalia)
Sub-Priory of the Blessed Adrian Fortescue (Great Britain) 1970
Sub-Priory of St Oliver Plunkett (Ireland) 1972
Sub-Priory of St George and St James (Spain) 1990

The National Associations, with dates of foundation

1859	Rhineland-Westphalia
1867	Silesia
1875	Britain
1877	Italy
1885	Spain
1891	France
1899	Portugal
1911	Netherlands
1920	Poland
1926	America (New York)
1928	Hungary
1929	Belgium
1934	Ireland
1951	Peru
1951	Argentina
1951	Cuba
1951	Mexico
1952	Canada
1953	USA (Western)
1954	Nicaragua
1956	Brazil (São Paulo)
1956	Brazil (Rio de Janeiro)
1956	Colombia
1957	Philippines
1957	Venezuela
1958	El Salvador
1959	Scandinavia
1961	Switzerland
1962	Romania
1965	Malta
1968	Uruguay
1970	Ecuador
1974	Australia
1974	USA (Federal)
1974	Monaco
1976	Guatemala
1977	Chile
1981	Lebanon
1984	Brazil (Brasilia)

Senegal has a National Committee.

[1] Expropriated 1808, restored 1816.
[2] Founded as two priories *c.*1180, expropriated 1796–1806, restored as one Priory 1839.
[3] Separated from Bohemia 1938.

BIBLIOGRAPHY AND NOTES

The vast bibliography of the Order of St John has been collected in F. de Hellwald, *Bibliographie Méthodique de l'Ordre Souverain de Saint-Jean de Jerusalem* (1885), brought up to date successively by E. Rossi, *Aggiunta à la* Bibliographie Méthodique etc. (1924) and by J. Mizzi, *A Bibliography of the Order of St John of Jerusalem 1925–1969* (Council of Europe publication, 1970). Many of the books and articles that have appeared since the last date are listed in the bibliography of A. **Wienand** (ed.) *Der Johanniterorden, Der Malteserorden* (3rd edition, 1988), which also has the merit of being the best general history of the Order. The Periodical **Annales** *de l'Ordre Souverain Militaire de Malte* (Rome, 1960–78) contains a vast number of articles on every aspect of the Order's history.

The works mentioned below are only intended to represent those most easily accessible and generally useful. The works detailed under each chapter heading are the source of all the information in that chapter unless separate sources are given in the individual notes.

Where the full author and title of a work are given, bold type is used for the abbreviated name by which it is referred to elsewhere. Subsequent references to a work use the abbreviated form of its title with, in brackets, the page on which the full title may be found (unless it heads the same chapter), e.g. **Wienand** [p. 287]. Unless otherwise stated, the language of a work's title should be taken as indicating the country of publication.

CHAPTER I *The Kingdom of Jerusalem*

J. **Riley-Smith**, *The Knights of St John in Jerusalem and Cyprus* (1967), virtually supersedes J. Delaville le Roulx, *Les Hospitaliers en Terre Sainte et à Chipre* (1904). The latter author's **Cartulaire** *Général* (4 volumes, 1896) remains the essential compilation of documents pertaining to the first two centuries of the Order. R. **Hiestand**, 'Die Anfänge der Johanniter' in J. Fleckenstein and M. Hellmann (eds), *Die Geistlichen Ritterorden Europas* (1980), provides invaluable further research on the early years. For the buildings of the Kingdom of Jerusalem see M. **Benvenisti**, *The Crusaders in the Holy Land* (Jerusalem 1970), and for the Hospital of Acre Z. Goldmann, *Akko in the Time of the Crusaders* (Haifa, 1987).

1 The discussion of this question in **Hiestand** places the point beyond reasonable doubt.
2 **Hiestand** demonstrates from papal documents that the early Hospitallers were not Benedictine lay brothers (as had formerly been conjectured) but a lay fraternity without vows or religious habit but with an oath to serve the poor.
3 The Bull *Pie postulatio voluntatis* addresses Gerard as *institutori ac preposito* of the Hospital. Though *institutor* may mean simply 'Superior', it seems redundant in this context except in the sense of founder. The phrase *Xenodochium quod . . . instituisti* also suggests the same. William of Tyre's statement that before 1099 Gerard had served in the Hospital *multo tempore* is also consistent with the idea that he was the founder of a house that originated before 1080. On the other hand, if we identify the Hospital of St John with the hospice said to have been founded by the Amalfitan Mauro, it would be necessary to place its date of origin before 1171, and the traditional view of Gerard as the founder, to the detriment of the true benefactor, would perhaps be due to a misinterpretation of *Pie postulatio voluntatis*.
4 This is stated by **Raybaud** [p. 290], Vol. 1, p. 10.
5 This is the thesis of **Riley-Smith**. **Hiestand**

objects that *Pie postulatio voluntatis* did not formally constitute the Hospital a religious order. Nevertheless it was the basis on which it was able to develop into one, without any subsequent act of foundation.

6 This activity is first mentioned in the Bull of Innocent II *Quam amabilis Deo* (dated 1139–43; **Cartulaire** Vol. 1, No. 130): 'The brethren maintain soldiers at their own cost so that the pilgrims may be able to travel the more securely to the Holy Places.' A supposed bull of the same Pope dated 1131 and attributing an armed role to the Hospitallers by both land and sea (wrongly printed as genuine in **Wienand** [p. 287]) is a forgery of the 1180s.

7 Girardus iacet hic, vir humillimus inter Eoos:
Pauperibus servus et pius hospitibus;
Vilis in aspectu, sed ei cor nobile fulsit.
Paret in his laribus quam bonus exstiterit.
Providus in multis, facienda decenter agebat,
Plurima pertractans multiplici specie.
Pluribus in terris sua sollers bracchia tendens,
Undique collegit pasceret unde suos.

Fulcher of Chartres, *Historia Hierosolymitana*, III *sub anno* 1120.

8 **Cartulaire** Vol. 1, No. 74: *Durandus, Hospitalis constabularius*, appears as a witness to a donation in January 1126. **Hiestand** and some other historians argue (with small probability in the context of this particular document) that 'constable' may be a non-military title, and contend that the armed role of the Hospital did not begin until after the grant of Bethgibelin in 1136. This view suffers from an inattention to the Spanish evidence of the early 1130s, for which see p. 139–140. It may be useful to study this question in the context of the protection of pilgrim travel, rather than of military events.

9 *Hedificium magnum et mirabile, ita quod impossibile videretur nisi quis videret.* Description by Nicolo de Martoni, quoted in **Gabriel** [p. 288], Vol. 1, p. 13.

10 William of Tyre, *Historia rerum in partibus transmarinis gestarum*, Book 20, Chapter 5.

11 So shown by a seventeenth-century engraving. If we are to take seriously the town map by Paulinus de Puteoli (Vatican Ms Lat. 1960, fol. 268v, printed in **Goldmann**, p. 6) the turreted central tower therein shown may perhaps be identified with this building.

CHAPTER II *Crown of Fortresses: Le Crac des Chevaliers*

The castle of Crac is fully described and illustrated in P. Deschamps, *Crac des Chevaliers* (1934). For other castles see **Benvenisti** [p. 287], W. Wiener-Muller, *Castles of the Crusaders* (1966) and T.S.R. Boase and R.L.W. Cleave, *Castles and Churches of the Crusader Kingdom* (1967).

CHAPTER III *Rhodes: The Sovereign Order*

J. Delaville le Roulx, *Les Hospitaliers à Rhodes* (1913) stops in 1421. The same period is covered by a wide variety of articles by A. **Luttrell** collected in *The Hospitallers in Cyprus, Rhodes, Greece and the West 1291–1440* (**1978**), *Latin Greece, the Hospitallers and the Crusades 1291–1440* (**1982**) and *The Hospitallers of Rhodes and their Mediterranean World* (1992); a complete history of the period by Dr Luttrell is in preparation. A. **Gabriel**, *La Cité de Rhodes* (1921) describes the city of the knights, with lavish illustrations, and may be supplemented by E. Kollias, *The Knights of Rhodes* (Rhodes 1989).

1 *Purgatorio*, canto XX, lines 86–88. 'I see the fleur-de-lys enter Anagni, and in His Vicar Christ made captive; I see him mocked a second time.'

2 Petrarch, *Liber Rerum Familiarum*, Book 15, letter 7 to the Provost of Saint-Omer, about 1352: *Rhodus, fidei clipeus, sine vulnere iacet inglorius.*

CHAPTER IV *A Medieval Grand Seigneur: Juan Fernandez de Heredia*

This chapter is wholly based on the articles by A. Luttrell in the collections cited under Chapter 3.

CHAPTER V *The Three Sieges*

E. **Brockman**, *The Two Sieges of Rhodes* (1969) describes those two events. For the period after 1522, F. **Braudel**, *La Méditerranée et le Monde Méditerranéen à l'époque de Philippe II* (1949) is essential reading. On the siege of Malta, the account of Admiral J.E. Jurien de la Gravière, *Les Chevaliers de Malte et la Marine de Philippe II* (1887) has not been bettered. It is the work of an experienced naval officer who was also an excellent historian.

A warning is due against two popular books on the siege of Malta: E. Bradford, *The Great Siege*

(1961) gives an accessible narrative but as a work of history is seriously deficient at every level; and C.E. Engel, *Le Grand Siège* (1965) not only repeats the worst errors of her predecessors but aggravates them with gross blunders of her own.

1 This is obviously a vast exaggeration, but the estimate of 15,000 given by **Brockman** seems an excess of anti-sensationalism. See K. Setton *The Papacy and the Levant* (New York, 1978), p. 352, for a brief but scholarly account which quotes contemporary estimates of ten, twelve and fifteen thousand casualties.

2 **Brockman's** estimate of 20,000 seems just as grudging as for 1480. Armies of thirty or forty thousand were common in important campaigns, and Brockman gives no evidence for such a low figure.

3 This is shown for the Langue of Provence by the figures given in **Gangneux** [p. 290], p. 893.

4 **Spagnoletti** [p. 293], p. 69, shows that 367 out of the 596 knights received in the Langue of Italy in the quarter-century 1550–75 came from states other than the Spanish dominions of Naples and Milan.

5 Iacomo **Bosio**, *Istoria della Sacra Religione . . . di San Giovanni Gerosolimitano* (1594). Bosio's uncle had been Bishop of Malta at the time of Homedes's election, and some of the stories he tells may have come down to him as family gossip. It should be borne in mind that Bosio's family exemplified the class of ennobled merchants that Homedes tried to exclude from the Order.

6 I.J. Guilmartin, *Gunpowder and Galleys* (1974), p. 183. Besides its chapter on the siege of Malta, this is a valuable book on all aspects of sixteenth-century naval warfare.

7 Ibid., p. 187, estimates 6,000 casualties, though contemporary accounts speak of 8,000.

CHAPTER VI *Malta*

No systematic history of the Malta period exists such as those for the period up to 1421, but there are good amateur accounts in E. Schermerhorn, **Malta of the Knights** (New York, 1929) and C.E. Engel, *L'Ordre de Malte en Méditerranée* (1957), *Histoire de L'Ordre de Malte* (1968) and *Chevaliers de Malte* (1972 – a collection of individual biographies). For the architecture of Malta see Q. Hughes, *The Building of Malta* (Valetta, 1956) and R. de Giorgio, *A City by an Order* (Valletta, 1985).

1 The manuscript *Ruolo Generale* in the National Library of Malta, compiled from the bulls of reception, shows the admission of 1,000 knights in the dozen years after 1565.

2 M. Fontenay, *La place de la course dans l'économie portuaire: l'exemple de Malte et des ports barbaresques*, p. 849, in the Congress *I Porti come Impresa economica* (Prato 1988).

3 List of 1635: **Spagnoletti** [p. 293], p. 66. List of 1631: **Malta of the Knights**, p. 68. Miss Schermerhorn misinterprets the absence of chaplains and sergeants in the figures for Italy by supposing that the Langue lacked those two classes.

4 *Ruolo Generale* (see note 1, above). The list of receptions in minority seems so inflated as to make exact figures unreliable; it is doubtful whether the number of receptions reflects that of the knights who really made their careers in the Order.

5 *Oeuvres du Seigneur de Brantôme*, quoted in **Malta of the Knights**, p. 181.

6 The system here described is first mentioned by **Bosio** in the election of Zacosta (*op. cit.* [p. 289], *sub anno* 1461).

7 **Brydone** [p. 294].

8 A document of Grand Master Gozon to the Castellan of Amposta Heredia, 1351, authorising him to admit knights *ex utroque parente nobili*: in **Luttrell 1982** [p. 288], *The Hospitallers of Rhodes: Perspectives, Problems, Possibilities*, p. 264. Similar documents of Grand Master de Pins to the Prior of England, 1358: A. Mifsud, *Knights Hospitallers of the Venerable Tongue of England* (Malta, 1914), p. 78.

9 **Luttrell 1982**, as in note 8.

CHAPTER VII *The Navy of the Religion*

R. Dauber *Die Marine des Johanniter-Malteser-Ritter-Ordens* (Vienna, 1989) is a magnificently illustrated history of the navy of the Order. For the *corso* see P. Earle, *Corsairs of Malta and Barbary* (1970) and numerous articles (unfortunately uncollected) by Michel Fontenay, some of which are cited below. The lack of a wider strategic view in histories of the Order and its navy makes it essential to supplement them with good general works such as, for the sixteenth century, **Braudel** [p. 288].

1 **Cartulaire** [p. 287] (Agreement between the city of Marseilles and the Templars and Hospitallers limiting the number of pilgrims they could transport to Palestine).

2 On the carracks of the Order see Michel Fontenay, *De Rhodes à Malte, L'Evolution de la Flotte des Hospitaliers au XVIe siècle* (Atti del V Convegno Internazionale di Studi Colombiani, 1987).

3 **Raybaud** [p. 290], Vol. 2, p. 193: defeat by 'six galleys of Bizerta'. Bizerta was the galley port of Tunis.

4 Michel Fontenay, 'Les Chevaliers de Malte dans le "Corso" méditerranéen au XVIIe siècle' in *Las Ordenes Militares en el Mediterráneo Occidental* (Congress of 1983 published in 1989, Madrid), p. 384.

5 Ibid., p. 393.

6 **Raybaud** [p. 290], Vol. 2, pp. 175 and 181 for the attacks, repelled with heavy losses, on Maometta (Hammamet) in 1606 and Susa in 1619.

CHAPTER VIII *Introduction*

The only general study of the Order's possessions in Europe is E. Schermerhorn, *On the Trail of the* **Eight-Pointed Cross** (New York, 1940), in which a vast amount of research is presented in a manner that can only be described as scatterbrained, especially from the topographical point of view; a searcher for Heitersheim using this volume as a guide would be taken 500 miles out of his way by the author's inability to distinguish the Breisgau from Breslau. This Introduction is otherwise based on general works and the local studies detailed under the respective chapters.

1 **Garcia Larragueta** [p. 292], Vol. 2, p. 606.

2 Ibid., Vol. 1, p. 117.

3 Details of Italian hospices from G. M. delle Piane, *San Giovanni di Prè* (1973), p. 145, 171 and **Bascapè** [p. 293], pp. 132, 224–5.

4 Indications (unfortunately very vague) of a novitiate role at Bologna in **Nasalli Rocca** [p. 292], p. 21, and at Manosque in **Reynaud** [p. 290], pp. 138, 140.

5 **Cartulaire** [p. 287], Vol. 1, No. 627.

6 Ibid., Vol. 4, No. 3308.

7 Saint-Gilles details from **Raybaud** [p. 290], Vol. 1, pp. 155, 306 and 395–96.

8 **Luttrell** 1982 [p. 288], Item I, 'The Hospitallers of Rhodes: Perspectives, Problems, Possibilities'.

9 **Raybaud** [p. 290], Vol. 2, p. 261.

10 **Du Bourg** [p. 290], p. 250.

11 Ibid., p. 400. 'That he will be to them a good lord and legal and will guard their right and their liberties and their usages and will guard them from wrong and from force of his own and of others' of his legal power.'

12 **Eight-Pointed Cross**, pp. 103, 104–5.

13 Ibid., p. 120.

14 Ibid., p. 148.

15 **Cartulaire** [p. 287], Vol. 1, No. 119.

16 **King** [p. 293], p. 69.

17 J. A. de Figueiredo, *Nova Historia da Militar Ordem de Malta* (1800), Vol. 3, pp. 145–46, quoting Juan Agustín Funes, *Crónica de la Ilustrísima Milicia . . . de San Juan* (1626).

18 **Gattini** [p. 293], p. 18.

19 Ibid., p. 65.

20 M. Fontenay, 'Le revenu des Chevaliers de Malte en France d'après les "estimes" de 1533, 1583 et 1776' in *Etudes en l'honneur de Pierre Goubert* (1984).

21 **Mannier** [p. 290], pp. 727, 734, 739.

22 **Annales** [p. 287], 1968, p. 27. 'It is difficult to believe that the said deceased was so ill supplied with clothes and without linen.'

23 **Gangneux** [p. 290], p. 898, and see also pp. 868–84 for evidence of increasing financial efficiency in the eighteenth century.

24 **Eight-Pointed Cross**, p. 83.

25 **Wienand** [p. 287], pp. 405, 408.

CHAPTER IX *The Tongues of Provence, Auvergne and France*

Four of the six French priories have been the subject of separate histories: the best is the manuscript by J. **Raybaud**, compiled from the archives of Saint-Gilles, of which he was archivist from 1722 to 1752: *Histoire des Grands Prieurs et du Prieuré de Saint-Gilles* (badly edited in 2 volumes by C. Nicolas, 1904, with a third volume by the editor taking the history to the end of the eighteenth century); the value of this work for the historiography of the Order transcends the limits of its own Priory. The other histories are M.A. **du Bourg**, *Histoire du Grand Prieuré de Toulouse* (1883), L. **Niepce**, *Le Grand Prieuré d'Auvergne* (1883) and E. **Mannier**, *Les Commanderies du Grand Prieuré de France* (3rd edn 1987). Other valuable works are A.M. Legras, *L'enquête sur l'ordre des hospitaliers* on the Priory of France in 1373, (1988), G. **Gangneux** *Les Grands Prieurés de Saint-Gilles et Toulouse de l'Ordre de Malte (Economie et Société en France Méridionale)* (1973), which studies the two Provençal priories primarily from the economic point of view but offers useful insights into many other aspects, and F. **Reynaud** *La Commanderie de . . . Manosque* (1981).

1 **Reynaud**, Appendix 1, argues, following **Raybaud**, that the saint whose relics were venerated at Manosque was not the founder of the Hospital. Since its proponents neither identify the deutero-Gerard nor explain why the references to the relics from 1283 onward fail to distinguish him from his more obvious Doppelgänger, this view must be considered implausible. On the other hand the transfer of

Gerard's bones to Provence is not proof that he was yet regarded as a native of the region, since the Order's archives were also moved there at the same time in prevision of the fall of Acre.

2 **Raybaud**, Vol. 1, p. 43.

3 **Du Bourg**, pp. 147–48.

4 Ibid., p. 586.

5 The three donations in the Albigeois, made to Brother Ancelin, which **Raybaud** dates to 1083–5 (pp. 12–13), should obviously be dated thirty years later. Ancelin was appointed to receive donations in France in 1113.

6 **Du Bourg**, pp. 28–31.

7 For the whole of this paragraph and the next see P. Ourliac, *Les Sauvetés du Comminges* (1947).

8 **Raybaud**, Vol. 1, pp. 24 and 28.

9 Ibid., Vol. 1, p. 30. The author does not say from what document he draws this information, but it is evidently earlier than the earliest comparable document in **Cartulaire** [p. 287], Vol. 1, No. 42, which lists the same six brethren and three more.

10 William of Tyre, *Historia Rerum in partibus transmarinis gestarum*, Book 16, Chapter 17. Peter of Barcelona was recalled to Jerusalem in 1119, became a canon of the Holy Sepulchre, was elected Prior of that order in 1130 and Archbishop of Tyre in 1158, and died about 1164.

11 He is named as one of the leading brethren of the Hospital in Jerusalem on 30 December 1120: **Cartulaire** [p. 287], Vol. 1, No. 53.

12 G. Gangneux, *L'Ordre de Malte en Camargue*, p. 21.

13 **Raybaud**, Vol. 1, pp. 107, 109, 118, 147 and 165.

14 **Annales** [p. 287], 1966, pp. 51–57: Aristide Donnadieu, *La participation des Frères de Saint Jean de Jérusalem à la restauration économique et sociale de la France à la fin de la Guerre de Cent ans*.

15 For the events at Beaulieu see J. Juillet *Les Dames Maltaises en Quercy-Turenne* (1966) and **Annales** [p. 287], 1976, p. 31. Accounts of the dispute gathered from the Order's side (for example in **Du Bourg**) should be treated with caution. It is worth noting that the brother of the Comte de Vaillac who supported his efforts to keep control of Beaulieu was an active Bishop of Tulle for fifty-three years who did much to strengthen the religious life of his diocese.

16 **Cartulaire** [p. 287], Vol. 1, No. 138 (Robert appears as *Dapifer* in 1141); No. 144 (he is mentioned next to Raymond du Puy in the donation of Crac to the Order). I am indebted to Professor J. Riley-Smith for this identification.

17 Comte de Toulgoët-Tréanna, *Les Commanderies de Malte en Berry* (1909), p. 46.

18 **Raybaud**, Vol. 1, p. 149.

19 **Niepce**, p. 227.

20 Ibid., p. 212 for the agreement of 1313 reapportioning commanderies.

21 P.F. Guélon, *Histoire de La Sauvetat Rossille* (1882).

22 Quoted in **Eight-Pointed Cross** [p. 290], p. 279: 'Eighteen boys of lovely figure, each one the son of a *Ban*, hold in their ravishing hands the glass of gold full of sparkling wine.' *Ban* is a Slavonic title translated as Margrave.

23 **Eight-Pointed Cross**, pp. 108 and 262–63.

24 **Raybaud**, Vol. 2, p. 235.

25 **Annales** [p. 287], 1962, pp. 18–24: Edmond Ganter, *L'Action apostolique de Jacques 1er de Cordon d'Evieu*.

26 The figures are taken from **Niepce**, pp. 173, 175; other details from the *Liber Conciliorum Status* 1776–89 (National Library of Malta). The account given by **Cavaliero** [p. 294], p. 44, illustrates that author's determination to substitute an *a priori* thesis of decline for the historical facts. He calls the pensions to the ex-Antonines 'a crushing annual burden of 62,000 *livres*' (this was only £2,583), inflates the compensation to the Order of St Lazarus to one million *livres*, alleges mysteriously that 'the union cost the Order 300,000 *livres* a year before the National Assembly confiscated the French commanderies in 1792', and forgets to mention that the Order received any revenue from the acquired property.

27 **Eight-pointed Cross**, p. 89. No reference is given for the statement. The *arpent* of the Ile-de-France was almost identical with the English acre. The donation of Montboire in Brabant, traditionally attributed to Godfrey of Bouillon (1100), was in fact made by Godfrey III of Lorraine in 1183.

28 **Mannier**, pp. 449, 720, 523 and 342.

29 Ibid., pp. 638–39: 'brought many people who at the said Marais were assembled, whom at the same place he made to dance, to carol, to pipe, to turn, and commanded to stop, and gave a pair of gloves to one named Honnerelle de Vaulx, as the fairest and the best dancer: which thing, Messire Enguerran did or had done without the permission or licence of the religious'.

30 Item XVI, *Fourteenth-century Hospitaller lawyers*, in **Luttrell 1978** [p. 288].

31 *La grande et merveilleuse et très cruelle oppugnation de la noble cité de Rhodes* (1525).

CHAPTER X *The Tongues of Aragon and Castile*

Two of the Spanish priories have attracted scholarly studies: J. **Miret y Sans**, *Les cases dels templers y hospitalers en Catalunya* (1910) and S. **Garcia Larragueta**, *El Gran Priorato de Navarra ... Siglos XII–XIII* (1957), supplemented for the fourteenth century by the same writer's 'La Orden de San Juan en Navarra. Siglo XIV' in *Las Ordenes Militares en el Mediterráneo Occidental* (Congress of 1983, published in 1989, Madrid). P. **Guerrero Ventas**, *El Gran Priorato de San Juan en el Campo de La Mancha* (1969) is concerned with the prioral territory rather than the whole Priory of Castile. For Portugal the Conde de **Campo Bello's** *A Soberana Militar Ordem de Malta e a sua acção em Portugal* (1931) is a popularisation of the scholarly but laborious J.A. de Figueiredo, *Nova Historia da Militar Ordem de Malta ... en Portugal* (1800).

1 **Miret y Sans**, pp. 24, 29.
2 **Garcia Larragueta**, p. 49.
3 Ibid., p. 38.
4 C. de Ayala Martínez, 'Orígenes de la Orden del Hospital en Castilla y León (1113–1157)' (a paper kindly communicated to me by Professor de Ayala before its publication in *Homenaje al profesor D. Luis Suárez Fernández*).
5 *Cartulaire* [p. 287], Vol. 1, No. 89. It may be plausible to connect this first appearance of an armed role with the initiation of the Order's work on the pilgrim route of Compostella three years earlier.
6 **Miret y Sans**, p. 24.
7 Ibid., p. 206.
8 Ayala Martínez (see Note 4, above).
9 For this paragraph see R. de Azevedo, 'Algumas achegas para o estudo das origens da Ordem de S. João ... em Portugal', in *Revista Portuguesa de Historia*, IV (1949). This article is an essential complement to the works of Campo Bello and Figueiredo for the twelfth century.
10 **Campo Bello**, p. 47. The Prior was one of the five prelates whom Sancho I made custodians of his will.
11 C. de Ayala, 'Alfonso X y la Orden de San Juan de Jerusalén' (unpublished paper for the Symposium of the Order of Malta in Madrid, March 1990).
12 Cf. **García Larragueta**, p. 137. Ferrán Perez Mozego, Prior of Castile 1279–85, Grand Commander of Spain 1285–93, 'a man of great understanding and frankness and of very good life'.
13 **Raybaud** [p. 290], Vol. 1, pp. 222, 256. In view of the succession of Navarrese priors from 1317 (implementing the conditions of transfer) the date 1314 seems probable for the annexation of Navarre to the Langue of Provence. This measure has escaped the notice of Garcia Larragueta (article cited above: 'La Orden de San Juan en Navarra, Siglo XIV'). The spelling of the names of the Provençal priors given in his list should be corrected as follows: 1297, Jourdan de Calderac; 1302, Guy de Severac; 1312, Pierre de Calderac; 1342, Guérin de Châteauneuf; 1348, Marques de Gozon; 1349, Austorge de Caylus.
14 **Raybaud** [p. 290], Vol. 1, p. 322.
15 **Miret y Sans**, p. 220; the house had previously been governed by male commanders.
16 W. Oakeshott, *Sigena – Romanesque Paintings in Spain and the Winchester Bible Artists* (London, 1972).
17 The best books on Sijena are J. Arribas Salaberri, *Historia de Sijena* (1975) and A. Ubieto Arteta, *El Monasterio Dúplice de Sijena* (Issue 1 of *Cuadernos Aragoneses de Trabajo*, published by the Instituto de Estudios Altoaragoneses, 1986 – a good monograph despite the error enshrined in the title). On Alguaire, J. Lladonosa i Pujol, *Historia de la Vila d'Alguaire i el seu Monestir Santjoaniste* (1981). J.M. Palacios Sanchez, *La Orden de San Juan y sus Monasterios de Religiosas en España* (1977) gives a general account of the Spanish convents.
18 See C. Barquero Goñi, unpublished paper, 'La Orden de San Juan en Castilla segun la Cronística Medieval (Siglos XII–XIV)' for the Symposium of the Order of Malta in Madrid, March 1990).
19 F. Fernandez Izquierdo, 'La Orden de Calatrava en la Edad Moderna', in *Las Ordenes Militares en el Mediterráneo Occidental* (Congress of 1983, published in 1989, Madrid), p. 197, gives the following figures of knights in 1572: Calatrava, 175; Alcantara, 60; Santiago, 310. At this period the number of Castilian and Aragonese Knights of Malta was in the region of 300.
20 For this and the next two paragraphs see J. Finat y Walford, 'Los tres últimos Grandes Priores de Castilla y León' (unpublished paper for the Symposium of the Order of Malta in Madrid, March 1990).
21 The *Ruolo Generale* of the Order for 1895 includes the names of 230 Spanish knights received between 1840 and 1867.

CHAPTER XI *The Tongue of Italy*

The commanderies of northern Italy have been admirably studied by E. **Nasalli Rocca** di Corneliano, 'Istituzioni dell'Ordine Gerosolimitano nell'Emilia e nella Romagna' (in *Rivista di storia del diritto italiano*,

Vol. 14) and G.C. **Bascape**, 'L'Attività Ospitaliera dell'Ordine si San Giovanni Gerosilimitano nel Medio Evo' (in *Rivista Araldica*, 34 (1936). L. Tacchella has added studies such as *I Cavalieri di Malta in Liguria* (1977). A. di **Ricaldone**, *Templari e Gerosolimitani di Malta in Piemonte* (1979) is essentially a compilation of documents, mainly from the seventeenth century. For the south there is M. **Gattini**, *I Priorati, i baliaggi e le commende del Sovrano Militare Ordine di San Giovanni nelle provincie meridionali d'Italia* (1928), and C. **Marullo** di Condojanni, *La Sicilia ed il Sovrano Militare Ordine di Malta* (1953). For the Middle Ages, a work of general utility is M. Roncetti, P. Scarpellini and F. Tommasi (eds), **Templari e Ospitalieri in Italia** (1987), especially a chapter by A. Luttrell with the same title as the book's. An excellent general study is A. **Spagnoletti**'s *Stato, Aristocrazie e Ordine di Malta nell' Italia Moderna* (*Collection de l'Ecole Francaise de Rome III*, 1988).

1 **Marullo**, p. 11.
2 What is not to be adduced in support of this view is the error made with astonishing parochialism by several Italian writers who run together the names of Saint-Gilles and Asti in the list of hospices given by the bull *Pie postulatio voluntatis* (*. . . Burgum Sancti Aegidii, Asten, Pisam . . .*) and search for a Borgo Sant'Egidio in which to locate the Hospital of Asti. It should be borne in mind, though, that the jurisdiction of the Dauphins of Albon, whose donation at Gap in 1112 perhaps made possible the foundation of Saint-Gilles (see p. 117), extended over the Alps almost to the frontiers of Asti.
3 **Ricaldone**, Vol. 2, p. 669.
4 L. Villari, 'San Gerlando d'Alemanna nella Sicilia del duecento', in the *Rivista Internazionale* of the Order of Malta, Dec. 1991, citing the same writer's *Storia Ecclesiastica della Città di Piazza Armerina* (1988).
5 **Gattini**, p. 75, and cf. **Wienand** [p. 287], p. 279.
6 This is the grant misdated by **Bosio** [p. 289] under 1120. The Grand Master Roger mentioned in the document is obviously Roger des Moulins (1177–87).
7 See L. Tacchella, *Le Donate nella Storia del Sovrano Militare Ordine di Malta* (1987), p. 35. Though she is often known as St Toscana, she was only beatified (in 1568: see E. Schermerhorn, 'Notes on the Commanderies of the Grand Priory of Venice', in *Archivum Melitense*, 9, No. 3, 1934).
8 F. Tommasi, 'Il Monastero Femminile di San Bevignate', in **Templari e Ospitalieri in Italia**, p. 53.
9 **Cartulaire** [p. 287], Vol. 4, No. 3308.
10 **Gattini**, p. 72.

11 A. Luttrell, in **Templari e Ospitalieri in Italia**.
12 **Gattini**, p. 107: there was a lay Count of Alife by 1384; subsequently the Order's properties at Alife were of little importance and belonged to the commandery of Boiano.
13 See **Raybaud** [p. 290], Vol. 1, p. 304, and **Gattini** p. 20 for Ettore d'Alemagna, Bailiff of Naples in 1428. Giacomo d'Alemagna was Pilier of Italy in 1420.
14 Lists of knights at the Great Siege are given by **Bosio** [p. 289] *sub anno* 1565. Statistics for 1565–1600 are taken from the manuscript *Ruolo Generale* of the Order in the National Library of Malta.
15 **Malta of the Knights** [p. 289], p. 158.
16 **Peyrefitte** [p. 295], Part 1, Chapter 6.
17 **Spagnoletti**, pp. 56–91 *passim*. The author inexplicably takes the *Ruolo* of 1789 as a record of all the knights who had entered since 1719, a mistake which somewhat distorts his statistical conclusions.
18 **Gattini**, p. 164: there were 61 commanderies in the three Neapolitan priories by 1791, compared with the 39 of earlier lists; and see ibid., pp. 7, 14, 62, 63, 71, 133 and 164 for details of new creations.

CHAPTER XII *The Tongue of England*

A general history is given by E. **King**, *The Knights of St John in the British Realm* (revised by H. Luke, 1967). The material status of the Hospitallers in the three kingdoms is described in the following volumes of the series *Mediaeval Religious Houses*: D. **Knowles** and R.N. **Hadcock**, *England and Wales* (1953), J. Cowan and D. Easson, *Scotland* (1976) and A. Gwynn and R.N. Hadcock, *Ireland* (1988). More scholarly than **King** are J.B. Cowan, P.H.R. Mackay and A. Macquarrie, *The Knights of St John of Jerusalem in Scotland* (1983) and W. Rees, *A History of the Order of St John of Jerusalem in Wales and on the Welsh Border* (1947). For Ireland I have relied on Sir L. Monson, 'The Knights Hospitallers in Ireland' (talk given to the St John Historical Society, Clerkenwell, in November 1984).

I am greatly indebted to Miss Pamela Willis, Curator of the Museum and Library of the Order of St John, for making available to me the material for her forthcoming gazetteer of the English Hospitaller properties. On the Anglo-Bavarian Langue see **Cavaliero** [p. 294], pp. 144–48, 159–61 and 170–1.

1 H.M. Chew, *The Priory of St John* (manuscript history in the Butler Papers at the Museum and Library of the Order of St John), p. 1: an act of

the English Priory is ratified by the Prior of Saint-Gilles in 1184/5.

2 M. Gervers, *The Cartulary of the Knights of St John of Jerusalem in England* (1982), p. LX.

3 **Knowles & Hadcock**, p. 494.

4 Ibid., p. 284 and cf. figures for other convents, pp. 253–86.

5 **Cartulaire** [p. 287], Vol. 4, No. 3308.

6 **Knowles & Hadcock**, p. 494.

7 Ibid., p. 305.

8 **Annales** [p. 287], 1964, pp. 59–68: D. Calnan, *Some Notes on the Order in Scotland*.

9 P.J.C. Field, 'Sir Robert Malory, Prior of the Hospitallers of St John of Jerusalem in England (1432–1439/40)', *Journal of Ecclesiastical History*, Vol. 28 (1977).

10 A. Mifsud, *Knights Hospitaller of the Venerable Tongue of England* (Malta, 1914), pp. 175–77.

11 See **Toumanoff** [p. 295], pp. 93–110.

CHAPTER XIII *The Tongue of Germany*

The history of the Langue of Germany is admirably described in **Wienand** [p. 287] especially pp. 282–408, with individual histories of selected commanderies. For the peripheral areas I have supplemented this account from three articles in **Annales** [p. 287]: J.M. van Winter, 'Les Archives de L'Ordre de Malte à La Valette et les Pays-Bas Septentrionnaux' (1965, pp. 156–61); T.H. Olsen, 'The Priory of Dacia' (1960 October–December, pp. 20–33); and B. Szczesniak, 'The Modern Knights of Malta in Poland' (same issue, pp. 10–14).

1 Wienand, p. 286 gives 1345 as the date, but it might seem more plausible to link this grant with the appointment of Montreal d'Albar as Prior of Hungary in 1348 (see above, p. 166)

2 **Malta of the Knights** [p. 289], p. 233.

3 *The New Cambridge Modern History*, Vol. 6, p. 582.

4 Baroness d'Oberkirch, *Memoirs* (1852), Vol. 1, p. 75. 'He was very rich, spent a great deal of money, and his luxury glittered over the whole of Germany.'

5 **Doublet** [p. 294], pp. 114–15.

6 P.M. Boisgelin de Kerdu *Ancient and Modern Malta* (1804): the Order's accounts printed at the end show that the income from responsions was reduced from the intended 500,000 *scudi* to 467,757.

CHAPTER XIV *Our Lords the Sick*

Of all aspects of the Order's history the most inadequately covered is its religious tradition, for which one is reduced to gathering scattered information in general works; next to it comes its medical history, at least as far as the first two centuries are concerned: E.E. **Hume**, *The Medical Work of the Knights Hospitallers of St John of Jerusalem* (1940) is to be preferred to the amateurish and diffuse I. Pappalardo *Storia sanitaria dell'Ordine Gerosolimitano di Malta* (1958), but both these studies need to be supplemented with general works such as the article by E.J. Kealy, 'Hospitals and Poor Relief', in the *Dictionary of the Middle Ages* (New York, 1985). The paper by A. Luttrell, 'The Hospitallers' Medical Tradition, 1291–1530' for the Congress of the London Centre for the Study of the Crusades (September 1992) became available too late for use in this book. For the Malta period there is the excellent P. **Cassar**, *Medical History of Malta* (1965).

1 William of Tyre, *Historia rerum in partibus transmarinis gestarum*, Book 7, Chapter 23.

2 **Cartulaire** [p. 287], Vol. 1, No. 70. This Rule may be as late as 1153.

3 Ibid., No. 46.

4 Ibid., No. 627.

5 Account of Jacques le Saige *c.*1520, quoted in **Gabriel** [p. 288], Vol. 1, p. 36.

6 **Cassar**, p. 300: the *Code de Rohan* declares that the health 'of all Italy and of various other Christian states' depends on the Malta lazaretto.

7 Manuscript *Usages et Ethiquettes observées à Malte, à la Cour du Grd Maitre* (1762) in the National Library of Malta, *Libr.* 291.

8 **Cassar**, p. 60.

9 **Raybaud** [p. 290], Vol. 2, p. 218.

10 C. Engel, *Chevaliers de Malte* (1972).

11 **Doublet** [p. 294], p. 69.

CHAPTER XV *The Closed Crown*

There are numerous eighteenth-century travellers' descriptions of Malta, the best being P. **Brydone**, *A Tour through Sicily and Malta* (1774) and J.M. Roland de la Platière, *Lettres écrites de Suisse . . . et de Malte* (1783). L.-O. **Doublet**, *Mémoires historiques* (1883) and A. Lacroix, *Déodat de Dolomieu* (1921: a collection of his correspondence) are important original sources, but it should be borne in mind that they are written by two men who betrayed the Order; the acceptance of their point of view by C. Engel in her three books (see p. 289) gives a perverse slant to her narrative. R. **Cavaliero**, *The Last of the Crusaders* (1960) gives a

full picture of the Order's life in the eighteenth century but is a classic example of amateur histories which impose a preconceived notion of decline on the historical facts, many of which are misrepresented.

1 'I cannot be king, I deign not to be duke, I am Rohan.'
2 Details of the court from the manuscript *Usages et Ethiquettes observées à Malte, à la Cour du Grd Maitre* (1762), National Library of Malta, *Libr.* 291.
3 N. Viton de Saint-Allais, *Histoire de l'Ordre de Malte* (1838), p. 202, is the only author to mention this increase (without giving a date), but the list of knights he gives also shows a brief inflation in the number of pages in the 1750s.
4 **Doublet**, p. 50. 'She is, my faith, pretty enough to paint' (or 'to gobble up'). 'Yes, if she hadn't been already.'
5 In 1740 there were 2,240 knights in the Order (C. Testa, *The Life of Grand Master Pinto*, Malta, 1989, p. 29, quoting the contemporary *Etat Curieux et militaire de l'Ordre de Malte pour l'année 1741*), compared with 1,715 in 1635 (see above, p. 77). There is no complete census for the later eighteenth century, but the 1,007 knights of the three French Langues in 1778 listed by Saint-Allais (see Note 3, above) and the 652 Italian knights in the *Ruolo* of 1789 (in **Spagnoletti** [p. 293], p. 56) point to an even larger number at that period. Fragmentary records of admission (e.g. **Gangneux** [p. 290], p. 893, for Provence) show increasing recruitment in the 1770s and 1780s.
6 Letter of Montesquieu to the *abbé* Conte di Guasco, 9 April 1754: 'It is perhaps the worthiest Order that exists in the world, and the one which contributes most to the maintenance of the honour and bravery of all the nations where it is disseminated.'
7 Letter of 24 November 1787 to the Marchese Sagramoso, quoted in **Cavaliero**, p. 175.

CHAPTER XVI Ruit Alto a Culmine Troia

For the period 1789–1830 we have in Comte Michel de **Pierredon**, *Histoire Politique de l'Ordre de Malte depuis la Révolution Française* (Vols 1 & 2, 1956 and 1963) the only well-documented study of any period of the Order's history after 1421. M. Galea in *German Knights of Malta* (Malta, 1986), includes a very full chapter on Grand Master Hompesch. An equally thorough study of the rule of Paul I of Russia is provided by C. **Toumanoff** and O. de Sherbowitz-Wetzor, *L'Ordre de Malte et l'Empire de Russie* (enlarged edition, Rome, 1979).

1 **Doublet** [p. 294]: 'If he had lived a year longer, ill and in pain as he was, he would have perished in the breach sooner than sign the surrender of Malta as his successor did.'
2 The preamble to the instrument of surrender declares it to have been negotiated 'sous la médiation de Sa Majesté Catholique le roi d'Espagne, représentée par M. le chevalier Filipe Amat, son chargé d'affaires à Malte'. Frisari is merely named as one of the representatives of the Order.
3 Tacitus, *Histories*, III, 84, 4, on the last days of Vitellius.
4 Letter of Nelson to Earl Spencer, First Lord of the Admiralty, 4 June 1799.

CHAPTER XVII Resurgence

Pierredon [p. 295], Vol. 2 is the main source for the years to 1830. For the subsequent period until modern times his third volume (1990) is not as valuable as **Wienand** [p. 287], especially Chapter 11.

1 The very hostile treatment of Caracciolo in **Pierredon**, Vol. 2, is not justified by the evidence he presents. A more favourable glimpse is offered by N.E. Ihre, 'L'Offre du Roi Gustave IV Adolphe de Suède de l'île de Gottland a l'Ordre S.M. de Malte' in **Annales** [p. 287], 1963, p. 71. Caracciolo had been the Order's ambassador to Naples and had been named Lieutenant of the Order by Pius VII in 1802 while he was looking for a knight on whom to confer the Grand Mastership, though Soltykoff's refusal to hand over the government until Tommasi accepted the office made the appointment nugatory.
2 Tacitus, *Agricola*, Chapter 42: *Proprium humani ingenii est odisse quem laeseris*, 'It is a pecularity of human nature to hate a person whom one has injured.'
3 D. Heffernan, *Sir George Bowyer* (1987).

CHAPTER XVIII An Intrigue in the Vatican

R. Peyrefitte, *Les Chevaliers de Malte* (1957) is a uniquely valuable source for the accuracy of its information and its uninhibited presentation. Nevertheless its strong anti-Vatican bias makes it essential to balance this book with the contemporary press reports, of which the best are those of Jean L'Hôpital which appeared in *Le Monde* between January 1952 and May 1962.

1 J. Cooney, *The American Pope* (1984), p. 39.
2 R.J. Gannon *The Cardinal Spellman Story* (1963), p. 59.
3 See the bull *Pastoralium Nobis* granted by Pius VI on 31 August 1779.
4 From the article, 'Les Chevaliers de Malte en conflit avec le Pape', in *La Presse*, 23 March 1957.

CHAPTER XIX *The Modern Order*

Wienand [p. 287] gives a full description of the present status and activities of the Order. The **Annales** [p. 287] have been continued since 1978 by the *Rivista Internazionale* published by the Order and giving news of its work.

1 E. Bradford, *The Shield and the Sword* (1972), pp. 221–22.
2 This letter is reproduced in **Toumanoff** [p. 295], Appendix I.
3 On the imitation Orders of Malta see A. Chaffanjon and B. Galimard Flavigny, *Ordres et Contre-Ordres de Chevalerie* (1982). The photographs are especially recommended.
4 See the *Observer* (London) 15 March 1987: 'Unchivalrous world of the bogus Knights' (report by Martin Bailey).
5 M. Baigent, R. Leigh and H. Lincoln, *The Messianic Legacy* (1986), Chapter 24, Section 4.
6 Address to the Chapter General of the Order held on 7 March, quoted in the *Rivista Internazionale*, December 1989, p. 4.

INDEX

297